Luxury Arts of the Renaissance

Luxury Arts
of the Renaissance

MARINA BELOZERSKAYA

THE J. PAUL GETTY MUSEUM
LOS ANGELES

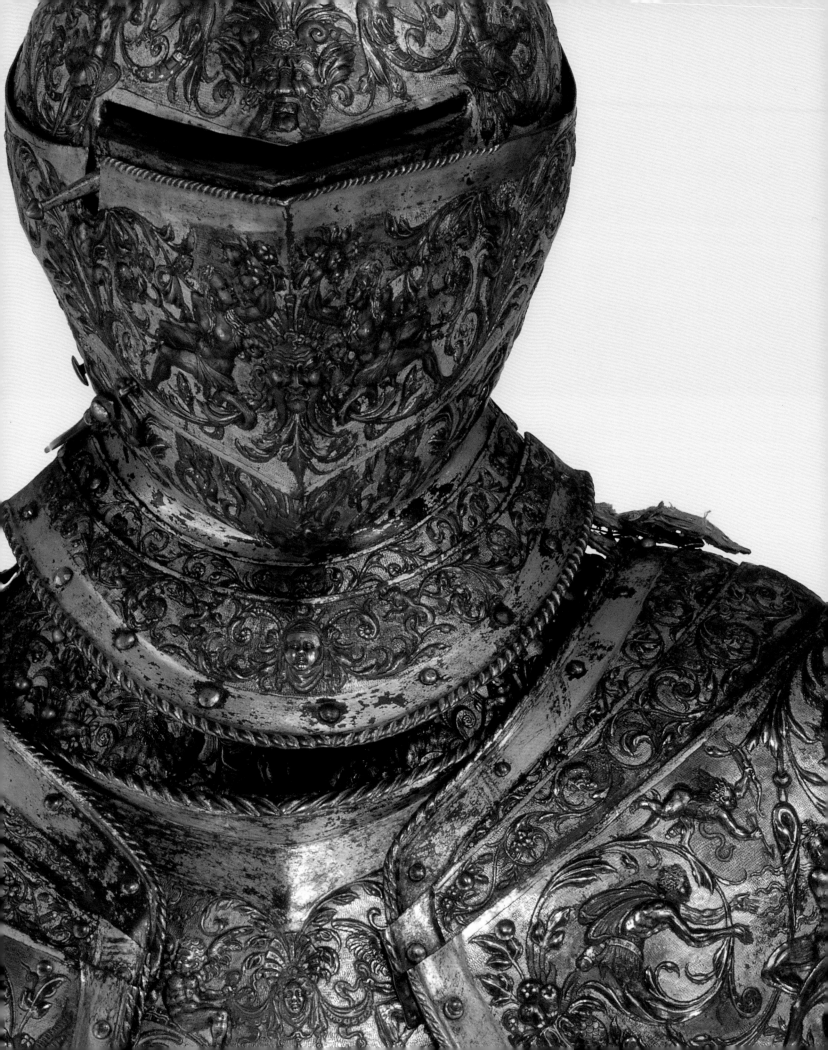

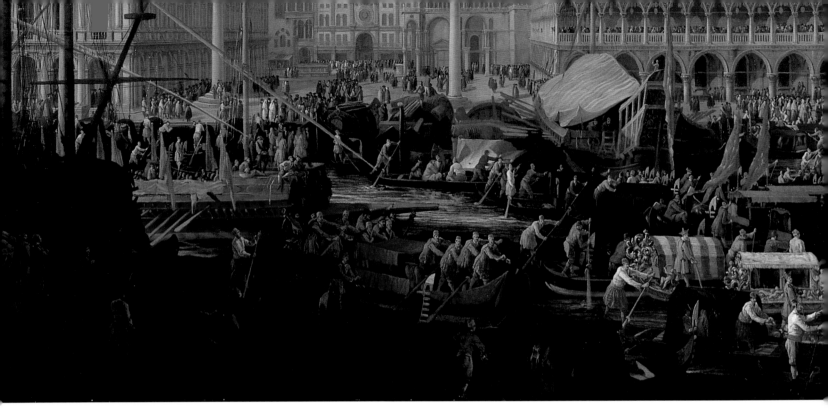

Contents

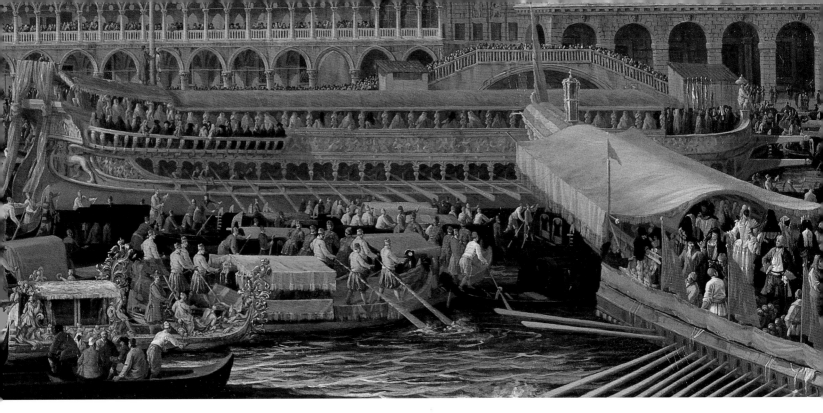

Abbreviations

attr.	attributed to
ca.	circa
ch.	chapter
cm	centimeter
DIAM.	diameter
ed./eds.	edited by/editors
edn.	edition
exh. cat.	exhibition catalogue
fl.	flourished
ft.	foot/feet
H.	height
kg	kilogram
lbs.	pound(s)
m	meter
r.	ruled
RMN	Réunion des Musées Nationaux, France
trans.	translated/translator
w.	width
WT.	weight

Acknowledgments

To my parents and grandparents

The luxury of writing this book in one uninterrupted stretch was made possible by the Bunting Fellowship at the Radcliffe Institute for Advanced Study, where I spent two wonderful years in a most supportive and inspiring environment. I am especially indebted to the enthusiastic encouragement of Rita Brock and to the kindness of Charles Cohen, Mary Dunn, John Oliver Hand, Joseph Leo Koerner, James Marrow, and Irene Winter. For inspiration early in this project I am grateful to Pat Berman, and for fruitful conversations and generous sharing of knowledge and information to Martha Buskirk, Alice Donohue, Eric Garberson, Graham Larkin, Miranda Marvin, Mark Meadow, Andrew McClellan, Stephanie Schroeder, Jeanne Vanecko, and Thomas Willette. Michael Vickers's thorough reading of the manuscript was most helpful and encouraging. Benedicte Gilman, with her eagle eyes and extraordinary efficiency, transformed the raw manuscript into a clean and consistent copy. She has also offered a great deal of enthusiastic support throughout the production process. Louise Barber's close proofreading caught some important discrepancies. Karin Lanzoni, Aria Cabot, and Marcia Reed provided valuable assistance with gathering images. Kurt Hauser made the book into a marvelous work of art. And Mark Greenberg and Kara Kirk gave it life at Getty Publications.

Every thought and word that went into this project have been enriched by the sharp mind and loving heart of Kenneth Lapatin, my greatest treasure.

My parents' and grandparents' pride and affection, as well as timely offers of wisdom and moral support, are cherished gifts, and to them I dedicate this book.

Prologue

Luxury has always been a charged and politicized concept. Archaic Greek aristocrats extolled it as an embodiment of their class and refinement, while in the aftermath of the Persian Wars the Athenians condemned it as soft, Eastern, and undemocratic. Ancient Romans reviled the opulence of the Etruscans, yet they staged huge public displays of imperial riches and supremacy during triumphs of Roman generals returning from foreign campaigns with spoils pillaged from vanquished nations. In medieval Europe, Saint Bernard of Clairvaux (1090–1153) criticized the splendid adornment of churches as corrupting, seducing the faithful with sensual pleasures, and leading them away from God. But Suger, the Abbot of Saint Denis (1081–1151), proclaimed the necessity of sumptuously embellishing the house of God in order to honor Him and to glimpse the radiance of Heavenly Jerusalem. This dichotomy persisted through the thirteenth, fourteenth, and fifteenth centuries, when pilgrimage centers and even churches of the mendicant orders were clad in gold, precious stones, and sumptuous textiles and resonated with exquisite music, while their sculptural and pictorial decorations and the sermons delivered in these churches condemned the sins of pride, vanity, and luxuria. The governments of Renaissance cities, from London to Venice, passed sumptuary laws to curtail extravagant spending on private luxuries ranging from clothes and jewels to banquets and wax candles; but when important foreign guests came to town, citizens were called upon to parade their wealth to impress visitors. Even in the Age of Enlightenment, as anti-monarchical sentiment propelled France toward revolution, leading thinkers defended luxury as a necessity for the well-being of the state. Luxury, in other words, has forever been a subject of contention: a mark of status and authority, a source of sensual and intellectual delights; but also a temptation to be shunned, a superfluity to be shed, a waste of resources that might be distributed more equitably. The very word *luxury* evokes strong emotions, whether desire or disgust, and seems to preclude a neutral response.

This book explores luxury arts as functional entities and looks at the practical purposes for which particular materials and artifacts were employed at the specific moment in time we call the Renaissance. The purpose of this voyage into the past is, not to judge anachronistically an era distant and different from ours, but rather to strive to recover and discover alternate modes of thinking and living and thereby to expand our horizons—the true reward of all travel.

In the fifteenth and sixteenth centuries, European elites viewed and used luxury arts as symbols that maintained, for better or worse, an established social order. They formulated their political and moral philosophy on a complex system of values sanctified by the Bible and ancient Graeco-Roman texts. The luxurious practices and display of luxury artifacts were incumbent on particular individuals because of their rank and social obligations. This principle had been set forth by Aristotle in his *Nicomachean Ethics*:

> Magnificence is an attribute of expenditures of the kind which we call honourable, that is those connected with the gods—votive offerings, buildings, and sacrifices—and similarly with any form of religious worship, and all those that are proper objects of public-spirited ambition, as when people think they ought to equip a chorus or a trireme, or entertain the city, in a brilliant way. But in all cases . . . we have regard to the agent as well and ask who he is and what means he has; for the expenditure should be worthy of his means, and suit not only the result but also the producer. Hence a poor man cannot be magnificent, since he has not the means with which to spend large sums fittingly. . . . But great expenditure is becoming to those who have suitable means to start with, acquired by their own efforts or from ancestors or connections, and to people of high birth and reputation, and so on; for all these things bring them greatness and prestige. . . . A magnificent man will also furnish his house suitably to his wealth . . . , and will spend by preference on those works that are lasting.[1]

Aristotle's prescription—viewed in the Renaissance through the prism of Cicero's discussion of the four cardinal virtues required of the *vir virtutis* (virtuous man) and through the scholastic elaborations of Thomas Aquinas and other Christian fathers—was repeatedly applied by eulogists and political theorists, not only to the just and honorable behavior of a ruler, but specifically to the visual and auditory creations with which he expressed his sovereignty.[2] These creations were viewed, not as luxuries in a sense of superfluity, but as expressions of dignity befitting the great. This book explores the very artifacts that constituted necessary and becoming manifestations of the virtuous man (and, more rarely, woman, for few women enjoyed equal political and economic opportunities). As Katie Scott notes in regard to the continuation of this phenomenon in eighteenth-century France,

> Today we are apt to view modes of expenditure as commensurate with levels of wealth rather than position or status, and to interpret choices of goods in terms of the satisfaction they may offer to personal and psychological needs rather than to social ones. Such a perception of con-

sumer patterns was largely alien to eighteenth-century society. For the *ancien régime*, consumption in its widest sense was not a matter of personal and private gratification but a public act of social responsibility; public because it offered itself to the scrutiny, judgment and even regulation of society; social because it customarily conformed to collectively arbitrated standards.[3]

The creations deemed magnificent and essential to exalted actors and contexts in fifteenth- and sixteenth-century Europe were not those we typically associate with Renaissance Art—paintings and sculptures first and foremost—but rather other products of artistry and imagination that have received far less attention in standard art-historical surveys: goldwork and carvings in precious and semiprecious stones, tapestries and armor, music, and ephemera ranging from sugar sculptures to parade floats. These artifacts inspired respect and wonder and communicated vital social, political, and religious concepts and aspirations through a combination of their valuable materials and the forms into which they were shaped. Thus, this volume offers a somewhat different perspective on the seemingly familiar Renaissance, as it aims to decipher the system of values and beliefs that underlay the period's appreciation for and consumption of luxury arts.

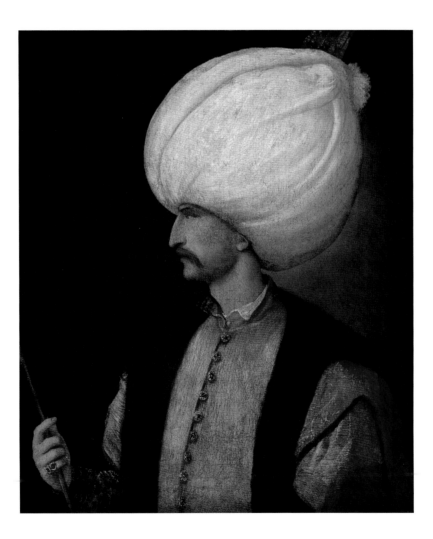

Fig. 2.
Attributed to TITIAN
(Italian, 1488 or
1490–1576), *Sultan
Süleyman the Magnificent*,
ca. 1530–1540. Vienna,
Kunsthistorisches Museum,
Gemäldegalerie, inv. 2429.

The Renaissance is, of course, itself a complex idea, and one re-formulated by each generation of students and admirers. The period covered here is roughly 1400 to 1550, from the flourishing of courts in the fourteenth century to the rise of superpowers in the first half of the sixteenth. Of course, styles of painting, sculpture, metalwork, weaving, and music evolved considerably over the one hundred and fifty years. Their transformations have been chronicled exhaustively in countless volumes. Nonetheless, despite advances in pictorial realism, the development of linear perspective, and the adoption of classicizing imagery, rulers of Church and state from the fourteenth to the sixteenth century continued to perceive and manifest their power in essentially similar ways, as well as to invoke historical precedents. Henry VII Tudor (1457–1509), for example, celebrated the wedding of his son, Prince Arthur, in 1501, by staging banquet entertainments and chivalric tournaments that deliberately echoed the famed wedding of the fourth duke of Burgundy, Charles the Bold (1433–1477; fig. 1), almost half a century earlier. Ferdinand II of Tirol (1529–1595), in his turn, exhibited the glory of the Habsburg dynasty by assembling an encyclopedic collection of arms and armor that stretched back a century and a half.

Because a social history of luxury arts is best approached thematically, the material featured in the following chapters is arranged, not as a progressive march through time, but as case studies that illuminate ideas and practices characteristic of the period as a whole.

Studies of Renaissance visual culture commonly treat regional traditions separately. Yet Renaissance courts and urban centers were closely bound into an international community through dynastic marriages, alliances, enmities, economic ties, and religious concerns. Princes and governments vigilantly watched each other's undertakings through their ambassadors and spies, scholars and merchants, and vied in their expressions of magnificence so as to maintain or augment their power and prestige. They competed with one another by visual means that were readily understood at home as well as abroad. Thus when Cosimo I de' Medici (1519–1574) was informed by his diplomats that his delegation looked shabby at the court of his future father-in-law, the viceroy of Naples, he responded by furnishing his palace with new splendor and establishing his own tapestry industry in Florence. Meanwhile, as the Ottoman sultan Süleyman I (1494/95–1566; fig. 2) advanced on Belgrade in 1532, he wore European regalia that emulated and upstaged his primary foes, the Holy Roman emperor and the pope.

In light of the chronological and geographical fluidity of material presented throughout this book, the division of media into separate chapters may, perhaps, seem arbitrary, for different artifacts answered the same needs. A gold reliquary offered to a church proclaimed its donor's faith, status, and wealth as much as a tapestry woven in gold, silver, and silk threads. By the same token, each art form served multiple needs. A splendid choir of musicians attested to a ruler's piety, magnificence, and learning. All the creations addressed here, moreover, functioned in ensembles, striving to affect the perceptions and emotions of their viewers through richly layered messages and displays. Separate treatment, nonetheless, permits a more detailed and orderly discussion of particular meanings and uses of goldwork and precious stones, tapestries and armor, music and ephemeral creations. To convey something of the multi-sensory deployment and reception of Renaissance arts, the concluding chapter brings together different media to demonstrate how they articulated key political and religious moments, such as

the summit between the kings of England and France at the Field of Cloth of Gold, where the two monarchs feasted, jousted, and prayed in utmost splendor.

A study of luxury arts necessarily focuses on the lives and concerns of the most lofty patrons. But we would do well to recall that there was no such thing as poor man's art in the Renaissance. All artifacts, including paintings and sculptures, required expendable wealth. The objects treated below constituted the most admired creations fashioned from the most sumptuous materials, which were affordable only to emperors, popes, and kings, that is to say, to ruling elites. A brief overview of the main characters of this book and the historical circumstances that motivated their actions and ambitions, including their exploitation of luxury arts, is, therefore, not out of place.

In the late fourteenth century the French Valois court dominated Europe artistically and culturally. The Hundred Years' War (1337–1453), a dynastic conflict between England and France, weakened France politically and financially and provided the Burgundian dukes, scions of the Valois family, with the opportunity to amass significant power both in France and in the territories in the Southern Netherlands, which they acquired through marriage. Rivalry and enmity between the Burgundian dukes and their cousins, the Valois kings, underlay much of fifteenth-century European politics. By siding alternately with England and France for the duration of the Hundred Years' War, the Burgundian dukes became central players in the European arena, outshining their titular superiors. They did so, not only through war, but also through astute luxury displays, made especially majestic thanks to the wealth they derived from their economically vibrant domains. The third and fourth dukes of Burgundy, Philip the Good (r. 1419–1467; fig. 3) and Charles the Bold (r. 1467–1477; see fig. 1), in particular, created the most magnificent court in Europe, a model for contemporary, and later, potentates.

Meanwhile, the English kings, steeped in conflict with France, intermittently linked themselves with the Burgundians. In 1468 Edward IV married his sister Margaret to Charles the Bold. A generation later, when King Henry VII Tudor (r. 1485–1509) sought to convince the rest of Europe of the viability of his new dynasty, he employed the visual language of power used by the Burgundian dukes. In their turn, the German emperors, titular owners of some of the territories occupied by the Burgundians, conducted an uneasy dialogue with the dukes: Holy Roman Emperor Friedrich III (r. 1440–1493), fearing the ambitions of Charles the Bold, denied him a royal title by slipping away from negotiations in the dead of night. The fragmented political map of German principalities made consolidation of authority perpetually difficult and necessitated maneuvers with foreign allies.

Fifteenth-century Italy was likewise divided. Its major powers were Naples, conquered in mid-century by King Alfonso of Aragon, a Burgundian ally; Florence, dominated politically, although not officially, by the Medici banking family and traditionally pro-French; Milan, ruled first by the Visconti and then by the Sforza and also mostly pro-French; Venice, whose might derived from wealth accumulated through her maritime empire in the East; and the papacy whose features and policies changed with each successive pontiff. These larger powers jockeyed for authority and territory by making and breaking coalitions with each other and with foreigners. Smaller Italian states sided with and against their more powerful neighbors, as well as with foreign sovereigns, or were subsumed by them.

Fig. 3.
MASTER OF GIRARD DE
ROUSSILLON, Philip the
Good in the presentation
miniature. From Jean
Wauquelin, *Roman de
Girard de Roussillon*, 1450s.
Vienna, Österreichische
Nationalbibliothek, Cod.
2549, fol. 6. Photo:
Bildarchiv der Österreich-
ischen Nationalbibliothek.

Upon the death of Duke Charles the Bold of Burgundy at the battle of Nancy in January 1477, King Louis XI of France (r. 1461–1483), who wove the web of forces that defeated the duke and was known for his perpetual machinations as "the Universal Spider," moved promptly to reclaim the Burgundian territories for the crown. His efforts, however, were soon hampered by Maximilian I Habsburg, future Holy Roman Emperor (r. 1493–1519; fig. 4). Son of Emperor Friedrich III, who had refused to bestow a royal crown on Charles the Bold, Maximilian married Charles's daughter Mary and zealously honored and defended his Burgundian inheritance. The marriage of their son,

Philip the Fair, and daughter, Margaret of Austria, to children of the Catholic Monarchs, Isabella of Castile and Ferdinand of Aragon, in 1497 precipitated the rise of superpowers that changed the political landscape of Europe from that of relatively small wrangling kingdoms to one of massive power blocks contending for dominance on the global arena.

Philip the Fair's son Charles V (r. 1515–1556; fig. 5) inherited the Burgundian, Habsburg, and Spanish territories of his ancestors, including their possessions in Italy and in the New World. He delegated his aunt Margaret of Austria to rule his Burgundian lands. His brother Ferdinand I was entrusted with Germany and Austria. Charles himself held court in Spain but spent much of his time traversing his domains and fighting his political and religious adversaries, chief among them the king of France, the Ottoman sultan, and the German Protestants.

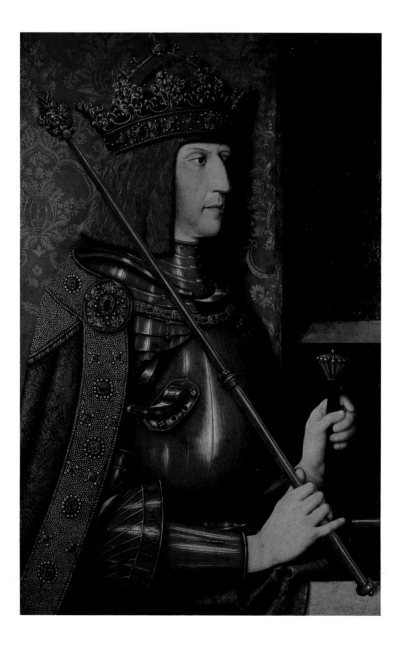

Fig. 4.
BERNARD STRIGEL (German, 1460/1461–1528), *Maximilian I Habsburg*, ca. 1507–1508. Vienna, Kunsthistorisches Museum, Gemäldegalerie, inv. 4403.

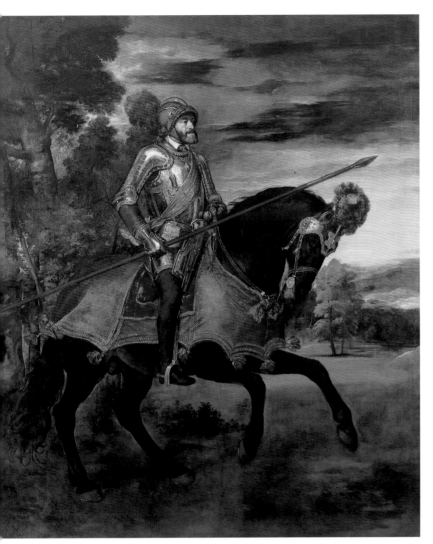

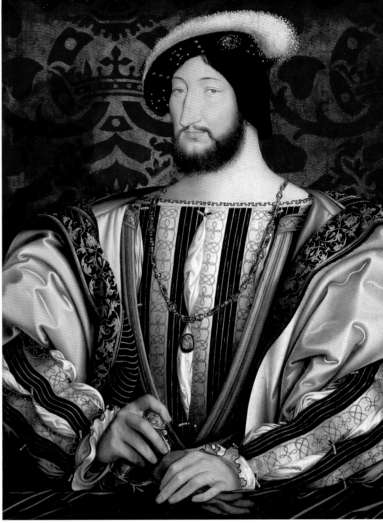

Francis I, King of France (r. 1515–1547; fig. 6), rivaled Charles V for supremacy. He had lost his bid for the imperial throne in 1519 and was captured by Charles at the Battle of Pavia in 1525. To curb Charles's power and expansion, Francis allied himself with the Ottoman sultan Süleyman I, called the Magnificent (r. 1520–1566; see fig. 2). Süleyman meanwhile had devoted himself to the conduct of holy war in Europe. He used European luxury arts, among other weapons, against his Western enemies, particularly Charles V and Pope Clement VII. Süleyman's incursions into Hungary and the eastern Mediterranean aided the German Reformation by compelling the emperor to soften his position toward Protestant princes in return for troops to fight Muslim invaders as well as the French king.

As he struggled against Francis I, Charles V intermittently associated with Henry VIII Tudor (r. 1509–1547; fig. 7), another contender for the imperial crown in 1519, but also an enemy of France. Henry's desire for international prestige led him to foster a magnificent court and to attract to England numerous continental scholars and artists, including the Dutch humanist Erasmus, German and Flemish armorers, and

Fig. 5.
TITIAN (Italian, 1488 or 1490–1576), *Charles V Habsburg at the Battle of Mühlberg*, 1547. Oil on canvas, 3.32 × 2.79 m (130¾ × 110 in.). Madrid, Museo del Prado, cat. no. 410.

Fig. 6.
JEAN CLOUET (French, 1485/1490–1541), *Francis I, King of France*, ca. 1530. Oil on wood, 96 × 74 cm (37¾ × 29⅛ in.). Paris, Musée du Louvre, Département des Peintures, inv. 3256. Photo: RMN/ Art Resource, NY. Photographer: Hervé Lewandowski. See also detail on p. viii.

8

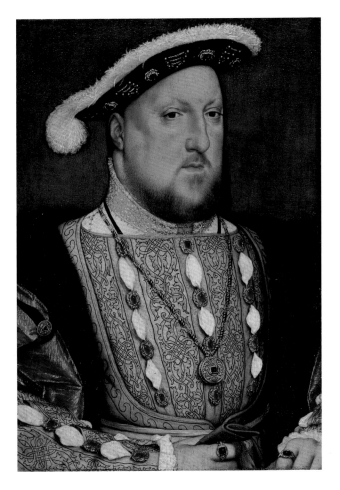

Fig. 7.
HANS HOLBEIN THE
YOUNGER (German,
1497?–1543), *Henry VIII
Tudor*, ca. 1536. Oil on
panel, 28 × 20 cm
(11 × 7⅞ in.). Madrid,
Thyssen-Bornemisza
Museum, inv. 1934.39.
© Museo Thyssen-
Bornemisza.

Venetian-Jewish musicians. Henry was initially a papal supporter: He joined Pope Julius II in the Holy League intended to prevent the French from acquiring territory in Italy, and later he supported Pope Leo X against the Reformation of Martin Luther. But the English king fell out with Rome after Clement VII declined to annul his marriage to Catherine of Aragon, aunt of Charles V, whom the pope did not wish to alienate.

The Medici popes Leo X (r. 1513–1521) and Clement VII (r. 1523–1534; fig. 8) shifted alliances with Henry VIII, Charles V, Francis I, and other continental powers, depending on the threats and benefits of such relations. Leo X, son of Lorenzo the Magnificent, loved learning and refined pleasures. Leo's rule in Rome was hailed as a "golden age," even though its excesses and nepotism also spurred the Reformation. Leo strove to reduce foreign influence in Italy, but he was pragmatic enough to accommodate the French king, who invaded the peninsula in 1515, and then to aid in driving the French from Milan when he needed Habsburg help to repress the Lutherans. Leo rewarded Henry VIII for writing against Luther by granting him the title "Defender of the Faith," and reputedly by presenting to him a set of tapestries depicting the Acts of the Apostles, a copy of the opulent ensemble he ordered for the Sistine Chapel. Loyal to his clan, Leo directed much energy to maintaining Medici rule in Florence and actively promoted the careers of his kinsmen, including his cousin Giulio, who became Pope Clement VII.

Clement was as politically engaged as Leo. In 1530, when Charles V attained indisputable dominion over Italy, Clement crowned him Holy Roman Emperor. Later that year an imperial army restored the Medici to power in Florence, from which they had been expelled three years earlier, soon after the sack of Rome by imperial troops. In orchestrating family alliances, Clement arranged marriages of his Medici kin with children of both the Holy Roman emperor and the French king. Yet the pope's accomplishments were undermined by political and fiscal difficulties, and particularly by the sack of Rome in May 1527, which resulted from his failed diplomacy and eroded the primacy of Renaissance Rome. The Florentine historian Francesco Vettori famously remarked that Clement "endured a great hardship to become, from a great and much admired cardinal, a small and little-esteemed pope."

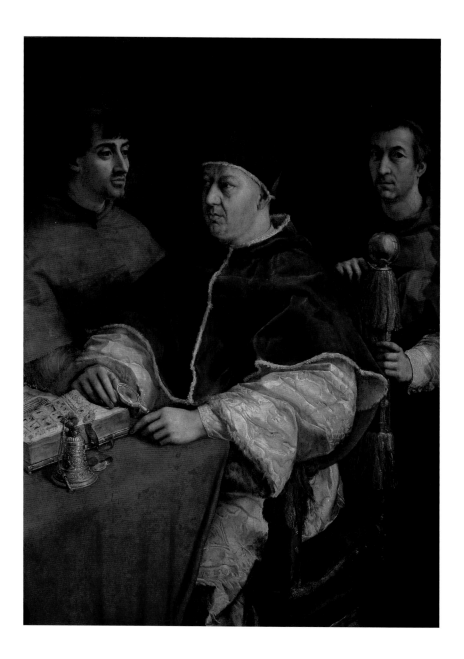

Fig. 8.
RAPHAEL (Italian, 1483–1520), *Portrait of Pope Leo X with the Cardinals Luigi de' Rossi and Giulio de' Medici* (the future Pope Clement VII), 1518. Oil on panel, 1.56 × 1.20 m (61¼ × 47 in.). Florence, Galleria degli Uffizi, inv. P. 1304. Photo: Erich Lessing/Art Resource, NY. See also detail on p. 262.

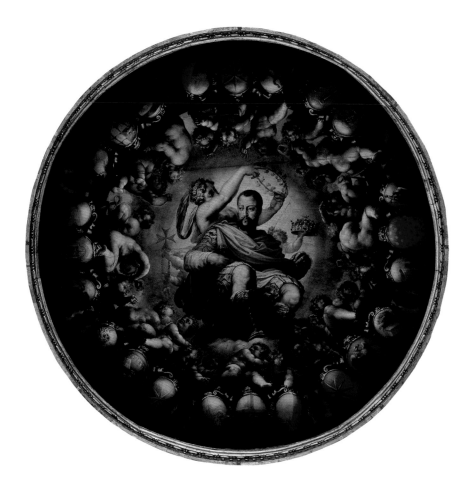

The international prestige of the Medici was nonetheless solidified by Cosimo i (r. 1537–1574; fig. 9), who abandoned the democratic pretensions of his fifteenth-century predecessors, consolidated Medici rule over Florence, and gained the hereditary title of duke of Florence and grand duke of Tuscany. Having employed the painter and art historian Giorgio Vasari, Cosimo acquired fame, not only for his own, but also for his ancestors' cultural achievements, for Vasari extolled them fulsomely in his influential *Lives of the Most Illustrious Painters, Sculptors and Architects* (1568), a work that profoundly shaped subsequent perception of the Renaissance, enshrining the triad of these arts of Florence and ignoring most of what is presented in the pages that follow.

As the foregoing summary demonstrates, European powers constantly interacted with one another, as well as with their Islamic foes, and they watched each other's actions with a keen eye. Luxury arts constituted vital and effective tools of their diplomacy. As citizens of democratic states, we might be uncomfortable with such overt displays of power and the ways in which they enforce authority and social distinctions. The fact that these arts continue to evoke strong responses, however, underscores the potency of their materials, craftsmanship, and connotations. The purpose of this book is, not to glorify them, but to try to understand how these objects functioned in the Renaissance and what this tells us about fifteenth- and sixteenth-century Europeans.

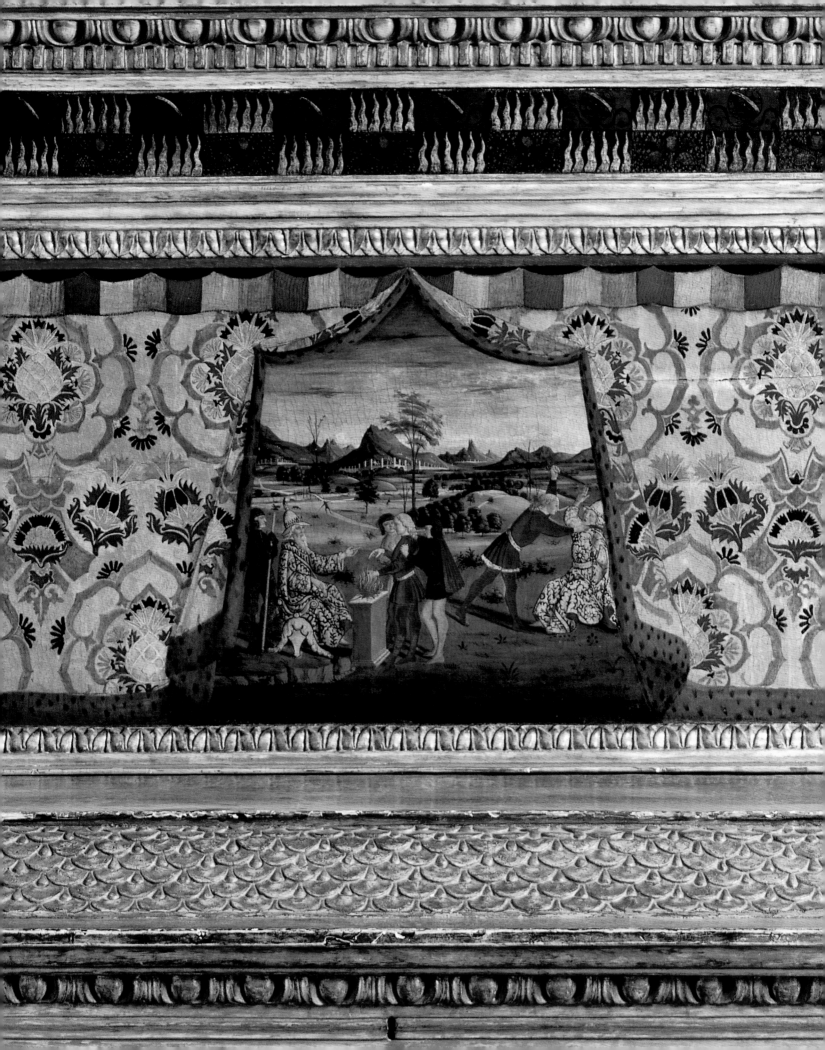

I

The Demise of Luxury Arts

Though God cannot alter the past, historians can.
— Samuel Butler

It is also generally agreed that such dominating concepts of modern aesthetics as taste and sentiment, genius, originality and creative imagination did not assume their definite modern meaning before the eighteenth century . . . The term "art," with a capital A and in its modern sense, and the related term "Fine Art" (Beaux-Arts) originated in all probability in the eighteenth century.
— Paul Oskar Kristeller[1]

The words *Renaissance art*, rolling so easily off the tongue, readily blossom before our eyes into visions of Leonardo's *Last Supper* and *Mona Lisa*, Michelangelo's *David* and the *Sistine Chapel*, Botticelli's *Birth of Venus*, and Raphael's *School of Athens*. So ingrained are these works in popular imagination that marketers deploy them as currency common and strong enough to sell just about anything, from T-shirts to refrigerator magnets. Even with such crass overuse these masterpieces retain their exalted status as icons of high culture.

Encountering such images again and again—in picture books and calendars, museum exhibitions and television programs—we seldom pause to consider why we have so naturally come to deem paintings and sculptures to be preeminent exemplars of Renaissance art. Today it seems self-evident that these are true Arts, while tapestries and goldwork, armor and ephemeral spectacles are "minor," "applied," or "decorative" arts. Yet such a hierarchy of aesthetic values is a recent invention, which began in sixteenth-century Florence as a theoretical proposition; it was foreign to the inhabitants of fifteenth- and sixteenth-century Europe, who valued a multiplicity of objects in diverse media.

Today the term *Art* denotes a physical expression of a rarefied intellectual activity that flows out of its creator in a unique and elevating way. For Renaissance patrons and artists "art" meant a craft or skill, often involving teams of workers who were more vested in the quality of the final product than in its originality. The resultant article was frequently credited to the person who commissioned it rather than to those who physically brought it into being. Renaissance men and women, like the ancients they strove to emulate, certainly admired skillfully manufactured artifacts but not necessarily their producers. The manual labor by which paintings, sculptures, weavings, and other objects came into being rendered their makers socially inferior.

Such opinion of craftsmen grew partly out of the rigid social hierarchy of the day and partly out of ancient writings to which Renaissance elites looked for inspiration and guidance. Plato would have excluded all who worked with their hands from citizenship in his republic. Aristotle viewed the craftsman as a kind of slave, laboring for others in dirt and sweat, depending on his hands for a living, and thus engaging in work that deformed the body and degraded the mind.[2] Plutarch stated that an artisan was unworthy of high regard:

> He who busies himself in mean occupations produces, in the very pains he takes about things of little or no use, an evidence against himself of his negligence and indisposition to what is really good. Nor did any generous and ingenuous young man, at the sight of the statue of Zeus in Pisa [i.e., Olympia], ever desire to be a Pheidias, or on seeing that of Hera in Argos, long to be a Polykleitos, or feel induced by his pleasure in their poems to wish to be an Anakreon or Philetas or Archilochos. For it does not necessarily follow, that, if a piece of work pleases for its gracefulness, therefore he that wrought it deserves our admiration.[3]

For the ancients, and their Renaissance heirs, the admirable arts were those involving only the mind: logic, rhetoric, grammar, arithmetic, geometry, astronomy, and music. No Muse of visual arts graced the company of the nine sisters. The five "fine arts" that came to constitute our modern system—poetry, music, painting, sculpture, and architecture—kept different company in antiquity. Poetry belonged with grammar and rhetoric; music with mathematics, astronomy, and dance; while painting, sculpture, and architecture were manual crafts.

Ancient thoughts on the arts were by no means monolithic, and postulates of individual authors were shaped by their particular interests. Cicero, for example, grouped political and military activities into the category of major arts; sciences, poetry, and eloquence into the second class; and painting, sculpture, music, acting, and athletics into a third, minor grade. Quintilian included in his loftiest group those arts that consisted only of studying things, such as astronomy; his second class of arts was concerned solely with actions that leave no tangible product, such as dance; and in his third rank were the arts that produce objects, among them painting. In all cases the ancient aristocratic bias against manual labor relegated visual arts to a low status, and since all visual arts resulted from physical exertion of some sort, no separation existed between "fine arts" and "crafts" as we understand them today.[4]

In the Renaissance, visual arts remained firmly imbedded in the sphere of menial activity, and artists continued to be considered ignoble because they undertook

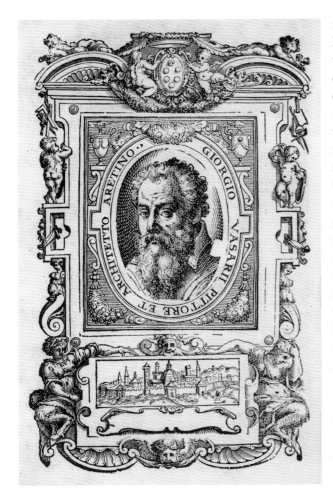

manual labor, participated in retail trade, and lacked learning. Although a few writers pondered the individual properties and possibilities of diverse arts—Leon Battista Alberti, for example, composed treatises *On painting* (1435), *On sculpture* (ca. 1440s), and *On architecture* (ca. 1452)—the handful of texts from this period that we mine for signs of change did not radically alter the actual status of mechanical arts and their practitioners. On the whole, Italian humanists—particularly those of the Quattrocento—said little about art in general, and even less about painting and sculpture. When they did comment on them, they worried about the usefulness of visual arts for moral instruction, and they were suspicious of the capacity of visual arts as a field for true discrimination or subtlety as compared to literary arts. The humanists also questioned whether, being the products of manual trades, visual arts could become learned activities.[5]

It was the modest status of his craft that prompted the Florentine painter Cennino Cennini in his *Libro dell'arte* (*Book of Art*, ca. 1390) to insist on painting's intellectual rather than practical foundation. Leonardo da Vinci strove to elevate painting to the stature of a liberal art on the strength of its involvement with mathematics,

Fig. 1-1.
Portrait of Giorgio Vasari. From Giorgio Vasari, *The Lives of the Most Illustrious Painters, Sculptors and Architects* (Florence, 1568), frontispiece. Los Angeles, Research Library, Getty Research Institute.

although he regarded the sculptor's trade as manual, dirty, and ignoble.[6] Michelangelo sternly admonished his nephew that he should not be addressed as "Michelangelo sculptor," but be called instead by his family name, for, hailing from minor nobility, he was keen to be recognized as socially superior to a mere craftsman. In fact, he declared, apparently in response to some Florentine's request for an altarpiece by him, that "he must find himself a painter: for I never was the sort of painter or sculptor who kept shop. Always, I have guarded against doing that, for the honour of my father and my brothers, though indeed I have served three Popes, as needs must."[7] By promoting his noble lineage, shunning the tainting association with trade, and working for the loftiest patrons, Michelangelo achieved a status granted to very few Renaissance craftsmen. He was the exception, not the rule.

While most artisans remained relatively humble in the eyes of the elite, their creations could be more or less prestigious depending on the materials from which they were produced. Objects fashioned from costly components, and thus used by the highest ranks of society, enjoyed the greatest esteem, not because of some abstract judgment about their intellectual worth, but because of their social, political, or religious value. All artifacts in this age served as means to an end—they were not ends in and of themselves—and their materials were of significance. The combination of premium materials with outstanding craftsmanship permitted the achievement of the most ambitious aims. As we shall see, splendid possessions evoked wonder, for they were seen

to reflect extraordinary powers. In a society marked by a strong hierarchy maintained and strengthened by visual means, luxury arts played vital roles as signs of authority and eminence. They demarcated the lofty from the lowly, the transcendent from the mundane.

The Enlightenment, however, demoted wonder as a suitable mode of learning and response—a manner of interacting with one's world embraced by Aristotle and his medieval and Renaissance followers. Citizens of democratic societies, moreover, have come to look down on overt power displays and draw a line between opulence and taste. Fifteenth-century Europeans have frequently been assumed to hold similar values. The Medici, for example, have been praised for their refined sensibility in amassing not only luxury arts but also numerous paintings.[8] The proposition that the Medici would just as—or even more—happily possess a painting as a precious vessel is belied by the profusion and high valuation of gold and lapidary works in their inventories. In fact, Lorenzo de' Medici focused his collecting chiefly on splendid objects of stone and metal as well as antiquities, and he commissioned very few paintings and sculptures. Numerous Renaissance texts as well as collecting practices reveal admiration for visual richness and equate beauty, preciousness, and magnificence with ornateness.[9] The concept of beauty in antiquity, which informed Renaissance attitudes, was often linked to moral good and usefulness.[10] Therefore, luxury arts were perceived by fifteenth- and sixteenth-century Europeans as expressions of the taste and virtues of their owners. Classical rhetoric and Renaissance writings inspired by it associated ornateness with decorum. Aristotle and Cicero stipulated that form, whether literary or visual, should aptly express and correspond to content. *Ornato* and *decoro* pertained to magnificence associated with and expected of the great.[11] Splendor, in other words, befitted the loftiest individuals, whether divine or mortal; and sumptuous creations suited situations and actors in which and for whom lesser materials simply would not do.

Renaissance inventories and wills, travel diaries and diplomatic dispatches, chronicles and poems, and visual images themselves speak eloquently of such an outlook. Contemporaries esteemed luxury displays because they answered the expectations and necessities of their society. Reporting to the duke of Milan on Galeazzo Maria Sforza's Florentine sojourn in 1459, his counselor praised the decoration of the Medici palace for its lavish fittings because they expressed the dignity of the host and honored his guests:

> This palace, and especially . . . its noblest parts, such as some of the studies, chapels, salons, chambers, and garden, all are constructed and decorated with admirable mastery . . . with gold and fine marbles, with carvings and sculptures in relief, with pictures and inlays done in perspective [*intarsia*] by the most accomplished and perfect of masters even to the very benches and floors of the house; tapestries and household ornaments of gold and silk; silverware and bookcases are endless and without number; . . . the ceilings of the chambers and salons are for the most part done in fine gold with diverse and various forms.[12]

This encomium highlights the coexistence of diverse artifacts in Renaissance interiors. Indeed, all contemporary arts functioned in layered ensembles. When dedicating a chapel in honor of God or a saint (as well as their family), patrons commissioned at once gold and silver liturgical vessels, silk-embroidered clerical vestments, stained-glass windows, and altarpieces. When staging courtly festivities, rulers enjoined musi-

cians and men of letters, goldsmiths and tailors, painters and joiners, cooks and per-
fumers to weave multisensory tableaux against which the ruler shone as the most pre-
cious jewel. Combinations of luxury creations in displays of overwhelming richness
most emphatically declared the spiritual and temporal superiority of their sponsors and
owners. The artisans whom we associate primarily with freestanding paintings or sculp-
tures also executed works ranging from furniture to sugar sculpture and temporary fes-
tive displays. The division between "fine" and "decorative" arts did not yet exist.[13]

Art Academy as Social Strategy

The rift between painting-sculpture-architecture and other visual arts began in
word, if not in deed, in January 1563, when a group of Florentine painters, sculptors, and
architects formed the *Accademia del Disegno* (Academy of Drawing), the first academy
of art. Asserting that *disegno*, or drawing, united the three arts as intellectual rather than
manual pursuits, these artists drew a wedge between themselves and other crafts. In
practice, however, the new institution was motivated less by lofty aesthetic notions than
by economic and political anxieties. The painters, sculptors, and architects endeavored
to break away from the large guilds to which they had traditionally belonged—painters
to that of doctors and apothecaries, and sculptors and architects to that of masons,
carvers, and builders—because they had too little power and representation there.
Eight years after the establishment of the academy, its members petitioned Medici
Grand Duke Cosimo I, the ruler of the city and their nominal head, to release them from
the obligation to belong to the city's guilds and to grant them the right to set up their
own magistracy. A year later the academy became incorporated into the Florentine guild
system as an independent entity.

The timing of the academy's foundation was opportunistic. Seeing their
moment in Cosimo I's consolidation of power over the city's institutions, the painters,
sculptors, and architects moved to separate themselves from their corporate bodies and
to place themselves directly under his control. Although the driving force behind the
creation of the academy was the Medici court painter Giorgio Vasari (fig. 1-1), the
effective administrative authority rested in the hands of the ducal representative
Vincenzo Borghini, a man "of rank and dignity"—a scholar, historian, and prior of the
charitable *Ospedale degli Innocenti* (Hospital of the foundlings). A painting commemo-
rating the inauguration of the academy portrays Cosimo I conferring the statutes of the
new organization upon Borghini, while the artists look on (fig. 1-2). The scene is purely
imaginary—the grand duke did not attend the academy's first meeting—but its sym-
bolic meaning is clear: Cosimo's nominal leadership made the academy an official and
weighty state institution.[14] By submitting to the control of the duke and welcoming into
their institution amateurs from the upper ranks of Florentine society—"worthy by
virtue of their judgment and the esteem in which they hold *disegno*"—the academicians
aggressively pursued social elevation. They used their new organization as an instru-
ment of access to the world of the great, the powerful, and the learned; and as a means
of shedding the association of the visual arts with menial occupations.[15]

Their ambitious rhetoric aside, the academicians neither cut relations with
labor, nor attained immediate ascent. Renaissance crafts were too deeply rooted in mate-
rials and their physical manipulation. It is not coincidental that painters had been

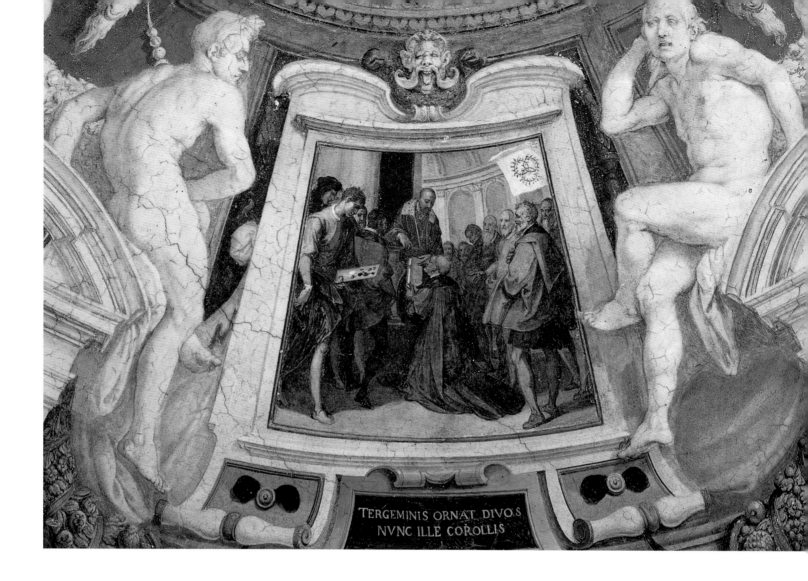

TERGEMINIS ORNAT DIVOS
NVNC ILLE COROLLIS

enrolled in the guild of doctors and apothecaries: They worked with minerals, plants, and oils. Sculptors had been associated with masons, carvers, and builders because they cut wood and stone. In insisting on a guild of their own, the academicians effectively affirmed the system of labor practices with which they were familiar and fundamentally in accord. What they sought was monopoly over their craft, not distance from it.

Concern to regulate their sphere of activity and influence also informed the academicians' decisions regarding whom to admit and whom to exclude from their ranks. Before the days of the academy, artists could practice more than one trade, provided they paid the matriculation fee to the appropriate guilds. Filippo Brunelleschi and Lorenzo Ghiberti, for example, began as goldsmiths and thus members of the silk guild. Upon receiving an appointment as architects of the Florence cathedral, they entered the guild of masons and carvers. Many Renaissance workshops combined diverse crafts. In the ateliers of the Pollaiuolo brothers and Andrea del Verrocchio, for instance, bronze-casting and jewelry-making coexisted with painting. Such diversification insured a steady flow of commissions and profitability to the shop.

Anxious for their market share as well as status, the academicians soon excluded the practitioners of other crafts. In 1564 Domenico di Michele Poggini was permitted to join the academy on the condition that he cease to practice as a goldsmith and be regarded exclusively as a sculptor. Simultaneous practice of two crafts threat-

CHAPTER I

ened conflict of jurisdiction and loyalty.[16] (One wonders whether the higher social standing of goldsmiths and their art threatened painters and sculptors enough to seek their active exclusion from the academy.)

The academy's insistence on a distinction between painting-sculpture-architecture and other arts resulted less in an actual change in the sphere of artists' deeds than in a consequential split between verbal rhetoric and physical praxis, for the practitioners continued to employ traditional techniques, materials, and tools. The theoretical texts generated by the academy, its admirers, and its intellectual heirs took one road, while the daily practices of craftsmen took another. Anthony Hughes has observed that

> the conventional nature of much sixteenth-century literature does not always make it easy to gauge what effect these writings had on the "real" world, or even whether particular examples were ever meant to have any effect at all. . . . There need be no obvious reasons to suppose that what painters, sculptors and architects wanted necessarily coincided with the interests of others, more advantageously placed on the social ladder.[17]

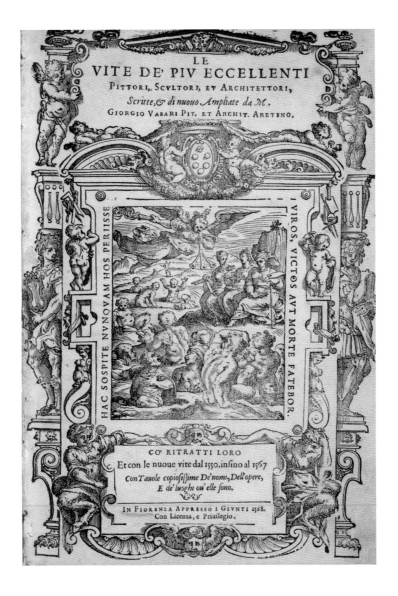

Fig. 1-3.
Giorgio Vasari, *The Lives of the Most Illustrious Painters, Sculptors and Architects* (Florence, 1567), title page. Los Angeles, Research Library, Getty Research Institute.

In fact, most artists belonging to the Florentine academy were little moved by the highfalutin proclamations of a verbal minority. Michelangelo, nominated as a cohead of the academy alongside Cosimo I, showed no interest in the institution whatsoever (its parochial concerns and association with the regime that put an end to the Florentine Republic, which Michelangelo cherished, likely disposed him against it). Only when the great master died in 1564 could the academy fully claim him as its own. Eager to co-opt Michelangelo's renown and stature, the academicians organized a lavish funeral for their idol. A commemorative book describing the proceedings and the decorations of the obsequies avowed that the arts practiced by Michelangelo were not manual, but liberal. The academy's own head, Vincenzo Borghini, meanwhile, pronounced that painting and sculpture occupied a middling position in the hierarchy of cultural values, above the merely mechanical trades, but below the "civil and speculative" practices. In an address marking his retirement he declared that when the academicians speak of theoretical matters, they leave "the house" where they are masters and enter that of poets and orators, where they do not belong. Theirs, he urged, was an "Academy for doing not for reasoning."[18]

The effect of a handful of ambitious academicians agitating for superior status was felt little for some decades. As Anthony Hughes has commented,

> A positive valuation of art does not necessarily go hand in hand with social recognition for the artist. In the culture of early modern Europe, a prince might well surround himself with paintings and sculpture, a burgher or a town council order a costly building, fountain or altarpiece, but these objects were intended to reflect the splendor and munificence of the commissioner before they advertised the inventiveness of the individuals or shops that fabricated them. . . . As the taxonomy of art, so the taxonomy of status during the period under review did not accord with our own. Dignity depended primarily on birth, and after that on office and occupation. . . . The achievement of the *Accademia del Disegno* was to have allowed a few individuals to enjoy rights long the prerogative of established civic figures, and to add something else to their status, too—the luster of the name of academician. We should only remember that that was not always visible to outsiders.[19]

The rhetoric of the Florentine academy, immortalized by its more ambitious members, took centuries to bear fruit. Whether in sixteenth-century Florence or in eighteenth-century Paris, the lofty assertions of the academicians continued to be belied by their manual work. The boundaries between "fine" and "decorative" arts remained blurred, or, more accurately, were not yet clearly defined, as artisans were still involved in a broad spectrum of production on which their livelihood depended. It is noteworthy that Giorgio Vasari himself—the man behind the establishment of the academy—designated his profession as *artefice* and *artigiano*, or craftsman and artificer (the term *artista* in that era referred to a master of arts at a university). Our notion of "artist," with all its lofty resonances, appeared only in the eighteenth century: In 1762 the *Dictionnaire de l'Académie française* defined an artist as someone who works with art and genius and whose hand must cooperate.

Five years after the foundation of the academy, its theoretical architect, Giorgio Vasari, published the second edition of his monumental encomium to Italian art, the *Lives of the Most Illustrious Painters, Sculptors and Architects* (fig. 1-3). The title of this influential text changed subtly but momentously from the first to the second edition. In the 1550 version architects were first in line of the enumerated artists; the 1567 revision gave painters the foremost place. The title, the biographies assembled behind it, and the driving narrative that linked them into a story of the awakening and triumph of art on Italian soil have profoundly shaped subsequent perceptions of this era. Vasari's aims and achievements, ambitions and animosities in writing the *Lives* have been explored by countless scholars.[20] What concerns us here is Vasari's influence on our notion of the Renaissance hierarchy of arts.

The 1550 edition, conceived amid the splendor of papal Rome, where luxury arts served to bring the radiance of heaven to earth, portrayed goldsmithing as the foundation of other arts. In his biography of Filippo Brunelleschi, Vasari detailed Brunelleschi's early training in such terms:

> Seeing him continually investigating ingenious problems of art and mechanics, [his father] made him learn arithmetic and writing, and then apprenticed him to the goldsmith's art with one of his friends, to the end that he might learn design. And this gave great satisfaction to Filippo, who, not many years after beginning to learn and to practice that art, could set precious stones better than any old craftsman in that vocation. He occupied himself with niello and with making larger works, such as some figures in silver . . . and he made works in low relief, wherein he showed that he had so great knowledge in his vocation that his intellect must needs overstep the bounds of that art.[21]

Other famous masters who began as goldsmiths included Lorenzo Ghiberti, Antonio Pollaiuolo, Andrea del Verrocchio, Sandro Botticelli, Domenico Ghirlandaio, Andrea del Sarto, and Albrecht Dürer. In stressing goldwork as a training ground for all arts, Vasari reflected the high status of that craft, not only for patrons who possessed such objects, but also for artists who produced them.

In the 1568 edition of the *Lives*, written in Florence contemporaneously with the foundation of the Academy of Drawing, goldwork was demoted as an archaic means of attaining excellence in art, one too punctilious to permit the passionate expression afforded by drawing and painting. A successful Medici court painter, Vasari now extolled his own profession, and, reversing his own previous narrative, turned goldsmiths into pupils of painters, sculptors, and architects. The displacement of goldwork from its pedestal was fueled by the academy's general position on this art and by Vasari's particular clash with the equally ambitious and vociferous goldsmith Benvenuto Cellini, who, seeing his craft supplanted, argued for its inclusion in the academy. Amending his text, Vasari pressed on with his new vision of artistic hierarchy. In one telling erasure he expunged the original flattering comparison of the farming skills of Giotto's father with that of a goldsmith—of the former's wielding his agricultural tools with the dexterity of the noble hand of a goldsmith or a gem carver.[22]

Vasari's deliberate alteration and even exclusion of aspects of the contemporary art scene appears throughout his book. Contradicting the popularity of Northern art in

Italy, he wrote briefly and condescendingly about Netherlandish and German masters, saying of Dürer that "if this man, so able, so diligent, and so very versatile, had had Tuscany instead of Flanders [*sic*] for his country, and had been able to study the treasures of Rome, as we ourselves have done, he would have been the best painter in our land."[23] Similarly, Vasari mentioned only as minor characters his competitors and enemies at the Medici court and thus effectively wrote them out of history: Giovanbattista del Tasso, Pierfrancesco Foschi, Francesco Bacchiacca, and others who enjoyed success in the 1530s and 1540s had barred Vasari's access to Medici patronage when he first arrived in Florence.[24]

Vasari's *Lives* have decisively shaped subsequent writings on Renaissance art. It was Vasari who divided the new era of art into three phases—the age of Giotto, the Quattrocento, and his own time—and praised his generation so compellingly as to immortalize the notion of early sixteenth-century Florentine art as the pinnacle of European accomplishment. It was Vasari also who, keen on his own ascent, emphasized the significance of the artist over the patron, reversing the extant social hierarchy in which the patron rather than the craftsman was assigned the authorship and glory of an artistic project.[25] Careful to flatter his patron, Cosimo I, and thus to enhance his career at the Medici court, Vasari presented Florentine achievements as superior to all others in fifteenth- and sixteenth-century Europe and laid the foundation for the perception of the Medici as the greatest patrons of the Renaissance. By focusing on painting, sculpture, and architecture, Vasari made secondary the luxury arts that his contemporaries continued to cherish and to use, the academy's rhetoric notwithstanding.[26]

"ART AND NATURE PLAY WITH ONE ANOTHER"

The remarkable proliferation of art and curiosity cabinets across sixteenth- and seventeenth-century Europe, meanwhile, illuminates the actual breadth of interests of Renaissance elites and the great variety of artifacts they found worthy of admiration and accumulation (fig. 1-4). The germ of such cabinets existed already in medieval and Renaissance princely treasuries, where objects of precious materials, magical powers, or exotic origins were amassed. With the expansion of European horizons through long-distance travel as well as growing curiosity about the natural world, princely storerooms evolved into encyclopedic museums.

The content of a typical art and curiosity cabinet was threefold. First, its art collection comprised goldwork and objects of precious stones; works in mother of pearl, amber, and ivory; glass and ceramic artifacts; automata and scientific instruments; as well as paintings and sculptures. Second, the natural history component spanned the mineralogical, botanical, and zoological realms. And, third, the collection of curios grouped curiosities that transcended the bounds of knowledge. The compilation of human crafts, nature's creations, and strange things that defied categorization revealed the extent of the power, reach, and learning of the collection's owner.

In the late sixteenth century Archduke Ferdinand II of Tirol assembled a marvelous *Kunstkammer* (art cabinet) at his castle at Ambras in Innsbruck. The collection sprawled across four interconnected buildings, three dedicated to arms and armor (which featured in many such museums and to which we shall return below), the fourth to all other manifestations of man's and nature's arts.[27] The two sections were linked by

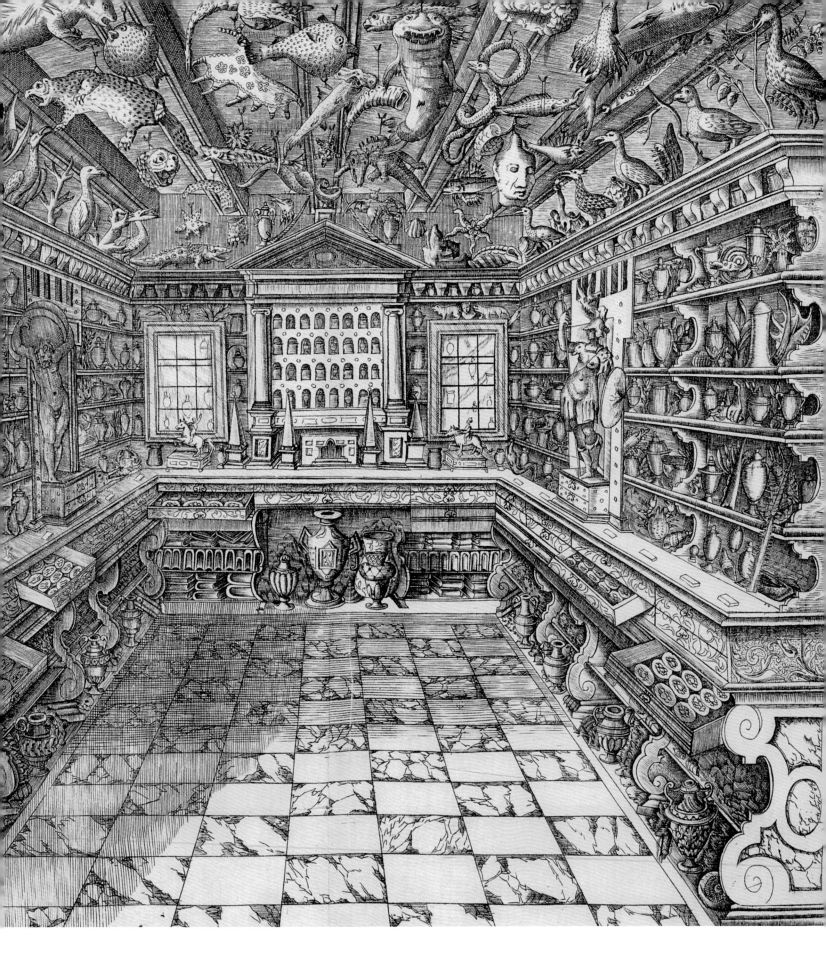

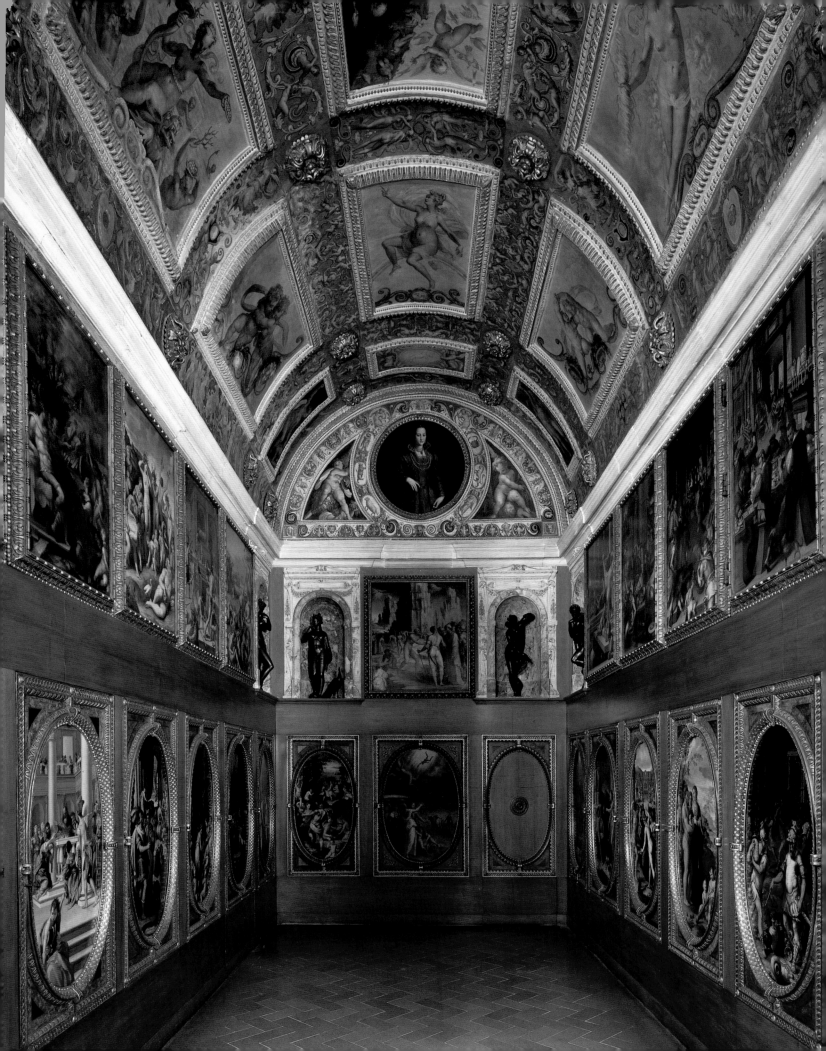

a "Turkish" chamber that held ethnographic objects, many of them trophies from Ferdinand's Turkish wars. In the art cabinet, pictures covered the walls, while eighteen cupboards placed along the main axis of the room housed objects grouped by material, stressing the connection between artifacts and their raw components, a system inspired by Pliny the Elder's *Natural History*.

The inventory of the art cabinet, compiled after the archduke's death in 1595, revealed not only the extraordinary richness of his holdings but also the order of their relative importance. The first cupboard contained works in gold, precious stones, and rock crystal carvings, including Cellini's *Saltcellar* (see fig. 11-31), presented to Ferdinand by King Charles IX of France. The second case displayed objects of silver, ranging from vessels to representations of animals and men. The third cupboard stored hard-stone creations; the fourth musical instruments; the fifth luxurious clocks, scientific instruments, and automata; the sixth bronzes. Then followed artifacts in glass and coral, ivory and fine woods. (As did other contemporary rulers, Ferdinand himself practiced glass-blowing and lathe-turning of ivory and fine woods.) Cupboard number nine included prized exotica from the Habsburg domains overseas and their spheres of expansion: pre-Columbian featherwork, Chinese porcelain and silk paintings, a cup made of rhinoceros horn of Indo-Portuguese origin, ivory horns and spoons from Benin. Interestingly, Ferdinand evinced little interest in Greek or Roman antiquities, and the so-called Antiquarium, a small room next to his library, contained only casts of the heads of the Laocoön group.

In these assemblies a multitude of objects coexisted peacefully, all deserving of a prince's regard. Paintings and sculptures assumed their place among a panorama of other man-made and natural artifacts and often performed decorative or didactic duty.

In the *Studiolo* (small study) of Francesco I de' Medici in Florence, designed by Vasari, treasures from across the globe occupied a series of cupboards, whose contents were suggested on painted covers conceptualized by Vincenzo Borghini (fig. 1-5). In a letter to Vasari, Borghini outlined his figurative schema, which was

> to serve for a closet in which to keep things that are rare and precious, both in terms of their value and artistic merit, that is to say jewels, medallions, precious stones, cut glass, crystal vases, mechanical devices and other objects, not too big, placed in their own cupboards and divided according to category. It seems to me that the invention must match the material and the quality of the things to be kept there so that it makes the room pleasant and ... serves partly as a sign and almost an inventory of the things, with the figures and the paintings above and around the cupboards indicating in a way what is conserved within them.[28]

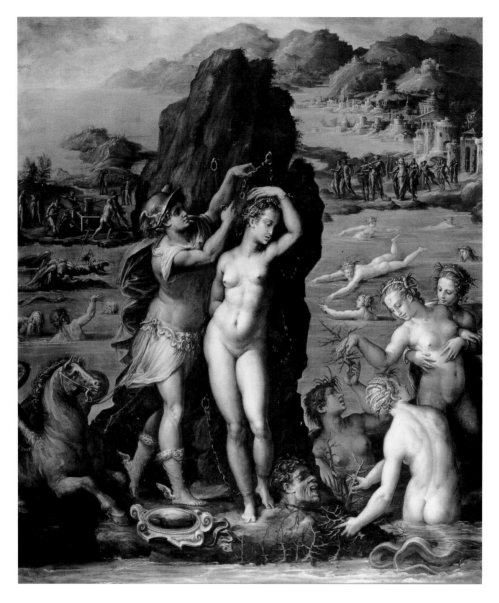

Vasari himself painted one cupboard panel showing the origin of coral as described by Ovid in the *Metamorphoses* (fig. 1-6). Having killed Medusa, Perseus

> . . . made a bed
> Of leaves and spread the soft weed of the sea
> Above, and on it placed Medusa's head.
> The fresh seaweed, with living spongy cells,
> Absorbed the Gorgon's power and at its touch
> Hardened, its fronds and branches stiff and strange.
> The sea-nymphs tried the magic on more weed
> And found to their delight it worked the same,
> And sowed the changeling seeds back on the waves.

Coral still keeps that nature; in the air
It hardens; what beneath the sea has grown
A swaying plant, above it, turns to stone.[29]

Coral was believed to have medicinal powers, as well as natural beauty, and was thus frequently found in princely collections. Other cupboard panels in Francesco's *Studiolo* depicted *A Diamond Mine*, *The Gathering of Ambergris*, *Pearl Fishing*, *A Goldsmith's Workshop*, *An Alchemist's Laboratory*, and so forth. By contrast, in the collection of Ulisse Aldovrandi, professor of natural philosophy at the University of Bologna and director of its botanical garden, pictorial representations supplied deficiencies by substituting images for unobtainable animals and plants.[30]

The shape of an individual collection depended on the social and economic status of its owner and his particular passions. The all-encompassing premise of the curiosity cabinets accommodated all manner of ambitions and a wide range of budgets. Some collectors did focus on paintings and sculptures. In 1659 Archduke Leopold Wilhelm Habsburg, for example, established in Vienna an art cabinet dedicated to paintings, sculptures, and drawings. It complemented his separately housed treasury of goldwork, precious-stone vessels, clocks, scientific instruments, and weapons. The archduke's collection of pictures included works by Bellini, Giorgione, Lorenzo Lotto, Paolo Veronese, Jan van Eyck, Hugo van der Goes, Geertgen tot Sint Jans, Quentin Massys, Peter Paul Rubens, and many others. His sculptural possessions comprised figures in marble and bronze, wood- and ivory-carvings, wax statuettes, and goldsmiths' wooden models. When the contents of this art cabinet joined other paintings of the Habsburgs in the eighteenth century, the objects were arranged into decorative symmetrical ensembles set in carved-gilt wainscoting. The layout seemed to matter more than individual components, as pictures were cut down or enlarged to fit their frames (fig. 1-7).[31]

In pondering the place of painting and sculpture between the Renaissance and the eighteenth century, we must also remember the broad range of artifacts and specialized craftsmen encompassed by these categories. There were numerous subfields within the sculpting and painting trades (and the same holds true for goldsmithing, weaving, armor manufacture, music, and other crafts). The subdivisions within each profession assured greater efficiency of production, especially when large commissions were at hand. In this layered system of labor organization—be it in fifteenth-century Bruges, seventeenth-century Rome, or eighteenth-century Paris—masters whom we credit with a particular painted altarpiece or carved tomb often served as general designers and contractors who delegated much of the actual physical work to trained assistants. Consider the case of Gian Lorenzo Bernini. In 1655, when Queen Christina arrived in Rome after abdicating the throne of Sweden, she was warmly welcomed by Pope Alexander VII. Among the honors the pontiff bestowed upon his guest—a recent convert to Catholicism—were a coach, a litter, a sedan chair, and harness for the horses and mules. The manufacture of the splendid coach was assigned to Bernini. When Christina went to inspect her present, Bernini, with becoming if false modesty, announced that "if anything is bad, that is my work." Christina graciously retorted, "Then none of it is yours." She was, in fact, correct. The drawings for the coach had been prepared by Giovanni Paolo Schor, the models made by Ercole Ferrata, and the execution carried out by a host of Bernini's workmen.[32]

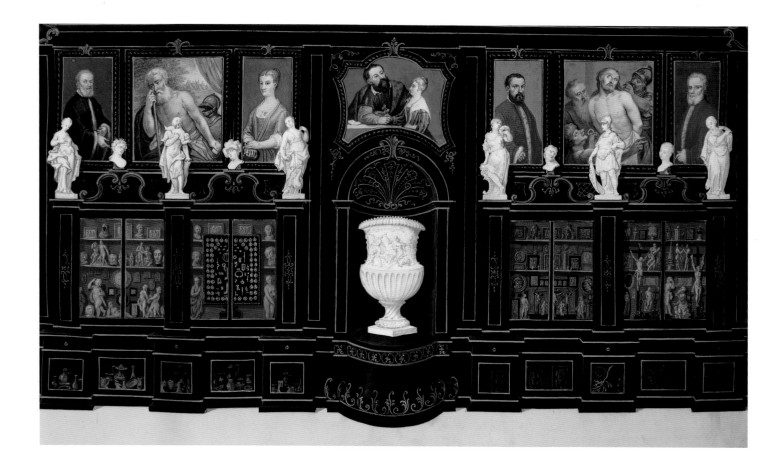

Today we hardly deem a coach a work of art. The fact that Pope Alexander VII offered a coach as a lofty state gift and Bernini undertook to execute it suggests a more pragmatic attitude toward visual arts. In that period an opulent carriage conveyed the majesty of a ruler no less than did her attire, palace decorations, or art and curiosity cabinet. Separately and together they all communicated the dignity and power of an illustrious personage. Artists, in their turn, exercised their talents and skills on whatever objects their patrons demanded and paid for. The most successful and celebrated painters, sculptors, goldsmiths, and other craftsmen took on the widest variety of projects. Raphael not only frescoed the Vatican apartments but also designed tapestries and plate, as well as ephemeral decorations for papal banquets. Bernini produced mirror frames and firedogs, carriages and even decorative nails that held them together. Nor did artists of the highest caliber shy away from fashioning butter and sugar sculptures for indoor banquets and fireworks and parade floats for outdoor displays. If the value placed on artifacts is any indication of their worth to their owners and their society, it may be instructive to note that a pair of brass finials for the chair of Pope Innocent XI, designed by the seventeenth-century sculptor Alessandro Algardi, cost ninety *scudi*. The same sum was paid to the sculptor Giuliano Finelli (who produced numerous carvings in Bernini's workshop) for a marble bust of Cardinal Scipione Borghese, which now graces the Metropolitan Museum of Art.[33]

Figs. 1-7 a and b. Vienna Hofburg, *Kunstkammer* of the Stallburg Gallery, a display set up between 1720 and 1728. Watercolor. From Ferdinand Storffer, *Specification deren in dem Schwarzen Kabinett…* (1730). Vienna, Kunsthistorisches Museum, Gemäldegalerie.

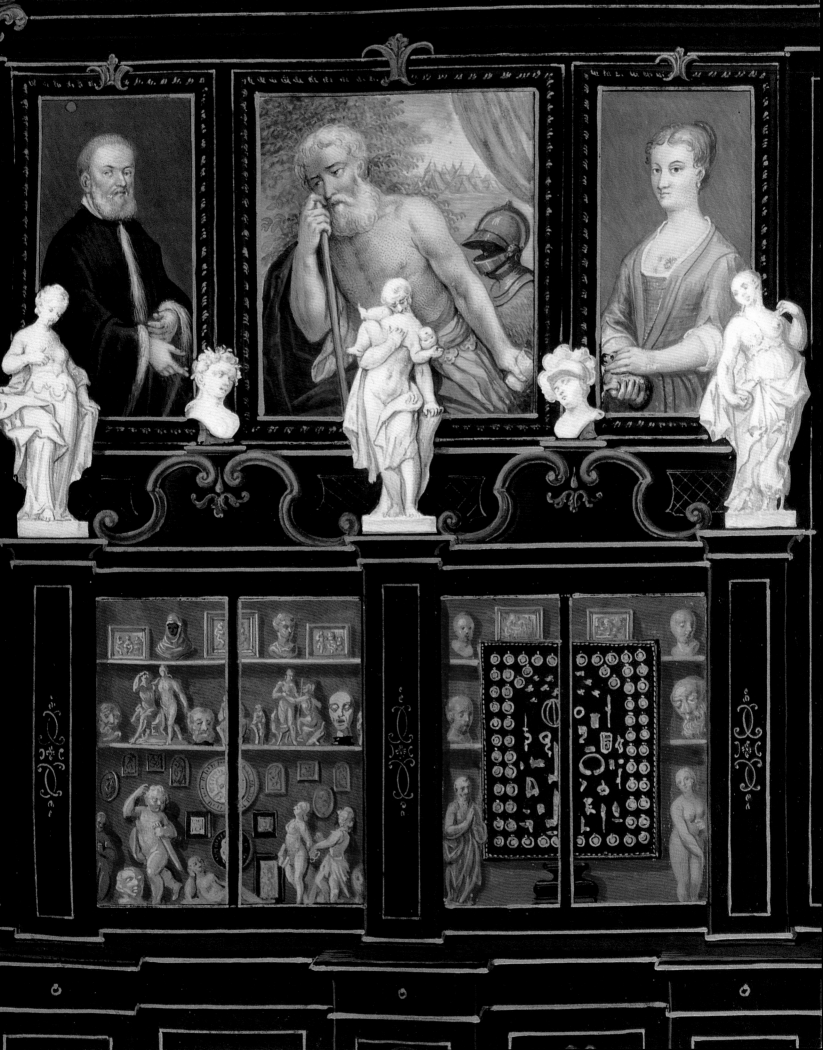

The eighteenth century is viewed as a turning point in numerous spheres. It led to the French Revolution and the explosion of consumer culture. It witnessed the rise of natural history and the formation of public museums, the formulation of aesthetics as a science of art and the evolution of professional art criticism. In the eighteenth century art academies became the chief centers of art education, and guilds irretrievably lost their power. Yet many of these transformations constituted continuations of earlier developments and practices. Public museums grew out of princely collections. Widespread consumerism snowballed from a more socially circumscribed procurement of luxury goods. Art discourse drew on previous writings about art, rhetoric, and civic achievements. And academic painters and sculptors went on earning their living by a multitude of commissions executed by hand.

Art academies did become more vocal and visible social players in the eighteenth century, but for reasons more practical than intellectual. Just like its Florentine predecessor, the French *Académie Royale de Peinture et de Sculpture* (Royal Academy of Painting and Sculpture) came into existence as a result of economic and social pressures. For centuries artisans working directly under royal command operated free of dues, restrictions, and supervisions of the *maîtrise*—the guild of master painters and sculptors of Paris—a professional association that trained and oversaw craftsmen practicing these arts. In the mid-seventeenth century, when the supply of official commissions outside the court was being seriously threatened, and the ruinously costly Thirty Years' War bred broad antimonarchical sentiment, the *maîtrise* decided to make a move against royal artisans and to seek monopoly over all Church and private commissions as well as every aspect of the art trade. The court artisans counterattacked. Headed by Charles Le Brun, painter to the queen, and supported by the art-loving royal counselor Martin de Charmois, they drew up a set of statutes establishing the Royal Academy in 1648. The monarchy welcomed the new foundation as a chance to re-assert its authority over its insubordinate urban subjects. The *maîtrise* was henceforth forbidden to interfere with royal artisans.

Yet the academy's future was far from assured, and in the following years of political turmoil its fortunes vacillated with those of the crown. To shore up their shaky foundation, the academicians proclaimed the lofty stature of painting and sculpture and introduced a regular series of theoretical lectures. These talks aimed, not only to encourage a new perception of the arts, but also to discourage the hostile and obstructionist guildsmen from attending the too densely learned and abstract disquisitions and thus getting involved with the academy. When the monarchy reclaimed control of the academy in 1654, it regained its fledgling strength and was accorded the privileges enjoyed by the *Académie française* (the French Academy, a literary and thus inherently noble institution): an annual pension, free lodging for its members, and the exclusive right to pose the model. In fostering the Royal Academy, the monarchy was less concerned with promoting a coherent artistic program, or singling out painters and sculptors for particular favor, than with controlling recalcitrant craft corporations and stimulating national commercial health predicated on the high quality of domestic manufacture.[34]

The foundation of the Royal Academy of Painting and Sculpture did implicitly place the *maîtrise* and its mercantile practices on a lower social rung: The academicians were expressly forbidden to engage in such trade activities as keeping a shop or show-

ing their works in the windows of their studios in order to garner sales. These marks of distinction, however, did not alleviate the academicians' need to earn a living, which they did by undertaking a variety of commissions and teaching. To prevail over the *maîtrise* in the long run, the academy's spokesmen actively advanced the claim that in its hands painting and sculpture had become liberal arts, a position propounded all the more emphatically because the academy had little else to distinguish itself from the *maîtrise*. For in practice, throughout the eighteenth century, the academicians worked alongside other craftsmen, especially on the embellishment of city palaces built by the nobility flocking back to Paris from Versailles.[35]

The monarchy's sponsorship of the academy devoted to painting and sculpture, moreover, coexisted with patronage of other arts. Between 1662 and 1667 Jean-Baptiste Colbert, Royal Superintendent of the Buildings, Arts, and Factories of France, oversaw the establishment of the royal manufacture dedicated to the production of luxury articles for the court—the *Manufacture des Meubles de la Couronne* (Factory of royal furniture), situated in the Hôtel Gobelins. A tapestry designed by Charles Le Brun and woven by the new institution illustrates a *Visit of Louis XIV to the Gobelins* (fig. 1-8). The king examines tapestries and plate, furniture and marquetry produced for his pleasure and profit—profit being an indispensable aspect of royal interest in artistic industries of the realm. Tapestries, silver, furniture, and opulent furnishings became the particular pride of the Gobelins, and hard-stone carvers were specially imported from Florence to propagate their art on French soil.

The mingling of diverse arts in the service of the crown is reflected in the appointment of Charles Le Brun, first painter at the court of Versailles and head of the Royal Academy of Painting and Sculpture, to the directorship of the Gobelins. Foremost academic painters and sculptors were allocated workshops at the factory alongside tapestry weavers and goldsmiths, cabinetmakers and other masters. All received a fixed remuneration and freedom from taxes, guard service, and obligation to quarter troops. Their sole duty, Colbert declared, was to make sure "that the work done here clearly surpasses in art and beauty the most exquisite work from foreign countries."[36] In fact, in addition to supplying the royal palaces, the Gobelins's mission was to preclude the need for foreign luxury imports and to make French wares competitive abroad.

The Gobelins became a model for luxury-arts production. German courts looked to it in establishing similar manufactures at home. Foreign princes visiting Paris toured the factory's workrooms. The 1757 *Almanach des Négociants* stated that "the sway of Paris over the taste of other nations in jewelry, in fashion, in all works of adornment and luxury is a source of great riches. Fashion alone draws to France many millions from abroad every year."[37]

The royal support of the Gobelins makes clear that while the Royal Academy of Painting and Sculpture promulgated the rhetoric of the superiority of its arts, luxury artifacts continued to serve as indispensable markers of rank, taste, and national pride. And the academicians themselves participated in the creation of both Gobelins wares and other opulent artifacts for elites. Charles le Brun designed weavings, mirrors, and tables alongside his paintings.[38] Sèvres porcelains were devised by academicians, including the sculptors Clodion (Claude Michel) and Étienne-Maurice Falconet.[39] The effective distinction between a member of the academy and other artisans was one of privilege and clientele—the former worked for state projects, the latter for patrons outside the court. The scopes of their work remained very much parallel.

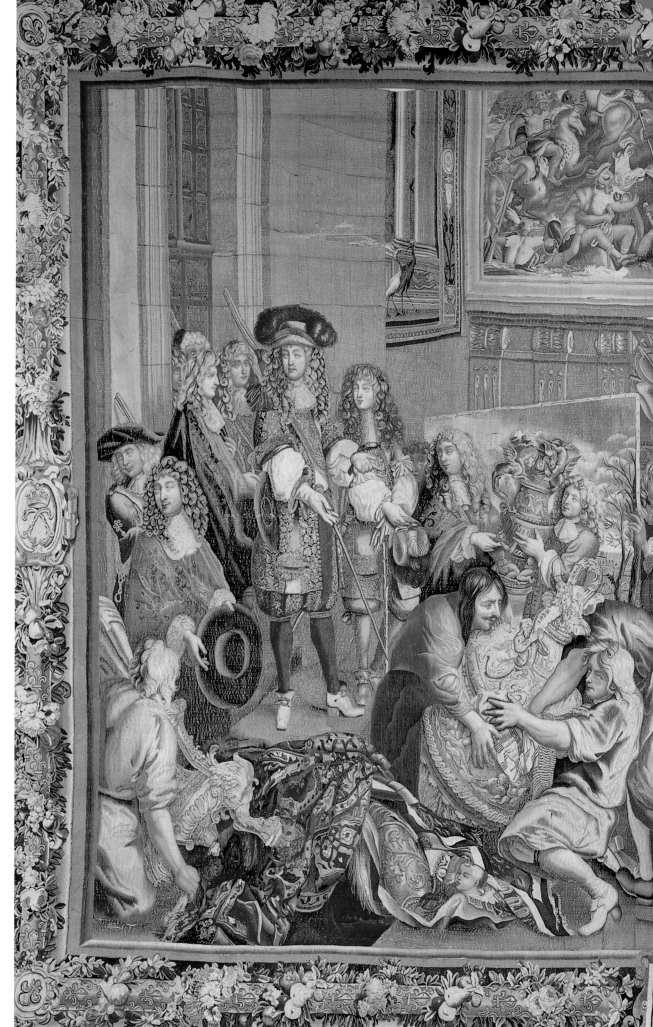

Fig. 1-8.
Visit of Louis XIV to the Gobelins Workshop, 15 October 1667, tapestry in the series *History of the King*. Designed by CHARLES LE BRUN (French, 1619–1690) and woven in the studio of Leblond at the Gobelins factory, 1673–1679. 3.75 × 5.80 m (147$\frac{5}{8}$ × 228$\frac{3}{8}$ in.). Versailles, Chateaux de Versailles et de Trianon. Photo: © RMN/Art Resource, NY. Photographer: Jean Schormans.

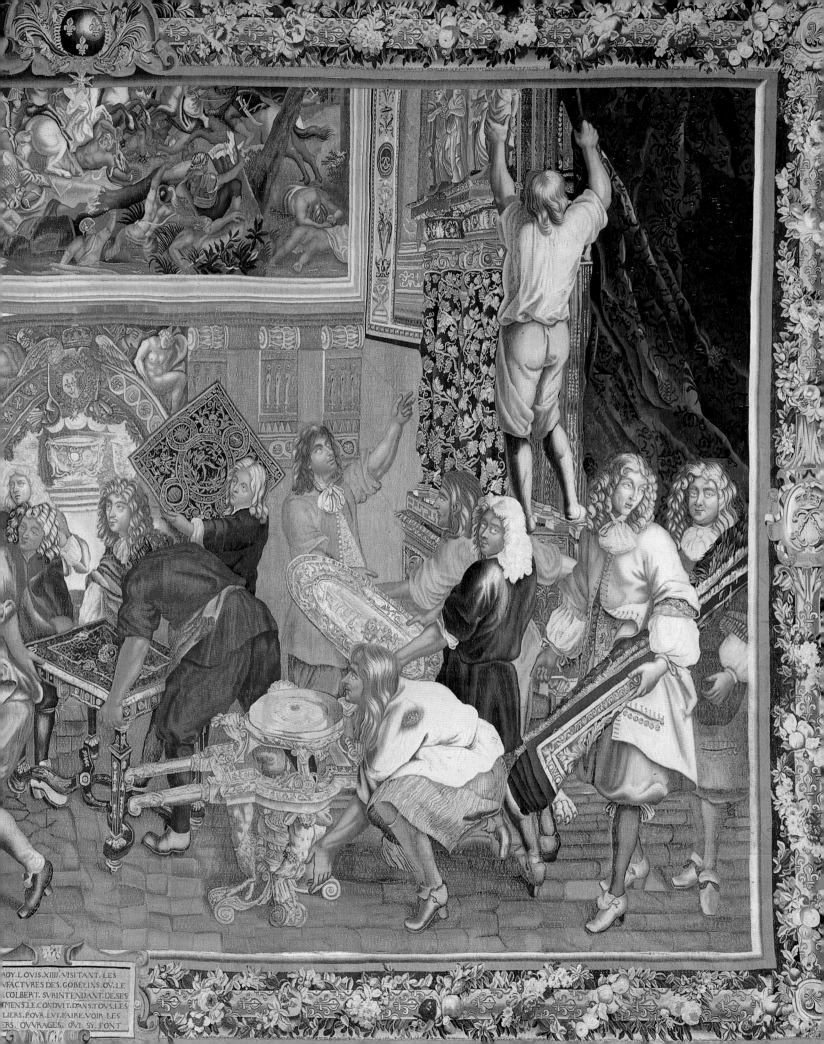

In fact, many of the paintings we admire today as freestanding works of art produced by such prominent figures as Charles-Joseph Natoire, Jean-Baptiste-Siméon Chardin, and Hyacinthe Rigaud (painter to the Sun King, Louis XIV) originally served quite mundane purposes in the palaces of the aristocracy: for example, decorating over-doors, or covering chimney openings during summer months. The same holds true for numerous Renaissance pictures, which likewise functioned as decorative items in an age when all arts were functional objects rather than purely aesthetic excercises. Botticelli's elegant *Venus and Mars* panel (fig. 1-9) was initially the backboard of a bench or a wedding chest. Such an intact chest made in Florence in 1472 offers a fuller view of this type of furnishings (fig. 1-10). The chest, carved by Zanobi di Domenico and painted by Jacopo del Sellaio and Biagio d'Antonio, illustrates edifying stories from Livy. The carving and gilding, plus the painting, amounted to a minor investment, costing as much as an altarpiece in an ornate frame painted and carved by the leading masters. A wedding dress, however, especially one made of opulent fabric, such as damask, cost a great deal more.[40] The price of paintings relative to other articles of noble living in seventeenth-century Paris are similarly instructive. Among the possessions of the French politician Jean-Baptiste Colbert inventoried at the time of his death in 1683 was a mirror measuring 124 × 65 cm (48⅞ × 25⅝ in.; its size made it a rare and luxurious commodity) set in a silver frame; it was valued at eight thousand *livres*; an original painting by Raphael, by contrast, was estimated at three thousand *livres*.[41]

The fluidity of boundaries between diverse arts continued for the duration of the eighteenth century, as did the opportunistic use of the rhetoric of art versus craft. Thus in the 1760s Parisian hairdressers, seeking to avoid the jurisdiction of the wigmakers' guild, filed a lawsuit against the guild claiming that theirs was an art analogous to poetry, painting, and sculpture. The hairdressers deployed terms such as chiaroscuro, composition, color, expression, the hierarchy of genres, rules of decorum, and the very

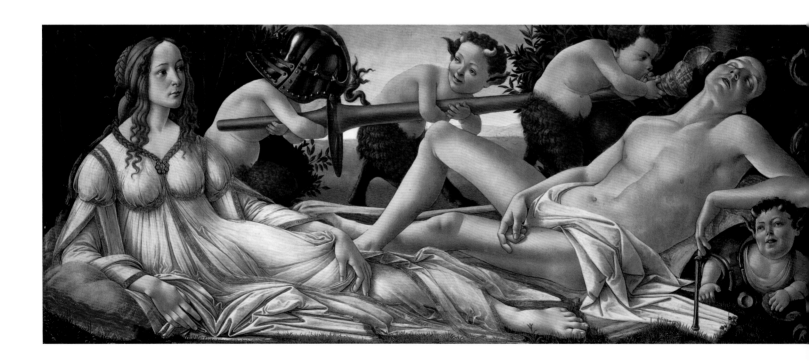

notion of genius to describe their art and to contrast it with the "purely manual practice" of wigmaking. With the support of the elegant Parisian society they won their case. A decree issued at Versailles and registered by the parliament in 1776 extended to them a degree of freedom to practice in the capital without guild interference. In other words, the discourse of art was readily appropriated by those eager to acquire greater professional autonomy and stature. No wonder the Royal Academy of Painting and Sculpture faced difficulties in setting apart the activities of its members.[42]

Not all academicians stridently promoted their institution. Scholars have remarked on "the collective apathy of eighteenth-century painters and sculptors for the theoretical dimension of their profession" and on the fact that they were "seemingly content to abandon into the care of *amateurs* and *gens de lettres* the elaboration of

Fig. 1-10.
The "Nerli cassone," one of a pair of wedding chests, carved by ZANOBI DI DOMENICO (Italian, active 1472), painted by JACOPO DEL SELLAIO (Italian, 1442–1493) and BIAGIO D'ANTONIO (Italian, ca. 1445–ca. 1510), Florence, 1472. Wood and gesso, tempera, and gilding, H. 2.12 m (83½ in.). London, Courtauld Institute of Art Gallery, Lee Collection, inv. F.1947.LF.5. See also detail on p. 12.

the principles of their art—principles upon which their claims to special status depended."[43] What they did staunchly defend were the practical privileges stemming from their classification as "liberal" artists, especially access to a lofty clientele and lucrative commissions.

Still, social recognition of the academicians' special status was not widespread, and they themselves uneasily balanced their high intellectual pretensions and low social rank. With the rise of art criticism in the eighteenth century the social origins of painters and sculptors became a source of troubled reflection. Their class background and education were indifferent at best. They remained men for whom art was still, in practice, very much a craft, and whose outlook extended little further than their studios and the wishes of their patrons.[44] The involvement of painters and sculptors in decorative projects alongside other artisans also rendered moot the polemical distinction between art and craft.

In Paris as in Florence the divide between the two occurred on the level of words more than of deeds and took place in the minds of the growing corps of professional critics rather than most artists. The conceptual gulf was widened by the fact that practitioners of crafts other than painting and sculpture were excluded from the academy, marginalized by the tradition of art discourse, and belonged to a nonliterate world of work that did not generate a body of texts that contemporaries and posterity could take as authoritative statements of professional claims.[45] Nonetheless, the Royal Academy won uncontested superiority over the *maîtrise* only in 1776, when the latter was abolished by royal decree along with all corporations.

What brought the academy's ideology as well as actual products into the public realm were the Salons (fig. 1-11)—formal art exhibitions sponsored by the academy—and the attendant diffusion of art criticism in the form of exhibition reviews and related publications. The Salons, held annually between 1737 and 1751 and biannually from 1751 to 1791, became major Parisian public entertainments. Although both the academicians and the critics wrestled with the definition of the "public" who attended and deserved to attend these shows, the Salons stimulated broad interest in the visual arts. They also contributed to the association of art with painting and sculpture. For while tapestries, furniture, and luxury furnishings also featured in these exhibitions, paintings, followed by sculptures, predominated.[46]

The written genre of Salon criticism stemmed from the increased interest of amateurs, philosophers, and cognoscenti in discussions about the visual arts, which ranged from treatises comparing diverse arts with each other and with poetry to guides for collectors. (A Hamburg dealer, Caspar F. Neickel, for example, composed *Museographia* [1727], which advised buyers on finding objects, caring for them in climate-controlled environments, and classifying them in systematic ways.[47]) Aesthetics, the new science of sensory perception inspired by natural philosophy, also made its appearance at this time and ushered in a written tradition of its own.

Inspired by developments in the natural sciences, philosophers and theoreticians grappled with ways in which arts could be marshaled into a clear system. In his treatise *Les Beaux-arts réduits à un même principe* (The fine arts reduced to a single principle, 1746) Abbé Charles Batteux made a decisive step toward fixing the group of fine arts as comprising music, poetry, painting, sculpture, and dance. His organizing rationale was the issue of pleasure versus utility. Fine arts, as he saw them, had pleasure as their end; the mechanical arts aimed at utility; architecture and eloquence combined

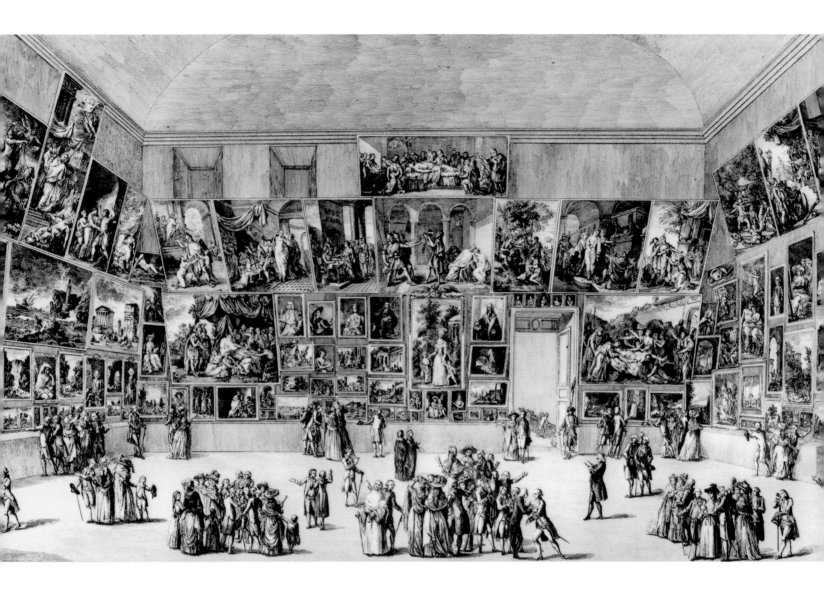

utility and pleasure. The *Encyclopédie, ou, Dictionnaire raisonné des sciences, des arts et des métiers* (Encyclopedia, or, Complete dictionary of sciences, arts, and handicrafts), published by Diderot and D'Alembert in Paris in 1751, defined painting, sculpture, architecture, poetry, and music as the fine arts and through its authority gave this grouping widespread currency and acceptance.[48]

The age also saw numerous written debates on the subject of luxury. Seventeenth-century French dictionaries defined luxury as a superfluous expenditure. In the first half of the eighteenth century, however, economic theorists began to defend luxury as indispensable to the material well-being of the nation and to social progress. Jean-François Melon, for example, sought to demonstrate the utility of luxury in his *Essai politique sur le commerce* (1734; trans. as *A Political Essay upon Commerce*, 1739), which inspired Voltaire's defense of luxury against austerity in *Le Mondain* (1736) and was echoed in Diderot's essay on "Luxury" in the *Encyclopédie*. Moral philosophers, meanwhile, decried luxury as socially and economically corrosive. François Quesnay and other physiocrats, or members of the school of French economists, viewed luxuri-

ous expenditure as injurious to the social body and bankrupting to its economic health; they argued that riches ought to be derived from cultivation of natural resources, and workers and peasants ought to be viewed as the true wealth of the nation. Ethicists, in their turn, condemned luxury as a destroyer of the moral fiber of man. In his *Traité philosophique et politique sur le luxe* (Philosophical and political treatise on luxury, 1786) Abbé Pluquet criticized luxury as detrimental to man's intellectual abilities, sentiments, and sense of duty toward his fellow man and society. Social critics concerned themselves with the effects of luxury on social order. In the aftermath of the Seven Years' War princes and financiers, duchesses and actresses, speculators and rakes surrounded themselves with opulence, confounding the traditional link between magnificence and rank and drawing resources away from productive uses. Gabriel Sénac de Meilhan's *Considerations sur les richesses et le luxe* (Considerations on wealth and luxury, 1787) attacked the replacement of pomp—the prerogative of superior station—with luxury incommensurate with one's social position. Like Aristotle, he argued that the great were meant to manifest their power and ascendance through splendor and ceremony because such displays defined their station in society. Their magnificence, in other words, was not frivolous, but necessary as a signaling system. But while acceptable when linked to the throne or the altar, magnificence became mere luxury at the hands of private individuals, who did not have adequate reason for such show, while it harmed others.[49] The split between the positive and negative charges of luxury indicates the highly politicized nature of the concept. Ignoring the intellectual debates, eighteenth-century urban dwellers actively supported the luxury trades, buying with abandon opulent textiles for clothes and interior decoration, elaborate furniture, mirrors, candelabras, porcelains, clocks, as well as paintings and sculptures. They aggravated the academicians by favoring decorative and light-hearted pictures and sculptures produced by nonacademic artists, rather than the monumental historical images that constituted part of the academy's claim to intellectual superiority. Parisian luxury merchants, who formed a corporation of their own, solicitously facilitated this rampant consumption and added foreign imports—notably Oriental porcelains and lacquers—to domestically manufactured goods. The diverse wares stocked in their shops, and the brisk trade these merchants conducted, attested to the continued appreciation for a multiplicity of arts even in the age of flourishing academic pedantry.[50]

THE AGE OF PUBLIC MUSEUMS AND ART EDUCATION

In the nineteenth century access to diverse arts was further democratized as princely collections became transformed into public museums. But in the process, artifacts that previously coexisted in the curiosity cabinets became separated into distinct categories and exhibitions organized along new didactic lines. Painting, sculptures, textiles, and metalwork were gathered in art galleries, each medium occupying a discrete space. Specimens of nature's ingenuity congregated in museums of natural history. Ethnographic collections housed trophies of conquests in foreign lands.

Enlightenment thinkers, such as D'Alembert, a mathematician and co-editor of the *Encyclopédie,* had derided art and curiosity cabinets as useless, fatiguing, and ostentatious. Wonder inspired by such encyclopedic assemblies no longer qualified as an admirable way to learn. D'Alembert and his contemporaries advocated instead a scien-

tific ordering of knowledge—a precise partition of animals, plants, minerals, and human artifacts.[51] Influenced by the division of the plant and animal worlds into genera and species—as quantified by Carolus Linnaeus and Buffon (George-Louis Leclerc) in the mid-eighteenth century—art museums began to classify their holdings according to chronological developments and national schools, with further subdivisions by works of individual masters and their ateliers. Such organization was put into effect at the Louvre, transformed from a royal gallery into a public educational institution. The growing belief that works of art, like flora and fauna, were subject to rational systematization and had an educational service to perform inspired the new "scientific" approach to museum displays across Europe.[52]

The rise of connoisseurship—the "science" of identifying and grouping works of art by scrutinizing the visual characteristics that distinguish a particular artist—furthered the classificatory mind-set of the new art museums. Connoisseurs such as Giovanni Morelli and Bernard Berenson examined with meticulous attention the way individual artists shaped such often repeated and unselfconscious elements of their compositions as ears or draperies, postulating from these features the signature style of the master that could be found in all his works. Connoisseurship was closely and at times incestuously linked to the art market, as expert attributions raised the price of a given work. Paintings and sculptures were most readily subjected to the probing eyes of connoisseurs; tapestries, goldwork, hard-stone vessels, armor, and other luxuries were not, for they were often produced by several hands and were by now viewed as inferior. Their anonymity further lowered their status on the art market and in museums.

The emergence of an antivisual rhetoric in the debates about classification of information—the argument that elucidation is better conducted through words than images—and the concern with a sequential narrative composed of facts that can be isolated, all contributed to a reliance on texts and fixed narratives. This transformed objects from multidimensional actors in their society into static examples of larger concepts. As Barbara Maria Stafford observes, "The shift from sensory impact to a rationalizing nomenclature was also a move from the extraordinary to the ordinary. Analysis meant that material things were decomposed into the normal or customary elements and then recomposed into a superior system knowable only through intellect, not perception."[53] Sensory impact had formed a significant component of the ascendancy of luxury arts. The reliance purely on intellectual constructions diminished the appreciation for these once complexly satisfying artifacts.

The rationalizing impulse of scientists, philosophers, and educators did not, however, cancel or diminish the diversified production of objects of utility and pleasure. The Great Exhibition of the Industry of All Nations, held in London in 1851, drew fresh attention to the visual arts as a source of pride and delight (fig. 1-12). The exhibition, held in the newly constructed Crystal Palace, gave priority to decorative over fine arts, placed emphasis on the materials from which objects were crafted, and extolled the role of science in converting raw matter into products of the highest quality and exquisite appearance. In a catalogue essay entitled "The Exhibition as a Lesson in Taste," Ralph Nicholson Wornum declared that the Great Exhibition "is of all things the best calculated to advance our National Taste, by bringing in close contiguity the various productions of nearly all the nations of the earth in any way distinguished for ornamental manufactures." Ornament, he went on to say, "is essentially of the province of the *eye*; it is beautiful appearances we require, not recondite ideas, in works of Ornamental Art."

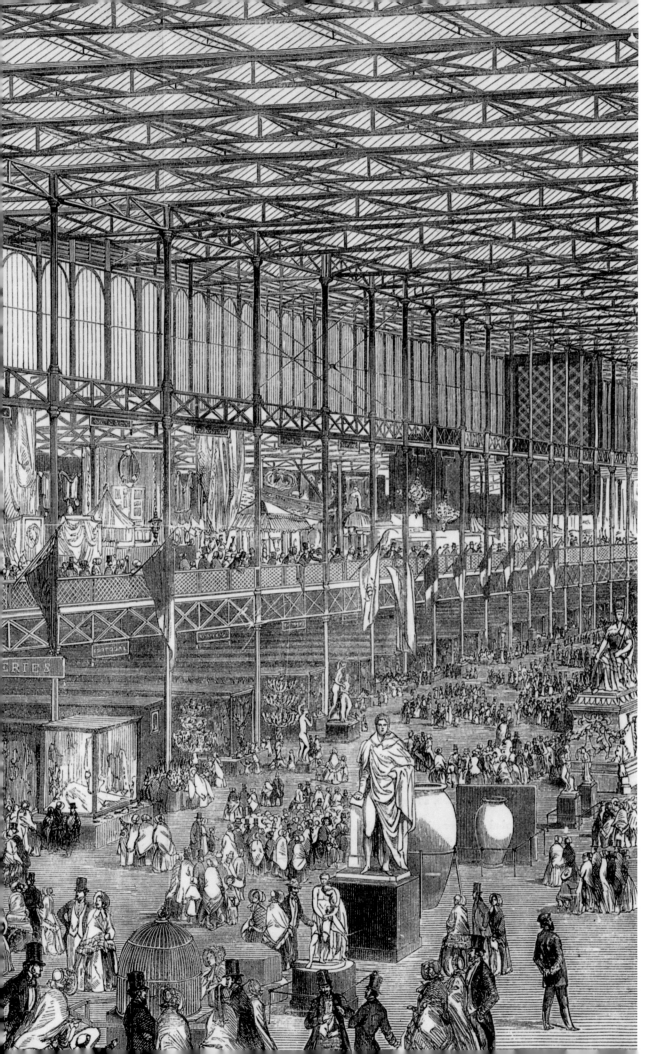

Fig. 1-12.
The East Nave of the Crystal Palace exhibition of 1851. From *The Crystal Palace and Its Contents* (London, 1852), facing p. 118. Los Angeles, Research Library, Getty Research Institute.

The purpose of ornament, according to Wornum, was to cultivate refined taste. "And it is by this character alone that manufactures will ever establish that renown which will ensure a lasting market in the civilized world."[54] The Great Exhibition spurred a good deal of writing and reflection on the role of manufacture in contemporary society and national politics, and it ushered in new educational initiatives centered on the crafts.

Art education for craftsmen existed already in the eighteenth century. In 1766 Jean-Jacques Bachelier had founded the *École Royale Gratuite de Dessin* (Free Royal School of Drawing) in Paris specifically to provide drawing instruction to children of the lower classes who intended to pursue a craft profession. The school's aim was to raise the quality of domestically manufactured goods to internationally competitive levels and thus to advance France's economic power. (By this time the notion of "craftsman" encompassed masons and carpenters, embroiderers and cabinetmakers, clockmakers and goldsmiths. The teachers in the Free Royal School were painters and sculptors from the Royal Academy.) By stressing the importance of the school to the national well-being, Bachelier succeeded in preserving his institution through the years of revolutionary turmoil and ensuring its support by the republic and the empire.[55]

In England educational programs in applied arts that combined industrial and aesthetic training received an impetus from the Great Exhibition. The Victoria and Albert (initially the South Kensington) Museum evolved as a direct result of this new orientation. As in France, economic concerns underlay the revival of interest in crafts and craftsmanship: England, too, sought to elevate the quality of domestic production to the level of continental, and particularly French, competition. The Victoria and Albert Museum thus directed its displays explicitly at artisans, designers, and manufacturers. By this time, however, the academic ideology had become entrenched, and despite the renewed respect for metalwork, textiles, furniture, glass, and ceramics, these creations were viewed as manufactured goods rather than art. The South Kensington Museum spawned imitations in both Europe and America. The Metropolitan Museum of Art, for example, was established for the stated purpose of "encouraging and developing the study of fine arts, and the application of arts to manufacture and practical life."[56] The commercially driven mission of such museums resonated with contemporary social ideals of a practical and moral education for the working classes through their experience of art.

Champions of decorative arts comprised art educators and museum personnel, theoreticians and artists. The German scholar and architect Gottfried Semper, for instance, had contributed to the design of the Swedish, Canadian, Danish, and Egyptian displays at the Great Exhibition of 1851. He helped found the Austrian *Museum für Kunst und Industrie* (Museum of Art and Industry, 1852) and worked for a period of time at the Victoria and Albert Museum. Intimately involved with the physical objects, Semper pondered ways to classify them so as to furnish a more purposeful rationale for museum presentation and education. His material-based ordering system—the division of artifacts into textiles, ceramics and glass, metalwork, furniture and woodwork—still underlies the organization of museum collections and slide libraries today. In his book *Der Stil*,[57] Semper, keen to elevate the status of "applied art" and the industrial artist, postulated a theoretical marriage between the fine and decorative creations.[58]

The role of ornament in relation to architecture was addressed by A. N. Welby Pugin and John Ruskin in their writings and public lectures. Ruskin suggested that all arts were, in fact, decorative. After all, sculpture decorated temple fronts, and Raphael's

paintings the Vatican apartments. Ruskin proposed a distinction between the indispensable decorative arts—those integrally linked to the place for which they were produced—and portable ones, such as Dutch landscape paintings, which he viewed as a less noble variety. William Morris, meanwhile, founded a company intended to harmonize design and craft in a wide variety of products—from furniture and stained glass to textiles and wallpaper. Morris believed that ornament required artistry, and that function and beauty should come together in the hands of a good craftsman. He advocated a reintegration of art and craft through the involvement of fine artists in decorative arts. In France, Paul Gauguin, too, rejected the sharp divide between fine and decorative arts drawn by the academic tradition and produced furnishings and ceramics alongside paintings and sculptures.[59]

Although the efforts of artists, critics, and museum personnel generated vibrant interest in artifacts beyond painting and sculpture, the latter tended to remain separate, either gathered into distinct museums or segregated into different parts of display. To this day the Kunsthistorisches Museum in Vienna, the Metropolitan Museum of Art in New York, and even the new Getty Museum in Los Angeles house paintings on the top floor, while decorative arts inhabit the ground level. Some continental museums did adopt a "period room" approach inspired by the archival trend in art scholarship. Instead of isolating objects by materials, they combined media in simulated historic environments. This method was not a wholly new departure. In post-Revolutionary France Alexandre Lenoir had organized salvaged remains of French medieval and Renaissance art in the evocative period rooms of his *Musée des Monuments Français* (Museum of French monuments). Lenoir was fascinated by the social information that art of the past could supply, and he strove to evoke the spirit of a given epoch through the disposition of objects, the lighting and decoration of the exhibition spaces, and the accompanying catalogue explanations.[60]

A number of art scholars, particularly German and Austrian, straddled the museum world with its multiplicity and sensuality of physical objects and the academic realm of theoretical formulations of the aesthetic and didactic value of art. As a consequence they brought broad and material-based perspectives to their writings. Julius von Schlosser spent two decades curating the decorative-arts section of the Kunsthistorisches Museum in Vienna. His publications covered such wide-ranging topics as musical instruments and curiosity cabinets, coins and embroideries, court arts of the fourteenth century, and the Italian Renaissance; and in his great tome entitled *Die Kunstliteratur* (Art literature, 1924) Schlosser traced the entire tradition of western art-history writing.

Yet with the professionalization of art history as a discipline and with the development of university curricula the parameters of art narrowed. In both scholarly writings and classroom teaching texts tended to take precedence over objects, and the academic triad of painting-sculpture-architecture assumed priority, particularly when it came to the Renaissance. The demise of royal patronage and princely collections had rendered luxury arts less vital and more morally suspect. Meanwhile, Modernist thinkers and practitioners, such as Adolf Loos with his "Ornament and Crime" (1908)[61] and Le Corbusier with his *L'Art décoratif d'aujourd'hui* (1925; trans. as *The Decorative Art of Today*, 1987), rejected decorative arts in favor of pure forms expressive of function, further discouraging interest in and appreciation for luxury arts. Even the Bauhaus, founded in 1919 by Walter Gropius as a fusion of an academy of fine arts with

a school of applied arts, put the former before the latter. In the manifesto defining the ideology of the new school, Gropius declared that "Architects, sculptors, painters, we must all return to the crafts! For art is not a 'profession.' There is no essential difference between the artist and the craftsman. The artist is an exalted craftsman." In practice, however, the teachers of crafts were not included in the Master's Council, and fine-arts instructors interpreted and refined the curriculum.[62]

It were sociologists and social historians, such as Norbert Elias, who once again turned a curious eye toward luxury arts and began to study them as valuable bearers of social meaning. The utilitarian nature of these creations proved an asset, rather than a disadvantage, to such inquiries and opened windows on religious, political, and social practices of the past.

BACK TO THE "PERIOD EYE"

The emphasis primarily on the aesthetic qualities of art by academies and museums—the reverential attitude toward the great masterpieces enshrined by both—significantly de-contextualized these objects and stripped them of the social and material potency their contemporaries had esteemed. The history of art became the story of timelessly beautiful creations that defied historical explanation and transcended time and place.[63] The Romantics had defined art as the quasi-divine creation of a personal genius. The new science of aesthetics championed disinterested appreciation. Thus, displayed in museum settings, paintings and sculptures that originally formed part of larger altarpieces, tombs, or decorative ensembles came to be transformed into autonomous works of art. Meanwhile, the combination of anonymity and functionality turned most luxury artifacts into less lofty examples of "minor" or "applied arts," even though no contemporary would have made such a distinction. Yet "art" is a slippery notion. Consider, for example, the fact that the purest exemplars of Western art are ones disassociated from functionality, while the most genuine pieces of "primitive" art are those that preserve traces of their use. African wood carvings or Native American ceramic vessels made entirely for art's sake are deprecated as "fake" or "tourist" creations.[64]

The evolution of attitudes toward diverse artifacts is a complex and unruly phenomenon. In pondering the gulf between Renaissance attitudes and our own, we must also contend with the pitfalls of survival. The material value of sumptuous arts often spelled their demise. Countless tapestries rich in gold and silver threads—the most elaborate and finest pieces—have been burned for their metal components; and much goldwork likewise went into the melting pot. The scant remains distort our notion of the quality and power of such creations. Ephemeral works—fireworks and sugar sculptures, processional floats and banquet spectacles—were crucial to the politics and aesthetics of the Renaissance, but we encounter them only as pale ghosts that dwell in occasional texts or engravings that drain them of impact. Contemporary accounts, meanwhile, reveal that what we consider "fine arts" were, with rare exceptions, a minor expense and event compared to the provisions for and impressions made by ephemera and luxury objects. In closing her study of Baroque Rome, Jennifer Montagu urges that any discussion of sculpture must bear in mind, not only the comparatively limited range of objects that we still have, but also the myriad of perishable table adornments, parade decorations, and pyrotechnic displays: "The industry that produced them was extensive

and manifold, and ranged from the great monuments of St. Peter's to a sugar bird on a table or a pile of smouldering ashes in the Piazza di Spagna. In order to understand one part of it, it is essential to be aware of the others."[65] It is my hope that the material presented in the following pages will do some justice to this panorama and enrich the seemingly familiar picture of "Renaissance Art."

Let us embark on this adventure with the words of Paul Oskar Kristeller, who concluded his inquiry into the evolution of the hierarchy of arts as follows:

> The various arts are certainly as old as human civilization, but the manner in which we are accustomed to group them and to assign them a place in our scheme of life and of culture is comparatively recent. . . . If we consider other times and places, the status of the various arts, their associations and their subdivisions appear very different. There were important periods in cultural history when the novel, instrumental music, or canvas painting did not exist or have any importance. On the other hand, the sonnet and the epic poem, stained glass and mosaic, fresco painting and book illumination, vase painting and tapestry, bas relief and pottery have all been "major" arts at various times and in a way they no longer are now. . . . The branches of the arts all have their rise and decline, and even their birth and death, and the distinction between "major" arts and their subdivisions is arbitrary and subject to change. . . . [H]istorical understanding might help to free us from certain conventional preconceptions and to clarify our ideas on the present status and future prospects of the arts and aesthetics.[66]

The foregoing discussion aimed to throw into relief the divergence between the theories that have come to shape our perceptions of early modern visual culture and actual practices. The following chapters will focus on the latter as they apply to the luxury arts of the Renaissance.

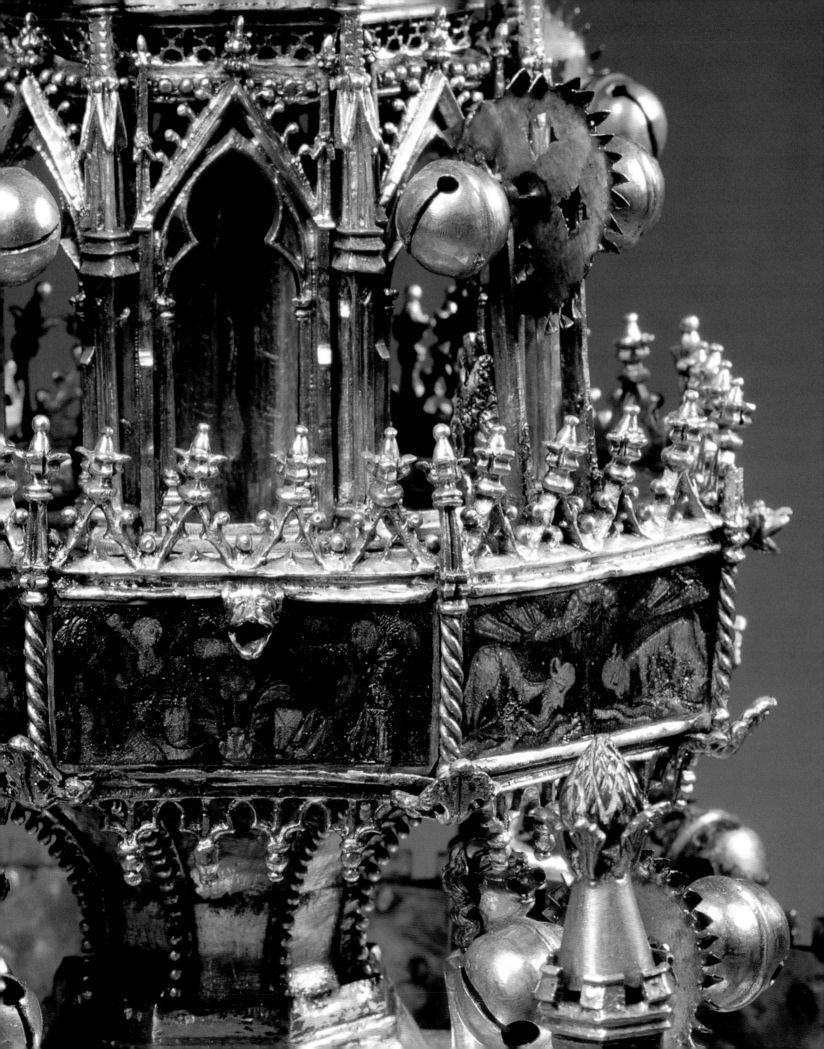

II

The Powers of Gold and Precious Stones

Afterwards the Duke caused his treasure and jewels to be shown to my lord which are beyond measure precious, so much so that one might say that he far outdid the Venetians' treasure in precious stones and pearls. It is said that nowhere in the world were such costly treasures, if only because of the hundred thousand pound weight of beaten gold and silver gilt vessels which we saw in many cabinets, and which were so abundant that we never thought to see the like.

—The Travels of Leo of Rozmital through Germany, Flanders, England, France, Spain, Portugal and Italy 1465–1467

Isabella d'Este, Marchioness of Mantua, was passionate about art (fig. II-1). She pestered Leonardo for anything by his hand; wrote detailed instructions to Andrea Mantegna and Giovanni Bellini regarding the pictures she wished them to produce; and kept abreast of the stocks, prices, and sales of antiquities through her dealers scattered throughout Italy. Among the treasures they procured for her were a late second-century-A.D. onyx vase carved for the Roman imperial family with the figures of Triptolemos accompanied by Ceres and Fortuna and symbolic of Emperor Caracalla's elevation to co-regency with Septemius Severus (fig. II-2), and a cameo depicting Augustus and Livia. These pieces headed the 1542 inventory of Isabella's possessions.[1] Best known today for her patronage of painters, Isabella expended far greater energy and resources acquiring creations in rare stones and gold. Her *Grotta*, which served as a private retreat in the Mantua palace, housed hundreds of gold, silver, and bronze medals and coins; dozens of carved semiprecious vessels mounted in gold settings; numerous engraved gems and cameos framed in gold; as well as bronze and marble statues.[2] Like other Renaissance worthies, Isabella sought ancient carvings in precious and semiprecious stones that combined valuable materials, excellent craftsmanship, and ancient pedigree. She augmented her holdings with objects inspired by ancient models. Among other commissions she ordered a gold medal with her portrait in profile and her name spelled in diamonds and colored enamel (fig. II-3).[3]

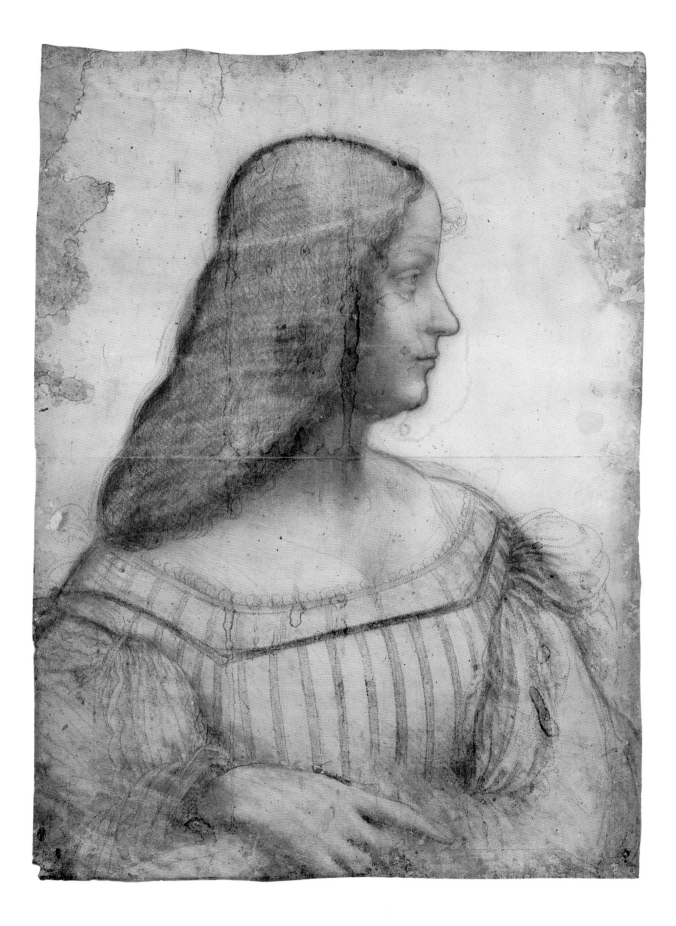

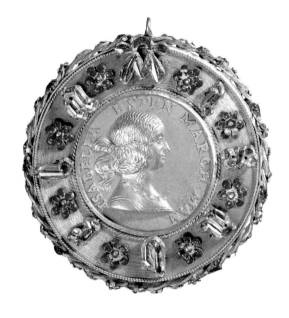

Fig. II-2.
Roman vase, ca. A.D. 54.
Five-layered sardonyx,
H. 15.3 cm (6 in.).
Brunswick, Herzog Anton
Ulrich-Museum –
Kunstmuseum des Landes
Niedersachsen, inv.
GEM 300. Photographer:
Bernd-Peter Keiser.

Fig. II-3.
GIAN CRISTOFORO ROMANO
(Italian, ca. 1470–1512),
Medal of Isabella d'Este,
ca. 1505. Gold, diamonds,
and enamel. Vienna,
Kunsthistorisches Museum,
Münzkabinett, inv. 6.272 bß.

Fig. II-1.
LEONARDO DA VINCI
(Italian, 1452–1519), *Portrait
of Isabella d'Este*, 1499.
Black and red chalk on
paper, 63 × 46 cm
(24⅞ × 18⅛ in.). Paris,
Musée du Louvre, Cabinet
des Dessins. Photo:
RMN/Art Resource, NY.
Photographer: Michele
Bellot.

 When Isabella came to divide her belongings among her heirs, she distributed them in accordance with contemporary notions of their importance. To her daughters, who were nuns, she left ivories from her oratory; to her son Cardinal Ercole, an emerald engraved with the head of Christ, which had belonged to her father; to her son Federigo, her most prized articles—the contents of the *Grotta* "for his delight and pleasure." Her favorite ladies-in-waiting, meanwhile, each received a painting of their choice.[4]

 Isabella's collecting practices and enthusiasms were typical of her age. Contemporary written and pictorial sources make it clear that objects rendered in gold and precious stones were among the most admired and valued effects of the elites because they communicated the status and refinement of their owners, radiated spiritual authority, and possessed medicinal and magical powers.[5]

The beauty and intrinsic worth of precious metals and stones constituted part of their prestige. Their exaltation in the Bible endowed these materials with spiritual preeminence. Gold and gems gleam in many Biblical passages as substances that reflect the glory of God. The books of *Exodus* and *Revelation* give the most influential texts. In *Exodus* 25 God enjoins Moses to fashion a sanctuary worthy of Him: an ark of shittim-wood overlaid with pure gold, a mercy seat of pure gold flanked by two golden cherubim, an offering table overlaid with gold and set with dishes of pure gold, and a menorah of pure gold to hold the seven candles. In *Exodus* 28, stipulating the attire for his high priest Aaron, God calls for garments made of gold, blue wool, and purple and scarlet linen (the costliest dyes) and a Breastplate of Judgment made "with cunning work." It is to be foursquare and set with four rows of stones—sard, topaz, and carbuncle in the first row; emerald, sapphire, and diamond in the second; ligure, agate, and amethyst in the third; and beryl, onyx, and jasper in the fourth. All of the stones are to be encased in gold and engraved with the names of the twelve tribes of the children of Israel.

In the eyes of God, gems and gold were the most fitting offerings his subjects could make to Him. Therefore, the materials enumerated in *Exodus* attained canonical status. In *Revelation* (21.11, 18–21) they form the very building blocks of Heavenly Jerusalem:

> And her light was like unto a stone most precious, even like a jasper stone, clear as crystal; . . . and the building of the wall of it was of jasper: and the city was pure gold, like unto clear glass. And the foundations of the wall of the city were garnished with all manner of precious stones. The first foundation was jasper; the second, sapphire; the third, a chalcedony; the fourth, an emerald; the fifth, sardonyx; the sixth, sardius; the seventh, chrysolyte; the eighth, beryl; the ninth, a topaz; the tenth, a chrysoprasus; the eleventh, a jacinth; the twelfth, an amethyst. And the twelve gates were twelve pearls; every several gate was of one pearl; and the street of the city was pure gold, as it were transparent glass.

By endowing precious stones and metals with spiritual authority, the Bible nurtured the perception of these substances as sanctified and gave rise to numerous learned commentaries on their numinous properties.

Among the most eloquent witnesses to such an understanding of goldwork and gems was Suger (1081–1151), Abbot of the French royal Church of Saint-Denis, which he rebuilt and adorned with devotion and discernment. Suger recorded his achievement and justified his use of sumptuous materials in a treatise on the administration of Saint-Denis. Although he lived and wrote in the twelfth century, his views on the spiritual properties of precious objects were shared by the fifteenth- and sixteenth-century faithful:

> Often we contemplate, out of sheer affection for the church our mother, these different ornaments both new and old; and when we behold how that wonderful cross of St. Eloy—together with the smaller ones—and that incomparable ornament commonly called "the Crest" are placed upon the golden altar, then I say, sighing deeply in my heart: *Every precious stone was thy covering, the sardus, the topaz, and the jasper, the chrysolite, and the onyx, and the beryl, the sapphire, and the carbuncle, and the emerald.* To those who know the properties of pre-

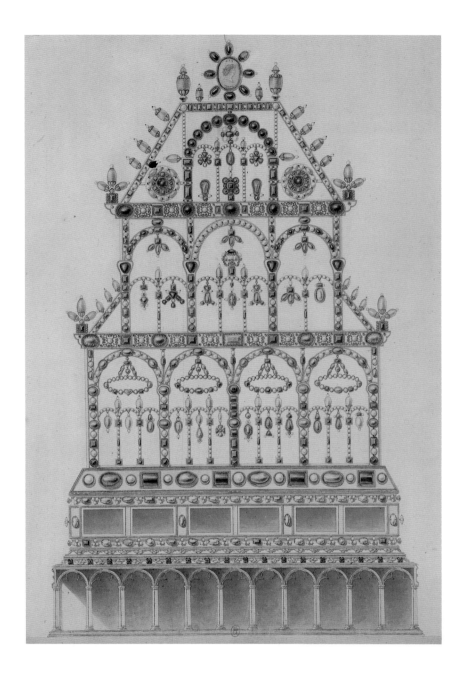

cious stones it becomes evident, to their utter astonishment, that none is absent from the
number of these . . . but that they abound most copiously. Thus, when—out of my delight in
the beauty of the house of God—the loveliness of the many-colored gems has called me away
from the external cares, and worthy meditation has induced me to reflect, transferring that
which is material to that which is immaterial, on the diversity of the sacred virtues; then it
seems to me that I see myself dwelling, as it were in some strange region of the universe
which neither exists entirely in the slime of the earth not entirely in the purity of Heaven;
and that, by the grace of God, I can be transported from this inferior to that higher world in
an anagogical manner.[6]

For Suger, as well as for Renaissance believers, gold and gems reflected divine luminosity; their contemplation transported the faithful closer to God and brought something of divine majesty to the world of men. Beholding the jeweled cross of Saint Eloy and the Crest, or *Crista* (fig. 11-4)—the screen reliquary radiant with gold and ancient gems that decorated the altar of Saint-Denis—Suger recalled biblical texts (such as the passage from *Ezekiel* italicized above) and the heavenly visions they sought to transmit. In this way the Bible transformed sumptuous materials into spiritual conductors.

Gold and gems, moreover, were, not only most suitable offerings to God, but also generous gifts from Him. Detailing the embellishments at Saint-Denis, Suger clarified this exchange: "We have thought it proper to place on record the description of the ornaments of the church by which the Hand of God, during our administration, has adorned His church, His Chosen Bride."[7]

Magnificence was integral to religious ritual, so God and man had to provide for it. As historian Richard Goldthwaite has cogently analyzed:

> This penchant for luxury arose in part from the structuring of religious practice around a complex liturgy and a body of objects that required appropriate display. Since the mass was regarded as a drama performed exclusively by a priest and re-creating the most dramatic moments in the life of the deity, its performance was a veritable spectacle, involving the priest in much moving around and requiring that all those things needed for the execution of the ritual—from the priest isolated on the stage around the altar to the church itself—contribute to a mystical and dramatic impact on the lay public. All the material objects needed for such a performance, in other words, had a significant and conspicuous presence in what was in effect a theatrical performance, and they had to be endowed with appropriate physical attributes of religious splendor. Moreover, the building in which this drama was played out received consecration for this specific purpose; and as sanctified space reflecting the heavenly city of God, it too demanded appropriate embellishment.[8]

Suger was emphatic about the necessity of resplendence in divine service:

> To me, I confess, one thing has always seemed preeminently fitting: that every costlier or costliest thing should serve, first and foremost, for the administration of the Holy Eucharist. If golden pouring vessels, golden vials, golden little mortars used to serve, by the word of God or command of the Prophet, to collect the blood of goats or calves or the red heifer: how much more must golden vessels, precious stones, and whatever is most valued among all created things, be laid out, with continual reverence and full devotion, for the reception of the blood of Christ![9]

There were, of course, those who saw simplicity as a more fitting expression of devotion, those for whom splendor tempted the mind and soul away from God. Answering such critics, particularly his contemporary Bernard, Abbot of Clairvaux (the later Saint Bernard), Suger insisted:

> The detractors also object that a saintly mind, a pure heart, a faithful intention ought to suffice for this sacred function; and we, too, explicitly and especially affirm that it is these that principally matter. [But] we profess that we must do homage also through the outward

ornaments of sacred vessels, and to nothing in the world in an equal degree as to the service of the Holy Sacrifice, with all the inner purity and with all outward splendor. For it behooves us most becomingly to serve Our Saviour in all things in a universal way—Him Who has not refused to provide for us in all things in a universal way and without exception.[10]

Suger inscribed this striving to serve God in the most becoming manner on the very objects he acquired for His church. One precious ewer, for example, bore the following verse:

> Since we must offer libations to God with gems and gold,
> I, Suger, offer this vase to the Lord.[11]

Precious materials, in other words, served to define the majesty of God, his saints, and his priesthood. Eulogizing Pope Leo x (r. 1513–1521) four centuries later, Zaccaria Ferrari described papal majesty through the pope's sumptuous appearance: "And we see the Medici Pope gleaming with jewels and gold, wearing the tiara shining with celestial light and seated to universal acclamation on the sublime throne."[12] As guardian of the most important church in Christendom, Leo was obliged to uphold the dignity of his office through his dazzling attire, ceremonies, and offerings. Thus, among the furnishings he bestowed on Saint Peter's and the Sistine Chapel were a silver-gilt liturgical dish set with crystal, rubies, and sapphires, and a set of magnificent tapestries designed by Raphael (see pp. 110–14).[13] It was not the sanctioned pontifical use of such objects but rather Leo's personal abuse of the grandeur of his office that spurred Luther's attack on the profligate practices of the papacy and led to the Protestant separation of spirituality from splendor and the attempt to strip the Church of luxurious trappings.

Lavish offerings to the Church reflected not only the glory of God but also the status of the donor. As vicars of God on earth, secular rulers presented rich gifts to God and the saints both to express their piety and to proclaim their rank. According to an anonymous late fourteenth-century chronicler of the reign of Charles vi of France, the king's uncle, Jean, Duke de Berry,

> was distinguished among the princes of the blood by his munificence, and he endowed several churches of the realm with relics and with *joyaux* enriched with gems. The royal monastery of St. Denis and the chapter of Notre-Dame-de-Paris must especially acknowledge this if they are not to incur the reproach of ingratitude. He enjoyed continually importing rubies, sapphires, and emeralds from the Orient. He also liked craftsmen who worked with pearls and precious stones, and from them he often ordered chasubles, copes, and other ecclesiastical ornaments enriched by gold fringes and of almost inestimable value. These were so numerous that he could have clothed with equal splendor the canons of three cathedrals. Animated always by an ardent devotion to the service of God, he maintained in his home many chaplains who day and night sang the praise of God and celebrated mass, and he took care to compliment them whenever the service lasted longer or was more elaborate than usual.[14]

Jean de Berry honored the Lord and His saints, not only with a private musical choir, but also with a personal collection of holy relics, common for rulers of the day.

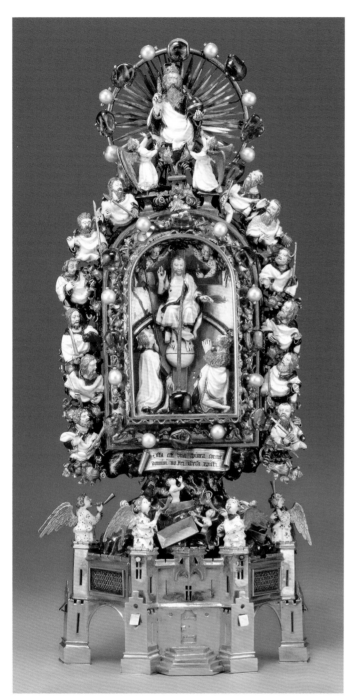

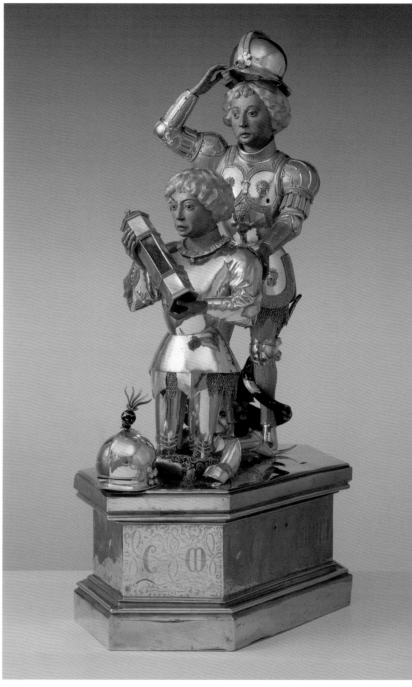

Fig. II-5.
Reliquary of the Holy Thorn,
made for Jean de Berry, ca.
1405–1410. Gold, enamel,
sapphire, gems, pearls, H.
30.5 cm (12 in.). London,
The British Museum, The
Waddesdon Bequest, no. 67.
© Copyright The Trustees
of The British Museum.

Fig. II-6.
GÉRARD LOYET, *Reliquary
of Charles the Bold*,
1467–1471. Gold and
enamel, H. ca. 1.3 m (51 in.).
Liège, Cathedral Treasury.
© IRPA-KIK, Brussels.

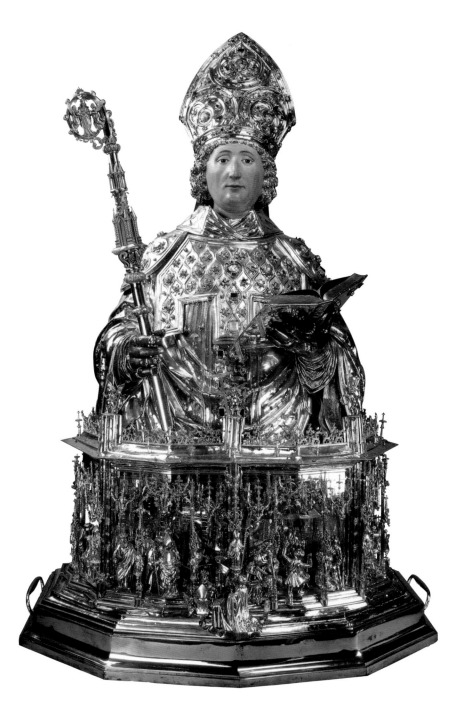

Fig. 11-7.
HENRI SOETE, *Reliquary bust of Saint Lambert*, 1505–1512. Liège, Cathedral Treasury.
© IRPA-KIK, Brussels.

Sacred remains were typically encased in receptacles of precious metals and stones. Berry's gold Reliquary of the Holy Thorn provided a setting for a remnant of the crown of thorns worn by Christ during the Passion (fig. 11-5). The thorn itself rests behind a large cabochon sapphire in the central niche, underneath Christ sitting in Judgment and between the supplicating Virgin Mary and Saint John. At the apex of the reliquary God the Father, crowned and holding a scepter and an orb, is framed by a golden halo made more radiant by gems and pearls. Apostles and angels surround the niche with Christ; the Dead rise from the verdant hillock below, awakened by the trumpeting angels.

Dedications of rich reliquaries were motivated by various concerns: desire to safeguard precious remains; calculation to attract renown and pilgrimage by augmenting the aura of relics through splendid presentation; and demonstration of the wealth and power of a given institution and of the history that brought it such fortune.[15] Some reliquaries came about as votive donations. Many rulers offered votives in precious metals to express their devotion, fulfill a vow, and mark their authority over a city and its shrines.[16]

In 1471 Charles the Bold of Burgundy bestowed on the cathedral of Liège a gold ensemble representing himself in the act of donating a reliquary to Saint Lambert (fig. 11-6). About 130 cm (51 in.) tall, the group was fashioned by the ducal goldsmith Gérard Loyet. The faces of Charles and Saint George, his patron saint, are enameled in flesh tones, with rosy cheeks, dark eyes, lashes, and brows. A cushion under the duke's knees imitates a gold design on a blue velvet ground. The dragon vanquished by Saint George has a green enameled hide and glowing red eyes. Ducal armorial devices, once riveted to the base, are now only intimated by the holes for their attachment, but Charles's motto, *Je lay Emprins* ("I undertook it"), is still visible. Charles commissioned the group to fulfill a vow—an offering of thanks to Saint Lambert for helping him subjugate Liège, which had twice risen in revolt against him.[17] After the city's decisive defeat in 1468, as his troops pillaged Liège, Charles assiduously protected Saint Lambert's bones and his church. By literally taking hold of the relics and later returning them to the saint in a resplendent container that perpetuated his homage, the duke asserted his hegemony over Liège in both political and religious terms. He stipulated, moreover, that this votive be displayed prominently during the special Mass to be celebrated henceforth every Friday "for peace and for the lord Duke." The duke's gold votive honored his divine aides and himself in a manner worthy of all three.

Many Renaissance reliquaries were fashioned predominantly of precious metals. The early sixteenth-century bishop Erard de la Marck ordered a massive—more than 1.5 m (5 ft.) tall—reliquary bust for the bones of Saint Lambert preserved in the Cathedral of Saint Lambert in Liège (fig. 11-7). This reliquary honored the saint through its materials—gold, silver, and gems; the greater than life-size "portrait"; and, on the base, sculptural scenes commemorating key events of his life.

The Magical Powers of Metals and Gems

The biblical use of gold and gems on the Breastplate of Judgment and in the architectural fabric of the Heavenly Jerusalem endowed these materials with spiritual virtues, but the tradition of ascribing magical and medicinal properties to them went back to pagan antiquity. Medieval and Renaissance treatises on the healing properties of stones and metals drew heavily on Theophrastus, Pliny, and other ancient authors and coexisted with biblical exegeses.[18] One of the most influential medieval lapidaries, *De lapidibus* (On stones), was written by Marbode, Bishop of Rennes in Brittany, between 1067 and 1081.[19] A practical guide to the therapeutic uses of minerals, it enjoyed a vast circulation among monks, apothecaries, physicians, goldsmiths, and rulers across Europe and provided the basis for many subsequent compendia. More than a hundred manuscripts of this work survive in Latin, French, Provençal, Italian, Irish, Danish, Hebrew, and Spanish.

Marbode's lapidary described some sixty stones and their powers. Diamonds, for example, made their wearer indomitable, drove off idle dreams and spirits in the night, warded off black poison, cured madness, and overcame strife. Sapphires, fit only for the hands of kings, preserved one from injury and fraud, conquered envy and terror, liberated one from prison, and promoted concord; they purified the eyes, cooled the body, made the wearer beloved by God and diligent in prayer; they also fostered chastity, although the last quality apparently failed to work for the duke of Burgundy, Philip the Good, who owned countless sapphires and fathered scores of bastards. Emeralds, meanwhile, helped men recover lost objects, aided in divination, made the wearer eloquent and persuasive, cured epilepsy, rested the eyes, averted tempests, and held in check licentious emotions. Amethysts prevented drunkenness, carnelians restrained anger, agates brought victory, and so forth.

Another major treatise, *De mineralibus*, composed by Albertus Magnus in the middle of the thirteenth century, catalogued the properties of stones and metals and addressed theories of mineral formation. Based on the practical knowledge of lapidaries, alchemists, and pharmacists, the compendium was recopied countless times and issued in printed editions in 1495 and 1518.[20] Therapeutic applications of precious stones and metals were widespread in the Renaissance. During Lorenzo de' Medici's last illness in 1492 his physicians treated him with a potion composed of ground gems. Lorenzo's court philosopher Marsilio Ficino, meanwhile, outlined an entire program of mineralogical and astrological medicines best suited for the health of an intellectual.[21] Drawing on ancient and medieval authorities, Ficino's *De triplici vita* (1489; trans. as *Three Books on Life*, 1989) prescribed gold and gems as potent curatives. Being incorruptible, gold could impart such a quality to man; thus Ficino offered a recipe for gold or magical pills that strengthened individual body parts and sharpened and illuminated the spirits.[22] Another elixir was to be prepared in the following manner:

> Take four ounces of sweet almonds, two ounces of pine-nuts, four ounces of hard sugar which they call "candy," and one and one half pounds of the other kind of sugar. Infuse all these things in rose-, lemon-, and citron-water in which red-hot gold and silver have been extinguished; boil it all gently. Finally, add one dram apiece of cinnamon, red ben, red sandal, and red coral, one-half dram apiece of the brightest pearls, saffron, and raw scarlet silk which has been pounded up very fine, twelve grains apiece of gold and silver, and one-third dram apiece of jacinth, emerald, sapphire, and carbuncle.[23]

Ficino further elucidated how to use metals and gems to call down the beneficial influence of the planets, for each celestial body was attracted to and acted through terrestrial matter:

> If you want your body and spirit to receive power from some member of the cosmos, say from the Sun, seek the things which above all are most Solar among metals and gems, still more among plants, and more yet among animals, especially human beings.... These must both be brought to bear externally and, so far as possible, taken internally, especially in the day and the hour of the Sun and while the Sun is dominant in a theme of heavens. Solar things are: all those gems and flowers which are called heliotrope because they turn towards the sun, likewise gold, chrysolite, carbuncle, myrrh, frankincense, musk, amber, balsam, yellow honey, sweet calamus, saffron, spikenard, cinnamon, aloe-wood and the rest of the spices.

In the same way, so that your body may not be deprived of Jupiter, take physical exercise in Jupiter's day and hour and when he is reigning; and in the meantime use Jovial things such as silver, jacinth, topaz, coral, crystal, beryl, spodium, sapphire, green and airy colors, wine, sugar, white honey.[24]

We may feel tempted to dismiss these recipes as ignorant superstitions. But the fact that they were set down in learned treatises by the leading minds of the time and used by men such as Lorenzo de' Medici invites us to hold back judgment and reflect on the very different mindset and world view of the Renaissance.

Geography and Learning

Today gems are expensive, but ubiquitous. In the Renaissance they were the preserve of the lofty and deserving few — and more potent for being exotic. Imported from faraway lands, gems radiated, not only spiritual authority and talismanic powers, but also the mystery and enchantment of the East.[25] Rubies hailed from India and Ceylon; sapphires from Ceylon, Arabia, and Persia; emeralds from Egypt; diamonds from India and Central Africa. In 1437 the Spanish merchant Pero Tafur, while visiting the monastery of Saint Catherine on Mount Sinai, witnessed an Indian caravan with

> so many camels . . . that I cannot give an account of them, as I do not wish to appear to speak extravagantly. This caravan carries all the spices, pearls, precious stones and gold, perfumes, and linen, and parrots, and cats from India, with many other things, which they distribute throughout the world. One half goes to Babylonia, and from there to Alexandria, and the rest to Damascus, and thence to the port of Beirut.[26]

The bazaar of Cairo was another fabled mart for precious substances of every sort. The Venetians, with their long-standing trade privileges in the East, acted as the chief intermediaries in the transport of these goods to the West. When Albrecht Dürer stayed in Venice in 1506, he spent much of his time hunting for gems and jewels for his humanist friend and patron Willibald Pirkheimer, a wealthy Nuremberg patrician. In one letter Dürer reports: "Now, as to what you commissioned me, namely, to buy a few pearls and precious stones — you must know that I can find nothing good enough or worth the money; everything is snapped up by the Germans."[27] In another missive he sends this update:

> I send you herewith a ring with a sapphire about which you wrote so urgently. I could not send it sooner, for the past two days I have been running around to all the German and Italian goldsmiths that are in all Venice with a good assistant whom I hired . . . so I hope that you will like it. Everybody says that it is a good stone, and that in Germany it would be worth about 50 florins; however, you will know whether they tell truth or lies. I understand nothing about it.[28]

The ownership of rare and precious objects reinforced social hierarchy, not only because it required great financial resources, but also because it demanded learning necessary to appreciate and interpret the qualities of these materials.[29] Men like

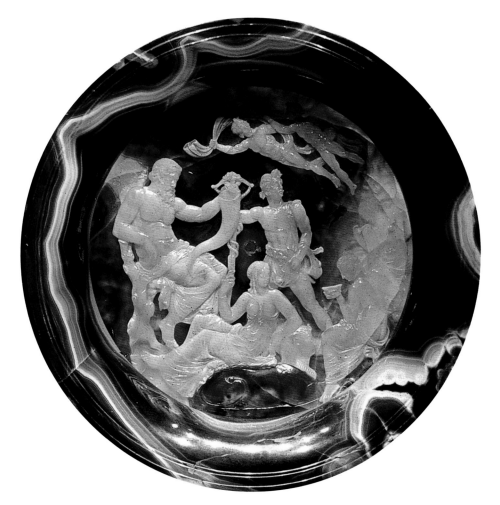

Fig. 11-8.
Interior of the *Farnese Cup*,
Roman (possibly from
Alexandria), first century
B.C. Cameo of four-layered
sardonyx and agate, DIAM.
20 cm (7⅞ in.). Naples,
National Archaeological
Museum, inv. 27611.

Abbot Suger, the duke de Berry, Lorenzo de' Medici, and Willibald Pirkheimer enjoyed an education that enabled them to identify the magical properties, moral meanings, scriptural associations, and other virtues of stones and goldwork and to make fine judgments as to what constituted a proper object of admiration and what did not.

The taste and discernment of Lorenzo de' Medici is readily traceable today because he habitually engraved his possessions with his initials: LAV. R. MED, with *R* standing for "Rexque paterque," Horace's title for the great Roman art patron Maecenas (*Epistulae* 1.7.37). Lorenzo's collection contained creations in rock crystal, jasper, amethyst, sardonyx, chalcedony, agate, porphyry, and other numinous materials set in gold. He owned the Farnese Cup (fig. 11-8)—an ancient bowl of sardonyx valued in his inventories at ten thousand *florins*. Among his jewels was a pearl of some thirty-eight carats, pure and perfect in color and texture, valued at three thousand *florins*. In comparison, his paintings were valued at one to ten *florins* each.[30]

Numerous ancient gems and vessels of semiprecious stones survived and circulated in Europe and the East among rulers and ecclesiastical institutions. Many of them came to Italy through Venetian commercial traffic in Byzantium, Syria, Egypt, and the Holy Land. Some were booty from the Crusades.[31] The Basilica of Saint Mark in Venice was conspicuously, if not militantly, aglow with such treasures, many of them trophies

Fig. II-9.
Vase in the form of an
eagle, called the "Eagle of
Suger." Ancient Egyptian or
Roman porphyry vase with
twelfth-century gold-and-
silver mount, H. 43 cm
(16⅞ in.). Paris, Musée du
Louvre, inv. MR 422. Photo:
RMN/Art Resource, NY.
Photographer:
Daniel Arnaudet.

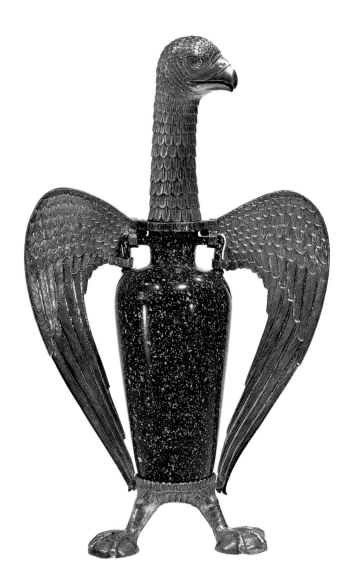

of the sack of Constantinople in 1204.[32] Reset in contemporary mounts, ancient carvings assumed or were assigned new (often christianized) roles. Abbot Suger documented such transformations at Saint-Denis:

> And further we adapted for the service of the altar, with the aid of gold and silver material, a porphyry vase, made admirably by the hand of the sculptor and polisher, after it had lain idly in a chest for many years, converting it from a flagon into the shape of an eagle; and we had the following verses inscribed on this vase: "This stone deserves to be enclosed in gems and gold. It was marble, but in these [settings] it is more precious than marble."[33]

Suger's eagle vase survives (fig. II-9): an Egyptian or Imperial Roman work, it has been placed in a twelfth-century gold mount.[34] Another vessel described by Suger as a "precious chalice out of one solid sardonyx" is likewise an ancient work (fig. II-10). Likely made in the second century B.C. in Alexandria, it was augmented in Suger's time with a gem-studded gold mount and further elaborated in the seventeenth century to suit another change in taste.

Fig. II-10.
Chalice of Abbot Suger,
second–first century B.C.
vase from Alexandria with
twelfth-century French
mounts. Sardonyx cup, gilt
silver mounts with precious
stones, pearls, glass insets,
and white glass pearls,
H. 18.4 cm (7¼ in.).
Washington, D.C., National
Gallery of Art, Widener
Collection, inv. 1942.9.277
(DA). Photographer:
Philip A. Charles.

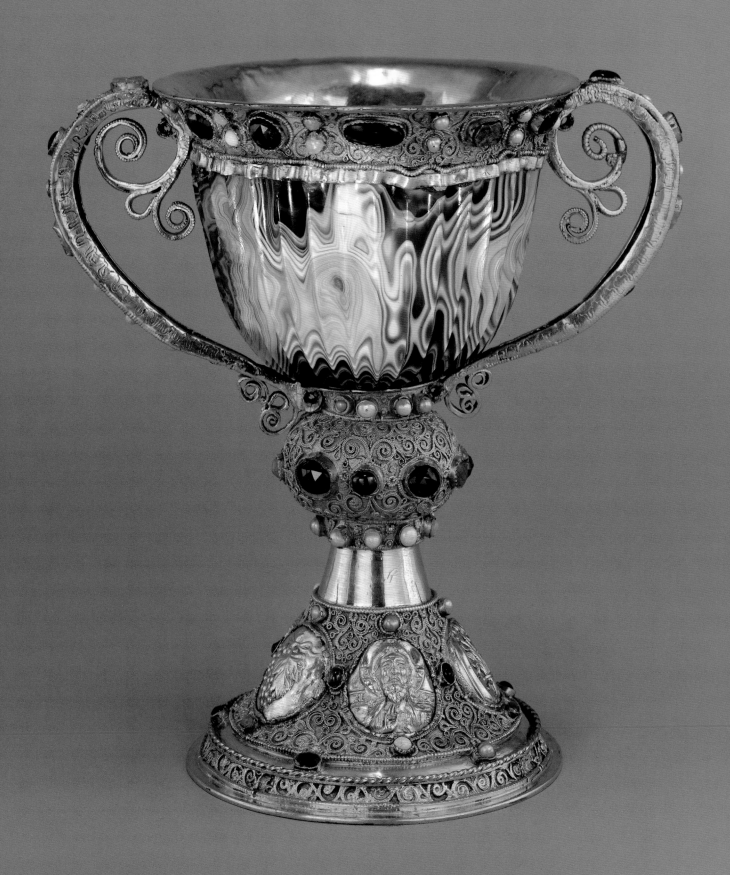

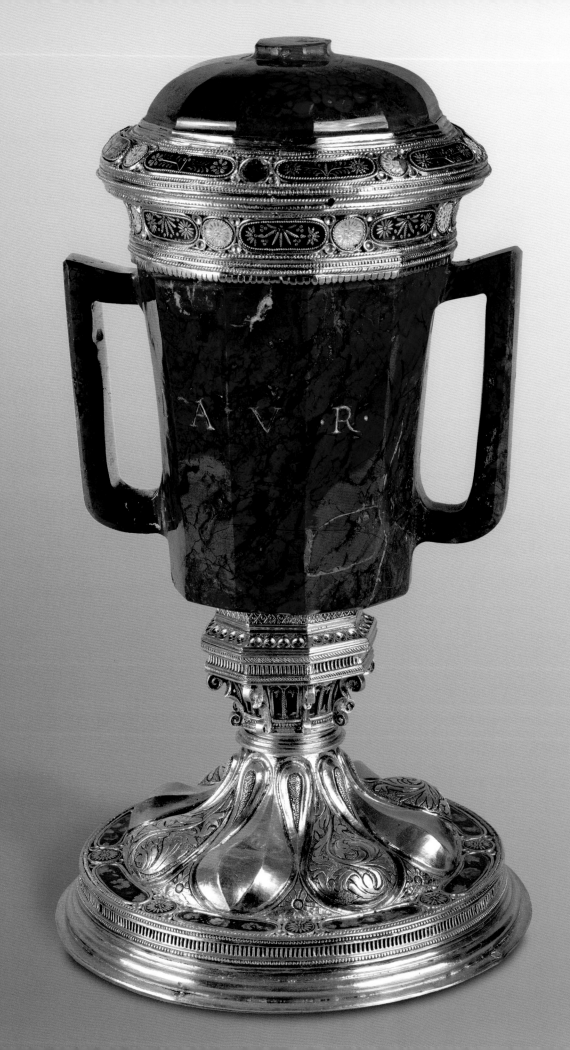

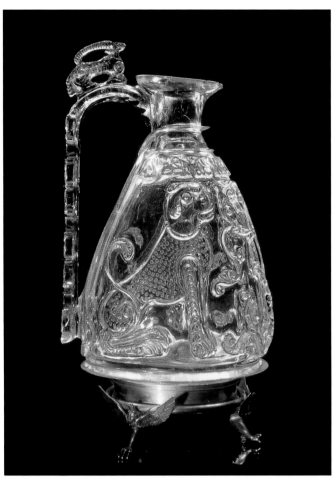

Fig. II 12.
Cup with the initials of
Lorenzo de' Medici, Central
Asia (Timurid), fifteenth
century. Jade, H. 5.4 cm
(2⅛ in.), DIAM. 12 cm
(4¾ in.). Florence, Museo
di Mineralogia e Litologia,
inv. 13636.

Fig. II-13.
Crystal ewer, Egypt, tenth
century, with sixteenth-
century metal mounts.
Venice, Treasury of San
Marco, inv. 80. By permis-
sion of the Procuratoria di
San Marco, Venice.

Fig. II-11.
MEDICI WORKSHOP, Jasper
vase, Venice, fourteenth–
sixteenth century; GIUSTO
DA FIRENZE, gilt and enamel
mounts, mid-fifteenth cen-
tury. Florence, Museo degli
Argenti, inv. 1921, N. 638.
Photo: Erich Lessing/Art
Resource, NY.

Paris and Venice—one a center of royal patronage, the other the emporium for
luxury arts—were chief production centers of new creations in precious and semi-
precious stones inspired by ancient exemplars. Lorenzo de' Medici had a jasper vase
manufactured in the Republic of Venice (fig. II-11); and Duke de Berry's inventories
refer to objects carved from chalcedony and crystal as "work of Venice."[35] Eastern arti-
facts, meanwhile, were prized for their refinement and exoticism. The Medici owned
a jade cup of Timurid origin with Lorenzo's initials, LAV, prominently carved on it (fig.
II-12). Fatimid cut crystal from Egypt constituted another valuable mark of distinction.
The inventories of the duke de Berry list "a crystal ewer, worked with animals, with a
handle of the same mounted in gold," and "a crystal ewer, worked with foliage and birds,
mounted in silver-gilt."[36] A similar object, reset in a sixteenth-century metal frame,
belongs to the Treasury of Saint Mark's in Venice (fig. II-13). Its original owner, accord-
ing to a carved inscription, was the fifth Fatimid caliph al-'Aziz Bi'llāh (r. 975–996).[37]
The Medici, too, owned a Fatimid ewer, such artifacts connoting the far-flung power and
cultivation of their owners. The movement of these objects from the East to the West
reflected not only commerce and conquest but an ongoing cultural dialogue and diplo-
matic exchange, differences of faith notwithstanding.

Elaborate ensembles of gold- and stonework, alongside tapestries and textiles, armor and rare animals, formed the most suitable gifts among royalty, their layered symbolic capital rendering them appropriate for the loftiest recipients. On New Year's Day, when princes exchanged gifts with their family and entourage, they habitually presented to their consorts, and received from their courtiers, pieces of ingeniously crafted goldwork. The gifts given by Henry VIII Tudor, his wives, and familiars are documented by detailed court records, each offering strictly correlated to the receiver's rank.[38] Thus the New Year Gift Roll for 1534 notes that the queen—then Anne Boleyn—presented the king with a table fountain designed by Hans Holbein, while Thomas Cromwell gave the king a ewer of mother-of-pearl garnished with gold.[39] These pieces have perished, but several designs for comparable goldwork drawn up by Holbein—such as a cup that the king had intended for Jane Seymour (fig. II-14)—capture the grandeur of royal exchanges.

The preservation of a few objects together with documents detailing their histories permits their study at the intersection of precious materials, fine workmanship, diplomatic relations, and capital. The *Goldenes Rössl* (golden pony) was given by Isabella of Bavaria to her husband, Charles VI, King of France, on 1 January 1404 (fig. II-15). The royal inventory describes it precisely, enumerating each figurative component and every gem.[40] Gems and pearls formed key parts of princely goldwork and comprised the greatest value of any given ensemble. Hence they were carefully registered in inventories and account books in case the precious stones were removed or replaced, as they often were. All figures in the *Goldenes Rössl*—the Madonna with Child, the angels holding a crown over her head, the infant saints at her feet, the kneeling Charles VI, his marshal, groom, and pony—are gold forms accented with enamel, which gives color to the garments and flesh. Enameled goldwork enjoyed great popularity in princely circles from the late fourteenth through the sixteenth century (and its appeal endured into more recent times, as Fabergé creations for the Russian czars indicate). King Charles VI doubtless rejoiced at the receipt of the *Goldenes Rössl*. Yet a year later the ensemble, along with other similar works, was pawned to Queen Isabella's brother, the duke of Bavaria, in exchange for much-needed cash.[41] Pawning or melting down was the fate of much goldwork, for aside from its spiritual connotations and aesthetic merits, it functioned as a form of deposit banking, readily convertible into cash should the ruler or his heirs fall short. Millard Meiss has described the transience of such artifacts in an apt metaphor: "Quite commonly the objects were melted down within a few years of their completion. The life of the goldsmiths was thus somewhat like that of cooks: a relatively long period of preparation and a relatively short one of enjoyment."[42]

Magnificent metal- and stonework accompanied most royal transactions. In the early sixteenth century the Medici pope Leo X and the king of France, Francis I, engaged

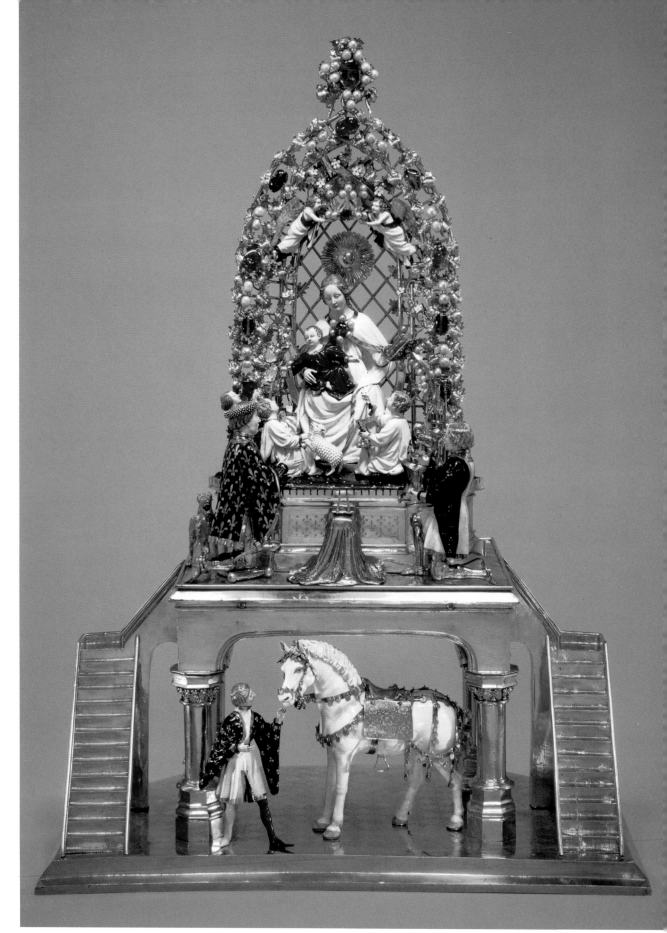

Fig. II-15.
Goldenes Rössl, Paris, 1403.
Gold, gilt silver, enamel,
pearls, and precious stones,
H. 62 cm (24⅜ in.).
Altötting, Treasury of
the Collegiate Church
[*Stiftskirche*].

in a delicate dance of political courtship. Francis sought papal alliance in his struggle for European supremacy against his rival, Emperor Charles V Habsburg; Leo wanted the French king's help in safeguarding Medici rule in Florence. As one step in this rapprochement, in February 1515 the pope's cousin, Cardinal Giulio de' Medici, was confirmed as archbishop of Narbonne. With Francis's invasion of Italy and victory at the Battle of Marignano on 14 September 1515, his presence on the peninsula threatened the pope both politically and geographically. To assure royal goodwill over the next few years, Leo regularly dispatched gifts to the French court. In 1518 he sent several programmatic paintings by Raphael to augment Francis's collection of Italian pictures, which the latter used as adornment of his baths, in the manner of the ancient Romans. Around 1520 the pope planned to offer Francis a metal incense burner, also conceived by Raphael and personalized for the French monarch by the addition of his heraldic devices: the salamander and the fleur-de-lis. The fate of this project is unclear, but its potential appearance is recorded in an engraving by Marcantonio Raimondi, who turned many of Raphael's designs into prints (fig. II-16). In 1533 the French royal family and the Medici intermarried. By this time Leo X was dead, and his cousin occupied the papal throne as Clement VII. Clement had consolidated Medici power in Florence, installed Alessandro as the city's duke, obtained recognition of the Medici dynasty from Emperor Charles V, and was now ready to cement the French alliance by marrying his

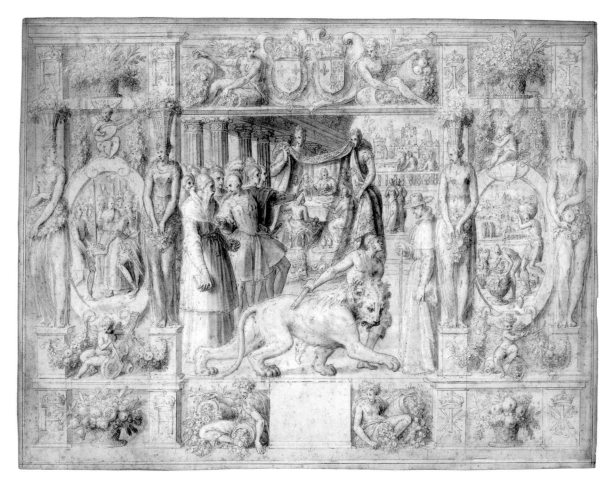

Fig. 11-18.
Antoine Caron (French, 1521–1599), *The Gifts Exchanged between Pope Clement VII and King Francis I*, ca. 1560–1574. Brown ink and brown wash on paper. From *Histoire française de nostre temps*. Paris, Musée du Louvre, Département des Arts Graphiques, inv. RF 29752-12. Photo: RMN/ Art Resource, NY. Photographer: J. G. Berizzi.

kinswoman, Catherine de Medici, to Francis's son, Henry II. In preparation for the arrival of the bridal fleet at Marseilles, Francis spent 4,623 *livres* moving plate, tapestries, and furniture that would adorn and solemnize the wedding. Clement brought along royal gifts, among them a silver-gilt casket with rock-crystal panels engraved with episodes from the life of Christ (fig. 11-17). The casket bore the enameled name, arms, and motto of the pope, emphatically proclaiming its origin.

The writer and courtier Nicolas Houel composed a poem in which he praised the wedding as one of the great events witnessed at court between the reign of Francis I and Charles IX—a eulogy augmented by twenty-seven drawings executed by Antoine Caron. Both men turned a keen eye to the gift exchange:

> The tournament having ended, the Holy Father
>> made a gift to the King of a unicorn's horn,
>> likewise the King gives him a beautiful tapestry,
>> Showing him thus his great generosity.
> And to gratify in kind the other side
>> To Ippolito, the nephew of the triple crown,
>> Likewise a lion he offers him,
>> Full of grandeur and courage.[43]

Caron's drawing shows, in the center, the proffering of the tapestry and the lion, while servants bear massive metal vases on the right, and the unicorn horn is on the left (fig. II-18). According to Benvenuto Cellini, Clement VII had staged a competition for the design of the gold mount in which the horn, valued at seventeen thousand *ducats*, was to be set. Recounting the contest, Cellini, typically, extolled his own design, decrying that of the Milanese goldsmith Tobia—"so crudely unimaginative that when I saw such a thing I could not help snickering to myself." Cellini's venom was all the more bitter because he lost; Caron's drawing shows Tobia's mount. The unicorn horn (in fact, a narwhal tusk) was prized as the best antidote to poison and was therefore set up to guard the royal plate whenever a great banquet was held. The political significance of the gift is clarified by a seventeenth-century commentator on a medal of Francis I, the reverse of which depicts a unicorn dipping its horn into a pond to render it pure: "Pope Clement VII made a gift of a unicorn horn, which expels poisons, to make him understand that he should keep his kingdom safe from heresy."

According to the *Physiologus*, an immensely popular collection of stories about real and imaginary beasts compiled in Alexandria in the second century A.D., the unicorn could purify lakes poisoned by snakes by dipping his horn into the water and making the sign of the cross over it. All other animals could then be refreshed, cleansed, and purified. The behavior of the unicorn paralleled that of Christ saving mankind from the sins brought into the world by Satan. Clement's horn

Fig. II-19.
Portrait of Francis I on bulla used to seal the Treaty of Amiens in 1527. Gold, DIAM. ca. 10.2 cm (4 in.). London, The National Archives, inv. TNA PRO 30/26/82/1.

Fig. II-20.
Portrait of Henry VIII on bulla used to seal the Treaty of Amiens in 1527. Gold. Paris, Archives Nationales (CARAN), inv. D 10055.

was meant to remind Francis of his commitment to serve the Church—part of the Franco-papal alliance.[44] As for the other gifts, the tapestry depicted Leonardo's *Last Supper* with the French royal arms displayed prominently above the head of Christ. The lion, previously shipped to the king from Algiers, was, of course, a princely beast; but it was also one of the emblems of Florence. The Medici had kept lions for generations, and, as true heirs of the ancient Romans, they staged animal combats to entertain visiting dignitaries. The gift of this animal to a papal nephew was thus doubly astute.

Back to diplomacy and goldwork, let us note in conclusion that it could literally seal political accords, as did richly wrought bullae authenticating major pacts. Two gold bullae secured the two copies of the Treaty of Amiens, signed on 30 April 1527 as an agreement to perpetual peace between England and France.[45] The bulla on the parchment kept by Henry showed the enthroned king of France (fig. II-19), his arms on the reverse; the bulla retained by Francis bore the analogous portrait and insignia of the English king (fig. II-20). Part of the complex political game played by Henry VIII, Francis I, Charles V, and the pope, the treaty proved as ineffectual as the Field of Cloth of Gold summit (see fig. VI-10). But at the time of the signing of the Treaty of Amiens, the weightiness and incorruptibility of the gold and the carefully detailed imagery of the bullae manifested the gravity of the pact they sealed.

Gold, Automata, and the Culture of Wonder

Goldwork could make still greater impact when, combined with feats of engineering, it was shaped into automata—devices that seemed to move on their own accord and perform intricate actions. The conjunction of precious materials and ingenious mechanics bespoke the owner's ability to command the most impressive resources. Treatises of ancient engineers, be it Philo of Byzantium (second century B.C.) or Hero of Alexandria (first century A.D.); tales of travelers to the courts of Byzantine and Chinese emperors, where fabulous automata entertained guests; and extant European examples stimulated the imagination and desire of European writers and rulers for such awe-inspiring machines.[46] While not all automata consisted of costly substances, gold, silver, and gems enhanced their princely aura and magical power.[47]

Elaborate machines frequently featured in French romances, which were widely read by European elites. Although not reliable guides to contemporary realities, these romances do reflect the attitudes and preoccupations of their day. Literary accounts of automata drew on existing contrivances and, by embellishing them, fostered the appetite for these wonders in life. One of the most popular romances, and hence influential texts, was Benoît de Sainte-Maure's *Roman de Troie*, a version of the Trojan War story overlaid with courtly and chivalric ideals. The *Roman* presented an array of artifacts that defined the royal realm. Notable among them was a collection of articles adorning the room in Priam's palace, the alabaster "Chamber of Beauties,"[48]

> which glistens with Arabian gold and the twelve [sic] twin stones which God decided were
> the loveliest of all when he gave them the name "precious stones"—sapphire and sard, topaz,
> chrysoprase, chrysolite, emerald, beryl, amethyst, jasper, ruby, precious sardonyx, bright car-
> buncle and chalcedony—these were to be found in great abundance the length and breadth
> of the Chamber. No other source of light was needed, for the Chamber on a dark night far

outshines the very brightest summer day. The windows are made of green chrysoprase and sard and fine almandite and the frames are moulded in Arabian gold. I do not intend to recount or to speak of the many sculptures and statues, the images and paintings, the marvels and the tricks there were in various places, for it would be tiresome to listen to.[49]

The author does, however, describe at length the most impressive objects in the room:[50]

In the four corners of the Chamber there were four tall handsome pillars: one was of precious yellow amber, another of powerful jasper; the third was of onyx and the fourth of jet: the least of them was worth more than two hundred marks of pure gold, I believe. There is no-one alive today powerful enough to acquire the two least valuable ones with either money or influence.

Each column was surmounted by a golden automaton. The first, shaped like a girl, held a mirror that reflected any shortcoming of the viewer and permitted him or her to adjust clothing or behavior so as to conform to courtly decorum. The second girl

performed and entertained and danced and capered and gambolled and leapt all day long on top of the pillar.... Seven or eight times a day it would perform a hundred rich and splendid tricks. In front of it was a great broad table of pure gold, on which it worked such wonders that everything it could possibly imagine—combats between bears and wild boars, griffons, tigers and lions; goshawks and falcons and sparrow-hawks and other birds in flight; the games that ladies and young girls play; councils and ambushes, battles, treasons, and armed assaults; ships sailing on the high seas; all the various fishes of the sea; single combats between champions; men with horns and grotesques; hideous flying serpents, demons and fearsome monsters—it has all these perform and reveal their nature every day.

. . .

[The third figure, representing a youth, sat] on top of the pillar in a magnificent chair. This was made out of a single piece of obsidian, which is a very valuable stone. If you see it at all frequently—so says the Book, which does not lie—you are refreshed and revitalized by it, your colour improves, and you will not suffer any great distress on a day when you see it even once. The figure's head was crowned with a golden chaplet, finely wrought with emeralds and rubies which shed great light on its face.

and it played twelve instruments more skillfully than King David. Those hearing the music felt not sorrow nor pain, not evil thoughts nor foolish desires. The automaton further scattered sweet-smelling flowers in the room.

The fourth statue watched people in the chamber and signaled to them what they ought to do and what was most important to them, but these signs were invisible to everyone else. It also indicated to visitors when it was time for them to depart; and "it kept those who came into the Chamber . . . from being disagreeable, uncourtly, or importunate." In its hand the figure held a censer "made from a single large, brilliant, and valuable topaz, with finely-engraved chains tightly interlaced with gold wire" and filled with sweet and salubrious gums that dispelled foolish ideas and could cure any sickness or pain.

The Chamber of Beauties presented to its guests—both within the novel and to its readers—a mirror of courtly society, reflecting what was considered exalted and civilizing at this time. Through their actions and instructions the ingenious automata were instrumental in creating the stately ambiance. And the substances from which they were crafted enhanced their power, authority, and impact.

While fictional automata were too complex to render in mere metal and stone, actual contrivances, often inspired by romances, formed vital parts of sovereign realm and court display. At the wedding of Charles the Bold and Margaret of York, held in Bruges in 1468, ancient history came to life in theatrical enactments of the Deeds of Hercules; and mythological and biblical characters delivered political messages and moral lessons from textiles lining the walls. Meanwhile, from the ceiling hung two massive chandeliers—large enough to conceal men operating their machinery. Representing Palaces of Glory and Fame, they offered mechanized spectacles comparable to those of romances. The chandeliers consisted of branches with candles illuminating three-dimensional castles perched atop mountains whose slopes were covered with lush trees, flowers, and grass. Along the mountain paths moved diverse personages both on foot and on horseback, men and women, and different beasts, while dragons issued forth from among the rocks and blew fire. All these were automata. The bases of the chandeliers and the branches with candles stood still, but the mountains with castles rotated. Seven large mirrors affixed to the bases reflected all that happened above, magnifying the spectacle many times.[51]

The creator of these devices, Jehan Scalkin, also produced a table fountain placed near the duke on the last day of the celebrations. Shaped like a tall and ornate palace with crystal columns, it had an attached mirror that revealed a view of the characters within—automata dancing the *moresca* in a garden setting. In front of the palace a statuette of John the Baptist poured rose water from his finger. The water cascaded into a lake full of fish at the fountain's base and reflected in a mirror set on the palace roof. A little man on top of the palace held a banner with ducal arms.[52]

Marvels—things "worth looking at," according to ancient concepts—were the aristocracy of phenomena. In *De partibus animalium* (On the parts of animals) Aristotle had suggested that wonder nurtured habits of concentration and expanded and sharpened the mind. Wonders played fundamental roles in fostering courtly ideals: They refined sensibilities and connoted the ruler's mastery over nature and man.[53] Displays of automata, furthermore, transferred the admiration from the objects to their owner, enhancing his charisma. They were, in a sense, secular analogues to exhibitions of relics, which, according to Guillaume Durand (ca. 1230–1296), "prompt wonder and are rarely seen, so that by them the people are drawn into church and are more affected."[54]

The large-scale automata described above required a variety of materials for their construction. Smaller pieces could be rendered primarily in gold and gilt silver (at least their elaborate external casings). Such work became the specialty of Nuremberg and Augsburg, which also manufactured superbly engineered and richly ornamented armor for European elites.[55] Albrecht Dürer—a Nuremberger, son of a goldsmith, trained as one himself, and son-in-law of an engineer—designed several table fountains for water or wine, to be operated by pressure tubing (fig. II-21). Their internal mechanisms were likely devised by his father-in-law, Hans Frey, known for his ability "to raise water by use of air."[56] Dürer's models recall the mountains teeming with figures that graced the wedding banquet of Charles the Bold. Given the awe inspired by the

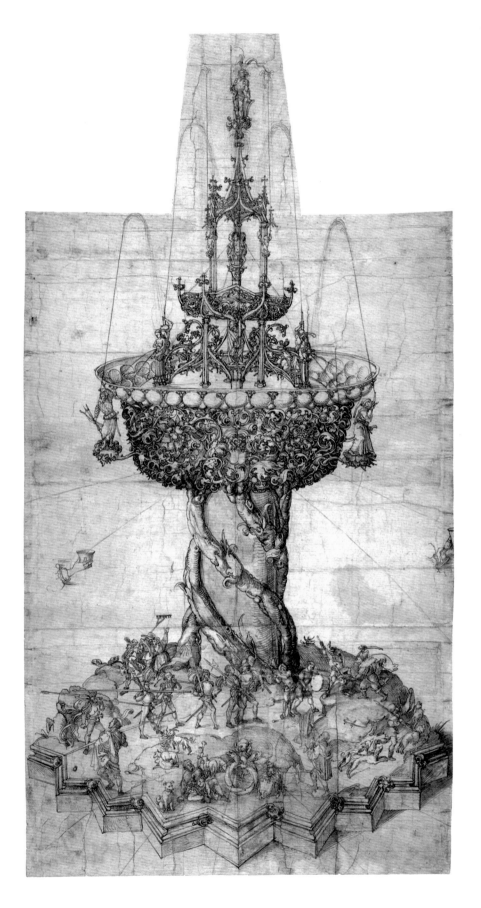

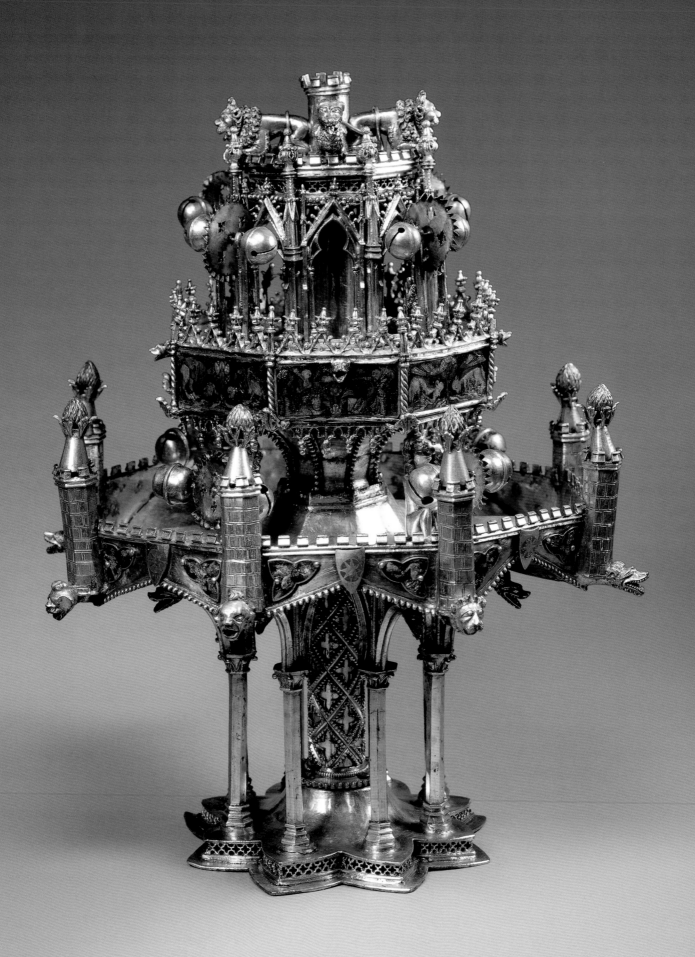

Burgundian court and its enduring fame, it would not be surprising if Dürer's visions, or the desires of his patrons, were in fact influenced by that source.

Few actual Renaissance automata survive, and one such—the late fourteenth-century silver-gilt and enameled table fountain from Burgundy or France, now in Cleveland—is not complete (fig. 11-22).[57] Its thirty-two spouts, shaped as gargoyles, lions, and dragons, once poured perfumed water. The flowing liquid caused metal wheels to turn and bells to ring, entertaining the diners. Said to have been found in a garden in Constantinople, the fountain may have been part of a diplomatic exchange between Europe and Byzantium, or just a fanciful story.

The silver and silver-gilt Schlüsselfelder Ship, weighing almost six kg (13 lbs.), was made in Nuremberg ca. 1502–1503 (figs. 11-23 and 24).[58] Not merely a table orna-ment, it was also a drinking vessel: The top portion of the ship is a lid, the bottom a container that can hold more than three liters. Seventy-four small cast figures populate the boat: Sailors climb up and down the rope ladder on the mainmast and man cannons; a group of people eat and drink around a table on the poop; other miniature travelers include a cook, a washerwoman, a fool, two monks—one reading, the other meditating—musicians playing instruments, two men playing cards, and a pair of embracing lovers. A specially manufactured case in which the ship was stored assured its preservation, as did the fact that it remained in one family for generations.

Eastern potentates were likewise eager patrons of European mechanical inge-nuity and expert goldworking. In the sixteenth century Augsburg craftsmen became preeminent clockmakers and goldsmiths, and their works played a crucial role in the annual Habsburg tribute sent to the Turkish sultan. After the fall of Constantinople to the Ottomans in 1453, European powers strove to maintain profitable commercial rela-tions with the infidels. Treaties with the Turks also helped to forestall further military conflicts. In the course of the sixteenth century the Habsburgs repeatedly renegotiated the terms of armistices with the Ottomans and delivered money and opulent gifts to the sultan, including Augsburg metalwork.[59] Not only the sultan, but his high dignitaries, such as the grand vizier and pashas, expected splendid gifts. Habsburg diplomatic needs nurtured domestic luxury industries. In crafting articles for the Ottoman court, German craftsmen heeded the Islamic prohibition against images of humans, but wild beasts and birds were acceptable and featured frequently in their works. Thus, Melchior Walther is recorded to have manufactured a gilded ostrich with built-in mechanisms that set the bird's eyes, beak, and wings in motion. A slightly later parrot clock (fig. 11-25) whistled on the hour, moved its bill, wings, and eyes, and dropped eggs from under its tail. Meanwhile, European fascination with the Ottomans is apparent in automata that depicted them. On one clock a turbaned Turk with two attendants rode forth on a boat (fig. 11-26). At the stroke of the hour he raised his sword, while the oars-men paddled and moved their heads. Fifteenth- and sixteenth-century clocks still served less as timekeepers than as elite objects of curiosity and delight. Exquisite, inventive, and costly, they made perfect royal gifts.[60]

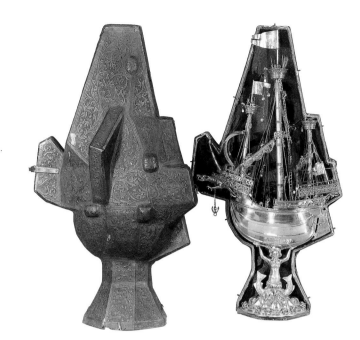

Figs. II-23 and 24.
Schlüsselfelder Ship,
Nuremberg, ca. 1502–1503.
Silver and silver gilt,
H. 79 cm (31⅛ in.).
To protect the delicate
mechanisms, the ship has
a custom-made case, seen
to the right. Nuremberg,
Germanisches National
museum, inv. HG 2146.

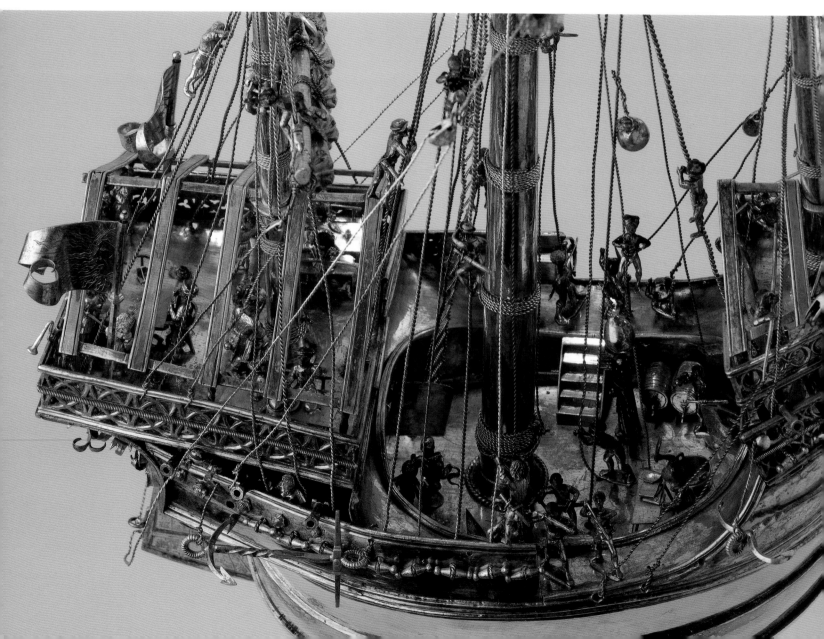

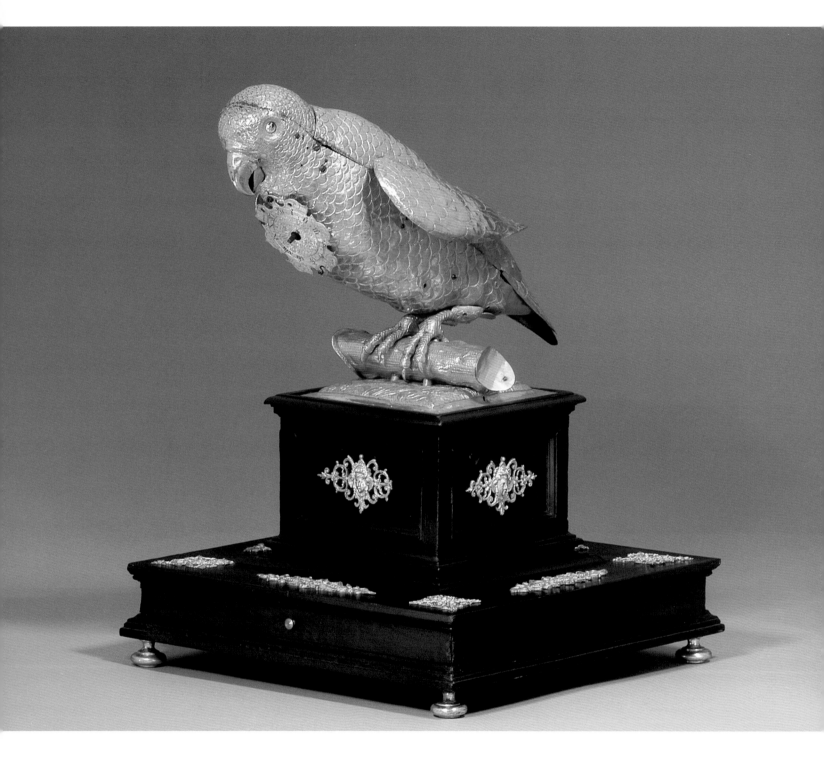

Fig. II-25.
Parrot clock, South
Germany, ca. 1600. Fire-gilt
copper on blackened pear-
wood base, H. 40.1 cm
(15¾ in.). Munich,
Bayerisches National-
museum, inv. R 2721.

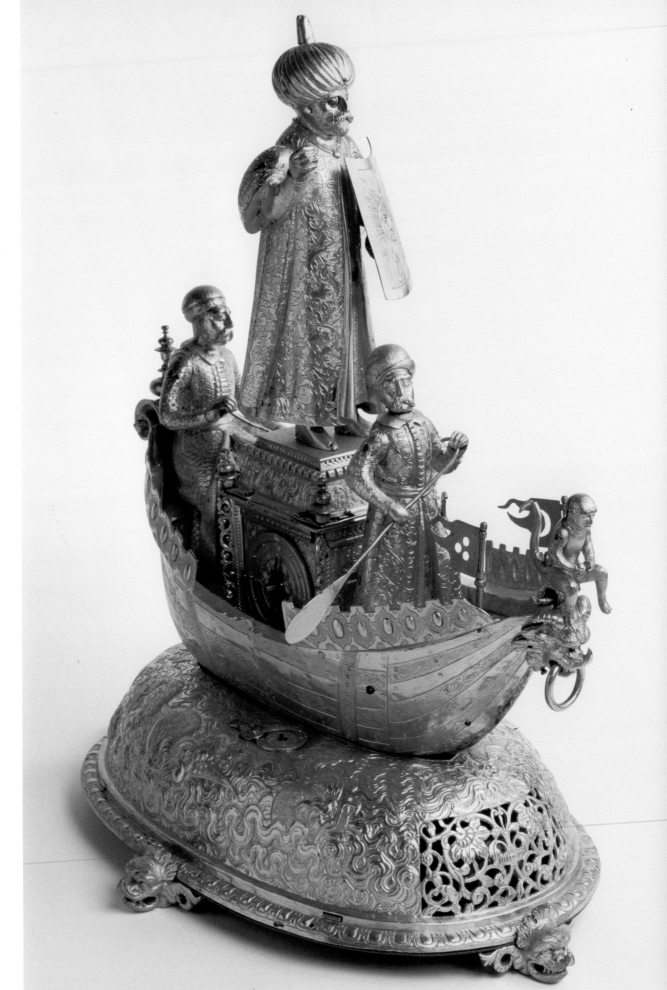

Fig. 11-26.
Clock with Turks in a boat,
Augsburg, ca. 1580–1590.
Gold-plated copper,
H. 42 cm (16½ in.).
Innsbruck-Ambras,
Kunsthistorisches Museum,
Sammlungen Schloss
Ambras, inv. KK 6873.

Goldwork imported from the New World—such as a statuette of an Aztec warrior (fig. II-27)—also provoked wonder and admiration. In 1520–1521, when Dürer encountered gold objects from the Americas in the palace of Margaret of Austria at Mechelen, he was, literally, dazzled:

> I saw the things which have been brought to the King from the new land of gold, a sun all of gold a whole fathom broad, and a moon all of silver of the same size, also two rooms full of armour of the people there, and all manner of wondrous weapons of theirs, harness and darts, very strange clothing, beds, and all kinds of wonderful objects of human use, much more worth seeing than prodigies. These things were all so precious that they are valued at 100,000 florins. All the days of my life I have seen nothing that rejoiced my heart so much as these things, for I saw among them wonderful works of art, and I marveled at the subtle Ingenia of men in foreign lands. Indeed I cannot express all that I thought there.[61]

Dürer was not always readily impressed, and he had traveled widely enough to bring a cosmopolitan outlook to the sights he encountered. His response to the American gold recaptures the role of wonder in this age in expanding the mind and delighting the soul of the most intellectual men.

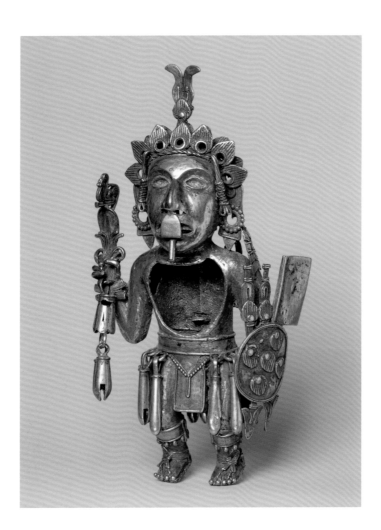

Fig. II-27.
Figure of a warrior, Central Mexico, Aztec, from Tetzcoco?, after 1325–1521(?). Cast gold-silver-copper alloy, H. 11.2 cm (4⅜ in.). The Cleveland Museum of Art, Leonard C. Hanna, Jr., Fund, inv. 1984.37. © The Cleveland Museum of Art.

Plate and finely wrought vessels, both used at table and exhibited on specially arranged sideboards, were another set of indispensable tools in domestic and international diplomacy. No princely banquet took place without extensive display of gold, silver, and gem-studded plate, and countless contemporary depictions attest to its necessity as a sign of sovereignty. A portion of the tapestry narrating the story of Esther and Ahasuerus represents Ahasuerus's banquet (see fig. VI-4). A whole pheasant (cooked and stuffed back into its skin) occupies a golden platter at the center of the royal table. It is flanked by two gold *nefs*—ship-shaped vessels for the personal utensils of the ruler. Saltcellars, sweetmeat dishes, covered goblets, and knives are close at hand. Servants hurry in with more dishes and pour the wine. Behind Ahasuerus, on the right, a three-tiered array of gold and silver vessels denotes his lofty rank. That plate is purely for show: It demonstrates the abundance of the royal treasury and the ruler's resources for peace and war. Its visual magnificence is mirrored by the auditory splendor of music performed by the wind players on the left.[62]

Precious plate was habitually augmented by luxurious accessories. Duke de Berry's table service of silver and gold, depicted in the January miniature of his famous *Book of Hours* (fig. II-28), was enhanced by crystal forks, serpentine and carnelian spoons, and (for his strawberries) crystal bowls mounted in gold and silver. Even his toothpicks were refulgent.[63] A late sixteenth-century Danish toothpick (fig. II-29), made in gold in the shape of a dragon and adorned with enamel and gems, is very similar to an object once owned by Queen Elizabeth I.[64]

Plate could also serve as a weapon. In 1461 Philip the Good of Burgundy accompanied Louis XI on the latter's triumphal entry into Paris as the new king of France. But Philip upstaged his kinsman Louis at every turn. He draped the facade of his Hôtel d'Artois with the *History of Alexander the Great* tapestries, thus declaring himself, rather than the new monarch, a modern-day Alexander. He sported such quantities of jewels on his dress and his horse's trappings that Louis and his retinue looked shabby in comparison.[65] At Louis's coronation banquet in Rheims, moreover, Philip had presented the king with a gift of two large *nefs* rendered in pure gold and decorated with precious stones; two *drageoirs*, or sweetmeat dishes, one of them of pure gold, embellished with gems and a golden statue of a maiden representing Love; as well as jugs, cups, flagons, and large bowls of precious materials. The observers were amazed by the scale of the gift, and by the wealth, and hence power of the duke compared to the king. Nor did they fail to notice that at a subsequent banquet held by Louis in Paris, the gold dishes "all bore the arms of Burgundy, and, just imagine, they were the same vessels which the duke had given to the king at his coronation in Rheims."[66] It was all too clear that the king did not have any plate of his own—a must for a ruler—other than what had been presented to him by the duke, which the latter had shrewdly marked with his own rather than the royal arms.

In another purposeful show of largess, the fabulously rich Sienese banker Agostino Chigi (1465–1520) deployed plate to extend his influence and fame. Chigi's financial empire—his bank at one point had a hundred offices in Italy and branches as far away as Cairo and London—supported and was being nourished by extensive industrial and trading ventures. He enjoyed the lucrative contract of farming alum deposits at Tolfa; and he financed the Borgias and popes Julius II (who granted him the right to

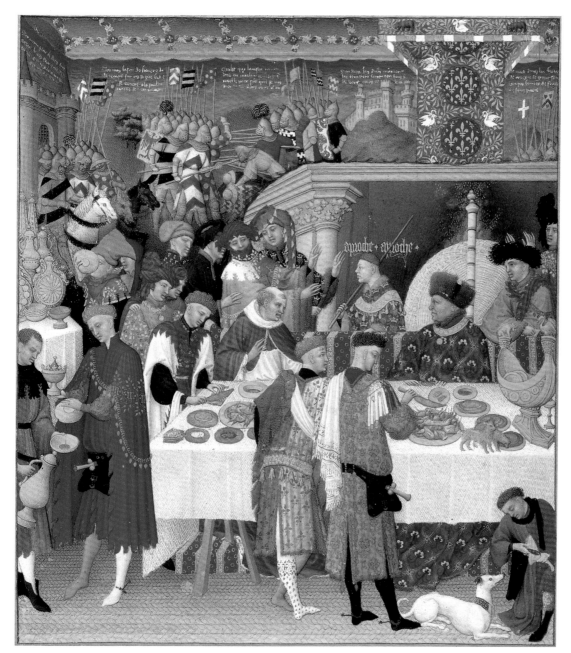

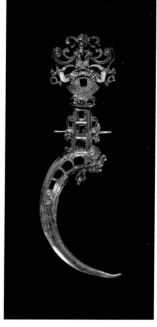

Fig. II-29.
Possibly CORVINIANUS SAUER
(German, apprenticed in
Denmark 1590s), Toothpick
in the form of a dragon,
late sixteenth century. Gold,
enamel, and precious stones.
H. 6.8 cm (2⅝ in.).
Copenhagen, National
Museum of Denmark,
Department of Danish
Middle Ages and
Renaissance, inv. D436/1972.

Fig. II-28.
LIMBOURG BROTHERS
(Herman, Jannequin, and
Paul; Netherlandish, all died
1416), *Feast of Jean de
Berry*. From *Les Très Riches
Heures du Duc de Berry*
(1416), January page.
Chantilly, Musée Conde,
MS. 65/1284, fol. 1v. Photo:
RMN/Art Resource, NY.
Photographer: R. G. Ojeda.

quarter the Della Rovere arms with his own) and Leo x. To entertain his guests on a scale
commensurate with his stature and ambitions, Chigi built a Roman-style villa on the
right bank of the Tiber, near the Vatican, with a dining loggia in a grotto overlooking the
river. Raphael, who executed a number of decorative projects in the villa, designed some
of Chigi's plate (fig. II-30). At one of the banker's famed parties it was rumored that
eleven cardinals had walked out with silver vessels tucked under their skirts. At anoth-
er banquet, it was reported, Chigi served the assembled cardinals and dignitaries their
own regional specialties arranged on golden plates embossed with their individual coats
of arms. After each course the plates were tossed into the Tiber, demonstrating the host's

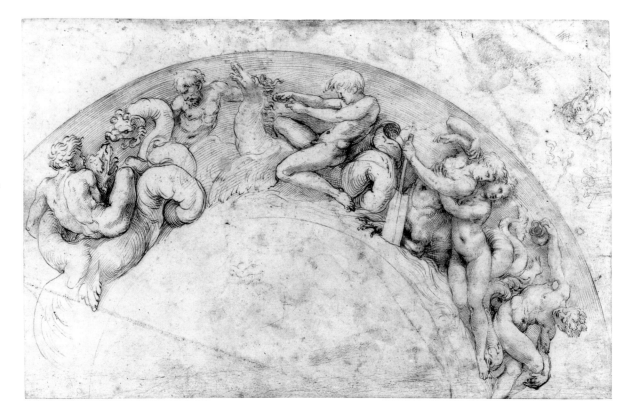

Fig. 11-30.
Probably RAPHAEL (Italian, 1483–1520), Design for the border of a salver, ca. 1516. Pen and brown ink on off-white paper, 23.2 × 36.9 cm (9⅛ × 14½ in.). Oxford, Ashmolean Museum, inv. WA 1846.211.

boundless wealth. But Chigi was no fool: Nets strung beneath the surface of the water safeguarded his fortune.[67]

King Francis I, meanwhile, used his gold dinnerware to proclaim his economic policies and aspirations. His intricate gold saltcellar, with sculpted figures of the Earth and the Sea reclining over an ebony base with Michelangelesque reliefs of the winds, was fashioned in Paris by Benvenuto Cellini between 1540 and 1543 (fig. 11-31). While it is best known today as an example of Florentine Mannerist style and the Italophile tastes of Francis I, the vessel bore more complex meanings for the king and his entourage. The magnificent container reflected the monarch's territorial and mercantile endeavors: his schemes regarding pepper and salt.[68]

Salt and pepper, used to preserve and flavor food in an era before refrigeration, were crucial commodities in domestic and international commerce.[69] Salt had furnished a steady income to the crown of France since the fourteenth century. Intent on obtaining still greater returns, Francis implemented a series of salt-tax reforms, the most ambitious in 1541. At the same time, the king sought to enter the lucrative spice market dominated by the Portuguese, and particularly the race for pepper. To this end he financed the westward voyage of Giovanni da Verrazzano in 1524 in search of a northern passage to Cathay, as well as a series of subsequent expeditions in 1534, 1535, and 1541. Verrazzano and those who followed him from France sought a new route to the riches of the East; instead they found the coast of North America.[70]

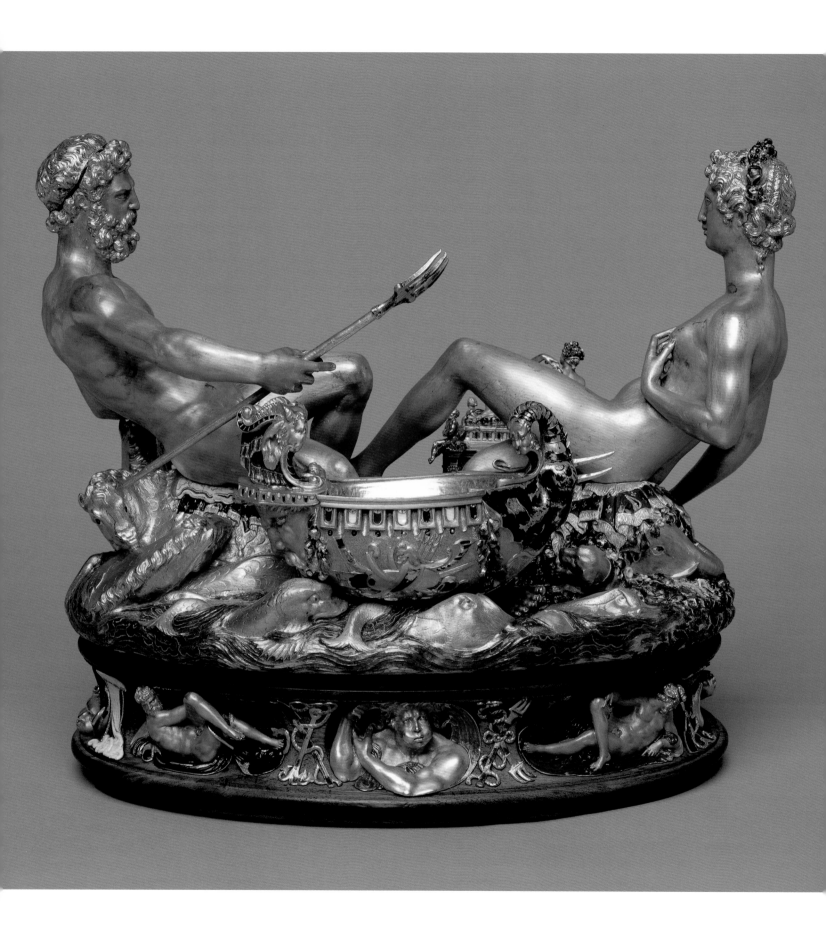

Saltcellars had graced princely tables for two centuries, and Francis's salt-and-pepper enterprises spanned two decades. But his intensification of these efforts coincided with the years of Cellini's work on the saltcellar and, presumably, its first display at the royal table. No contemporary source comments on the use of the vessel at Francis's banquets, but it is reasonable to suppose, given its resplendent and programmatic aspect and the one thousand *scudi* expended on its manufacture, that Francis would readily have deployed it for its layered meanings, particularly as an advertisement of his economic schemes that enabled him to underwrite such lavish artifacts.

Cellini, in fact, fashioned the pepper container in the form of a triumphal arch, as if wishing into existence the fruition of the royal spice ventures. The arch is flanked by a female bearer of the horn of plenty facing the Earth, and by Hercules facing the Sea. Hercules holds the apples of Hesperides. Their acquisition was the Greek hero's final labor, buying him immortality: They could be obtained only by his traveling to the ends of the earth—west, the same direction in which Francis's explorers sailed—and returning with its spoils. Cellini may also have designed for Francis a gold pendant depicting the Greek hero raising the "Pillars of Hercules," the Straits of Gibraltar, through which Mediterranean-based ships reached the Atlantic. The strongman's muscular torso is made of a baroque pearl (fig. 11-32).

Francis termed himself the Gallic Hercules—as opposed to the Habsburg Hercules, Charles v, who used the twin columns as his personal device and declaration of his expansionist policies. The image of the Greek hero honored both rulers when Charles visited Paris in 1540: A more than 2 m (7 ft.) tall statue holding the two columns (used as candelabras) was designed for this occasion by Rosso Fiorentino and cast in silver and gilded by the goldsmith Pierre de Brimbal.[71] The statue, alas, has perished, but Cellini's saltcellar continued its service as a tool of royal diplomacy and propaganda. In 1570 King Charles IX, grandson of Francis I, presented it to Archduke Ferdinand II of Tirol in gratitude for his service as a proxy at Charles's wedding to Elizabeth Habsburg. Ferdinand displayed it and other diplomatic offerings in his museum at Ambras as testimonies to the Habsburgs' central role in European politics. His collection of luxury arts, like those of his peers, chronicled his and his dynasty's accomplishments in the visual language vital to many Renaissance political and social transactions.

Fig. 11-32.
Possibly BENVENUTO CELLINI (Italian, 1500–1571), *Hercules raising the pillars of the Strait of Gibraltar*, France (Paris), about 1540. Gold, enamel, and a baroque pearl, 6 × 5.4 cm (2⅜ × 2⅛ in.). Los Angeles, The J. Paul Getty Museum, inv. 85.SE.237. Photographer: Jack Ross.

Fig. 11-31.
BENVENUTO CELLINI (Italian, 1500–1571), *Saltcellar*, 1540–1543. Gold, niello work, and ebony base, H. 26 cm (10¼ in.). Vienna, Kunsthistorisches Museum, inv. 881.

THE LANGUAGE OF PERSONAL ADORNMENT

In the majestic manuscript known as the *Grandes Heures* of Jean de Berry, a
richly decorated Book of Hours from the extensive art collection of this cultivated duke,
the illustration of Sext in the Hours of the Holy Ghost depicts Jean before Saint Peter at
the Gates of Heaven (fig. 11-33). The duke gestures to a large pendant of sapphire sur-
rounded by pearls that hangs on a massive gold collar around his neck. It is misleading
to see this simply as a bribe. Given the religious resonances of jewels—pearls often
referred to Christ, and sapphires, which have the color of the sky, to the celestial
sphere—Berry's offer speaks of both his dazzling persona and a suitable offering to the
radiant city of God.

Renaissance jewelry often blurred the lines between piety and personal pride.
Elites wore crosses and rosaries rendered in precious materials, medallions and rings
with images of saints under whose protection they placed themselves, and hat badges
showing the Virgin, a biblical scene, or an allegory of virtue. One such badge represents
Prudence in an enameled gold relief; the woman's face and arm are carved of chal-
cedony (fig. 11-34). She gazes into a hand-held mirror made of a table-cut diamond. The

mirror indicates her ability to see herself truthfully. A fashionable lady who would have worn this ornament could truthfully admit to her love of luxury.

In other circumstances personal jewels connoted secular bonds.[72] An enameled gold hat badge with a portrait of Charles v (fig. 11-35), made in either France or Spain early in his reign, was likely used as a sign of alliance or loyalty, a common purpose of jewelry at the time. It shows the young ruler wearing the chain of the Order of the Golden Fleece, while the inscription on the reverse reads "Charles R(oi) de Castille, Leon, Grenade, Arragon, Cecilles 1520." The medallion's worn aspect attests to its life of service.

Other jewels revealed their owner's learning, or admiration for antiquity. While in Rome as a papal hostage in 1512, Isabella d'Este's young son Federigo sought to make a present to his cultured mother. It was to be inspired by a celebrated ancient sculptural group unearthed six years earlier. In a letter to Isabella, Federigo wrote:

> Theobaldo told me that Caradosso would be pleased to execute for your Excellence or for me a Laocoon with his sons and the serpent, made of gold relief, like the one of marble, raised with a hammer and not cast. . . . Furthermore, if it would please you he would render this Laocoon in the form of a medallion of half relief, to wear on a hat, and he would produce a first rate work, for he had already made one for Theobaldo for wear on his beret, with the representation of Hercules overcoming Antaeus.

Fig. 11-35.
Hat badge with a portrait of Charles v, French or Spanish, 1520. Gold and enamel. Vienna, Kunsthistorisches Museum inv. 1610.

Strapped for funds, Isabella, alas, had to "postpone for the moment this appetite of ours, to a more comfortable time when to satisfy such excellent work and workman."[73]

Garments of lofty persons provided another site for statements in goldwork and gem stones. In 1414 Charles d'Orléans, the brother of the king of France, bought hundreds of pearls for the embroidery of the sleeves of his tunic with the words of the song *Madame, je suis plus joyeux* and its musical notes.[74] In a portrait of Anna of Hungary and Bohemia (fig. 11-36), sister-in-law of Emperor Charles v, the queen's hat and dress, richly decorated with pearls, speak of her exalted stature. So does the attire of King Henry viii in a portrait by Hans Holbein the Younger, who rendered with great care the rich textures of royal clothes and the affixed gems set in finely worked gold mounts (see fig. 7). The Burgundian dukes appeared at important diplomatic gatherings in clothes so thickly covered with gold embroidery and gems that observers could not discern the color of the cloth underneath and walked away all the more awed by the power of these rulers. In our modern, more democratic societies our clothes may be distinguished by costlier or cheaper fabrics, fancier or plainer tailoring, but these distinctions are fairly subtle, and many of us pay little attention to them. In the Renaissance, fabrics and cuts of dress, colors and embellishments proclaimed far more emphatically the wearer's social standing and corresponding privileges and rights. Hence the alertness of contemporary diplomats and chroniclers to costume and jewelry and to the messages they purposefully conveyed. Hence, too, the meticulous replication of these particulars in contemporary portraits and the attempts of sumptuary laws to check social transgressions perpetrated through clothes and jewels inappropriate to the wearer's rank.

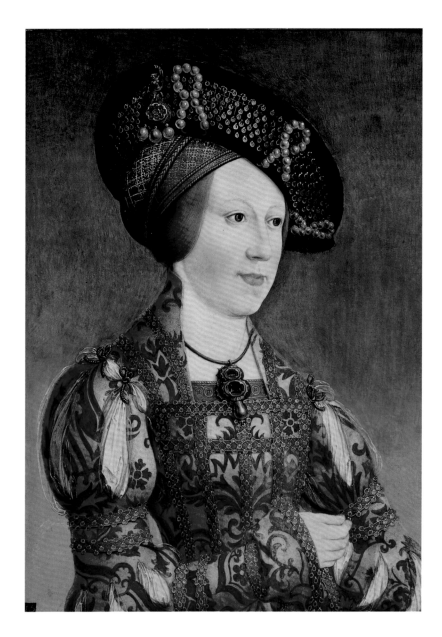

Among the more extravagant items of personal ornament were *zibellini,* sable
or marten pelts with the animal's head rendered in precious materials—gold or crystal
shapes with eyes of sapphires, mouth of rubies, and a tongue made to move.[75] Such furs
offered luxury of both appearance and warmth. The inventory of Mary Queen of Scots
listed numerous "martens." Titian's portrait of Eleanora Gonzaga, Duchess of Urbino (fig.
11-37), shows a *zibellino* with a wrought gold head. A surviving crystal version (fig. 11-38)
was likely produced in Venice, famous for its lapidaries and jewelers.

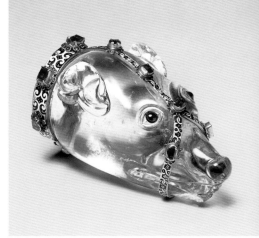

Fig. 11-38.
Unknown artist, Marten's head, French or Italian?, ca. 1560–1570. Crystal mounted in enamelled gold set with rubies, 6.6 × 3.0 cm (2⅝ × 1⅛ in.). Zurich, Thyssen-Bornemisza Collections, inv. DEC 0731.

Fig. 11-37.
TITIAN (Italian, 1488 or 1490–1576), *Portrait of Eleanora Gonzaga della Rovere, Duchess of Urbino,* about 1537–1538.
Oil on canvas, 1.14 × 1.02 m (44⅞ × 40⅛ in.). Florence, Galleria degli Uffizi, inv. 919. Photo: Erich Lessing/Art Resource, NY.

To us such objects may appear tasteless and such luxury offensive. For Renaissance men and women, skillfully wrought goldworks and finely carved stones, as well as other arts of magnificence, which we shall explore below, were not frivolous expressions of hedonism but vitally functional objects that structured social, political, and religious relations through the resonances of their materials, imagery, and contexts of use. Since contemporary visual and verbal sources place a great emphasis on these arts, we should take a closer look at them so as to gain a better understanding of their seemingly familiar, yet very different world.

III WOVEN NARRATIVES OF RULE

In the hall where the sideboard was situated were hung the tapestries of the great battle of Liège, where Duke John of Burgundy and Duke William of Bavaria, count of Hainault, defeated the Liègeois near Othée in the year 1408. . . . The hall . . . of the chamberlains was hung with a superb tapestry showing the coronation of King Clovis, called Louis, the first Christian king of France; the renewal of the alliance between him and King Gundobad of Burgundy; the wedding of King Clovis to Gundobad's niece; his baptism with the Holy Ampula; his conquest of Soissons; how the stag showed him the way across a river which he had not dared to cross; and how the angel gave an azure cloth with three fleurs-de-lys in gold to a hermit, who gave it to the queen, who passed it on to the said King Clovis to bear for his coat of arms.

. . .

Soon afterwards, just before the wedding day, another tapestry was hung in this place, of King Ahasuerus, who governed 127 provinces. . . . The chapel was hung with a fine embroidered tapestry of the Passion; before then it had been of the human pilgrimage. In the Duke's oratory, the altar cloth showed the Seven Sacraments. . . . In Madame's dressing-room . . . was the history of the good Lucretia. . . . In Mademoiselle of Burgundy's room, a tapestry of trees and personages in antique fashion. In my lord the bastard's room, a tapestry with his arms and, in his dressing room, very rich embroidered ancient histories.

—JEHAN DE HAYNIN, LORD OF LOUVIGNIES, *MÉMOIRES* (1468)

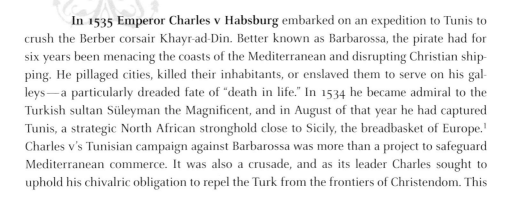

In 1535 Emperor Charles v Habsburg embarked on an expedition to Tunis to crush the Berber corsair Khayr-ad-Din. Better known as Barbarossa, the pirate had for six years been menacing the coasts of the Mediterranean and disrupting Christian shipping. He pillaged cities, killed their inhabitants, or enslaved them to serve on his galleys—a particularly dreaded fate of "death in life." In 1534 he became admiral to the Turkish sultan Süleyman the Magnificent, and in August of that year he had captured Tunis, a strategic North African stronghold close to Sicily, the breadbasket of Europe.[1] Charles v's Tunisian campaign against Barbarossa was more than a project to safeguard Mediterranean commerce. It was also a crusade, and as its leader Charles sought to uphold his chivalric obligation to repel the Turk from the frontiers of Christendom. This

was a family tradition: Charles's ancestors on both the Burgundian and Spanish sides had aspired to such leadership. John the Fearless, second Duke of Burgundy, had fought and was captured at Nicopolis in 1396; Philip the Good, his son, had founded the Order of the Golden Fleece with the stated purpose of regaining the Holy Land and defending the Faith. For years he agitated for a crusade, and his magnificent Feast of the Pheasant aimed to rally his subjects and allies to that cause; but he never managed to turn this zeal into action. Charles's grandparents on his Spanish side, the Catholic Monarchs Isabella and Ferdinand, in contrast, did fight successfully against the Moors in Granada, evicting them from Spain in 1492. In heading a new crusade to Tunis, Charles thus built on his ancestors' aspirations, reputations, and deeds.

The lines of enmity in Tunis, however, were not as straightforward as Christians versus infidels, for Barbarossa was supplied with arms by Charles's long-term rival, the king of France, Francis I. Francis had lost a bid for the imperial crown to Charles in 1519, fought him unsuccessfully for control of Italy (and was captured at the Battle of Pavia in 1525), and allied himself with the sultan in an attempt to curb Charles's further expansion. In setting off for Tunis, therefore, Charles aimed to repel the threat to his hegemony by a three-headed beast—the Süleyman-Francis-Barbarossa alliance. Crusading rhetoric served to bind Charles's allies to him. His armada consisted of more than four hundred ships carrying nearly thirty thousand fighting men from multiple states bordering the Mediterranean, whose own religious righteousness was intertwined with political and economic anxieties brought on by the combined Berber, Turkish, and French naval power.

The campaign lasted approximately two months and ended in the capture and sack of Tunis. The expedition, however, was neither glorious, nor successful. Although Charles's forces and arms far surpassed those of his foe, the gates of Tunis were opened to his troops by Christian slaves who had escaped from prison. The bloody sack of the city ordered by Charles was unnecessarily brutal. Barbarossa eluded capture, continued his raids, and became even stronger than before. Francis remained allied with the sultan and his admiral. Still, Charles's reputation was vastly enhanced by his leadership of the new crusade, and he augmented it further, and counterbalanced the actual political failure of the war, by means of a magnificent textile account of the campaign, the eleven-piece tapestry ensemble detailing the *Capture of Tunis*.

Expecting to garner great propaganda benefits from the war, Charles enlisted the Dutch painter Jan Cornelisz Vermeyen, who previously served Margaret of Austria, Charles's aunt and regent of the Spanish Netherlands. Vermeyen's task was to document the campaign pictorially, and he inserted himself into several scenes as an eyewitness and guarantor of their truth. In the depiction of the *Skirmishes on the Cape of Carthage*, for example, he sits on a hillock under a tower on the left, intently sketching in a large album the action unfolding below (fig. III-1).

Whether Charles envisioned a tapestry set from the start is not clear. Weaving commenced only a decade after the war. The emperor may initially have thought to spread the fame of his crusade through prints. For within a year of the expedition, on 26 May 1536, the Council of Brabant granted Vermeyen exclusive rights "to print certain portraits and depictions of the armies of his Royal Majesty and of the siege before Tunis." The monopoly was renewed on 19 March 1538. When Charles decided to produce a set of tapestries, Vermeyen drew up cartoons based on the sketches he had made during the campaign.

The tapestry ensemble is an official chronicle, written in thread. Its overall scheme—the choice of which events to highlight and what to omit—was apparently formulated by Alonso de Santa Cruz, a cosmographer and historian in the service of Charles V who used several eyewitness accounts to craft a most lucid and suitable record.[2] The profusion of detail—the carefully observed topography, diverse military engagements, the plight of civilians and individuals both famous and anonymous—all endow the tapestries with the semblance of veracity. The large scale of each panel—averaging some 5 × 9 m ($16^{1}/_{2} \times 29^{1}/_{2}$ ft.)—and the unfolding of minutely delineated action from one tapestry to the next creates a kind of moving picture, with a captivating opening, mounting drama of combat, and edifying resolution.

Fig. III-1.
Skirmishes on the Cape of Carthage, fourth tapestry in the *Capture of Tunis* series. Designed by JAN CORNELISZ VERMEYEN and woven in Brussels by WILLEM DE PANNEMAKER, 1549–1551. 5.25 × 9.25 m ($206^{5}/_{8} \times 364^{1}/_{4}$ in.). Madrid, Patrimonio Nacional de España, inv. 10005918. © Patrimonio Nacional.

The series opens with a map of the Mediterranean basin (fig. III-2)—the territory that stood at the center of the conflict geographically, economically, and politically—and proudly depicts a multitude of ships sailing from major ports of Spain (the largest land mass on the right) and Italy (bottom center) toward Tunis (at the top left). Depicted in bird's-eye view, the woven map presents the cities, islands, gulfs, and winds "at exactly the distance at which they really lie" according to the text in the explanatory tablet in the bottom right corner. The observer is even invited to measure these distances, in miles or in leagues, with the help of the scales provided above the tablet. The designer of the weavings, Vermeyen, stands by the text, compass in hand, personally attesting to the accuracy of the measurements and the following depictions.

It is interesting to consider how the viewer was meant to read and interact with the woven scenes. A clue is supplied by the captions appearing in their borders: They invite, and expect, the beholder to enter into the tapestried world. In the *Landing off the Cape of Carthage* (fig. III-3), for example, the tablet in the right border orients the viewer by stating: "One has to imagine that one looks from the fleet, which is coasting from the port of Farno to its anchorage at the Cape of Carthage, with the north to the side, over the left shoulder." The message compels the spectator to assume a position and viewpoint within the scene, standing on a ship in the foreground and facing the Cape of Carthage in front of him, with the north lying behind his back.[3] Contemporaries, in other words, were trained to perceive tapestries as a world into which they were summoned as participants. The monumental scale of the weavings, their figures frequently life size and dressed in garments similar to those of the viewers, and their highly relevant stories all made tapestries a preeminent form of visual communication and persuasion.

Today we often find it difficult to read and admire these seemingly convoluted and confusing scenes. But what we see are mere pale echoes of the tapestries' original character and impact. Much of their visual information is simply lost. The first components of tapestries to suffer are dark colors—the browns and the blacks that once defined shapes and gave clarity to compositions. Dyed with iron, these yarns corrode easily, causing contours to blur and details to lose their crispness. The bleaching of silk prior to dyeing also damaged yarns; and other colors have faded due to exposure to light.[4] Tarnish, meanwhile, darkens silver threads, while fine gold wires coiled around silk cords to form gleaming threads easily fray, taking with them much of tapestries' luster and three-dimensional effects. The wear and tear of tapestries as they hang on walls, sagging and ripping under their own weight, their deterioration from dampness and mildew and frequent movement from one location to another, as well as repeated folding and rolling, have all contributed to the decomposition of the designs. So have the successive interventions of conservators and restorers. The turbulent histories of many hangings did little to benefit their preservation. In the aftermath of the French Revolution, the *Lady and the Unicorn* ensemble (fig. III-4) was used as covers for greenhouses; and the *Apocalypse* tapestries (fig. III-5), which had belonged to Louis d'Anjou, brother of Jean de Berry, were deployed to protect orange trees against frost, stop up holes in walls, and line stables. Moreover, the practice of melting down tapestries to extract their metal content has destroyed the finest weavings, leaving an unbalanced picture of this art. Most of the collection of some 408 tapestry ensembles that belonged to Francis I perished in the melting pot in 1797.

Fig. III-2.
Map of the Mediterranean Basin, first tapestry in the *Capture of Tunis* series. Designed by Jan Cornelisz Vermeyen and woven in Brussels by Willem de Pannemaker, 1549–1551. 5.2 × 8.95 m (204³/₄ × 352³/₈ in.). Madrid, Patrimonio Nacional de España, inv. 10005895. © Patrimonio Nacional.

Fig. III-3.
Landing off the Cape of Carthage, third tapestry in the *Capture of Tunis* series. Designed by Jan Cornelisz Vermeyen and woven in Brussels by Willem de Pannemaker, 1549–1551. 5.3 × 9.25 m (208⁵/₈ × 364¹/₄ in.). Madrid, Patrimonio Nacional de España, inv. 10005915. © Patrimonio Nacional.

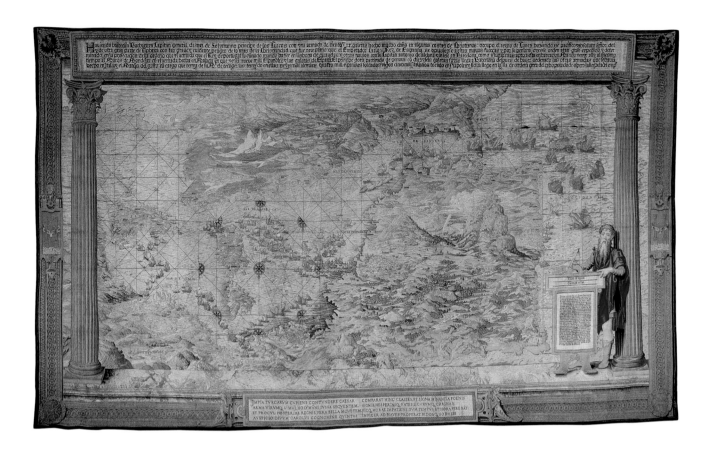

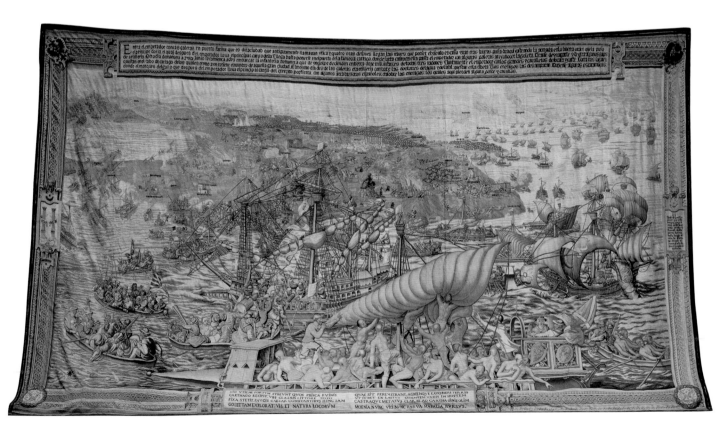

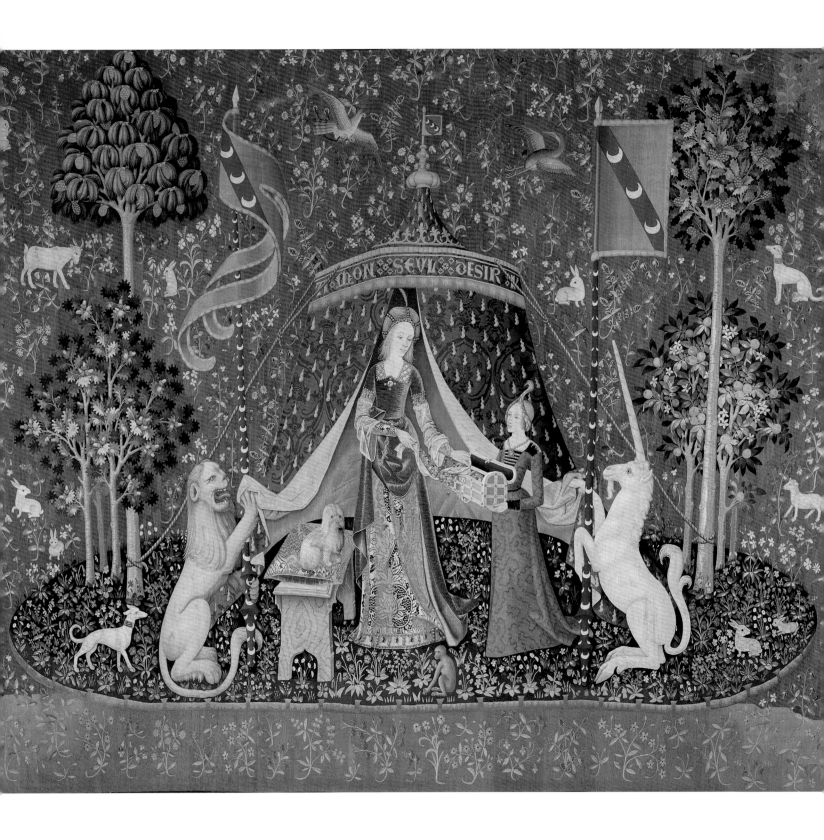

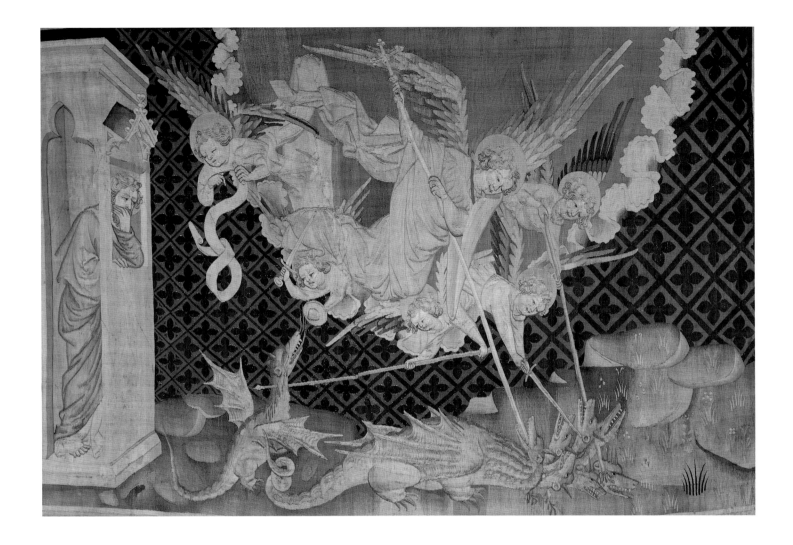

Fig. III-4.
"A mon seul desir" (*The Choosing of the Jewels*), detail of the central group of a tapestry in the *Unicorn* series. Woven in the Netherlands based on cartoons made in Paris, 1484–1500. Paris, Musée du Moyen Age (Cluny), inv. CL 10834. Photo: RMN/Art Resource, NY. Photographer: René-Gabriel Ojeda.

Today tapestries are furthermore viewed under conditions vastly different from those for which they were made. On blank museum walls, under uniform electric light, weavings lose their vibrancy. Their original mode of illumination—warm and mobile torch- and candlelight—brought out the shimmer of silk and the glitter of gold and silver threads. Activated by air currents, tapestries came to life in busy rooms, and their life-size figures appeared to move and mingle with the similarly dressed inhabitants. The particular stories depicted in the weavings—readily understood by and relevant to their contemporaries as they are not to us—turned them into interactive tableaux, rather than passive artifacts.

It is the combination of imposing size, splendid materials, and resonant subject matter that made tapestries so prestigious in the Renaissance: articulate markers of wealth, power, and distinction. Because of their visual impact and sovereign connotations, tapestries functioned as eloquent expressions of their owners' ambitions and accomplishments, policies and threats, faith and taste. Hence, consequential topics, such as Charles V's campaign in Tunis, were conveyed by preference in this medium.

Fig. III-5.
Saint Michael Battling the Dragon, detail of the *Apocalypse* tapestry. Designed by HENNEQUIN OF BRUGES and woven by NICOLAS BATAILLE, ca. 1373–1380. Château d'Angers, Musée des Tapisserie, inv. 49. Photo: © Centre des monuments nationaux, Paris. Photographer: Caroline Rose.

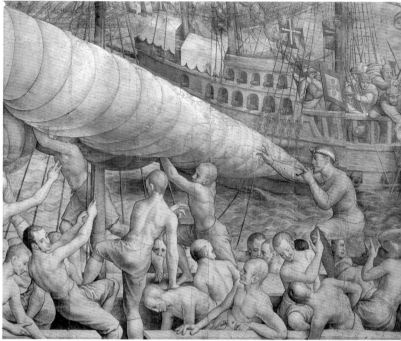

Figs. III-6 a–c.
Jan Cornelisz Vermeyen,
Details of cartoon of
*Landing off the Cape of
Carthage*, 1546–1548.
Charcoal and watercolor on
paper mounted on canvas.
Vienna, Kunsthistorisches
Museum. Cf. fig. III-3,
reproduced here in black
and white.

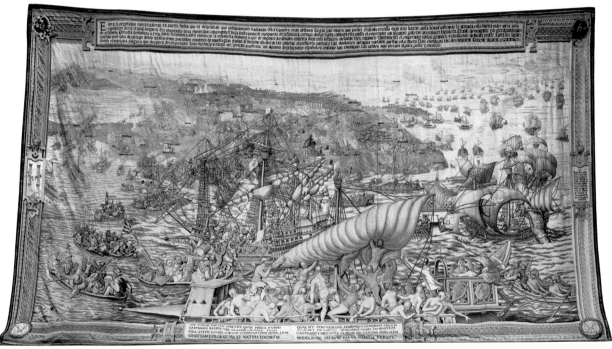

CHAPTER III

The *Capture of Tunis* weavings aimed to craft the emperor's image. Their production was of utmost state importance. The process of their manufacture, therefore, has left an extensive documentary trail.[5] By following it, even in brief, we glean some of the complexity, expense, artistry, and political gravity of this ensemble.

First, Vermeyen and his workshop spent four years working almost exclusively on the monumental cartoons that each measured more than $5 \times 7.5–12.5$ m ($16^1/_2 \times 24^1/_2–41$ ft.; figs. III-6 a–c). The cartoons appear as mirror images of the weavings, as tapestries were woven from the back so as to keep the front free of knots and thread tangles. Cartoons corresponded to how weavers faced them on the looms. As Vermeyen completed each cartoon, he passed it on to Willem de Pannemaker—the most prominent tapestry entrepreneur in Brussels at that time—to be turned into splendid weavings. De Pannemaker was instructed to use the best and brightest yarns, and the number of silk, silver, and gold threads to be employed in various parts of the compositions was carefully specified.[6] Altogether, 559 pounds of silk in sixty-three different colors, seven kinds of gold threads, and three kinds of silver went into the production of the ensemble, amounting to eight hundred pounds in weight and costing 8,500 Flemish pounds.

Kept away from Brussels by diverse obligations, Charles nevertheless took a keen interest in the progress of the work. In letters to his sister, Mary of Hungary, the regent of the Netherlands after the death of their aunt Margaret of Austria and overseer of numerous imperial artistic undertakings, the emperor voiced his desire to see the completed portions of the set and his frustration at being unable to do so.[7] Mary took full charge of the project from the start. She commissioned Vermeyen to draw the cartoons and supervised de Pannemaker as he transformed them into tapestries. She instructed him to engage seven weavers on each tapestry from dawn to dusk, so as to advance the project faster. Normally five weavers would suffice on a tapestry 5 m ($16^1/_2$ ft.) wide, for a single weaver worked on some 80–100 cm (ca. 3 ft.) before him, sitting alongside his colleagues at the loom (large tapestries were woven sideways, with the shorter vertical dimension as their horizontal plane). Each weaver engaged on the *Capture of Tunis* had only about 75 cm to complete, enabling a more rapid progress than usual. To expedite the project further still, de Pannemaker hired outside labor, paying such high wages that he alarmed his colleagues and violated Charles's own regulations regarding weavers' earnings. Seeking to quell the resultant discontent of the weavers' guild, the emperor passed an edict forbidding its members to agitate against de Pannemaker.[8]

Mary also oversaw the ordering and delivery of the necessary supplies, inspected completed hangings, and corrected mistakes. She paid close attention to the Spanish captions in the borders and demanded amendments to the woven text when weavers, unfamiliar with that language, introduced errors.[9] And she raised the vast sums necessary to underwrite the lavish ensemble, which, including cartoons, tapestries, and inspection of the weavings by guild judges, cost some twenty-seven thousand Flemish pounds, at a time when the emperor was virtually bankrupt from years of war.

The significance of the commission to Charles V is reflected in the promise to de Pannemaker of a life pension of a hundred Flemish pounds per annum upon the fulfillment of his contract. In the end, the emperor was so pleased with the final product that he doubled the amount. The resonance of the *Capture of Tunis* for the imperial family is further attested by Mary's commission of a smaller edition of the ensemble for her own use as Charles's regent.

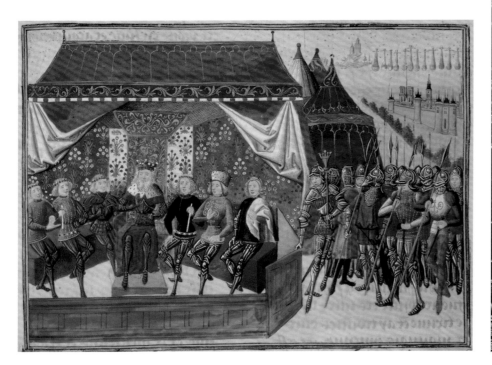

PRINCELY ART PAR EXCELLENCE

The appeal of tapestries to Renaissance rulers is often ascribed to their porta-
bility, and, indeed, unlike wall- or panel-paintings, tapestries could be easily relocated to
whatever space a prince wished to adorn. The complexities of transport did not trouble
rulers or hinder their displays. Rulers did not travel lightly, and they had servants
to attend to such matters. Shuttling between their residences, the Burgundian dukes
brought along dozens of carts loaded with furnishings and garments, treasures and neces-
sities. In April 1435, as Philip the Good moved from Dijon to Arras and Lille, seventy-
two carts carried his possessions: Five of them contained jewels, four tapestries, one
chapel furnishings, one spices, and one musical instruments and minstrels' gear. The
duchess Isabella's belongings occupied an additional fifteen carts, including two for her
jewels, two for her tapestries, one for her spices, and three for her trunks. Even the one-
year-old Charles, Count of Charolais, had two carts of his own filled with his toys and
clothes. The move across a mere 240 miles took almost a month, and the hire of carts
alone—most of them drawn by five or six horses—cost nearly five thousand franks.

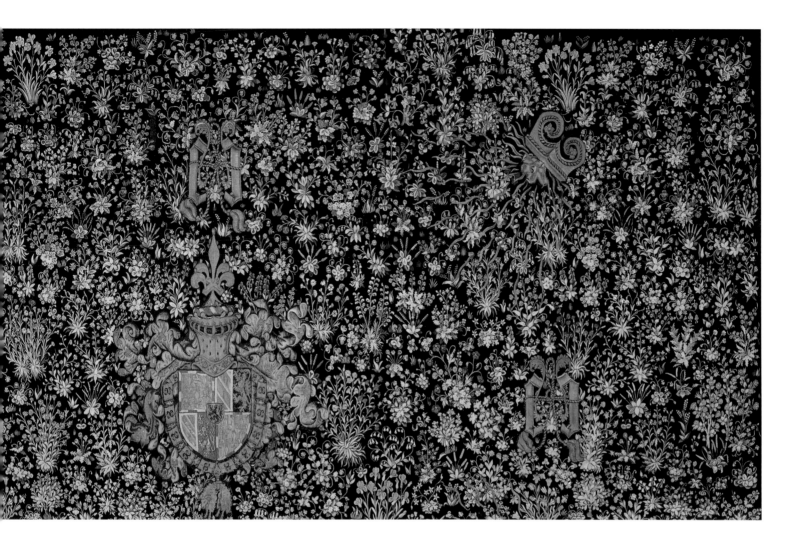

Fig. III-8.
Detail of *Millefleur* tapestry
of the Burgundian dukes.
Woven in Brussels by
JEAN LE HAZE, 1466. Bern,
Historisches Museum,
inv. 14. Photographer:
Stefan Rebsamen.

An equerry specially deputized for this purpose oversaw the operation. And this was just a simple move from one residence to another. More involved and voluminous was the transport of indispensable belongings for a major occasion. In preparation for his wedding to Isabella, Philip dispatched to Bruges from Dijon and Lille fifteen wagon-loads of tapestries, fifteen of arms and armor for tournaments that regularly accompanied such diplomatic gatherings, fifty of jewelry and furniture, and one hundred of Burgundian wine.[10]

Tapestries were indispensable to the articulation of a ruler's authority and might. Their exorbitant cost, resulting from the vast quantities of expensive materials and their labor-intensive manufacture, made tapestries an elite art par excellence. Rulers surrounded themselves with tapestries even at war, instantly creating and defining spaces of power. A miniature in a copy of Froissart's *Chronicles of France* depicts the king of Hungary, framed by a brocade cloth of honor, holding a war council in a tent lined with a millefleur (a thousand flowers) tapestry (fig. III-7). By draping battlefield dwellings with magnificent textiles, rulers aimed to impress their enemies with their grandeur and to threaten them with specific messages woven into hangings. Among the

tapestries brought to war in 1476–1477 by Charles the Bold of Burgundy were the *Triumph of Caesar* ensemble and the *Millefleur* weaving (fig. III-8) with the ducal arms prominent at its center—a proclamation of paradise brought to earth by the Burgundian rule.[11] The 1544 inventory of objects that accompanied Emperor Charles V on his travels and campaigns listed fifteen sets of tapestries (ninety-six weavings in all), including the nine *Los Honores* hangings, which alluded to the monarch's virtues; six tapestries with the *Story of Alexander the Great*; twelve *Deeds of Hercules*; a six-piece set devoted to *David and Goliath*; ten to *Our Lady* and the *Passion of Christ*; and others besides.[12] The emperor thus had ready at hand a thematic ensemble for every occasion and declaration.

Fig. III-9.
FRANS HOGENBERG (Flemish,
ca. 1540–ca. 1590), *The
Abdication of Emperor
Charles V in Brussels in
1555.* Etching, 20 × 27.7 cm
(7⅞ × 10⅞ in.). Brussels,
Bibliothèque royale de
Belgique, inv. SII 92796.

A ruler simply could not do without tapestries around his person, and contemporaries paid close attention to these expressions of his majesty. For tapestries physically distinguished a sovereign as the lofty presence, whether at home or on the road, framing him or her during solemn processions and royal feasts, and formulating ideological messages through meticulously chosen subject matter and sumptuous materials.[13] The great size of individual pieces and of entire ensembles, often stretching for dozens of meters, projected princely grandeur and propaganda to large audiences. When tapestries were taken down and removed from the palace or the city (often leaving behind the merely frescoed walls), the departure of an illustrious personage and the aura surrounding him was unmistakable.

An engraving by Frans Hogenberg commemorates the ceremony of the *Abdication of Emperor Charles V in 1555* (fig. III-9), when, exhausted by years of warfare and rule over his vast and contentious domains, he stepped down from the throne in favor of his son Philip II. The print illustrates how tapestries served to construct the environment on such a weighty occasion. Hung one next to another and covering the entire walls from floor to ceiling, tapestries merged with the world of their viewers and incorporated their beholders into their fictive world. Frequently masking windows and doorways—in Hogenberg's engraving an attendant on the far left pulls aside a corner of a tapestry, revealing an entryway—tapestries strove to complete the illusion of the wholeness of the woven reality.

The tapestries shown in the engraving are fictive. During Charles's abdication the *Gideon* ensemble, woven in 1449 for the duke of Burgundy, Philip the Good, the illustrious ancestor of Charles V, adorned the great hall of the Brussels palace. The eight-piece *Story of Gideon*, which does not survive, was the most celebrated Burgundian weaving, and its fame and prestige endured for generations. Gideon, the Biblical counterpart to Jason, was the patron of Philip's Order of the Golden Fleece. For just as Gideon had assembled a select army of Israelites to overthrow their Midianite oppressors, so Philip the Good sought to marshal Christian nobility to combat the infidels in a new crusade. And just as Gideon restored religion and wisely ruled his people, so Philip sought to present himself as defender of the Church and begetter of a golden age in his domains. Through the exhibition of the *Gideon* ensemble Philip emphatically cast himself as a perfect prince and a model Christian knight. By using these tapestries after his death, his heirs, Charles V included, presented themselves, not only as great monarchs and champions of crusades, but as worthy successors of one of the most admired Renaissance sovereigns.

The *Story of Gideon* set stretched to ninety-eight meters in length, took four years to complete, and cost 8,960 *ecus d'or*. To ensure the exclusivity of his set, Philip

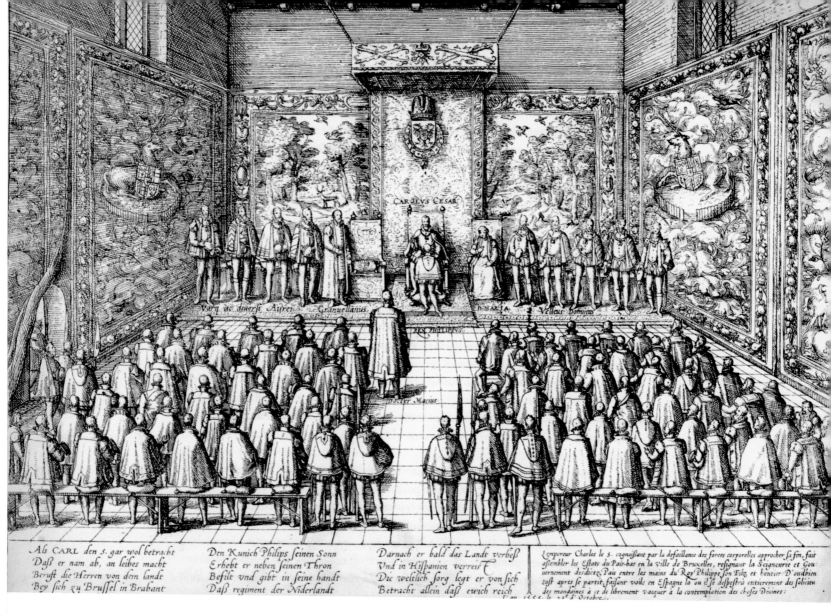

CAROLVS CESAR

Varÿ ac diuersi Aurei &c Granuellanus D. MARIA Velleus Bohunus

Rex Philippus

Docter Masius

Als CARL den 5. gar wol betracht
Daß er nam ab, an leibes macht
Beruft die Herren von dem landt
Bey sich zu Brussel in Brabant

Den Kunich Philips seinen Sonn
Erhebt er neben seinen Thron
Befilt vnd gibt in seine handt
Daß regiment der Niderlandt

Darnach er bald das Lande verließ
Vnd in Hispanien verreist
Die weltlich forg legt er von sich
Betracht allein daß ewich reich

L'empereur Charles le 5. cognoissant par la defaillance des forces corporelles approcher sa fin, fait
assembler les Estats du Pais-bas en la ville de Bruxelles, resignant la Seigneurie et Gou-
uernement desdictz Pais entre les mains du Roy Philippe son Filz, et bientost D'oudbien
tost apres se partit, faisant voile en Espagne la ou il se despestra entierement des solicitu-
des mondaines à ce de librement vacquer à la contemplation des choses Divines:
L'an 1555. le 1er d'Octobre.

purchased the cartoons from the weavers for an additional sum of three hundred *ecus d'or.* Baudouin de Bailleul of Arras furnished the cartoons, and Robert Dary and Jehan de l'Ortie of Tournai turned them into weavings comprised of Venetian gold and silver threads, the finest silks, and precious stones. The *Story of Gideon* was the most opulent tapestry ensemble of the time, the single most expensive nonarchitectural ducal commission, and the most extolled Burgundian artwork of the day.[14] Descriptions of its use at key political assemblies indicate how carefully contemporaries looked for and read such expressions of rulers' overall magnificence and specific ambitions. Reporting in May 1461 to his Sforza employer, the diplomat Prospero da Camogli detailed the deployment of the *Gideon* tapestries and other artifacts at Philip the Good's chapter of the Order of the Golden Fleece held at the Abbey of Saint-Bertin:

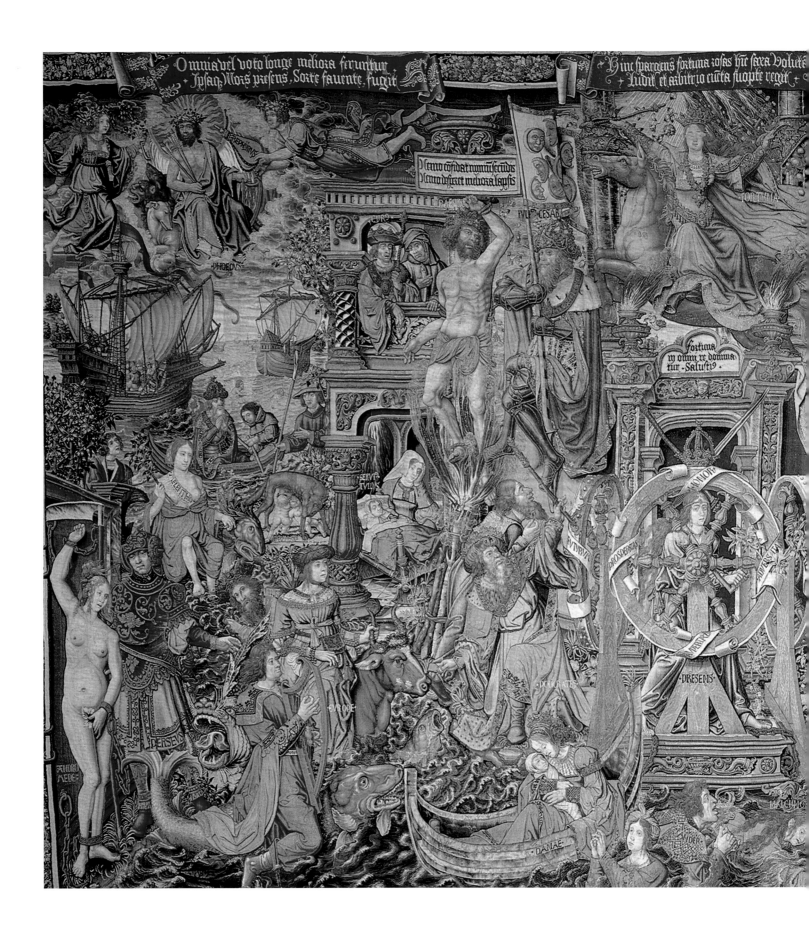

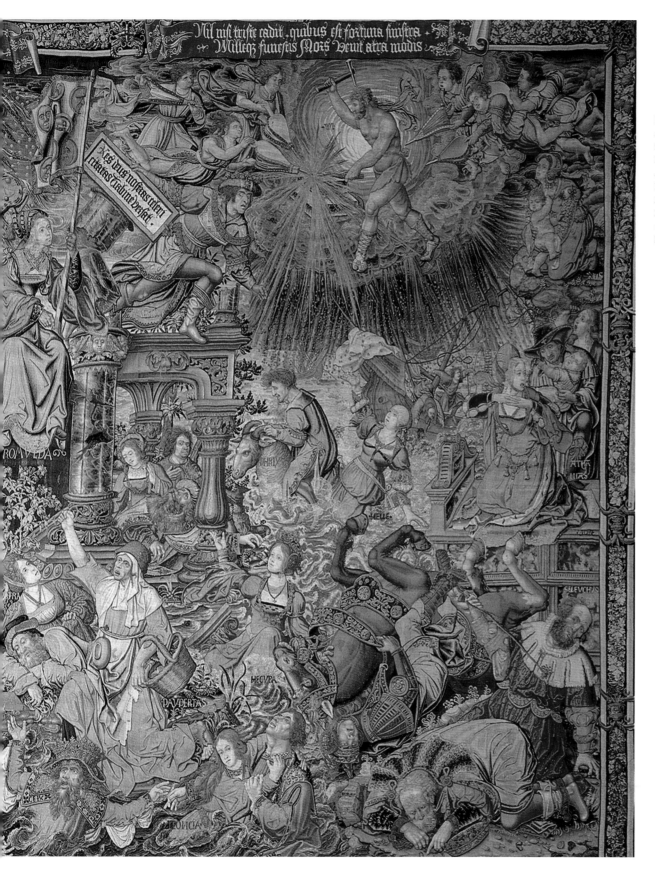

Fig. III-10. *Fortuna*, first tapestry in the *Los Honores* series. Designed by PIETER VAN AELST and woven in Brussels, 1520–1525. Madrid, Patrimonio Nacional de España, inv. 10026276. © Patrimonio Nacional.

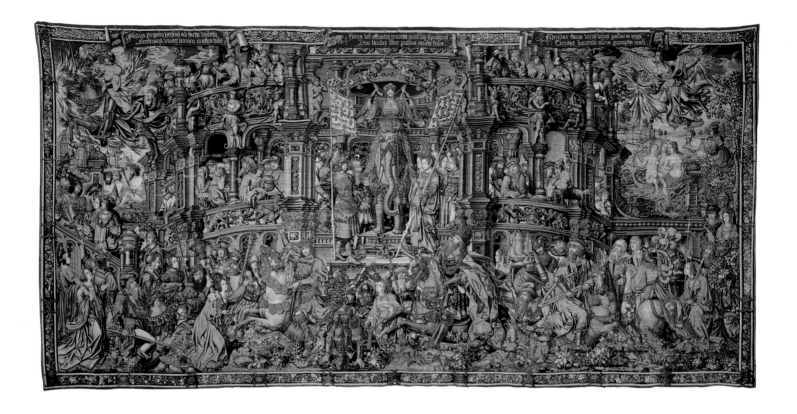

Fig. III-11.
Fame, tapestry in the
Los Honores series.
Designed by PIETER VAN
AELST and woven in
Brussels, 1520–1525.
Madrid, Patrimonio
Nacional de España, inv.
10026280. © Patrimonio
Nacional.

Fig. III-12.
Detail of *Nero*, from *Infamy*,
tapestry in the *Los Honores*
series. Designed by PIETER
VAN AELST and woven in
Brussels, 1520–1525.
Madrid, Patrimonio
Nacional de España, inv.
10026279. © Patrimonio
Nacional.

piece shows a town siege, Alexander's ascent into the sky in a cage born by the griffins, his descent underwater in a glass tube, and a battle against monsters.

Alexander's exploits and immortal fame made him an irresistible ideal. Philip the Good's tapestried encomium became a doubly potent political tool. Charles the Bold, inheriting the set from his father, deployed it in 1469, alongside the *Story of Hannibal*, when he met with the leaders of the rebellious city of Ghent: The tapestries delivered a thinly veiled threat that the duke would crush any uprisings.[19] Charles again exhibited the *Alexander* cycle in 1473 at Trier at his rendezvous with Emperor Friedrich III Habsburg from whom he sought a royal crown.[20] Charles V who, in his turn, inherited the *Alexander* ensemble, continued to use it as an effective statement of his sovereignty; the tapestries' pedigree augmented their message. In fact, numerous European rulers sought duplicates of this persuasive visualization of princely might. Francesco Sforza, Duke of Milan, bought a copy from Pasquier Grenier in January 1459; Edward IV of England acquired a version in 1467–1468; and the Catholic Queen Isabella of Spain gave three *Alexander* tapestries to Margaret of Austria at the turn of the sixteenth century.[21]

The Bible provided another source of effective allegories shrewdly employed by European princes of Church and state. Cosimo I de' Medici, The Duke of Florence, chose a cycle of tapestries dedicated to Joseph to proclaim his moral probity and wise rule. Having consolidated his power, Cosimo began to pour energy and resources into building a splendid and hence viable court. His father-in-law, Don Pedro de Toledo, Charles v's viceroy of Naples, maintained a great household. Reporting from Naples in 1539, Jacopo de' Medici, sent to perform Cosimo's marriage by proxy to Pedro's daughter Eleanora, reported that the finery, courtly demeanor, and gifts of the Florentine delegation fell far short of the expected norm. With the arrival of Eleanora in Florence, Cosimo, keen to elevate his international reputation, placed a new emphasis on the opulence of his person and palace.[22]

Cosimo's efforts centered on his new home, the Palazzo Vecchio—the traditional seat of the republican government of Florence, which he appropriated and refurbished for his own use. In redecorating the republican meeting halls as his state reception rooms, Cosimo took particular care with their textile adornment. He not only purchased tapestries in Flanders, their chief place of manufacture, but also established a tapestry industry in Florence itself.[23] Enticing to his city two Flemish weavers previously employed by his rival Ercole II d'Este of Ferrara, Cosimo bid them to set up two workshops. He promised each the high yearly stipend of six hundred *scudi*, suitable working quarters, twenty-four looms (de Pannemaker used about twelve for the

Fig. III-13.
Alexander the Great, tapestry. Woven in the WORKSHOP OF PASQUIER GRENIER, ca. 1459. Rome, Arti Doria Pamphilij s.r.l.

Fig. III-14.
*Joseph Pardoning His
Brethren,* tapestry in the
Story of Joseph series.
Designed by BRONZINO
and others and woven in
Florence by NICOLAS
KARCHER, 1549–1553.
Florence, Palazzo Vecchio.
Photo: Scala/Art Resource,
N.Y.

Capture of Tunis), and payment per tapestry based on materials, quality, and size. The workshops were not only to supply the needs of the court but also to train all local youths who wished to learn the art, thereby grooming Tuscan expertise to rival that of Brussels. Indeed, in setting up his workshops, Cosimo imitated the statutes of the Flemish weaving guilds, down to requiring that letters FF (*Factum Florentiae,* or Made in Florence) be woven into the finished hangings just as BB (*Brabant-Bruxelles*) had to appear on all tapestries made in Brussels.[24] Cosimo's political and commercial acumen in promoting local production drew on such precedents as Francis I's establishment of a court atelier at Fontainebleau in 1539 and similar ventures at the ducal courts of Ferrara and Mantua .[25]

The success of Cosimo's initiative is illustrated by the twenty-piece ensemble of the *Story of Joseph*, designed by court painters Bronzino, Pontormo, and Salviati, and destined for the *Sala dei Dugento* (Council Hall of the Two Hundred, in the Palazzo Vecchio).[26] Joseph, a model Biblical ruler and statesman renowned for his chastity,

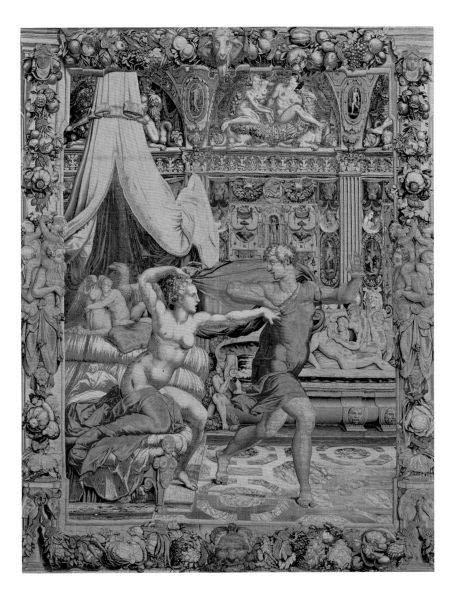

Fig. III-15.
*Joseph Fleeing from the
Wife of Potiphar*, tapestry
in the *Story of Joseph* series.
Designed by BRONZINO
and others and woven in
Florence by NICOLAS
KARCHER, 1548–1549.
Florence, Palazzo Vecchio.
Photo: Scala/Art Resource,
N.Y.

clemency, clear judgment, and beneficial rule, provided apt metaphors for the Medici souereign. Like Joseph, Cosimo came from a junior branch of an extended family, triumphed over exile, rose to a lofty position despite adversity, and was persistently loyal to his clan. Also, like Joseph, Cosimo cultivated the virtues of self-control, prudence, and magnanimity. The tapestry depicting *Joseph Pardoning His Brethren* (fig. III-14) articulates the virtues dear to the Medici duke.[27] Famous for his marital fidelity (in contrast to the extreme licentiousness of his predecessor) and for the rigorous moral standards he enforced in his city, Cosimo conveyed this aspect of his rule through the woven scene of *Joseph Fleeing from the Wife of Potiphar* (fig. III-15). Other parts of the series spelled out further virtues and attainments of their owner.

The cost of the *Story of Joseph* series reflected its political weight: It came close to the expense of constructing a good-sized church.[28] Commenting on the *Joseph* cycle in his *Life* of Jacopo da Pontormo, Giorgio Vasari recounted how:

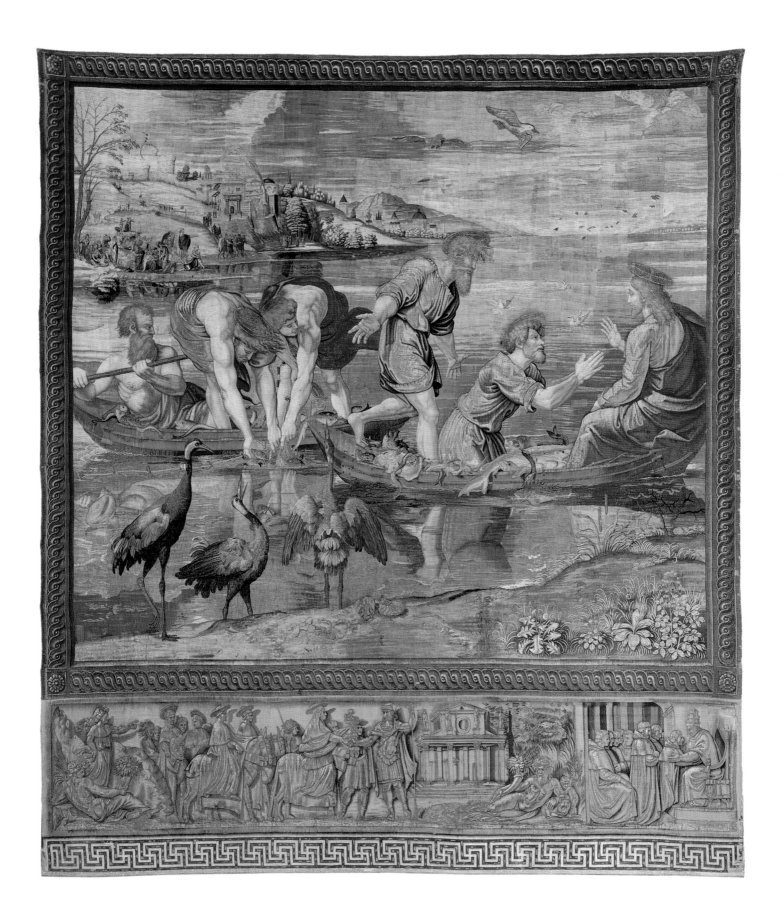

The Lord Duke then brought to Florence the Flemings, Maestro Giovanni Rosso [Janni Rost] and Maestro Niccolò, excellent masters in arras-tapestries, to the end that the art might be learned and practiced by the Florentines, and he ordered that tapestries in silk and gold should be executed for the Council Hall of the Two Hundred at a cost of 60,000 crowns, and that Jacopo and Bronzino should make the cartoons with the stories of Joseph.[29]

Vasari supervised the fresco decorations of Cosimo's *palazzo*. Unable to match the grandeur of the *Story of Joseph* weavings, he gave them but these few lines. The high price of the project, however, confirmed the loftiness of his patron, which in turn elevated Vasari's own prestige.

The preciousness of the *Joseph* ensemble is also attested by the care with which it was used—or, rather, was seldom used—by the Medici duke. For the most part, together with other gold and silver fabrics, the *Story of Joseph* rested in the *guarderoba segreta* (secret closet) and saw the light of day only during special events, when Cosimo's image was at stake. Frescoed walls, modest wool tapestries, cloth, or leather drapes served as everyday decorations. According to the 1553 inventory of the Palazzo Vecchio, all the precious tapestries containing silk and gold were in storage, and only wool tapestries enlivened some of the rooms.[30] It was, therefore, all the more impressive that Emperor Charles V actually traveled with fifteen tapestry sets.

Cosimo's kinsman Pope Leo X instigated perhaps the most famous tapestries with biblical allegories of rule, in this case of his leadership of the Christian Church: the *Acts of the Apostles*, designed by Raphael (fig. III-16). Leo X's pomp and splendor were legendary. He was said to have exclaimed, "Let us enjoy the papacy since God has given it to us." Even if he did not utter these very words, Leo's reputation for luxury made them seem plausible, and his hedonism precipitated the Protestant Reformation.[31] A portrait of the pontiff by Raphael—which also includes Leo's cousins, Cardinals Giulio de' Medici (the future pope Clement VII) and Luigi de' Rossi—captured the self-assured persona of this prince (see fig. 8 and p. 262). Vasari was awed by Raphael's meticulous depiction of the visual signs of papal dignity:

> In this the figures appear to be not painted, but in full relief; there is the pile of the velvet, with the damask of the Pope's vestments shining and rustling, the fur of the lining soft and natural, and the gold and silk so counterfeited that they do not seem to be in color, but real gold and silk. There is an illuminated book of parchment, which appears more real than the reality; and a little bell of wrought silver, which is more beautiful than words can tell. Among other things, also, is a ball of burnished gold on the Pope's chair [a reference to the device of the Medici], wherein are reflected, as if it were a mirror . . . , the light from the windows, the shoulders of the Pope, and the walls round the room.[32]

Reporting from Rome in April 1523, Venetian ambassadors, too, marveled at Leo's opulent surroundings, including the tapestries that lined the halls of the Vatican palace.[33] It was entirely within Leo's character and vision for his office to order a set of resplendent tapestries for the Sistine Chapel, a series with which to honor, not only his pontifical forebearers, the apostles Peter and Paul, but also himself and the golden age of his rule.

Leo's embellishment of the Sistine Chapel, however, was also a practical step, for his predecessor, Julius II, had initiated such a vast and ambitious rebuilding of the Basilica of Saint Peter that he rendered it virtually unusable for decades. In Julius's and Leo's time the church, with the western portion of its roof removed, stood exposed to rain, wind, and cold, making the celebration of major feasts most uncomfortable, and often impracticable, open-air events. To avoid such inclement conditions, some of the services were transferred to the Vatican Palace chapel (called Sistine after Pope Sixtus IV, who constructed it in the fifteenth century). Leo turned the chapel into a full substitute for the basilica, and it was only natural for him to seek to demonstrate the preeminence of this space—the locus of the most important liturgical services of Christendom, even if temporarily—through splendor worthy of God and of Leo X. Writing on Easter Sunday 1513, Parid de' Grassis, the master of ceremonies of the papal chapel under both Julius and Leo, rejoiced that "the papal majesty shone again in the chapel in all respects as in Saint Peter's."[34]

Leo's contributions to the dignity of the Sistine Chapel included replacing the old windows with new ones of stained glass (now lost, but probably bearing his arms); presenting new rose-colored coverings for the papal throne as well as new vestments for the celebrants of Mass; fashioning a new lectern from solid silver covered in gilt; and commissioning multiple sets of tapestries, including the ten-piece *Acts of the Apostles*. The pope, Paris de Grassis recorded, "desired, by all means, whatever sustained the papal majesty in the liturgy." Only the most impressive objects, exquisitely fashioned from most expensive materials, would accomplish this task. In focusing on tapestry as his major contribution, Leo X emulated his predecessors, Leo III and Leo IV, the most notable Carolingian patrons of this art. When Sixtus IV first built the chapel, moreover, he had envisioned its adornment with textiles, painting its walls with fictive tapestries of silver and gold still visible today. Leo X, cognizant of the potency of tapestries as expressions of majesty and of the inadequacy of frescoes for the task, draped the chapel walls with real weavings fashioned in actual silks, silver, and gold. The recognition that tapestries were "luxuries" was reflected in the symbolic suspension of their use during Holy Week.[35]

The *Miraculous Draught of Fishes*, which opens the *Acts of the Apostles*, sets their programmatic tone. It illustrates the calling of the first apostle described in the Gospel of Luke (5.3–10). Christ bids Peter to "launch out into the deep, and let down your nets for a draught." In fulfillment of Christ's promise, Peter's boat overflows with fish. By recognizing Christ's divinity, Peter receives the charge to be henceforth the fisher of men, the catcher of souls in the name of Christ and steerer of the great ship of the Church. As Peter's heir, the pope continues this mission. Hence the tapestries celebrate the office of the pontiff through their imagery, and the specific glory of Leo X through their splendor.

Pieter van Aelst of Brussels, the leading tapestry weaver and entrepreneur of the day, who also supplied the Habsburgs and the Tudors, was charged with weaving the ensemble. Touring the Netherlands in July 1517, Cardinal Luigi d'Aragona, of Neapolitan royal blood, visited his workshop. In the words of his secretary, Antonio de Beatis:

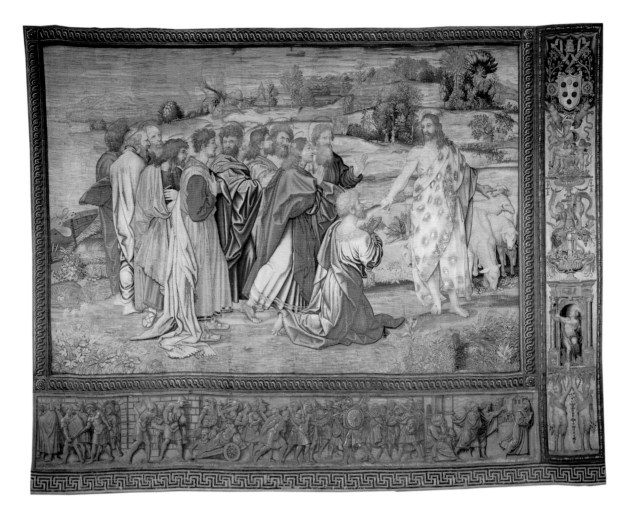

Fig. III-17.
The Charge to Peter,
tapestry in the *Acts of the
Apostles* series. Designed
by RAPHAEL in 1514–1516
and woven by PIETER
VAN AELST in Brussels,
1516–1521. Wool, silk, and
gilt-metal-wrapped thread,
4.84 × 6.33 m (190⅝ ×
249¼ in.). Vatican
Museums, Pinacoteca, inv.
43868. Photo: P. Zigrossi..

Here in Brussels, Pope Leo is having 16 tapestries made, chiefly in silk and gold. They are said
to be for the chapel of Sixtus in the apostolic palace in Rome. Each piece costs 2,000 gold
ducats. We went to the place where they were being made and saw a completed piece show-
ing Christ's delivery of the keys to St. Peter, which is very beautiful. Judging from this one,
the Cardinal gave it as his opinion that they will be among the finest in Christendom.[36]

The tapestry described by Beatis, the *Charge to Peter* (fig. III-17), continues the
theme of the *Miraculous Draught of Fishes*. According to the Gospel of Matthew
(16.17–19), after the Resurrection, Christ, clad in white robes—rendered in the tapes-
try in shimmering silver threads—appeared to his apostles. Peter, whose faith was supe-
rior, recognized Him through the force of his belief. This firm faith was to be the foun-
dation of Christ's Church, and hence Peter was given the care of Christ's flock and the
keys to the kingdom of heaven. The pope inherited this commission, as well as that of
Paul, to whom the other half of Leo's tapestries were dedicated. The borders of the weav-
ings, with the arms of the Medici in the vertical pilasters and scenes from the life of Leo
and of the apostles in the horizontal bands, re-enforced the link between the pope and
the first guardians of the Church and made explicit Leo's contribution to the dignity of
the Sistine Chapel.

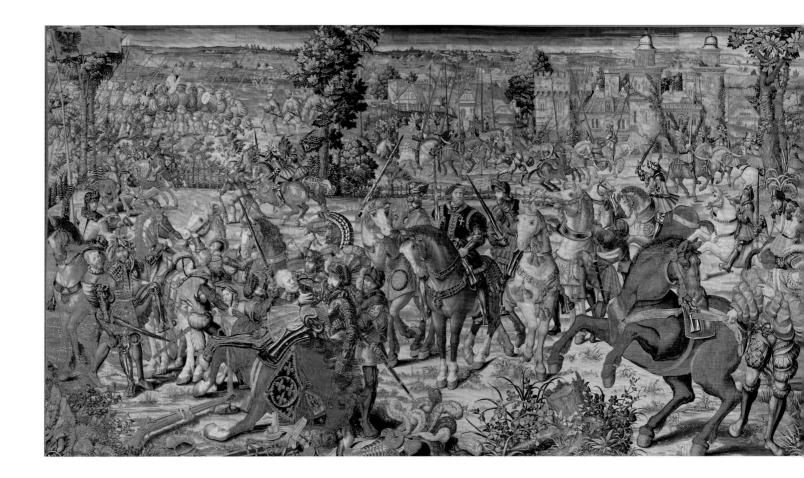

The tapestry project began in 1515; the first seven hangings dressed the papal chapel in December 1519, and the entire set was finished by the time of Leo's death in December 1521. The weavings cost fifteen thousand *ducats*, a little less than the accumulated salaries of the choristers of the Sistine Chapel over the same period. Raphael received a thousand *ducats* for the cartoons. The bejeweled tiara of Leo X was valued at 17,785 *ducats*. The authority of Leo's ensemble as a symbol of religious faith and political power prompted numerous rulers to seek its copies. Henry VIII reputedly received a set from Leo himself, as a reward for becoming the Defender of the Faith in 1520–1521. Another copy is said to have been made for Margaret of Austria. Francis I ordered yet another version, which was melted down for its gold in 1797. Cardinal Ercole Gonzaga of Mantua, who aspired to the papal throne but lost the election to Pius IV, purchased a set as well, but his contained no gold and silver threads, which were beyond his station and means. Up to the late eighteenth century more than fifty re-editions had been made—in Brussels, England (at Mortlake), and France (at the Gobelins Manufacture).

Fig. III-18.
The Decisive Moment of the Battle of Pavia: The French King Is Taken Prisoner, tapestry from the *Battle of Pavia* series. Designed by BERNAERT VAN ORLEY, ca. 1526–1528 and woven in the DERMOYEN WORKSHOP, Brussels, ca. 1528–1531. 4.35 × 8.80 m (171¼ × 346½ in.). Naples, Galleria Nazionale di Capodimonte, inv. IGMN 144489. Photo: Erich Lessing/Art Resource, NY.

When John the Fearless was captured by the Turks at the Battle of Nicopolis on 25 September 1396, his father, Duke of Burgundy Philip the Bold, sent a *Life of Alexander* tapestry woven with gold threads as part of the ransom demanded by Sultan Bayazid. The Turkish potentates, no less than their European counterparts, deemed themselves heirs to the legendary Greeks. The tapestry dispatched to the sultan was intended to please him doubly—through a flattering comparison with Alexander expressed in the medium of tapestry. According to the chronicler Jean Froissart, Bayazid "took great pleasure in seeing the tapestries of Arras."[37] As gifts, tapestries were as carefully tailored to their recipients as they were when rulers hung them on their own walls.

The appeal and value of European tapestries to the Ottoman sultans even prompted some speculative ventures by enterprising businessmen. The Dermoyen firm of Brussels had been purveyors to Charles V and Francis I. In the 1530s the firm apparently hoped to make the Turkish ruler a customer as well. Carel van Mander, the Vasari of the Netherlands, states in his life of Pieter van Aelst, the weaver of Leo X's *Acts of the Apostles*, that in 1553 the artist traveled to Istanbul to draw cartoons for tapestries to be offered to Sultan Süleyman.[38] An astute politician, Süleyman the Magnificent—who also claimed to be the Alexander of his age—had acquired other European luxury arts and used them to proclaim his political supremacy over his European foes—especially Charles V and the pope—in the language they best understood.[39] As savvy entrepreneurs, the leaders of the Dermoyen firm were banking on selling yet another costly European product to the clever Turk. Thus, while Pieter van Aelst worked on developing designs that might best please the sultan, the Austrian merchant Jakob Rehlinger brought samples of tapestries already produced by Dermoyen to demonstrate the quality of the completed hangings to this potential client.[40] It is hardly coincidental that the samples included a piece from the *Battle of Pavia* set (fig. III-18), which commemorated Charles V's victory over Francis I, and a piece from the *Hunt of Maximilian* ensemble, which celebrated Charles's Habsburg heritage. The tapestries extolling the emperor were plausibly chosen to provoke the sultan into a tapestry counterattack—a cycle that would demonstrate the supremacy of the Ottoman ruler over his primary foe.[41] In the end, no order was placed, and Van Mander attributed the failure of this venture to the Islamic prohibition on figurative representations. Anti-European factions at the Sultan's court may also have thwarted this project sponsored by the pro-European vizier Ibrahim Pasha. Still, the Dermoyen initiative illustrates the recognition that tapestries were vital expressions of sovereignty and effective weapons of diplomacy across territorial and religious divides.

The episode also points to the use of tapestries as a means of competition between princes, whether a ruler ordered a new set to outshine his enemy or purchased a version of an ensemble owned by his peer. Just as Leo X's *Acts of the Apostles* were copied for several rulers, so were other key tapestry cycles of the Renaissance. For once a particular ensemble evinced its potency, it was sought by other rulers eager to capitalize on its efficacy as a sign of authority, learning, and taste. Originality, important to the modern notion of Art, was not so highly prized in the Renaissance: Patrons regularly cited extant creations when ordering their own versions. Since "Art" served as a means toward a greater end, an artwork of demonstrable power was worth emulating and, in a sense, co-opting.

Consider the *Trojan War* tapestry cycle, first presented to the duke of Burgundy, Charles the Bold, by the town magistracy of Bruges in 1472. Apparently the duke expressed a desire for the ensemble; the city obliged by financing its execution by Pasquier Grenier of Tournai. The eleven-piece set—woven in the costliest materials and stretching to more than 95 m (311 1/2 ft.) in length and 4.5 m (14 3/4 ft.) in height—narrated the story of the Trojan War much favored at the Burgundian court.[42] In the crowded and action-packed compositions the Greeks and the Trojans wear fifteenth-century armor adorned with goldwork, thereby bridging the gap between ancient heroes and fifteenth-century rulers, who looked to the ancients for models of wisdom and conduct. The depicted events are elucidated in French captions at the top and Latin ones below. In the culminating tapestry of the set, showing the *Fall of Troy* (fig. III-19), the action begins on the far left, where Greek ships lie anchored in the harbor, and builds up in tension as the splendidly caparisoned wooden horse—the treacherous gift of the Greeks—is wheeled toward the city amid a throng of tightly packed troops bristling with spears and pikes. At the climactic moment, emphasized as such by its architectural frame, Neoptolemos slays King Priam in the temple. He then proceeds to behead Priam's daughter Polyxena in order to avenge the death of his own father, Achilles. Behind them Troy erupts in flames. From the safety of his study, at the far right, Homer gestures didactically toward the destruction and his narrative of the great war.

Many European princes claimed Trojan decent, and illustrations of the epic and its heroes remained in continuous demand. The desirability of this particular tapestry series, however, was considerably enhanced by its association with the duke of Burgundy. Capitalizing on both the lucrative theme and the role of the Burgundian court as the arbiter of taste across Europe, Grenier produced numerous re-editions of the ensemble. Among those who ordered it were Henry VII Tudor, a ruler on the ascent seeking to shore up his new dynasty; Charles VIII of France, an enemy of the Burgundians; Ferdinand of Naples, their ally; and Mathias Corvinus of Hungary, Ferdinand's son-in-law and self-made king who hailed from a family of mercenary soldiers and fashioned his sovereign identity with the help of carefully selected artifacts. Federigo da Montefeltro—also an upstart, a mercenary army commander who rose in rank by establishing his own splendid court at Urbino and carefully staging displays of his cultivation and taste—likewise purchased a copy of the *Trojan War* set. And when Francesco II Gonzaga of Mantua married Isabella d'Este in 1490, he borrowed Federigo's ensemble to serve as part of the festive and programmatic decoration for the celebration of the new union and its promise.[43]

Fig. III-19.
The Fall of Troy, eleventh tapestry in the *Trojan War* series. Woven in the WORKSHOP OF PASQUIER GRENIER, Tournai, ca. 1470–1490. Zamora, Museo de la Catedral. © IRPA-KIK, Brussels.

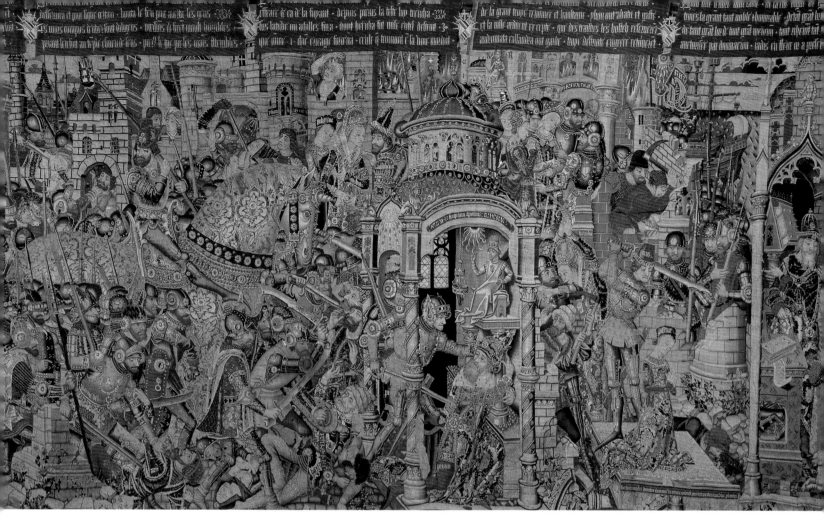

Tapestries for Social Climbing

Because tapestries so eloquently communicated the ascendance of their owners, not only rulers but lesser individuals who rose to power and wealth solemnized their accomplishments and status through this art form. François de Taxis (1459–1517), Master of the Posts of the Habsburg domains, commissioned a tapestry set depicting the *Legend of Notre-Dame du Sablon* shortly before his death to glorify the miraculous Virgin of Brussels, his Habsburg patrons, and himself at the end of an impressive career. The four tapestries were probably intended for his funerary chapel in the Church of Notre-Dame du Sablon: They were observed in that location by Calvete de Estrella, the chronicler of King Philip II of Spain's voyage to the Netherlands in 1549. Ostensibly illustrating the miraculous transfer of a statue of the Virgin from its original seat in Antwerp to Brussels in 1348, the tapestries rewove history to the renown of Taxis and his Habsburg benefactors.[44]

The first tapestry (now fragmented and partly lost) begins with the appearance of the Virgin to Beatrix Soetkens, a pious old spinster of Antwerp who took care of the miraculous image of Notre-Dame à la Branche in a local church. Upset by the neglect of her statue by the inhabitants of the city, the Virgin visits the sleeping Beatrix and bids her to take the image out of its niche to have it cleaned and polychromed. Beatrix follows her command, takes the statue to an artist to restore it, and returns the renewed image to its home (the captions in the scrolls in the borders explain the depicted events).

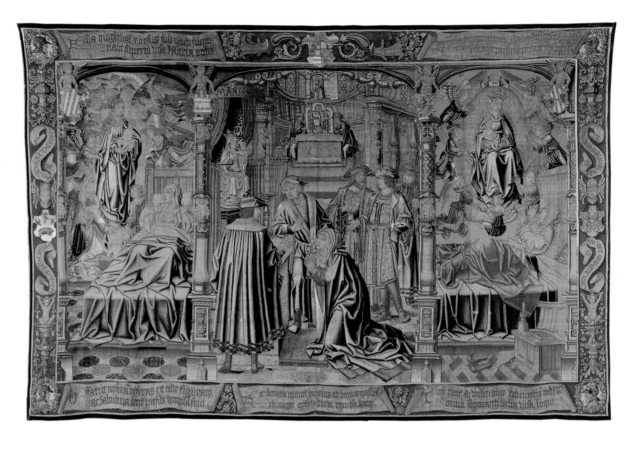

Fig. III-20.
The Virgin Orders Beatrix to Take Her Statue to Brussels, second tapestry in the *Legend of Notre-Dame du Sablon* series. Brussels, 1516–1518. St. Petersburg, The State Hermitage Museum, inv. no. T-2976.

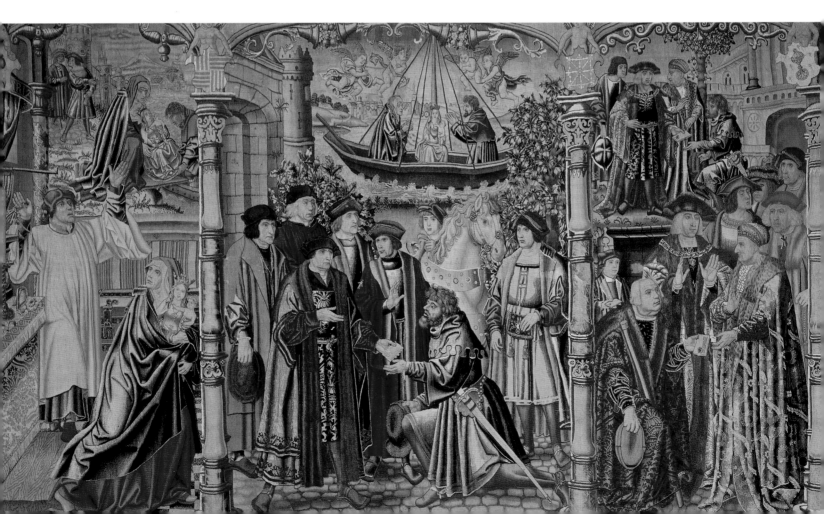

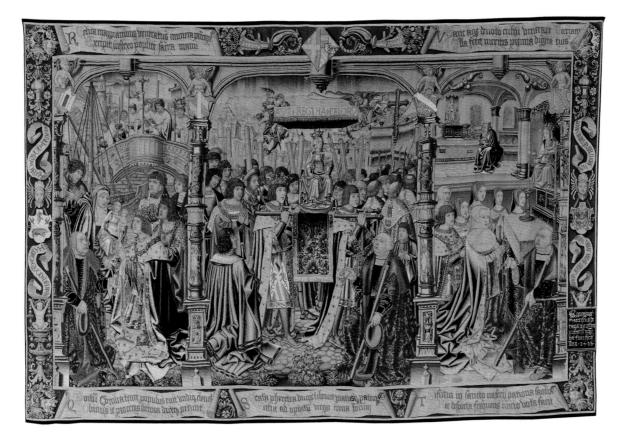

Fig. III-22.
The Statue of the Virgin Arrives in Brussels, fourth tapestry in the *Legend of Notre-Dame du Sablon* series. Brussels, 1516–1517. Wool and silk, 3.41 × 5.28 m (134¼ × 207⅞ in.). Brussels, Musées royaux d'Art et d'Histoire, inv. 3153.

The second tapestry shows the Virgin appearing again to the obedient Beatrix and ordering her to transfer the statue to the Church of Notre-Dame du Sablon in Brussels (fig. III-20). Beatrix attempts to do as the Virgin has requested: She returns to the church to ask permission to take the statue away. Quite understandably, the request is denied by the magistrates of Antwerp. This causes the Virgin to visit Beatrix for the third time and to exhort her to persevere in her mission.

The third tapestry (fig. III-21) depicts the successful removal of the statue by Beatrix as the sacristan, who tries to prevent her, is struck motionless. Beatrix transports the miraculous image by boat to Brussels. Meanwhile the magistrates of Antwerp dispatch a letter to John, Duke of Brabant, apprising him of these extraordinary events. It is here that mid-fourteenth-century reality begins to merge with the life of the man who commissioned the tapestry ensemble more than a hundred years later: In the right part of the weaving, François de Taxis himself genuflects in front of Emperor Friedrich III Habsburg (in the role of the duke of Brabant) and his son Maximilian I, either delivering a letter or receiving the mandate to found the imperial post. For it was Friedrich who presided at the birth and organization of the postal service in his domains, Maximilian who sustained and extended the service (and under whom Taxis served as chief of messengers), and Taxis who became Master of the Posts in 1504.

The fourth and last tapestry expands the contemporary portrait gallery and history, further compressing the centuries to Taxis's advantage (fig. III-22). On the left Beatrix hands the statue to a crowned prince wearing an ermine-lined cloak and the

Fig. III-21.
The Statue of the Virgin Is Transported to Brussels, third tapestry in the *Legend of Notre-Dame du Sablon* series. Brussels, 1516–1518. Brussels, Musées de la Ville de Bruxelles, Maison du Roi.

collar of the Order of the Golden Fleece. This is Philip the Fair, son of Maximilian I and Mary of Burgundy, from whom he inherited the Netherlands and the province of Brabant. On the one hand, Philip plays the role of John, Duke of Brabant, who had welcomed the statue of the Virgin to Brussels in 1348. On the other hand, Philip is himself, the ruler who appointed François de Taxis to the title of Captain and Master of the Posts headquartered in Brussels. The widely dispersed domains and even wider territorial ambitions of the Habsburgs made a well-run European postal system particularly important. Taxis's service as chief of messengers under Maximilian made him a natural choice for the appointment as master of the posts. Taxis's appearance in all three scenes of the fourth tapestry, a sealed document in his hand confirming his office, explains the transformation of the fourteenth-century duke of Brabant into a succession of Taxis's Habsburg patrons.

The Habsburg portrait gallery and flattery continue in the central scene of the fourth tapestry, where the statue of the Virgin, borne on a litter covered with a ceremonial canopy, is conveyed to its new seat at Notre-Dame du Sablon by the reigning duke of Brabant, Charles Habsburg, King of Spain (the eldest son of Philip the Fair, and the future Charles V), as well as by his younger brother Ferdinand, who ruled the Germanic territories for Charles. François de Taxis genuflects in the foreground of the procession, while opposite him, his back to the viewer, kneels his nephew and heir, Jean-Baptiste de Taxis. On 12 November 1516, Jean-Baptiste, together with his uncle, received from Charles a contract that placed the Taxis family in charge of the post in all imperial territories. Hence the constellation of the four men in this scene.

In the right panel the statue of the Virgin assumes its place over the altar at Notre-Dame du Sablon, prompting the worshipful adoration of the imperial family: Margaret of Austria kneeling in the first row, followed by Ferdinand and his four sisters. A modestly dressed matron behind the imperial family is likely Dorothy Luytvoldi, the wife of François de Taxis. A woman sitting by the altar above is Beatrix Soetkens, who dedicated the rest of her life to the service of the miraculous Virgin.

Honoring his regal patrons further, Taxis added their armorial devices to the borders of his tapestries: In the second and third weavings the shield in the top center is that of Philip the Fair and his son Charles; the shield in the top center of the fourth tapestry belongs to Margaret of Austria. Taxis's own arms appear in the left side margins. In the top right scroll of the last hanging he perpetuates his own name, accomplishments, and faith: "The noble François de Taxis, of pious memory Master of the Posts, caused these to be made in the year 1518." Taxis died in 1517 and did not see the project to completion, but his memory and glory endured in the tapestries that spoke of his power, wealth, and illustrious connections.

As the examples discussed above indicate, the impact of tapestries derived in part from their size and imagery and in part from the costly materials used in their manufacture: gold, silver, and silk threads in the most imposing pieces—substances that themselves had to be processed with skill before they could be incorporated into weavings. Gold and silver threads—flat wires of metal wrapped around a silk core—were a specialty of Venice. Much of the silk was supplied by the Tuscans. Wool, the material that predominated in cheaper weavings, came from England and Spain. The manufacture of tapestries from these ingredients was the specialty of Southern Netherlands. Thus, just as their usage, so the creation of tapestries was an international phenomenon.

The production of tapestries called for multiple skilled and well-organized weavers directed by a master entrepreneur. At the rate of about the surface of one hand a day, weaving took a long time and many hands. Since many tapestries were large— 5×7 or 9 m ($16^{1}/_{3} \times 23$ or $29^{1}/_{2}$ ft.) was common—and each weaver was responsible for about one meter, or the span of an arm, before him on the loom, a row of workers usually labored on a single hanging. Since many tapestry sets consisted of multiple pieces, a series of looms, sometimes situated in different cities, were simultaneously engaged in executing a single ensemble.

Penelope at Her Loom (fig. III-23)—a fragment from one piece of what was once a ten-part series devoted to virtuous women—shows the weaving of tapestry on a low-warp, or horizontal, loom, typically used in Southern Netherlands. Commissioned by Ferry de Clugny, Bishop of Tournai, who rose to the rank of a cardinal in 1480, the hanging retells the story of Penelope laboring on her tapestry by day only to unravel it at night in order to stall the vexing suitors until her husband, Odysseus, returns from his epic voyage. An inscription at the bottom edge of the tapestry spells out her commitment: PENELOPE COIVNX SEPER VLIXIX ERO—"The wife of Ulysses I shall always be." Penelope holds a shuttle with the weft thread in her right hand and manipulates the harness of the loom with her left in order to pass the shuttle between the warps, thus building up the fabric line by line. Behind her hangs a product of the tapestry craft—a millefleur design, the most common type of fifteenth-century Netherlandish weaving. A carpet with geometric patterns typical of Eastern textiles decorates her table. It may allude to the land to which Odysseus had departed so long ago.[45]

The tapestries illustrated in this chapter belonged to the loftiest owners and represent this art at its best. Like any other art form, of course, tapestries varied widely in their quality. The status and resources of the owner determined the inclusion or omission of silver and gold threads and silks, the number of colors employed in the weaving, and the fineness of texture. The more warp yarns a piece contained and the thinner each yarn was, the finer the texture of the piece and the greater the refinement of pictorial details. Contemporaries carefully discerned gradations of quality and paid close attention to the presence of precious materials. The price and magnificence of tapestries woven with gold, silver, and silk were immeasurably greater than the cost and appeal of the cheaper weavings rendered only in wool.[46]

Tapestries could be custom ordered, acquired ready-made, or bought second-hand. Since many sets illustrated standard scenes, they were often produced on speculation: Mythological and chivalric narratives, scenes of pastoral and leisure activities, religious stories centered on the Virgin and Christ, as well as millefleurs motifs were

Fig. III-23.
Penelope at Her Loom,
detail of the tapestry *The
Story of Penelope and the
Story of the Cimbri Women*
from the series *The Stories
of Virtuous Women.* French
or Franco-Flemish, ca.
1480–1483. Wool. Boston,
Museum of Fine Arts, Maria
Antoinette Evans Fund,
inv. 26.54. © 2004 Museum
of Fine Arts.

Fig. III-24.
Narcissus, detail of a
tapestry from a series
devoted to mythological
characters. French or Franco-
Flemish, ca. 1480–1520.
Wool and silk. Boston,
Museum of Fine Arts,
Charles Potter Kling Fund,
inv. 68.114. © 2004 Museum
of Fine Arts. See also detail
on p. 88.

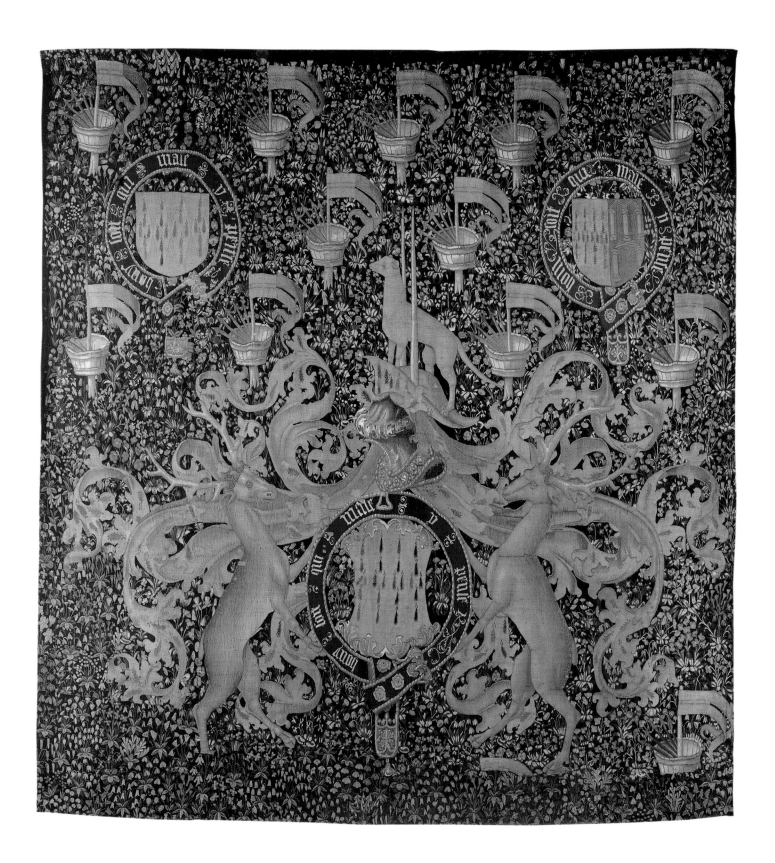

frequently ready-made. Millefleurs often framed figural compositions and armorial devices, providing elegant adornment for a noble home or identifying the space as belonging to a particular family. One fine example, fashioned in wool and silk, depicts *Narcissus*—a modish youth, who gazes rapturously at his own reflection in a marble fountain on which a couple of birds have perched to drink and rest (fig. III-24). The field around him consists of countless, but readily identifiable flowers, and animals and birds frolic among them. The hanging probably formed part of a series devoted to mythological characters from Ovid's *Metamorphoses*.[47] A millefleur weaving with the *Arms of John Dynham* (1433–1501; fig. III-25) was commissioned by an English knight who had served four kings. Dynham first offered his fealty to Henry VI of Lancaster in 1458; he then switched to Edward of York, helping him to cross the Channel after his defeat at Ludlow. Dynham earned ascent to the peerage when Edward became king. Under Edward and then Richard III, Dynham served as governor of Calais. He must subsequently have helped Henry VII Tudor in his conquest of England, for the new king appointed him Lord Treasurer of England, a post he retained until his death. Dynham was made a Knight of the Garter ca. 1487, and his tapestry was likely ordered to commemorate that honor. The inscription *Honi soit qui mal y pense* (Shame to him who thinks ill of it) is the motto of the Order of the Garter. The weaving, composed of silk and wool, with the prominently depicted garter at its center, probably adorned the great hall of Dynham's home at Lambeth, Surrey.[48]

Inventories of princes, noblemen, and wealthy burghers also frequently record millefleur tapestries with leisurely pastimes—hunting, picking fruit, playing music, or games. Such a series once belonged to Thomas Bohier (d. 1524), Finance Minister and one of the leading personalities during the reigns of Kings Charles VIII, Louis XII, and Francis I of France. Bohier and his wife, Catherine Briçonnet (d. 1526), who also hailed from a highly placed clan, began to build their château at Chenonceau around 1513 or 1515, and tapestries decorated some of the rooms of their new residence. In one wool-and-silk piece from their now-dispersed collection a servant brings a game board to an elegantly dressed couple, while next them a woman gathers in her skirt pears shaken from a tree by a young man (fig. III-26).[49] The arms of Bohier and his wife have been rewoven into the finished body of the tapestry: an indication of a premade hanging personalized after purchase, a common practice at the time.

The great quantities of hangings regularly purchased by rulers suggest that tapestry merchants kept ready stocks and could quickly supply weavings upon demand.[50] Merchants also assembled drawings and painted cartoons that could be shown to prospective clients and efficiently converted into textiles. Pasquier Grenier, the renowned fifteenth-century tapestry merchant of Tournai, provided a number of rulers with a *Trojan War* ensemble because he kept the initial drawings. Unless a customer purchased the cartoons to preclude duplication of his hangings—as Philip the Good did with his *Gideon* ensemble—tapestry merchants apparently retained the "copyright" to a given set.

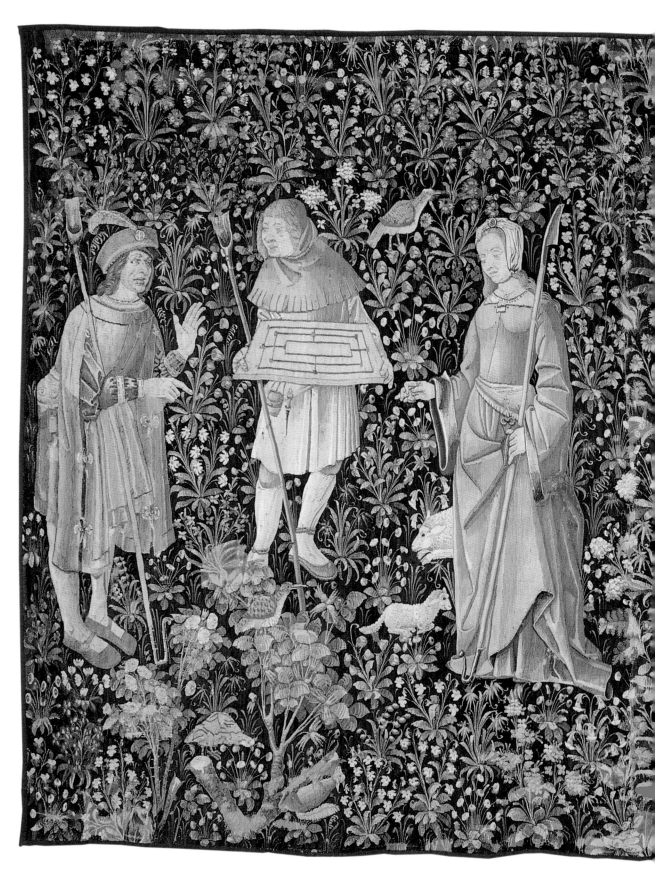

Fig. III-26.
*Game Playing and Fruit
Picking,* tapestry from the
Noblemen in the Country
series. LOIRE VALLEY
WORKSHOP, ca. 1510. Wool
and silk, 2.25 × 3.95 m
(88⅝ × 155½ in.). Paris,
Musée du Louvre,
inv. OA 9407. Photo: RMN/Art
Resource, NY. Photographer:
Jean Schormans.

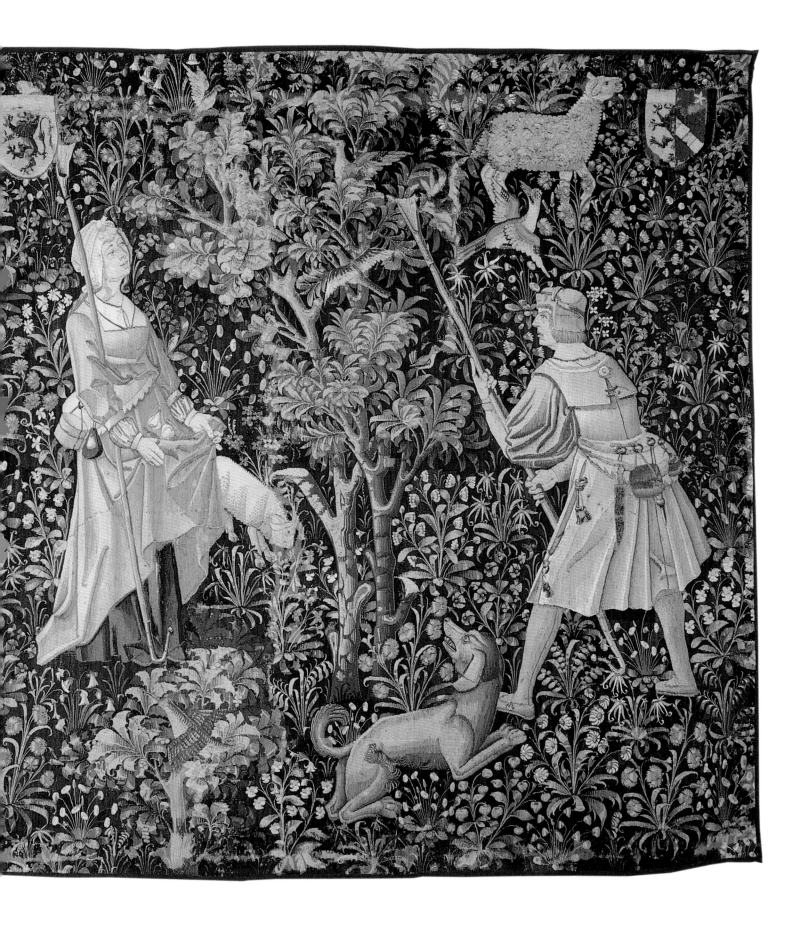

Tapestry merchants were essential for the complex process of manufacture and sale of weavings. Acting as both entrepreneurs and managers, they negotiated contracts, financed the purchase of expensive raw materials, and organized and paid weavers during the lengthy course of execution. They also habitually engaged in additional businesses: Pasquier Grenier, for example, dealt in wine. Nor were tapestry merchants the only ones to capitalize on this prestigious and lucrative merchandise. The Medici, who rose in the world through their banking empire, also traded in jewelry, silk brocades, damasks, and tapestries (and supplied Netherlandish weavers with raw silks). The Medici correspondence with their employees in Bruges contains regular requests for weavings both for their own use and for resale to customers throughout Europe.[51] In 1453 Gierozzo de Pigli reported to Giovanni de' Medici that he had purchased the *History of Samson* for Astorre Manfredi, the lord of Faenza, and he had ordered the *Triumph* tapestries for the Medici themselves. In 1462 Tommaso Portinari informed Giovanni that he had ordered tapestries for Count Gaspare de Vimercato.[52] Other Medici clients included the Sforza of Milan, the Este of Ferrara, the dukes of Savoy, and several popes: In 1460 the Medici sold Pope Pius II a tapestry with silk and gold thread for the sum of 1,250 gold *ducats*.[53] Nor were the Medici the only bankers to diversify their business in this manner. At the beginning of the sixteenth century the banking house of Gualterotti of Antwerp similarly exported tapestries to England, Portugal, Spain, Italy, and France.[54]

The Medici correspondence makes it clear that fine-quality weavings did not always need to be commissioned. They could be found on the open market at which rulers themselves often shopped. Queen Isabella of Spain acquired some of her tapestries in this way. On 23 July 1504 her agents bought for her at Medina del Campo a *Mass of Saint Gregory* hanging composed of silver, silk, and gold (fig. III-27). Isabella owned two such weavings, and scholars debate whether the sole survivor was that purchased at the fair or the one presented to her by her daughter, Juana la Loca. The word BRVESEL (Brussels), woven into the hem of the priest's blue nethergarment, advertises its place of manufacture. Seeking to safeguard their international reputation and to assure the quality of their products, the tapestry weavers of Brussels—the premier European center for the craft at this time—incorporated the city mark into their goods. Weavers also wove their own name or signature signs into the borders of their hangings, thus both authenticating and advertising their work. Janni Rost, the Fleming employed first by Ercole d'Este and then Cosimo I de' Medici, "signed" his tapestries with a roast on a spit (fig. III-28).

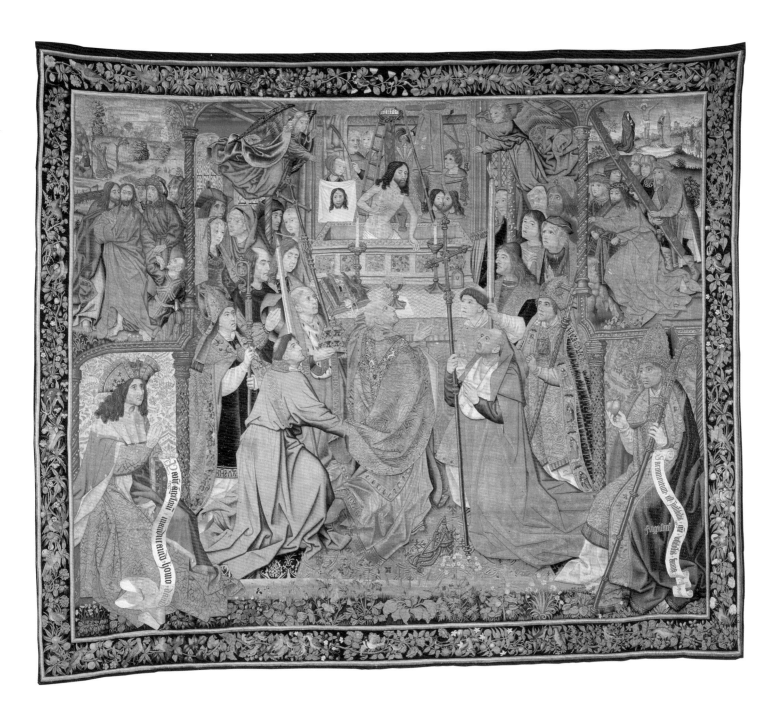

Fig. III-28.
Janni Rost's "signature"
on *The Lament of Joseph*
tapestry in the *Story of
Joseph* series. Drawn by
PONTORMO and woven by
ROST. Rome, Palazzo del
Quirinale, inv. ODP 111.

Fig. III-29.
Detail of *Bird's-eye view
plan of Antwerp*, ca. 1556.
Anonymous woodcut after
a drawing by VIRGILIUS
BOLONIENSIS. Antwerp,
Museum Plantin-Moretus,
Stedelijk Prentenkabinet,
inv. V.VI.1.2.

Netherlandish weavings dominated the European market throughout the
fifteenth and sixteenth centuries: Arras, Brussels, and Tournai produced the most
renowned goods. Antwerp, meanwhile, hosted major fairs at which luxury arts and
other products from the Netherlands and the rest of the world were briskly sold to an
international clientele. Touring the Burgundian Netherlands in 1438, the Spanish mer-
chant adventurer Pero Tafur admired the plenitude of the Antwerp mart:

The fair which is held here is the largest in the whole world, and anyone desiring to see all Christendom, or the greater part of it, assembled in one place can do so here. The Duke of Burgundy comes always to the fair, which is the reason why so much splendour is to be seen at his court. For here come many and diverse people, the Germans, who are near neighbours, likewise the English. The French attend also in great numbers, for they take much away and bring much. Hungarians and Prussians enrich the fair with their horses. The Italians are here also. I saw three ships as well as galleys from Venice, Florence and Genoa. As for the Spaniards they are as numerous, or more numerous, at Antwerp than anywhere else. I met merchants from Burgos who settled in Bruges, and in the city I found also Juan de Morillo, a servant of our King.

As a market Antwerp is quite unmatched. Here are riches and the best entertainment, and the order which is preserved in matters of traffic is remarkable. Pictures of all kinds are sold in the monastery of St. Francis; in the church of St. John they sell the cloths of Arras; in a Dominican monastery all kinds of goldsmith's work, and thus the various articles are distributed among the monasteries and churches, and the rest is sold in the streets. Outside the city at one of the gates is a great street with large stables and other buildings on either side of it. Here they sell hackneys, trotters and other horses, a most remarkable sight, and, indeed, there is nothing which one could desire which is not found here in abundance. I do not know how to describe so great a fair as this. I have seen other fairs, at Geneva in Savoy, at Frankfurt in Germany, and at Medina in Castille, but all these together are not to be compared with Antwerp.[55]

Tafur's description not only conveys the richness and excitement of the Antwerp fair but also elucidates the specialized venues for art merchandise. Monasteries, with their cloisters, provided ideal covered spaces for exhibiting goods. Tapestries were sold at the Dominican and Carmelite cloisters, as well as at the new Butcher's Hall. In 1551–1553 the property developer and speculator Gilbert van Schoonbeke erected a specially designated *Tapissierspand*, or tapestry market hall. A colored woodcut produced in 1556 of the town plan of Antwerp includes the new structure: a rectangular building 80 × 37 m (262 × 121 ft.) with four pointed gables and three aisles almost 6.5 m (21 ft.) high, which allowed hangings to be displayed to full advantage (fig. III-29).[56] This real estate venture reflected the booming business in Netherlandish weavings taking place in Antwerp.

Fig. III-30.
Three Coronations altar
hanging. Brussels,
1470–1480. Wool, silk, and
silver and gold thread,
1.7 × 3.35 m (66⅞ ×
131⅞ in.). Sens, Cathedral
treasury, inv. TC A 2.
Photo: Musées de Sens.
Photogrrapher: J. P. Elie.

For most of this chapter, I have focused on Renaissance tapestries as political
and social artifacts, for such were their roles first and foremost. Let us, however, in con-
clusion, savor the artistic merit and aesthetic allure of this art. Consider the *Three
Coronations* altar hanging (fig. III-30), presented to the Sens cathedral by Charles II
Bourbon (1434–1488), son of Duke Charles I and Agnes of Burgundy, sister of Philip the
Good.[57] Charles II was a man of lofty station: He was made archbishop of Lyons in 1447,
papal legate in 1465, member of the king's council in 1466, godfather to Charles VIII in
1470, and cardinal in 1476. He was extremely wealthy and had refined taste.[58] The exqui-
site quality of his *Three Coronations* weaving was a fitting offering to God and a memo-
rial to his own faith, rank, and patronage of the cathedral. Because the tapestry stayed
for centuries in its intended "home," with no undue disturbance, it has preserved much
of its original brilliant color and exquisite detail. The weaving shows the Coronation of
the Virgin at the center and its two Old Testament prefigurations in the "wings": On the
left Solomon crowns his mother, Bathsheba; on the right Ahasuerus touches the shoul-
der of Esther with his golden scepter. The extremely high count of twenty-seven warp
threads to the inch allowed the weavers to render the delicately modeled faces with a
slight blush on the cheeks and moist red lips, the glimmering jewels, the soft furs, and
the sumptuous velvets and brocades. King Ahasuerus (fig. III-31), an old man, has aging
flesh that sags and wrinkles; he wears a richly brocaded coat whose velvet sleeves catch
light and form complex shadows, while the fur trim above the elbows creases and

CHAPTER III

responds to the effects of light; his throne, meanwhile, shines with rubies, sapphires, and pearls. We are so accustomed to praising such consummate pictorial effects in Renaissance paintings, yet their reproduction in tapestries—a far more complex task—usually goes unremarked. The aesthetic and technical achievement of the *Three Coronations* hanging shows this art form at its finest and helps us better understand the admiration for it by contemporaries in countless Renaissance written and pictorial records.

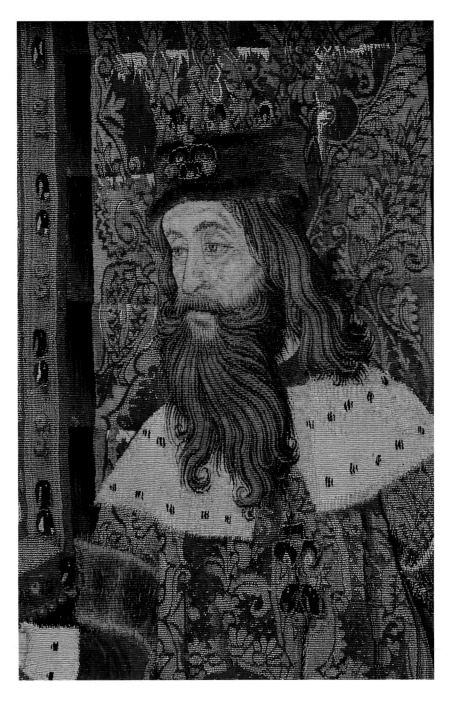

Fig. III-31.
Ahasuerus, detail from the *Three Coronations* altar hanging (see fig. III-30).

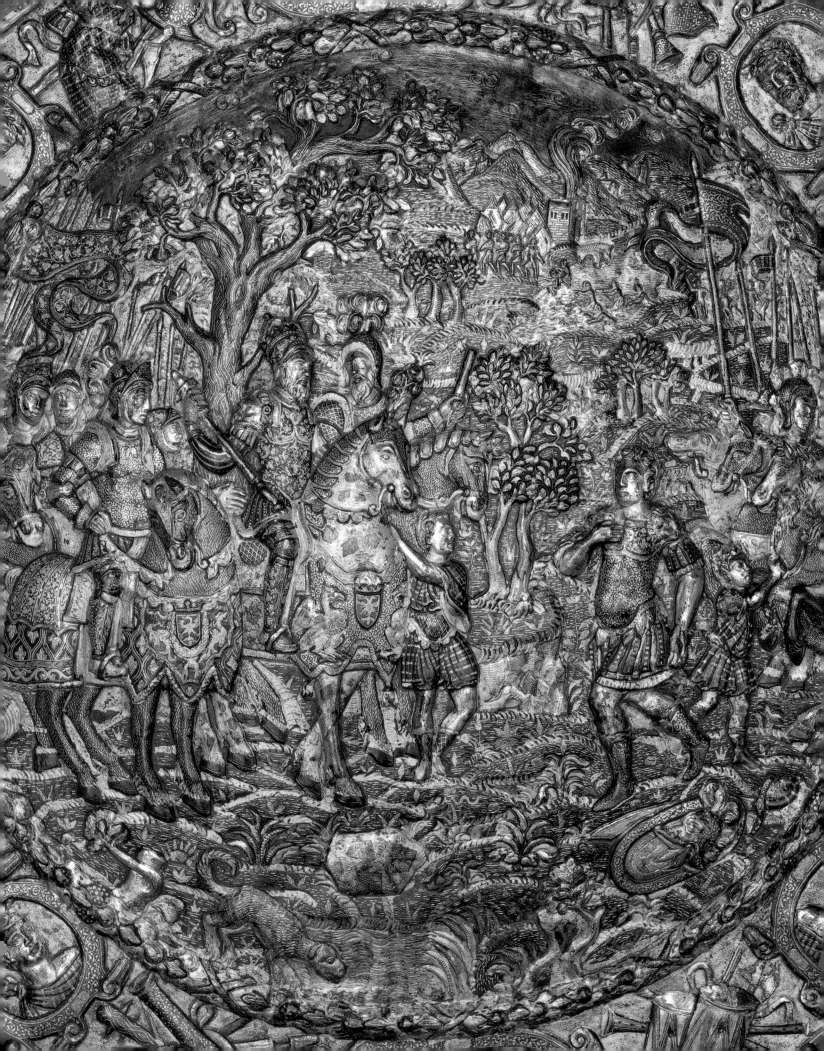

IV ARMOR: THE HIGH ART OF WAR

His yron coate all ouergrowne with rust,
Was vnderneath enueloped with gold,
Whose glistring glosse darkned with filthy dust,
Well it appeared, to haue beene of old
A worke of rich entayle [engraving], and curious mould.

—EDMUND SPENSER, *THE FAERIE QUEENE*, BOOK II, CANTO VII, STANZA 4 (1590)

At Ambras Castle in Innsbruck, Archduke Ferdinand II of Tirol (fig. IV-1), nephew of Charles V Habsburg, assembled a vast collection of arts and curiosities that filled four interconnected buildings. One of these housed the *Kunstkammer* (art cabinet), whose exhibits we have already noted (see p. 28). The other three halls contained armor. This immense assemblage reflected not a childish fascination with military paraphernalia but a profound concern with history, an interest also manifested by Ferdinand's collection of more than a thousand portraits of European noblemen and women and books devoted to the Habsburgs and related dynasties.[1]

Ferdinand became governor of Tirol and the Vorlande (the western Habsburg possessions, in Switzerland, Alsace, and Swabia) in 1564. Upon the death of his brother Emperor Maximilian II in 1576, Ferdinand became the head of the family. Each item in his museum, and the collection as a whole, manifested the Habsburgs' role in and impact on international history from the reign of Maximilian I in the late fifteenth century to Ferdinand's own day. The predominance of armor in the Ambras display highlighted the prevalence of military ethos in contemporary culture.

Ferdinand's armory was divided into five rooms, each articulating a particular theme. The first room glorified chivalry: It presented more than seventy harnesses worn in knightly tournaments from the days of Maximilian I to Ferdinand's time. The second room reflected a contemporary passion for curiosities: Here stood the armor of children, giants, and dwarfs, juxtaposed in startling and marvelous contrasts. The 2.3-m-tall ($7\frac{1}{2}$ ft.) suit of armor of the footman Bona, for example, towered over the harness of the court dwarf Thomerle. The third room extolled the military prowess of the archduke himself. It featured his personal armor, which he had donned in the field and in the lists

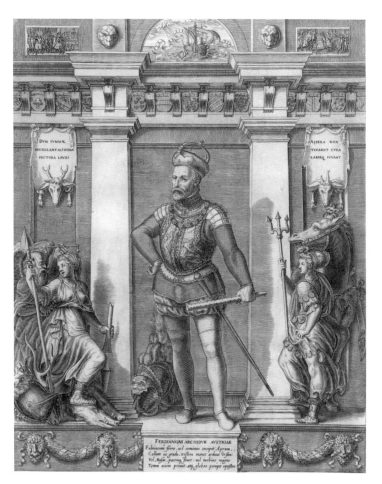

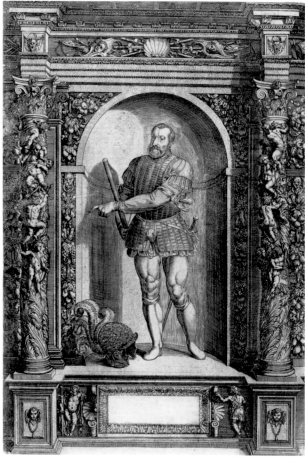

(tournament enclosures), seventeen items in all, arranged in chronological order. Banners painted with the Labors of Hercules hung from the ceiling, proclaiming Ferdinand a new champion of exemplary virtues and deeds. Another hall housed armor of Turkish origin, booty of the archduke's campaign in Hungary, all symbolic of Christian and Habsburg triumphs over Islam. But the heart of the collection consisted of 120 suits that had belonged to famous rulers and military champions and through them chronicled the history of Europe. Displayed in hierarchical order—from armor of emperors and kings to that of generals of non-noble birth—the suits also presented a social register. Ferdinand himself assumed a place in this gallery of worthies through the armor he had worn in the campaign against the Turks in 1556.

 To gather a collection of such scope, the archduke dispatched solicitations across Europe for armor and portraits of its owners. Whenever he succeeded fully, he displayed the likeness of a given worthy alongside his suit. He also published a catalogue of this hall, entitled *Armamentarium heroicum* (Armory of heroes). On its pages portraits of armor-clad worthies faced their written biographies. Thus, for example, the great Italian condottiere Francesco Maria della Rovere, dressed in a harness crafted by Filippo Negroli, pointed to the record of his deeds laid out on the adjacent page (fig. IV-2).[2]

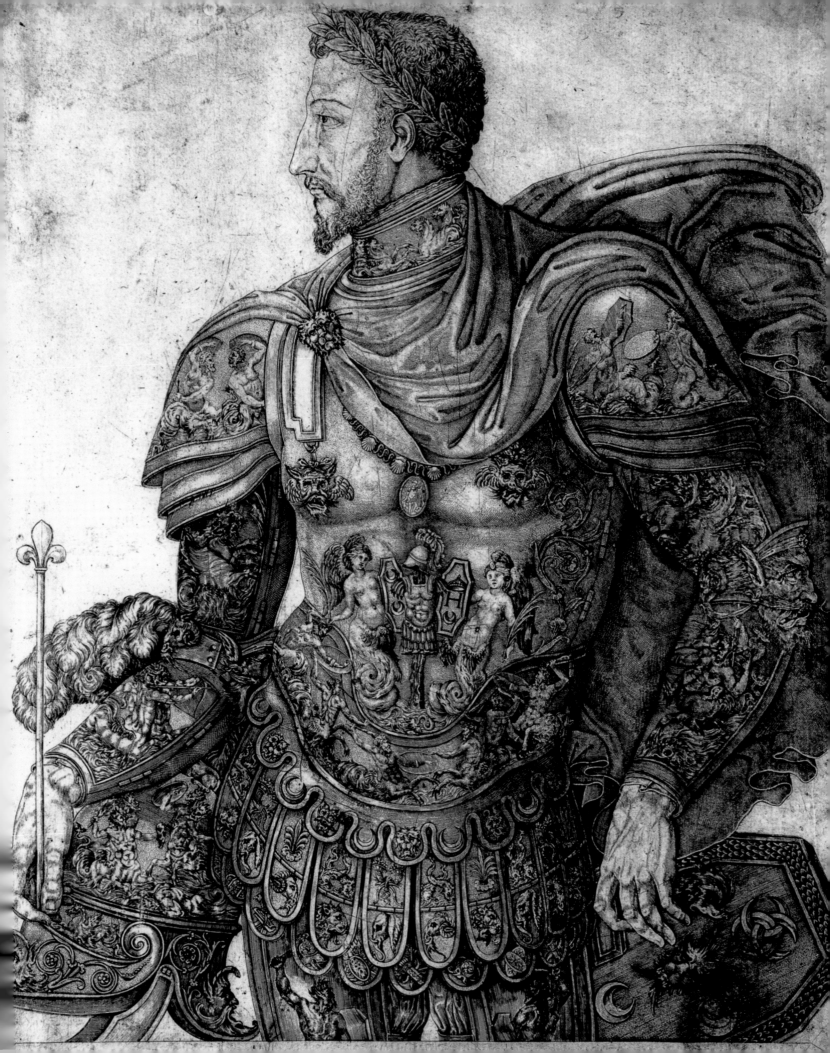

The importance of superbly crafted and richly decorated armor to the image of a Renaissance ruler is apparent, not only from the archduke's collection and its catalogue, but also from numerous period portraits. No other attire so cogently expressed strength and nobility, chivalry and the revival of valor of ancient heroes and statesmen. The portrait of Henry II of France, engraved and published by Niccolò della Casa in the year of the king's coronation (1547), presented the new monarch in a splendid harness *all'antica* (fig. IV-3). And Michelangelo, seeking to render in the most flattering guise the inconsequential Medici dukes entombed in the New Sacristy of San Lorenzo in Florence, endowed them with dignity and authority by dressing them in fine *all'antica* armor (fig. IV-4).

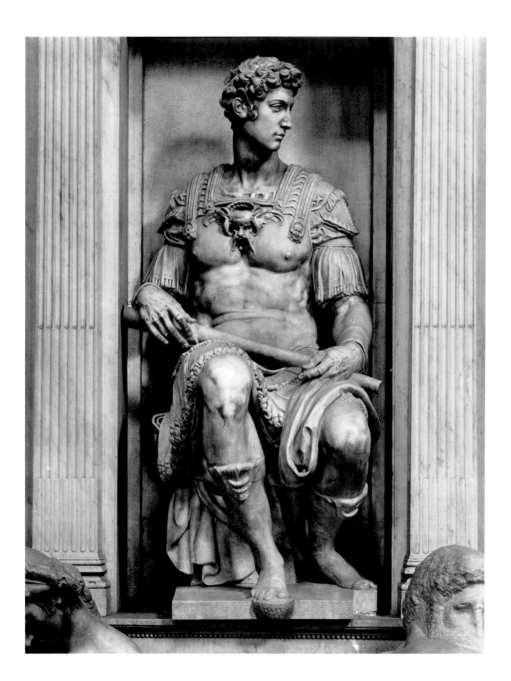

Fig. IV-4.
MICHELANGELO (Italian, 1475–1564), Monument to Giuliano de' Medici, ca. 1520–1534. Marble, H. 1.73 m (68⅛ in.). Florence, San Lorenzo, Medici Chapel. Photo: Alinari/Art Resource, NY.

While Ferdinand assembled and recorded the armor of many worthies, his uncle, Charles v Habsburg, amassed a great collection of primarily his own armor and arms. Engaged in wars with rivals, infidels, and heretics for most of his rule, the emperor embodied much of contemporary history. To document his political and military accomplishments through the armor he wore, Charles ordered an *inventario iluminado*, an illustrated inventory of his collection.[3] The album is an invaluable resource: It attests to the original appearance of the emperor's suits, many of which have been damaged over time; it clarifies their uses in diverse contexts, for individual pieces were donned for specific purposes; and it presents a kind of pictorial narrative of his ambitious and bellicose reign. Even when Charles abdicated the throne in 1555, he took with him to his retirement home, the monastery of San Yuste, his favorite harnesses and weapons as well as Titian's portrait commemorating Charles's victory over the Protestants at Mühlberg (1547)—a painting that faithfully reproduces the armor Charles wore on that critical campaign (see fig. 5). He also assigned a generous annual pension to the renowned Augsburg armorer Desiderius Helmschmid, who created his Mühlberg suit.

The Ubiquity of War, the Practicality of Armor

Charles v's whole career was punctuated by wars. He took part in his first battle at age fifteen and fought somebody somewhere every year of his reign. Warfare was endemic in Renaissance Europe, and all major rulers engaged in military confrontations. The Burgundian dukes, for example, crushed repeated revolts in Ghent and Liège. The kings of England and France disputed their dynastic rights in the Hundred Years' War. Pope Julius II donned armor to safeguard papal territories. The Spanish monarchs crusaded against the infidel in Granada, and Charles v did the same in Tunis. With one martial campaign generating or spilling into the next, armor remained in constant demand.

While harnesses of various constructions had been produced over the ages, the fifteenth century saw the development of a new art form: full armor of articulated steel plates that resisted piercing wounds and offered a wide scope for decorative elaboration. The closely fitted, smooth metal plates encased the body in a solid protective membrane, whose glancing surfaces deflected blows of lances and swords. Hard, but malleable, steel plates also lent themselves to a multitude of elegant forms. Meticulous engineering of plate armor ensured the most advantageous combination of defense, flexibility, and refinement.

A fifteenth-century miniature depicting a knight arming for combat conveys the intricacy of military attire (fig. IV-5). The knight has already put on the plates for the legs. His servant now laces his padded arming doublet. Helmet, breastplate, and other pieces await their turn on a trestle table. Because of the suffocating layers of clothing and armor required for adequate protection, and because of the vigorous exercise involved, a contemporary chronicler, Antoine de La Sale, recommended that tournaments take place only in cold weather. War, however, left less choice about when to fight. Early and rigorous training prepared Renaissance men to maneuver with grace and skill in such massive hardware. And although a full metal suit weighed at least 23–28 kg (50–60 lbs.) and was worn over thickly padded undergarments, a well-made, custom-tailored harness efficiently distributed this weight and bulk throughout the body.

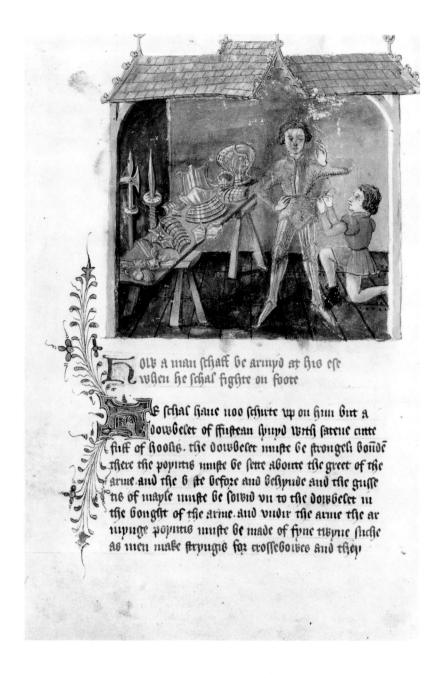

Fig. IV-5.
How a man schall be armyd at his ese when he schal fighte on foote. The man is putting on protective padded clothing, which goes under the metal armor. Ca. 1450. New York, The Pierpont Morgan Library, MS. M. 775, fol. 122v.

Hoꝛ a man schaꝇ be armyd aꞇ his ese
when he schaꝇ fighꞇe on fooꞇe

He schaꝇ haue noo schurꞇe vp on him buꞇ a
dowbeleꞇ of ffusꞇean lynyd wꞇꞇh saꞇeue cuꞇꞇe
fuꝉꝉ of hooꝉis. the dowbeleꞇ musꞇe be sꞇꞇongeꝉi bonde
there the poynꞇꞇs musꞇe be seꞇꞇe abouꞇe the gꝛeeꞇ of the
arme and the b sꞇe befoꝛe and besꞁyude and the guss
ns of mayꝉe musꞇe be soꝛw̓d vn ꞇo the dowbeleꞇ in
the bougꞁꞇ of the arme and vnder the arme the ar
mynge poynꞇꞇs musꞇe be made of fyne ꞇwyne suche
as men maꝛe sꞇꝛyngis foꝛ cꝛosseboꝛbes and they

The structural integrity of steel suits ensured the preservation of the wearer's body. Decorative elaboration of armor safeguarded his dignity and honor. As in the case of other luxury arts, high-end armor distinguished its owner as a man of superior rank.

The most practical decoration for plate armor was engraving: Being flush with the surface, it did not catch weapon points, yet permitted extensive ornamentation. The engraved suit of Henry VIII, for example, is covered with finely incised scenes from the lives of Saints George and Barbara and the royal badges of the rose, pomegranate, and portcullis (figs. IV-6 and 7). Originally the whole suit was also washed in silver, which added splendor without sacrificing utility, for the harness was first and foremost a superb piece of engineering, offering full defense in combat.[4]

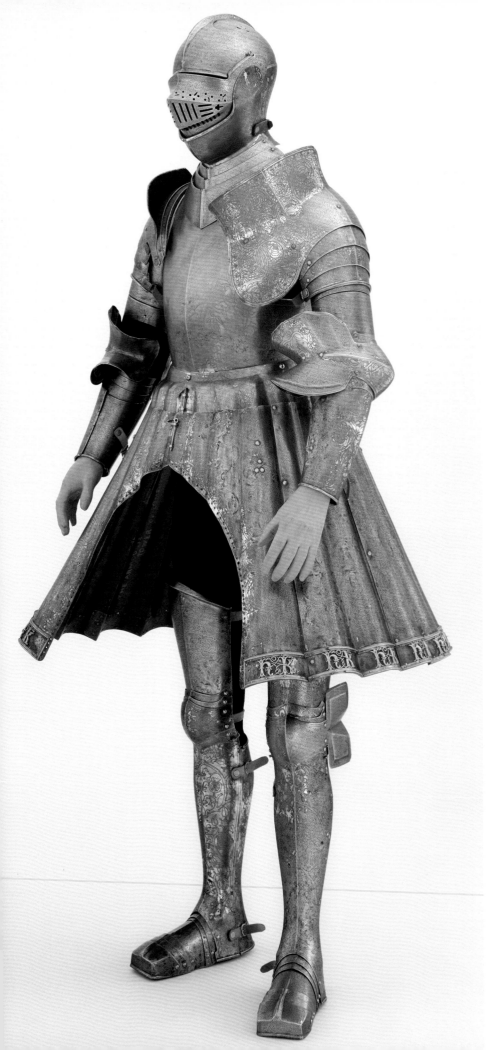

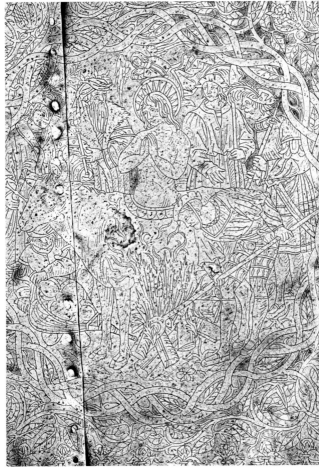

Fig. IV-6.
Silvered and engraved
armor of Henry VIII,
Greenwich, ca. 1514. WT.
30.12 kg (66 lbs. 6 oz.).
Leeds, Royal Armouries,
inv. II.5. © The Board of
Trustees of the Armouries.

Fig. IV-7.
Detail of engraving of
Saint George on a bull over
a log fire, from the shaffron
of a horse armor by MARTIN
VAN ROYNE, presented to
Henry VIII by Maximilian I,
probably Flemish, ca. 1510.
Leeds, Royal Armouries,
inv. VI.1. © The Board of
Trustees of the Armouries.

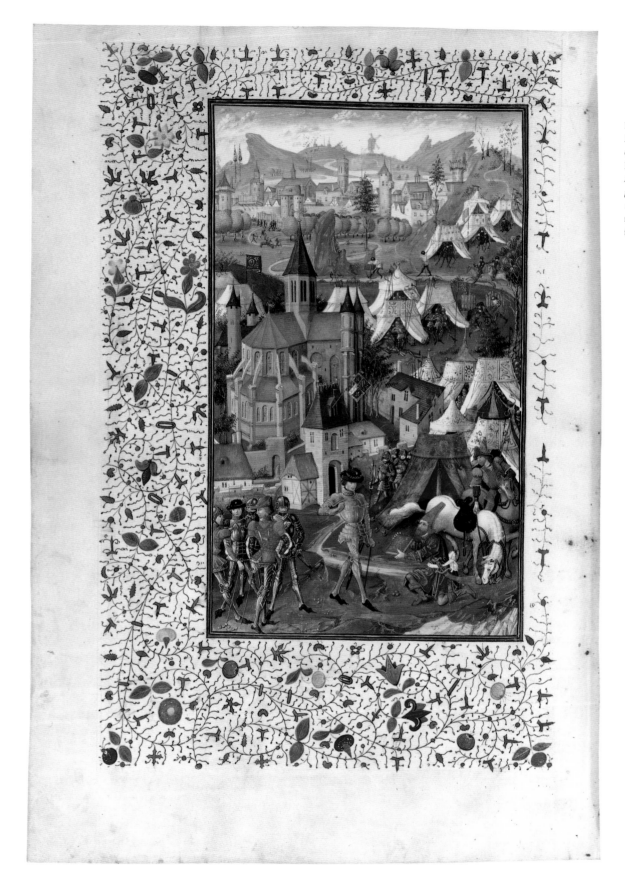

Fig. IV-8.
Philip the Good at the Siege of Mussy l'Évêque. From Bertrandon de la Broquère, *Advis directif pour faire le passage d'Outremer*, Lille, 1455. Paris, Bibliothèque nationale de France, MS. fr. 9087, fol. 152v.

While smoothly polished or finely engraved suits were most effective in battle, harnesses elaborately adorned with gems or sculptural reliefs served as powerful weapons for warfare of another kind. Rulers deployed magnificent dress as much to impress as to intimidate and threaten one another. The Burgundian dukes, for instance, regularly marched into war wearing suits bedecked with designs of gold and precious gems. A depiction of *Philip the Good at the Seige of Mussy l'Évêque* communicates something of this assertion of supremacy through opulence (fig. IV-8). (The miniature illustrates a book entitled *Advis directif pour faire le passage d'Outremer* [Advice on traveling in the East], composed by Bertrandon de la Broquère, a Burgundian spy sent to collect intelligence in the Holy Land in preparation for a Burgundian-led crusade.) In a busy landscape of troops, tents, and a besieged city, the duke stands out at once in his golden harness and black hat embellished with a thick gold chain and a gold brooch set with a massive pearl. Contemporary inventories and witnesses confirm that rubies, diamonds, and pearls covered some ducal armor from helmet to greaves.[5] Describing the departure of Philip the Good on an expedition against Luxemburg in 1443, Olivier de la Marche observed that alongside the splendidly dressed duke, his courtiers, too, wore armor embellished with gems, their display augmenting the might of their leader.[6] Among the booty captured by the Swiss from Charles the Bold at the Battle of Granson in 1476 was a sword set with seven big diamonds, as many rubies, and fifteen large pearls.[7] In 1513 Henry VIII paid his goldsmith Robert Amadas £462.4s.2d to decorate a headpiece with gold and precious stones.[8] And when Lorenzo de' Medici wore armor studded with jewels to the tournament he staged in Florence on 7 February 1469—to celebrate a recently signed peace with Venice, mark his ascent to power, and honor his betrothal to Clarice Orsini—spectators were awed, not only by the fabulous richness of his costume, but also by the seemingly careless loss of its jewels in the heat of the joust.[9] Lorenzo's pennant, designed by Andrea del Verrocchio, moreover, bore the words, spelled out in pearls, *Le temps revient* (The time returns)—an allusion to the returning golden age; and his prize for winning the competition was a helmet inlaid with silver and surmounted by the figure of Mars. As Niccolò Machiavelli remarked in his *History of Florence* (1525), "During times of peace he [Lorenzo] entertained the city with festivals, at which were displayed jousts and representations of ancient deeds and triumphs. It was throughout his aim to make the city prosperous, the people united, the nobility honored."[10] A scion of merchants and bankers, Lorenzo was particularly keen to assert his princely status, which he did by lavish patronage of luxury arts.

Bartolomé Bermejo's *Saint Michael Fighting the Devil* gives an idea of the appearance of fifteenth-century jeweled plate armor, wholly appropriate to a warrior saint (fig. IV-9). Saint Michael's gold breastplate is polished to such a high finish that it reflects the spired Heavenly Jerusalem as in a mirror. Gems and pearls accent the edges of the breastplate, sleeves, sabatons (shoes), and rivets at elbows and knees. The center of the shield is carved of rock crystal; a ruby and four pearls articulate its summit. Even the vanquished monster at Saint Michael's feet wears ornate armor with snakelike sleeves and glowing buttons on the breastplate that echo its gleaming eyes. The kneeling donor at the saint's feet is Antonio Juan, Lord of Tous. His heavy chain and sword indicate that he himself was a knight.

The Ottoman sultan Süleyman I received the sobriquet "the Magnificent" because of his opulent displays of power seen, among other ways, in his use of luxury armor and other regalia as weapons in the war against his European foes. Ironically, the Europeans themselves provided this ammunition to the Turk. In 1532 a group of Venetian goldsmiths fashioned a gold helmet to sell to the sultan. So outstanding was this object that before it was sent east, it was displayed for three days in the Doge's Palace, and engravings perpetuated its fame (fig. IV-10). The Venetian diarist Marino Sanuto, awe-struck, left a verbal description written on 13 March 1532:

> This morning, I Marino Sanuto, saw on the Rialto something the memory of which ought to be preserved. The [goldsmiths] Caorlini have produced a very beautiful helmet of gold, full of jewels and consisting of four crowns, on which are jewels of very great value, and an aigrette of gold of excellent workmanship, to which are fixed four rubies, four large and very beautiful diamonds worth 10,000 ducats, large pearls each of twelve carats, a long and very beautiful emerald . . . , a large and very beautiful turquoise, all of which are costly jewels. . . . I have been told that this helmet has been made in order to be sold to the Sultan for over 100,000 ducats.[11]

In another part of his *Diary* Sanuto enumerated all the jewels that adorned the helmet and tallied up their value at 144,400 *ducats*. The headpiece was a product of collaboration between Venetian merchants and goldsmiths; the sultan's chief treasurer, Defterdar Iskander Çelebi; and the grand vizier Ibrahim Pasha. All stood to benefit from the transaction. Venetian trade in the East depended on favorable relations with the Ottomans. The Ottomans found the Venetians, with their far-flung commercial empire, useful partners as well. The helmet formed part of the ongoing political and economic exchange between the two states and was one of many European luxuries proffered to the sultan and his court. As we have seen above, German automata featured prominently in the Habsburgs' tribute to the Ottomans. The year the Venetians manufactured the helmet, they also sold Süleyman a gold throne studded with jewels and pearls, the value of which was estimated at forty thousand *ducats*. And Sanuto reported that "this helmet will be sent together with a jewel-studded saddle and saddle cloth ordered by another partnership. These, too, are estimated to be worth 100,000 ducats."[12] A scepter of precious materials completed this set, and the entire ensemble was commemorated in contemporary and later prints.

Ottoman rulers certainly rode on opulent saddles, but scepters and crowns were foreign to their sovereign displays. Their use was actually aimed back at the Europeans: While the helmet astonished the Westerners, it was ignored in Ottoman historical texts and miniatures depicting the sultan.[13] The shape of the helmet—a quadruple crown—and the way Süleyman put it to use conducted a dialogue with the headgear of his adversaries, Pope Clement VII and Emperor Charles V. The papal tiara traditionally assumed the form of a triple crown. By adding the fourth tier, the sultan proclaimed his superiority over the head of Christendom, and by including the Venetian helmet in his triumphal procession through Europe, Süleyman declared himself, rather than Charles V, a new Caesar. In a procession following his coronation as Holy Roman Emperor in 1529, Charles's pages had solemnly carried the emperor's helmets that associated him with Caesar and articulated his imperial claims; and Charles himself rode in full armor with a gold eagle on his helmet, a scepter in his hand, his horse clad in a

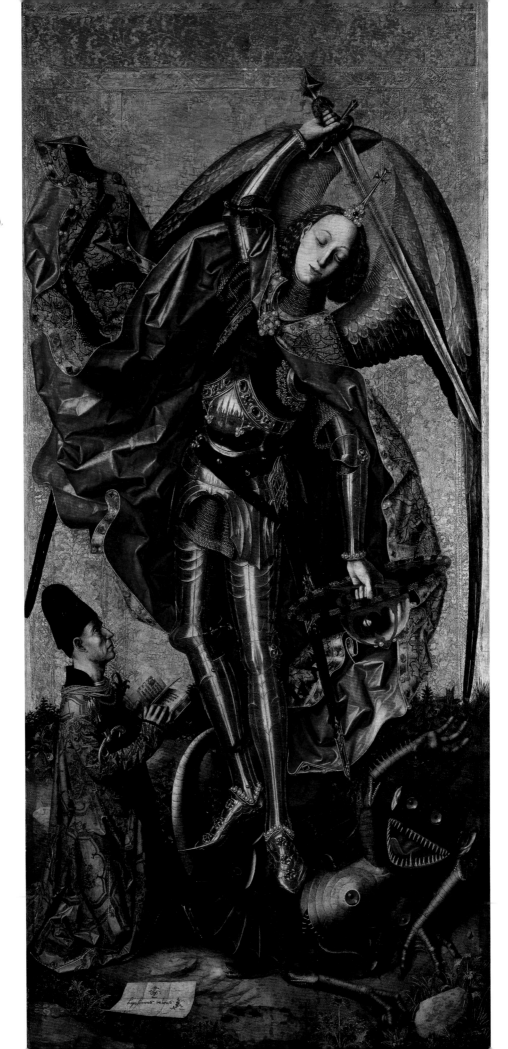

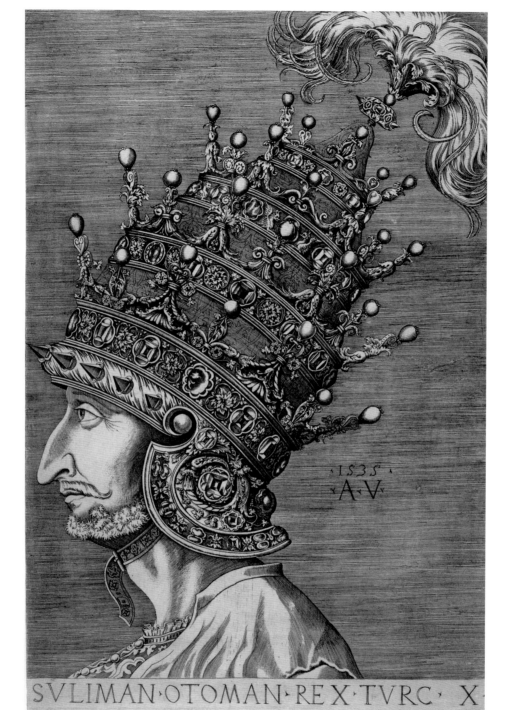

Fig. IV-10.
AGOSTINO VENEZIANO
(Italian), *Portrait of
Süleyman I in a Venetian
crown with four tiers of
goldwork and pearls*, 1535.
Engraving, 43.4 × 29.5 cm
(17⅛ × 11⅝ in.). London,
The British Museum,
1859,0806.307.

SVLIMAN·OTOMAN·REX·TVRC· X

gem-studded cape of gold cloth.[14] As Süleyman marched on Vienna in 1532, he aimed
to present his enemies with a similar, but superior spectacle.

The sultan's advance dazzled and stupefied the Europeans. During his entry
into Belgrade, his standard-bearers carried flags with Ottoman crescents and the name
of the prophet Mohammed embroidered in pearls and gems. One hundred select royal

pages rode forth holding damascened lances. Twelve of the sultan's favorite pages displayed his helmets shimmering with jewels and pearls, including the Venetian headpiece. Süleyman himself wore a large turban and a caftan of purple gold brocade lined with fur and embroidered with jewels. The gold chain around his neck was so massive that two attendants had to support it to relieve its weight. The sultan's horse was dressed in a chamfron (head plate) adorned with a turquoise as large as an egg and encircled with gems valued at fifty thousand *ducats*. The saddle was estimated by the onlookers to be worth seventy thousand *ducats*. The contemporary Ottoman historian Celalzade congratulated the grand vizier Ibrahim Pasha on the skillful choreography of Süleyman's progress and the exhibition of his might to the whole world. The Venetian Pietro Zen commented that the sultan's purchase of the stupendously costly helmet was "an excellent and notable payment at a time like this."[15] The Habsburg ambassadors were turned into "speechless corpses."[16]

The Venetian helmet served to announce Süleyman's aspiration to surpass both the pope and the emperor and articulated his desire to revive the Roman Empire with both Constantinople and Rome under his rule. The distinctly Western appearance of the helmet shrewdly presented these ambitions and threats in a visual language most accessible to the sultan's European foes. Domestically, he had no use for this artifact. Once the helmet had fulfilled its function, he stripped the precious tiers of gold and gems and sent the denuded but still exquisite object back to the Europeans. Around 1550 the German artist Hans Mielich drew it as part of the illustrated inventory of the treasures of Duchess Anna of Austria and her husband, Duke Albrecht v of Bavaria.

CHIVALRIC DISPLAYS

An outgrowth of the culture of war, tournaments provided another vital arena for the display of military prowess, personal excellence, and premium armor. In his *Book of the Courtier* (1528) the Italian diplomat and courtier Baldesar Castiglione proclaimed: "I judge the principal and true profession of a courtier ought to be in feats of arms." The courtier's show of martial abilities was a complement to those of his master. Extolling the accomplishment of Guidobaldo da Montefeltro (1472–1508), Duke of Urbino, Castiglione wrote that while his lord was incapacitated by gout and

> could not engage personally in chivalric activities as he had once done, he still took the greatest pleasure in seeing others so engaged. . . . Wherefore, in jousts and tournaments, in riding, in the handling of every sort of weapon, as well as in revelries, in games, in musical performances, in short, in all exercises befitting noble cavaliers, everyone strove to show himself such as to deserve to be thought worthy of his noble company.[17]

Tournaments served as an expression of nobility and an assertion of class consciousness—at most European courts, those of non-noble birth were not permitted to participate. Notable diplomatic events—be it a reception of foreign dignitaries or marriage negotiations, weddings or births of royal children—occasioned these ritualized competitions in skill and pomp. Contemporary witnesses described in minute detail the martial feats and opulent costumes of knights, and champions commemorated their victories in lavishly illustrated volumes.

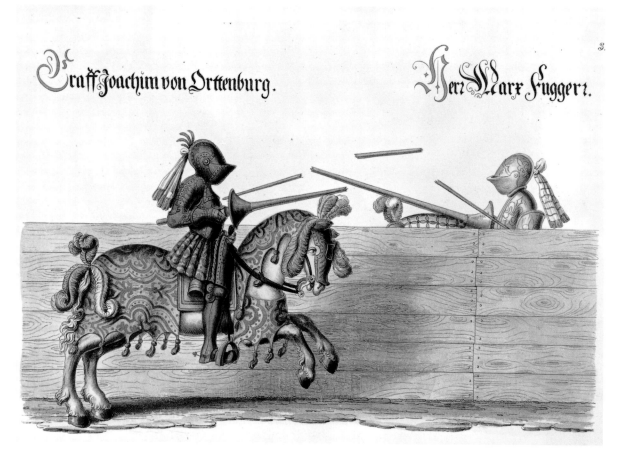

Graff Joachim von Orttenburg.

Herr Marx Fugger.

Fig. IV-11.
"Italian Joust" fought at a
German wedding tourna-
ment. From Hans Burgkmair
the Younger, *Tournament
Book of 1529*. Stockholm,
The Royal Library, National
Library of Sweden.

Chivalric contests took diverse forms, and each sport required distinct armor that best shielded the contestant in a given event. In a joust two mounted challengers, separated by a barrier, rode at full speed against each other with the aim of unseating the opponent and/or breaking a lance against his upper body. Hans Burgkmair the Younger portrayed a joust performed during the wedding in Augsburg in 1553 of Count Jakob von Montfort and Katarina Fugger, daughter of an immensely wealthy banker (fig. IV-11). The participants wear field armor reinforced on the left side—where the lance would strike—and frog-mouthed helmets that fully protect the head, leaving just the thinnest opening at eye level. The high and narrow eye slit of such helmets made it necessary for the wearer to lean forward as he rode forth. Just prior to the impact he straightened up and actually struck blindly. Removing the helmet or its visor was a risky move. Federigo da Montefeltro (Guidobaldo's father) lost the bridge of his nose and right eye and acquired his singular profile when, during a tournament held in the winter of 1450 to commemorate Francesco Sforza's ascent as ruler of Milan, he unwisely exposed his face.

Maximilian I Habsburg, one of the keenest Renaissance proponents of chivalry and patrons of armor (see fig. 4), became passionate about jousts at an early age. The story of his life and reign titled *Weisskunig* (The white [upright] king) contains an image of Maximilian as a boy enacting a contest between two toy horsemen (fig. IV-12). A surviving pair of bronze toy jousting knights helps to bring these childhood games to life

(fig. IV-13). In an autobiographical novel entitled *Freydal* (The fair and courteous youth) Maximilian recounts his participation in sixty-four tournaments. The richly illustrated narrative includes a picture of a joust in which Maximilian unseats Count Jörg von Montfort (fig. IV-14). Both knights wear trick breastplates that explode into the air when hit at the center. This German invention added further drama to the fast-paced encounter between charging knights.

Another form of chivalrous combat that Maximilian practiced with ardor and expertise was foot tourney, or a duel between two contestants fought on foot over a barrier or in an enclosed arena. Champions wielded rebated swords, spears, axes, or war hammers and delivered a prescribed number of blows. Maximilian's *Freydal* depicts the emperor engaging Claude Vaudrey with war hammer and shield (fig. IV-15). Both contestants wear head-to-foot armor, which features a tonlet, or metal skirt, fashionable in the first half of the sixteenth century. A surviving suit of tonlet armor of Emperor Charles V is decorated with a delightful frieze of hunting dogs pursuing a bear, a stag,

Fig. IV-12.
Maximilian I Habsburg as a child (on the right side of the table) playing jousts. Woodcut. From Hans Burgkmair the Elder (German, 1473–ca. 1531), *Weisskunig*, ca. 1512 (facsimile, Stuttgart, 1956), pl. 15.

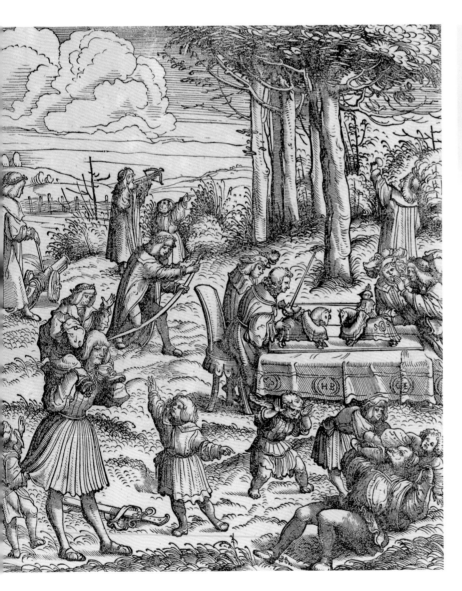

Fig. IV-13.
Toy jousting knights, ca. 1500. Bronze. Vienna, Kunsthistorisches Museum, Kunstkammer, inv. P 81 and P 92.

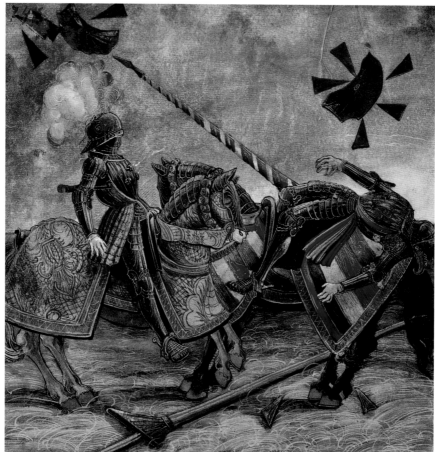

Fig. IV-14.
Maximilian I Habsburg
unseats Count Jörg von
Montfort. From *Freydal*,
1512–1515, fol. 248. Vienna,
Kunsthistorisches Museum,
Kunstkammer, inv. P 5073.

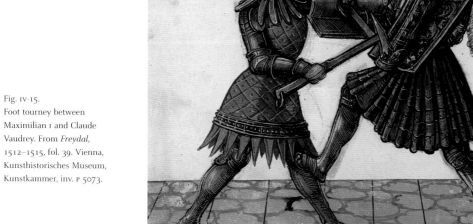

Fig. IV-15.
Foot tourney between
Maximilian I and Claude
Vaudrey. From *Freydal*,
1512–1515, fol. 39. Vienna,
Kunsthistorisches Museum,
Kunstkammer, inv. P 5073.

and a boar (fig. IV-16). In *Freydal* Maximilian's harness is adorned with gold and silver stripes, and his helmet ends in a crown-shaped crest and a great spray of ostrich feathers. Plumes of exotic birds were expensive and luxurious. On civilian headpieces they were frequently enhanced with settings of gems and pearls. A conical holder at the back of the helmet secured these ornaments.

While jousts and foot tourneys constituted a kind of martial dance for two, tourneys or mêlées brought teams of mounted knights into confrontation in an open arena. Many tournaments lasted for several days, each day devoted to a different competition. Mêlées typically took place on the final day. Lucas Cranach the Elder's woodcut captures the heady excitement and confusion of such mock battles (fig. IV-17). In this event participants wore full field armor with numerous articulated steel lames (narrow strips of steel riveted together horizontally) that permitted maximum movement of arms and knees. They fought with lances, clubs, or swords secured in special locking gauntlets that kept the weapon attached as the knight gave and received rapidly falling blows.

Fig. IV-16.
Attributed to KOLMAN HELMSCHMID (Augsburg, 1471–1532), Tonlet armor of Charles V, Augsburg, ca. 1525–1530. Madrid, Real Armería, inv. A 93. © Patrimonio Nacional.

Fig. IV-17.
LUCAS CRANACH THE ELDER (German, 1472–1553), *A tournament* (*mêlée*), 1509. Woodcut, 29 × 41.3 cm (11⅜ × 16¼ in.). Stockholm, Nationalmuseum, inv. B 315/1981.

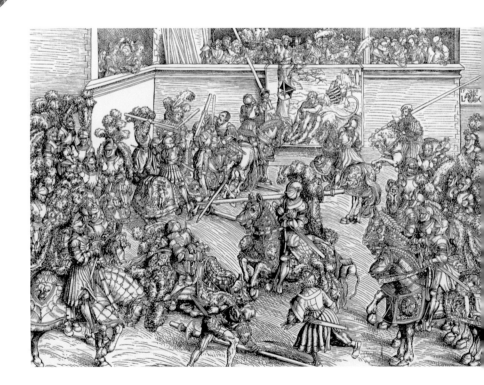

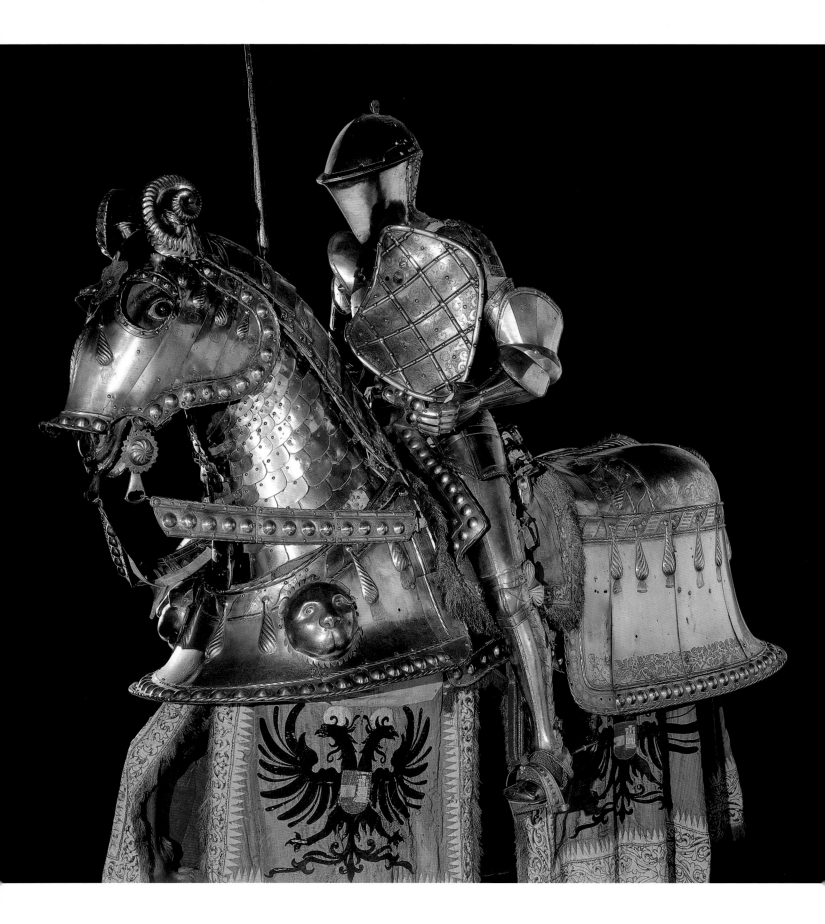

Until the middle of the fifteenth century battlefield armor augmented with specialized pieces sufficed to protect the wearer in any number of chivalric combats. But as contests became more differentiated by the first half of the sixteenth century, distinct armor evolved for each course, and horses, too, were dressed in either full steel plates or heavily padded caparisons. The jousting armor of Charles V exemplifies an ensemble for rider and mount (fig. IV-18). The emperor's armor is asymmetrical, its left side—the one facing the opponent—being more heavily protected. A targe (light shield) attached to the breastplate is etched with the Burgundian devices of flint and firesteel set in a quilt-like grid; other plates are outlined with etched ornamental bands. The frog-mouthed helmet weighing nearly 9 kg (20 lbs.) offers a solid barrier against blows to the head. Its front is smooth, but the back is decorated with embossed and etched monsters breathing fire. The horse's bard (armor), which weighs 44 kg (97 lbs.), includes a chamfron (head defense) with ram's horns, a crinet (neck guard) with dragonlike scales, and a peytral (breastplate) adorned with lion's heads. The crupper (rump cover) imitates draped cloth with tassels and is etched with scenes of Samson battling the Philistines and David fighting Goliath (figs. IV-19 a and b).

Fig. IV-18.
Attributed to KOLMAN HELMSCHMID (Augsburg, 1471–1532), Tournament armor of Charles V, Augsburg, ca. 1520. Madrid, Real Armería, inv. A 37. © Patrimonio Nacional.

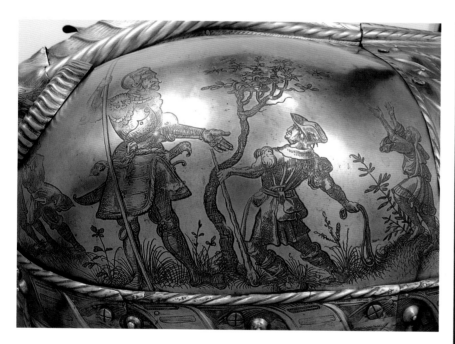

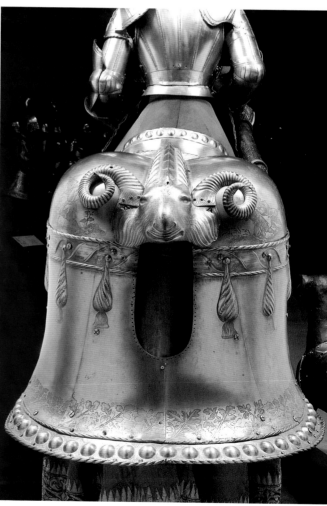

Figs. IV-19 a and b.
David fighting Goliath, etched detail on the right crupper of the tournament armor of Charles V; and the ram's head above the horse's tail, which echoes the horns on the chamfron (cf. fig. IV-18).

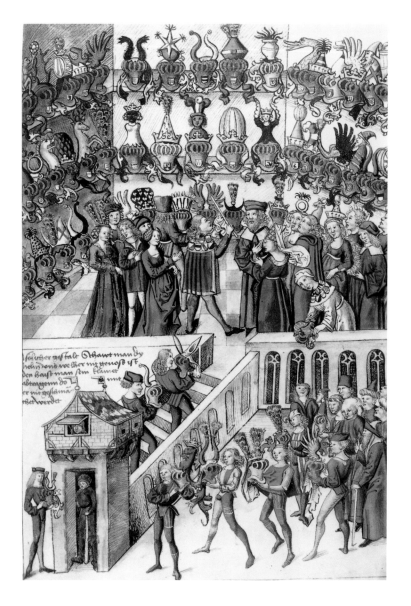

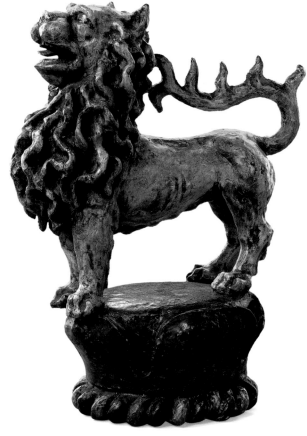

No matter how well made, royal harnesses did not always forestall serious injuries or deaths. King Henry II of France died in 1559 as the result of a jousting mishap. France had just signed a peace treaty with Spain, and to seal the accord Henry gave his daughter Elisabeth in marriage to Philip II Habsburg. At the same time the king married his sister to the duke of Savoy. The double wedding, held on 30 June, included a tournament in which Henry took active part. In his joust against the count of Montgomery, the king's helmet was struck by his opponent's lance. The blow caused the visor to flip up, and the lance splintered in Henry's eye. His death ten days later put a serious damper on further royal participation in chivalric combats.

Some tournament events, however, were more playful than bellicose. In the baston course, run like a joust, contestants aimed to batter off the crest decorating the adversary's helmet. Elaborate crests developed in the middle ages in order for knights to identify one another more readily in the confusion of battle. The *Wappenbuch* (Book of heraldry, 1483) of Conrad Grünenberg—the recognized authority on German her-

Fig. IV-20.
The exhibition of helmets before the tournament. From Conrad Grünenberg, *Wappenbuch*, Munich, 1483, p. 233. Munich, Bayerische Staatsbibliothek.

Fig. IV-21.
Helmet crest, German, sixteenth century. Carved and polychromed wood, H. 21.6 cm (8½ in.). Dresden, Historisches Museum, Staatliche Kunstsammlungen, inv. N 160. Photographer: Jürgen Karpinski.

aldry—portrays the judgment of crests that habitually took place on the eve of tournaments, providing an opportunity to assess the merits of individual costumes and to expel champions found guilty of acts unworthy of a knight (fig. IV-20). In this illustration squires bearing their masters' helmets enter a cloister on the ground level, proceed to a guarded gate, and request permission to enter. They mount the stairs and emerge into a hall whose walls are lined with helmets bearing the most varied crests. In the center the king-of-arms, surrounded by the ladies, judges each blazon.[18]

Most crests were fashioned of perishable materials. A sixteenth-century wooden German crest in the form of a lion confidently posed atop a blue hat captures the arrogance and pomp of Renaissance tournaments (fig. IV-21). A mid-fifteenth-century iron helmet with a wooden troubadour crest once graced the coffin of a knight of the Teutonic Order (fig. IV-22). In death, as in life, a blazon identified and ennobled the knight.

Cennino Cennini vividly describes the manufacture of a crest from leather. His instructions, spelled out in his *Libro dell'Arte* (ca. 1390; trans. as *The Craftsman's Handbook*), are as follows:

Whenever you have occasion to make a crest or helmet for a tourney, or for rulers who have to march in state, you must first get some white leather which is not dressed except with myrtle or *ciefalonia* [this material cannot be identified]; stretch it, and draw your crest the way you want it made. And draw two of them, and sew them together; but leave it open enough on one side so that you can put sand into it; and press it with a little stick until it is all quite full. When you have done this, put it in the sun for several days. When it is quite dry, take the sand out of it. Then take some of the regular size for gessoing, and size it two or three times. Then take some gesso grosso ground with size, and mix in some beaten tow, and get it stiff, like a batter; and put on this gesso, and rough it in, giving it any shape of man, or beast, or bird.... This done, take some gesso grosso ground with size, liquid and flowing, on a brush, and you lay it three or four times over the crest with a brush. Then, when it is quite dry, scrape it and smooth it down, just as you do when you work on a panel. Then, in the same way, as I showed you how to gesso with gesso sottile on panel, in that same way gesso this crest. When it is dry, scrape it and smooth it down; and then if it is necessary to make the eyes of glass, put them in with the gesso for modeling.... Then, if it is to be gold or silver, lay some bole [sticky red clay], just as on panel; and follow the same method in every detail, and the same for painting, varnishing it in the usual way.[19]

Fig. IV-22. Ceremonial helmet of a Teutonic knight, Central Germany, about 1450. Painted wood and sheet iron, H. 78 cm (30¾ in.). Vienna, Museum of the Teutonic Order, inv. P-032.

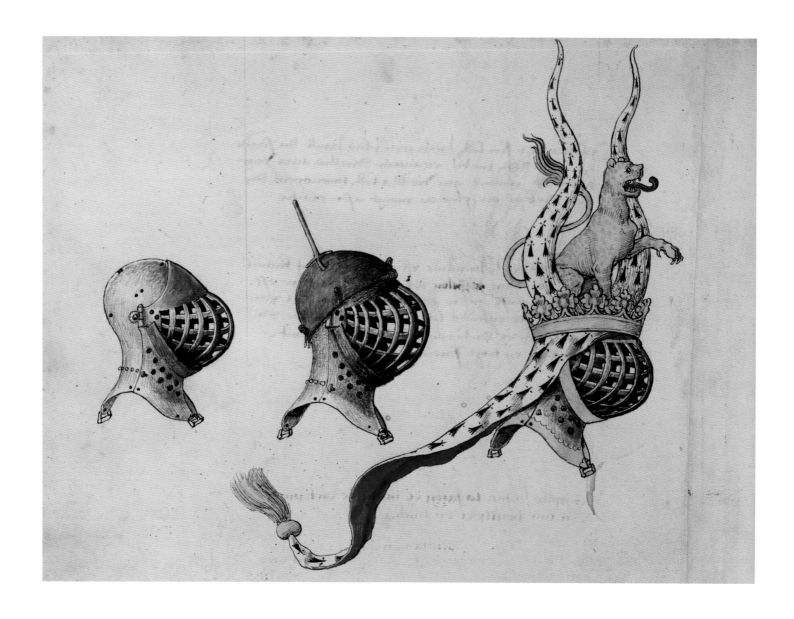

King René d'Anjou's *Book of Tourneys* (ca. 1460) illustrates how to fasten the crest on a baston-course helmet (fig. IV-23). It also demonstrates how to dress a horse in a padded caparison and how to construct lists with a barrier around the edge and stands for judges and ladies. The book, furthermore, elucidates the complex rules of engagement in various courses as well as the ceremonies surrounding tournaments. It emphasizes throughout the importance of splendid attire, impressive retinue, and richly appointed lodgings to the honor of the participating knight.

Fig. IV-23.
Helmet for a baston course.
From King René d'Anjou,
Book of Tourneys (*Le Livre
des Tournois du Roi René*),
ca. 1460. Paris, Bibliothèque
nationale de France, MS.
fr. 2695.

The political resonance of luxury armor made it a "uniform" for rulers on parade. Whether entering their own cities or those of their enemies or participating in splendid processions accompanying coronations or funerals, marriages or baptisms, rulers regularly donned armor fashioned especially for these displays. Much of this armor drew its inspiration from ancient history, mythology, and surviving artifacts and sought to present the wearer as a new Hercules, Alexander, or Caesar. In the Renaissance the deeds of Greek and Roman heroes and statesmen were filtered through the chivalric lens, and chivalric culture was viewed as part of the inheritance from antiquity. As Ghillebert de Lannoy, a counselor to Philip the Good and a member of the Order of the Golden Fleece, wrote in his *Enseignement Paternels* (Book of paternal advice, ca. 1440):

> Read Valerius Maximus, Tullius, Lucan, Orosius, Sallust, Justin and other *hystoriographes*, and you will find marvellous, honourable and innumerable examples of how our predecessors loved honour and the public weal, how they exposed themselves to death for the good of the land, and also of how they preserved their reputation with the discipline of *chevalerie*.[20]

Lannoy's text manifests the adaptation of ancient texts and concepts to contemporary ideals and the merging of the notions of ancient valor with values of chivalry.

Fig. IV-24. Parade sallet in the form of a lion's head, Italy, ca. 1460. Steel, bronze, gilded and partly silvered, semi-precious stones, H. 28.3 cm (11⅛ in.). New York, The Metropolitan Museum of Art, Harris Brisbane Dick Fund, 1923, inv. 23.141. © 1986 The Metropolitan Museum of Art.

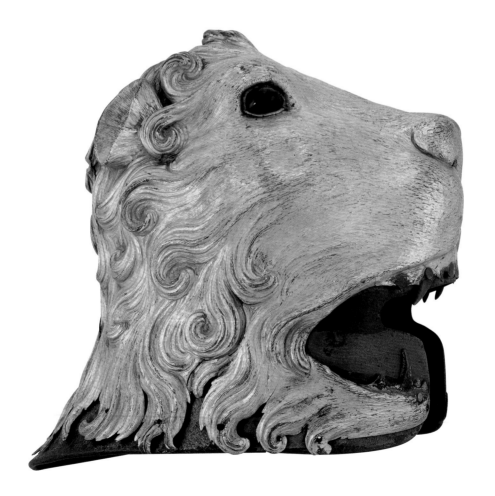

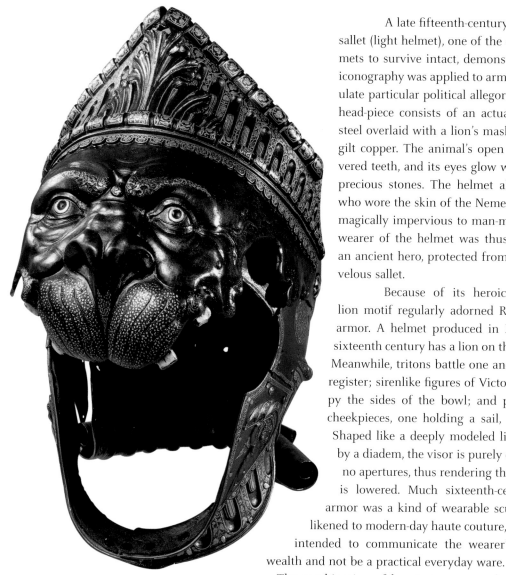

A late fifteenth-century Italian lion's-head sallet (light helmet), one of the earliest parade helmets to survive intact, demonstrates how ancient iconography was applied to armor in order to articulate particular political allegories (fig. IV-24). The head-piece consists of an actual battle helmet of steel overlaid with a lion's mask of embossed and gilt copper. The animal's open mouth reveals silvered teeth, and its eyes glow with polished semiprecious stones. The helmet alludes to Hercules who wore the skin of the Nemean lion, which was magically impervious to man-made weapons. The wearer of the helmet was thus transformed into an ancient hero, protected from harm by his marvelous sallet.

Because of its heroic associations, the lion motif regularly adorned Renaissance parade armor. A helmet produced in Milan in the mid-sixteenth century has a lion on the front (fig. IV-25). Meanwhile, tritons battle one another in the upper register; sirenlike figures of Victory and Fame occupy the sides of the bowl; and putti frolic on the cheekpieces, one holding a sail, another a trident. Shaped like a deeply modeled lion's face crowned by a diadem, the visor is purely decorative and has no apertures, thus rendering the wearer blind if it is lowered. Much sixteenth-century ceremonial armor was a kind of wearable sculpture. It may be likened to modern-day haute couture, which is similarly intended to communicate the wearer's exclusivity and wealth and not be a practical everyday ware.

The combination of heroic imagery and visual grace made Renaissance parade armor not only a necessary component of sovereign dignity but also a desirable collector's item. While the original owner of the Milanese lion helmet is unknown, by 1596 the helmet was in the Ambras collection of Ferdinand II of Tirol. It is even included in the archduke's engraved portrait in the *Imagines gentis Austriacae*, a monumental history of the Habsburg dynasty (see fig. IV-1).[21] Ferdinand appropriated the lion to his own needs: Associating himself with Hercules, he also holds the ancient hero's knotty club.

Fig. IV-25.
Lion helmet, Milan, mid-sixteenth century. Vienna, Kunsthistorisches Museum, Hofjagd- und Rüstkammer, inv. A 693.

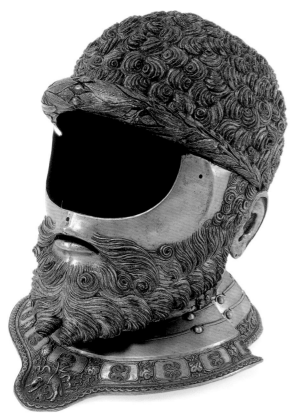

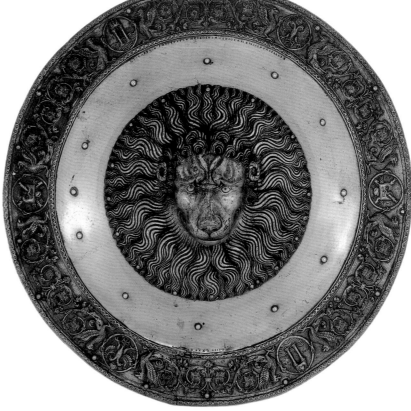

The armorer Filippo Negroli of Milan (ca. 1510–1579) contrived some of the most technically sophisticated and artistically beguiling parade harnesses of the Renaissance, his specialty being embossed armor—steel plates with sculptural reliefs. His brother Francesco (ca. 1522–1600) enhanced these suits with gold and silver inlays. Among the pieces the Negroli fashioned for Charles V is a helmet shaped like the emperor's own head with its golden locks and beard (fig. IV-26). The curly hair is encircled by a laurel wreath, turning the emperor into a Roman victor. An accompanying shield has a high-relief lion's head at its center and a border of vegetation scrolls with griffins flanking Charles's device of twin columns—the Pillars of Hercules (fig. IV-27). The iconography of this ensemble transformed the emperor into an ancient hero and flattered him with the virtues of strength, courage, and magnanimity.

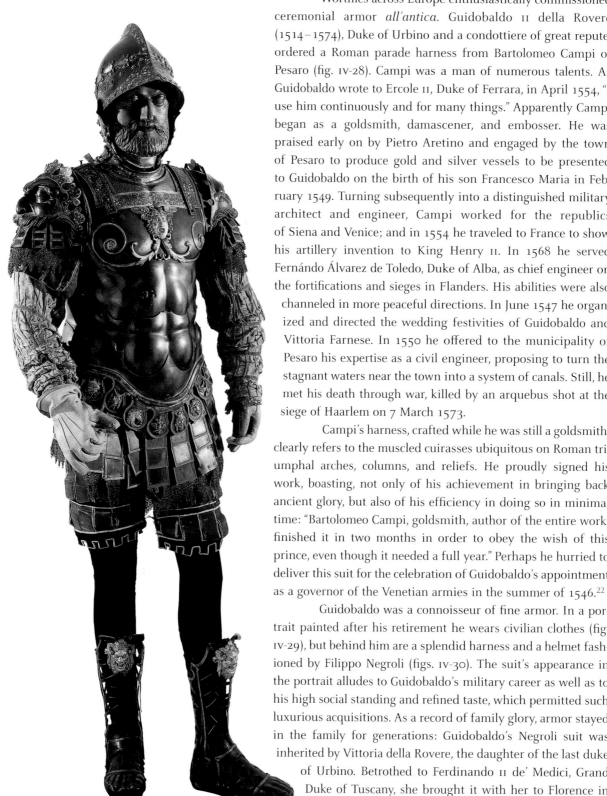

Worthies across Europe enthusiastically commissioned ceremonial armor *all'antica*. Guidobaldo II della Rovere (1514–1574), Duke of Urbino and a condottiere of great repute, ordered a Roman parade harness from Bartolomeo Campi of Pesaro (fig. IV-28). Campi was a man of numerous talents. As Guidobaldo wrote to Ercole II, Duke of Ferrara, in April 1554, "I use him continuously and for many things." Apparently Campi began as a goldsmith, damascener, and embosser. He was praised early on by Pietro Aretino and engaged by the town of Pesaro to produce gold and silver vessels to be presented to Guidobaldo on the birth of his son Francesco Maria in February 1549. Turning subsequently into a distinguished military architect and engineer, Campi worked for the republics of Siena and Venice; and in 1554 he traveled to France to show his artillery invention to King Henry II. In 1568 he served Fernándo Álvarez de Toledo, Duke of Alba, as chief engineer on the fortifications and sieges in Flanders. His abilities were also channeled in more peaceful directions. In June 1547 he organized and directed the wedding festivities of Guidobaldo and Vittoria Farnese. In 1550 he offered to the municipality of Pesaro his expertise as a civil engineer, proposing to turn the stagnant waters near the town into a system of canals. Still, he met his death through war, killed by an arquebus shot at the siege of Haarlem on 7 March 1573.

Campi's harness, crafted while he was still a goldsmith, clearly refers to the muscled cuirasses ubiquitous on Roman triumphal arches, columns, and reliefs. He proudly signed his work, boasting, not only of his achievement in bringing back ancient glory, but also of his efficiency in doing so in minimal time: "Bartolomeo Campi, goldsmith, author of the entire work, finished it in two months in order to obey the wish of this prince, even though it needed a full year." Perhaps he hurried to deliver this suit for the celebration of Guidobaldo's appointment as a governor of the Venetian armies in the summer of 1546.[22]

Guidobaldo was a connoisseur of fine armor. In a portrait painted after his retirement he wears civilian clothes (fig. IV-29), but behind him are a splendid harness and a helmet fashioned by Filippo Negroli (figs. IV-30). The suit's appearance in the portrait alludes to Guidobaldo's military career as well as to his high social standing and refined taste, which permitted such luxurious acquisitions. As a record of family glory, armor stayed in the family for generations: Guidobaldo's Negroli suit was inherited by Vittoria della Rovere, the daughter of the last duke of Urbino. Betrothed to Ferdinando II de' Medici, Grand Duke of Tuscany, she brought it with her to Florence in 1631, where it became a treasured possession of the Medici clan.[23]

Fig. IV-28.
BARTOLOMEO CAMPI OF PESARO (Italian, d. 1573), Roman-style parade armor of Guidobaldo II della Rovere, 1546. Steel, gold, silver, and brass, WT. 20.17 kg (44 lbs. 6 oz.). Madrid, Real Armería, inv. A 188. © Patrimonio Nacional.

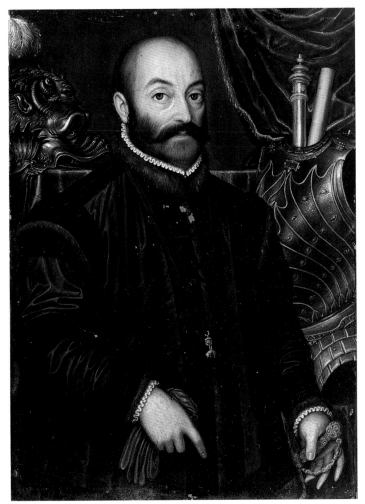

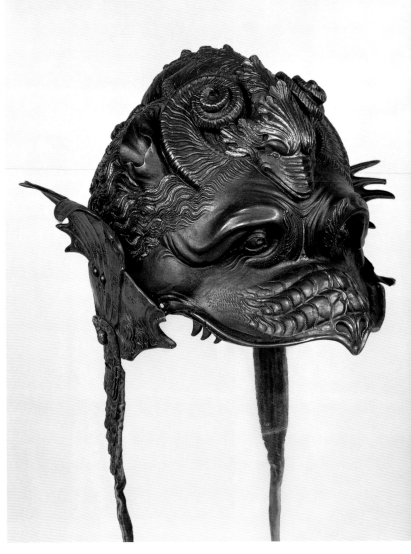

Bartolomeo Campi's muscled harness, meanwhile, passed into the Habsburg imperial collection in Madrid, a gift to Philip II who inherited his father's armor and his passion for this art. Many portraits of Philip II painstakingly reproduce his magnificent suits. In a likeness painted by Alonso Sánchez Coello (fig. IV-31), for example, he wears the parade harness made by the armorer Desiderius Helmschmid and embellished by the goldsmith Jörg Sigman, both of Augsburg (fig. IV-32).[24] The suit cost three thousand gold *escudos* (Titian was paid roughly one-twelfth this amount per imperial portrait he painted for Charles V). Given Philip's love of choice armor, a gift to him of Bartolomeo Campi's Roman suit was appropriate, indeed. Alas, the circumstances of its presentation are unknown, although some guesses may be made. The harness may have been offered to the Spanish king by Guidobaldo II or by his son Francesco Maria II in gratitude for

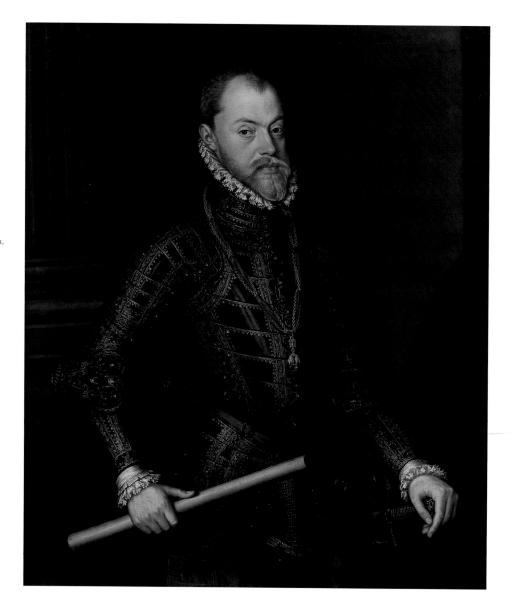

Fig. IV-31.
ALONSO SÁNCHEZ COELLO
(Spanish, 1531 or
1532–1588), *Portrait of
Philip II, King of Spain*,
ca. 1575. Oil on canvas,
109.5 × 92.4 cm (43⅛ ×
36⅜ in.). Glasgow Art
Gallery and Museum, The
Stirling-Maxwell Collection,
Pollok House, inv. PC 159.
© Glasgow City Council
(Museums).

being invested with the Order of the Golden Fleece, an honor Guidobaldo attained in
1561 and Francesco Maria in 1585. Alternatively, Francesco Maria may have bestowed
the suit upon Philip II while in training at the Spanish court. Scions of princely families
frequently sojourned at foreign courts, learning the intricacies of diplomacy, cementing
alliances between ruling families, and forming vital connections for the future.
Francesco Maria arrived in Madrid in 1565, at the age of sixteen, and stayed for three
years. At that time Philip was engaged in installing the Real Armería—the Royal
Armory, intended to glorify the memory of his father and make the imperial armor an
inalienable property of the crown (a privilege not extended to the rest of the effects,
including precious stones, jewels, and tapestries). Perhaps Francesco Maria and his
father offered Campi's splendid harness as their contribution to this newly arranged
collection.

CHAPTER IV

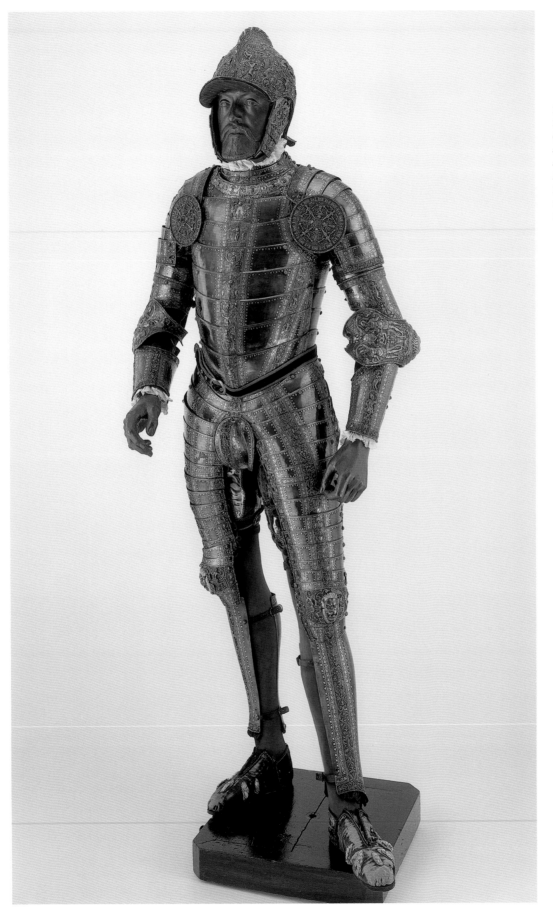

Fig. IV-32.
DESIDERIUS HELMSCHMID
(German, 1513–1578/1579)
and JÖRG SIGMAN, Parade
armor of Philip II,
Augsburg, 1549–1552.
Madrid, Real Armería,
inv. A 239·42. © Patrimonio
Nacional.

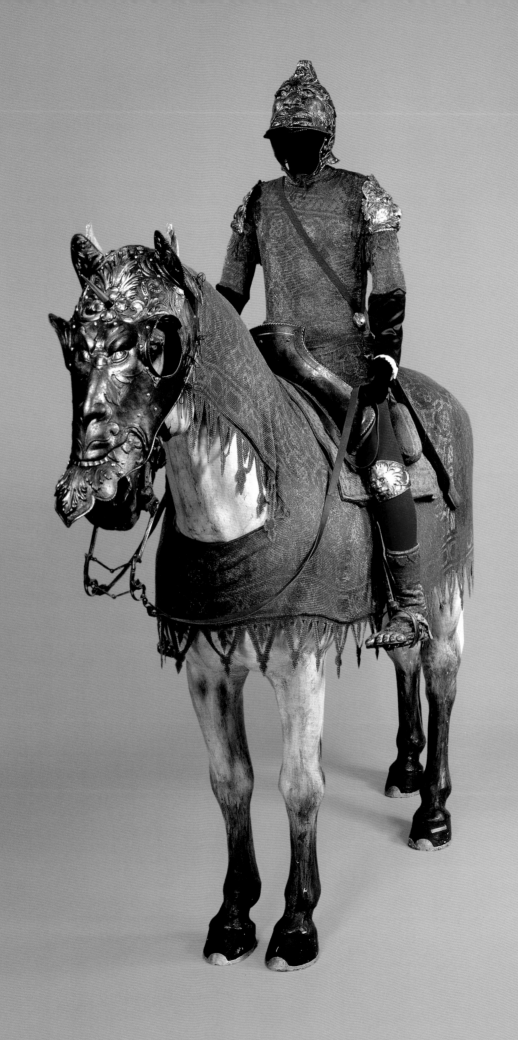

Fig. IV-33.
GIOVAN PAOLO NEGROLI
(Italian, 1513–1569), Chain-
mail armor for Archduke
Ferdinand II of Tirol and his
horse, 1545–1550. Vienna,
Kunsthistorisches Museum,
Hofjagd- und Rüstkammer,
inv. A 783 (armor), A 784
(bard).

Not only princes, but their horses, too, came to be dressed in richly wrought ceremonial suits. A well-bred and well-trained horse was itself a luxury. A weapon and a means of defense in military engagements, a horse was a sign of rank and wealth in parades. In the patterned Roman-style chain-mail armor for man and horse executed for Ferdinand II of Tirol by Giovan Paolo Negroli, Filippo's cousin, the animal is transformed into a monster by a half human, half leonine mask (fig. IV-33).[25] The grotesque face on the man's helmet echoes that of his mount, and lion heads stare from the shoulder- and knee guards. By the mid-sixteenth century, plate armor largely replaced chain mail for reasons of aesthetics and defense. Ferdinand may have desired a lightweight suit that evoked Roman armor in its tailoring and ornament, but without the bulk. The refined polychromatic effect of the set derives from the use of two kinds of tiny butted rings, measuring just three millimeters in diameter—gray iron and yellow brass. Butted, as opposed to riveted, rings and patterned mail design were unusual in Europe, but they were readily found in the Orient. Ferdinand's domains on the eastern edges of the Holy Roman Empire were of necessity exposed to Hungarian and Turkish influences. The archduke fought in campaigns against the Turks but was also fascinated by their culture. His armory, as mentioned above, devoted a room to Turkish armor, and participants in his tournaments often wore Oriental costumes. Ferdinand's parade suit bespeaks the complexity of cultural currents that inspired and informed Renaissance princely displays.

Antiquity furnished most of the decorative motifs on Renaissance parade armor, but occasionally current events appeared on it as well, albeit in heavily classicizing guise. A Milanese shield of ca. 1560 (fig. IV-34) contains an embossed and damascened scene of the surrender of Prince Elector Johann Friedrich of Saxony to Charles V Habsburg after the Battle of Mühlberg (1547)—a crucial episode of the emperor's reign. The battle marked the defeat of the Protestant German princes at the hands of the Catholic league headed by Charles. The depiction on the shield repeats one of twelve prints designed by Maerten van Heemskerck at the time of Charles's abdication in commemoration of the emperor's chief victories.[26] In the prints, and on the shield, history is recast in the noblest light.

The Spanish historian Luis de Ávila witnessed the battle and recorded the grim realities of the war as well as the appearance of its protagonists. The emperor fought in the gilt steel armor crossed by a sash of crimson taffeta that Titian depicted in his commemorative portrait (see fig. 5). On the shield, however, Charles sports a Roman-style cuirass with lion-headed pauldrons (shoulder pieces), and a crown atop his helmet. The vanquished prince elector battled in a great shirt of mail and a black cuirass, which Charles kept as a memento of his victory. In surrendering, moreover, the prince elector defiantly approached the emperor on horseback. On the shield, however, Johann Friedrich, shown as a jaunty youth attired in an elegant *all'antica* harness, compliantly approaches Charles on foot. The classicizing trappings make the scene more heroic and equate Charles with the great Roman generals. This association is re-enforced by images on the accompanying helmet that show Marcus Curtius leaping into the abyss and Horatius defending the Sublician Bridge.

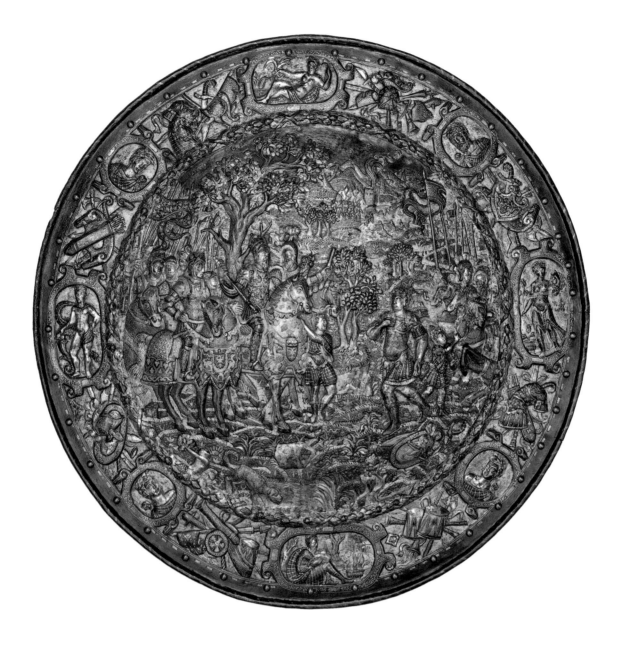

Ceremonial armor need not have served exclusively as a vehicle for weighty political allegories. It could be playful and funny as well. As tournaments often took place during Lent, they could merge with the masquerades enlivening that season and thus call for fantastic suits. A helmet with a fox visor, fashioned for Emperor Ferdinand I by the armorer Hans Seusenhofer and the etcher Leonard Meurl, turned the ruler into a cunning animal (fig. IV-35). And Henry VIII owned a whimsical helmet shaped like a bespectacled fool, his chin stubbly, eyes wrinkled, and ram's horns sprouting from his head (fig. IV-36). It is, alas, uncertain whether this headpiece was a gift of Maximilian I, whether it was intended to be worn by the king or his favorite jester, Will Sommers, or what particular joke it implied.[27]

Fig. IV-34.
Parade shield with the surrender of Prince Elector Johann Friedrich of Saxony to Charles V Habsburg after the Battle of Mühlberg, Milan, ca. 1565–1580. Steel, copper alloy, gold, silver, and textile, DIAM. 58.4 cm (23 in.). New York, The Metropolitan Museum of Art, Gift of Stephen V. Grancsay, 1942, inv. 42.50.5. © 2002 The Metropolitan Museum of Art. See also detail on p. 134.

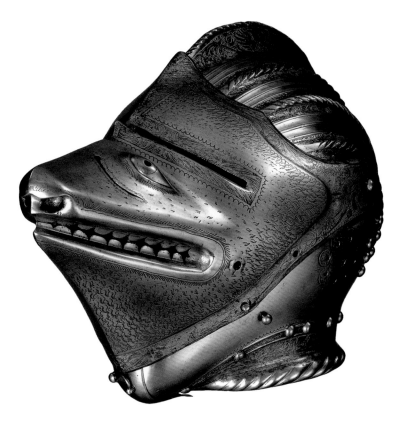

Fig. IV-35.
HANS SEUSENHOFER
(Austrian, 1470–1555) and
LEONARD MEURL, etcher
(d. 1547), Emperor
Ferdinand I's helmet with
a fox visor, Innsbruck,
1526–1529. Etched and
gilded steel. Vienna,
Kunsthistorisches Museum,
Hofjagd- und Rüstkammer,
inv. A 461.

Fig. IV-36.
KONRAD SEUSENHOFER
(d. 1517), Henry VIII's fool
helmet, Innsbruck, ca.
1512–1514. Steel, formerly
silvered, H. 33.5 cm
(13⅛ in.). W. 48.5 cm
(19⅛ in.). Leeds, Royal
Armouries, inv. IV.22.

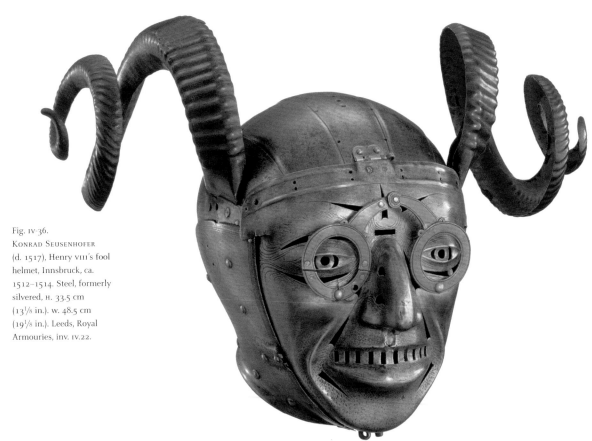

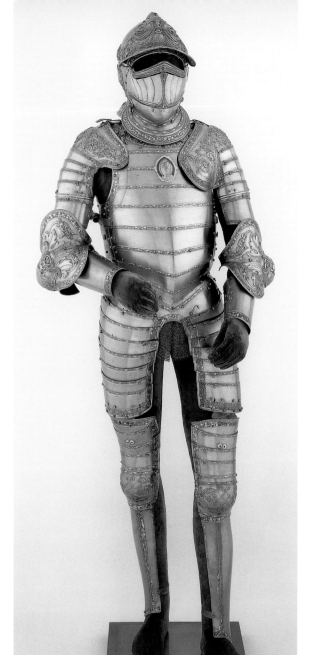

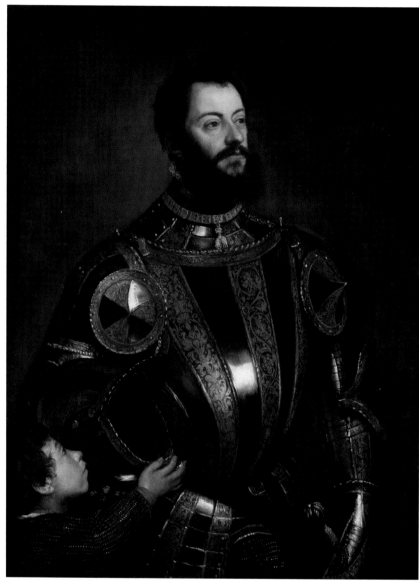

GARNITURES

The growing number of occasions requiring specialized armor prompted the development of garnitures, or harnesses with a number of interchangeable pieces that enabled owners easily to alter suits to fit the event, be it mounted or infantry combat, war, tournament, or parade. Each element of a garniture had its own purpose, but it harmonized structurally and aesthetically with the other components. The Masks Garniture of Charles v is the largest and best preserved of such Italian Renaissance ensembles, its name inspired by the grotesque masks that figure prominently in its decoration (fig. iv-37).[28] Produced by the Negroli brothers in 1539—Filippo did the embossing, Francesco the damascening, and their cousin Giovanni Battista probably the

Fig. iv-37.
Filippo and Francesco
Negroli (Italian,
ca. 1510–1579 and
ca. 1522–1600), Masks
Garniture of Charles v,
Milan, 1539. Steel, gold,
and silver. Madrid, Real
Armería, inv. a 139.
© Patrimonio Nacional.

hammering—the garniture cost the vast sum of 6,216 imperial *lire*. It may have been a gift from Alfonso d'Ávalos, Marchese del Vasto, himself a connoisseur of fine armor as is emphasized in his majestic portrait by Titian (fig. IV-38). This hero of the Battle of Pavia in 1525 and of the expedition to Tunis in 1535 became governor of Milan and captain general of the imperial army in Italy in February 1538. He had good reason to offer a lavish gift to his master.[29]

The Eagle Garniture ordered by Ferdinand I for his son Ferdinand II of Tirol was created in 1547 by Jörg Seusenhofer of Innsbruck and etched by Hans Perckhammer (fig. IV-39). The name of the ensemble derives from small gilded eagles—the heraldic emblem of old Austria—decorating it throughout. One of the largest garnitures on record, it consisted of eighty-seven parts that could be assembled into twelve different harnesses for use in diverse field battles and tournaments. The basic unit was the field armor for heavy cavalry. The foot-combat suit used the tonlet (metal skirt) and closed helmet. The jousting armor was given its asymmetrical appearance by the heavy left shoulder, arm, and elbow defenses, and by the lance rest on the right side. The garniture cost 1,258 *florins*, roughly twelve times the annual income of a high-ranking civil servant of the time. And this amount covered only the hammering and the etching. The gilding cost an additional 463 *florins*.[30] The immense expense of such sets made them affordable only to the wealthiest and most exalted men. The money spent on garnitures by Renaissance rulers has been likened to such modern-day luxuries as yachts and executive jets.

Fig. IV-38.
Titian (Italian, 1488 or 1490–1576), *Portrait of Alfonso d'Ávalos, Marchese del Vasto, in Armor with a Page*, Bologna, 1533. Oil on canvas, 109.9 × 80 cm (43¼ × 31½ in.). Los Angeles, The J. Paul Getty Museum, inv. 2003.486.

Fig. IV-39.
Jörg Seusenhofer (mentioned 1528–1580) and Hans Perckhammer (mentioned 1527–1557), Eagle Garniture of Ferdinand II of Tirol, 1547. Gilt steel and leather. Vienna, Kunsthisorisches Museum, Hofjagd- und Rüstkammer, inv. A 638.

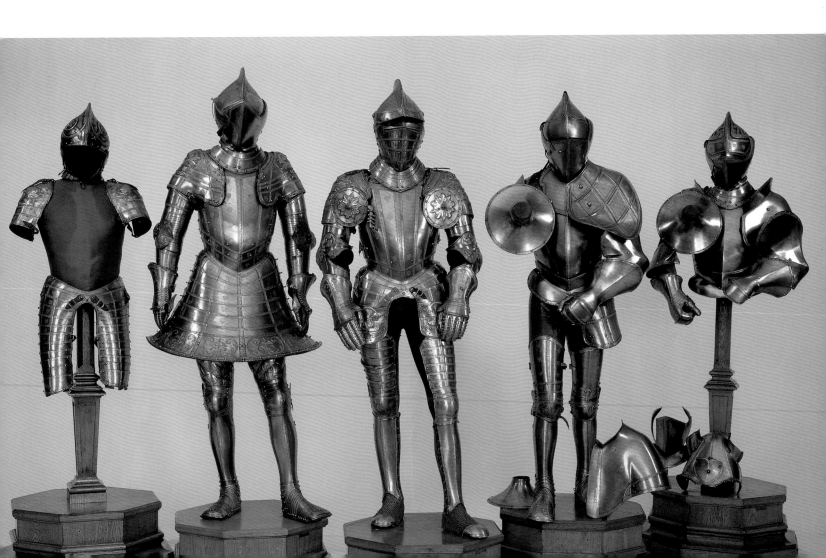

Run-of-the-mill harnesses were manufactured throughout Europe. But top-quality plate armor came from a handful of locales with access to key resources: nearby mines rich in iron ore, a steady supply of wood for charcoal, swift-flowing water for driving hammers and polishing mills, and proximity to international trade routes. The South German cities of Augsburg, Nuremberg, Passau, and Landshut, the Tirolese towns of Mühlau and Innsbruck, and Milan and Brescia in Northern Italy had these crucial assets and all developed into centers for production of the best armor of the day.

Milanese suits dominated the market for much of the fifteenth century. (A "Milliner" was originally a Milanese merchant who purveyed armor, weapons, and clothing.) The city's industry flourished already in the eleventh century, and by the fourteenth century it could supply on short notice both costly custom-tailored pieces for elites and cheaper ready-made harnesses for large armies. Business-savvy, the Milanese fitted their wares to the tastes of their foreign clientele and established branches abroad.[31] Close links between armorers and other metalworkers with whom they cooperated were reflected in the city's geography. The centrally located *Via Armorari* (street of the armorers) flowed into the *Via Spadari* (street of the swordmakers) and ran parallel to the *Via degli Orefici* (street of the goldsmiths).

Throughout the fifteenth century the Missaglia family of Milan enjoyed the greatest esteem for their craft. They served the Visconti and Sforza dukes of Milan, the Gonzaga of Mantua, the Este of Ferrara, the Medici of Florence, the kings of France, and assorted German princes. In 1464 Francesco Missaglia journeyed to the Burgundian court to measure Philip the Good for three suits of armor; Missaglia was also recommended to the king of England.[32] The Missaglia suit constructed for Friedrich I, Elector Palatine, demonstrates the high quality and elegance of their creations (fig. IV-40). The long, pointed toes of the steel shoes reflect current shoe fashions, which armor often followed. Missaglia shops located in Rome, Naples, Barcelona, and Tours speak of the family's skills as entrepreneurs.

The reputation of the Missaglia and their usefulness to the dukes of Milan are clear from the honors and privileges they received at home. Duke Filippo Maria Visconti knighted Tommaso Missaglia in 1435. Tommaso's son Antonio, who inherited the business, was made a count and granted numerous concessions by the Sforza, who succeeded the Visconti. Antonio owned several polishing mills, leased and then owned an iron mine, and exchanged his house on the Piazza Castello for a fief worth 15,200 *lire*, thus rising to the class of landed gentry.[33] The commercial success and resultant wealth of the Missaglia elevated their social standing. Their dwelling on the *Via Spadari* was an imposing, multi-story mansion whose facade and internal courtyard were frescoed with flowers, fruits, landscapes, and heraldic emblems of the Sforza and the Missaglia. The house formed a stopping point on the tour of the city given to visiting dignitaries.[34]

The Missaglia, however, lost their edge in the first quarter of the sixteenth century. They gradually sold off their mills, workshops, and even their house to a new clan of armorers—the Negroli, who began in the mid-fifteenth century as employees of the Missaglia. The Negroli achieved their greatest ascendance in the second quarter of the sixteenth century when Filippo and his brothers fabricated the most remarkable armor of the Renaissance. Their cousins, Gerolamo and Giovan Paolo, ran two other flourishing workshops, delivering large quantities of undecorated soldiers' armor as well as high-end suits.

Fig. IV-40.
Tommaso Missaglia (Italian, fifteenth century) and workshop, Armor of Friedrich I, Elector Palatine, Milan, ca. 1450–1455. Vienna, Kunsthistorisches Museum, Hofjagd- und Rüstkammer.

Fig. IV-41.
Lorenz Helmschmid (German, 1450/1455–1515), Armor of Maximilian I, Augsburg, ca. 1480. Vienna, Kunsthisorisches Museum, Hofjagd- und Rüstkammer.

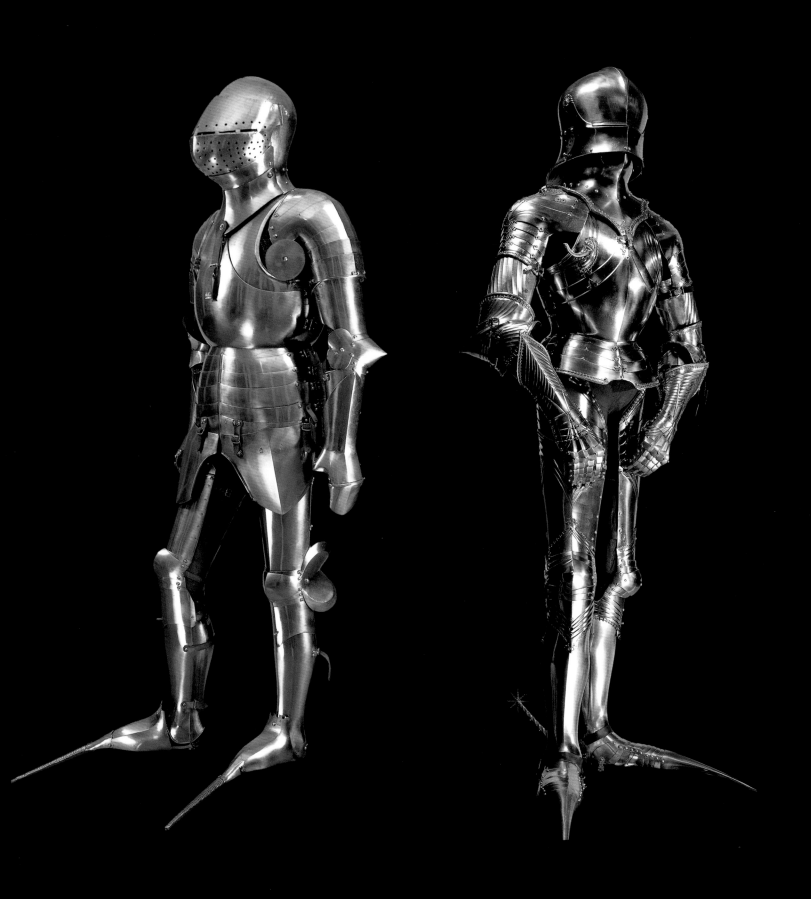

Fig. IV-42.
DESIDERIUS HELMSCHMIDT
(German, 1513–1578/1579)
and JÖRG SIGMAN, Shield
from the parade armor
of Philip II, Augsburg
1549–1552. Madrid,
Real Armería, inv. A 241.
© Patrimonio Nacional.

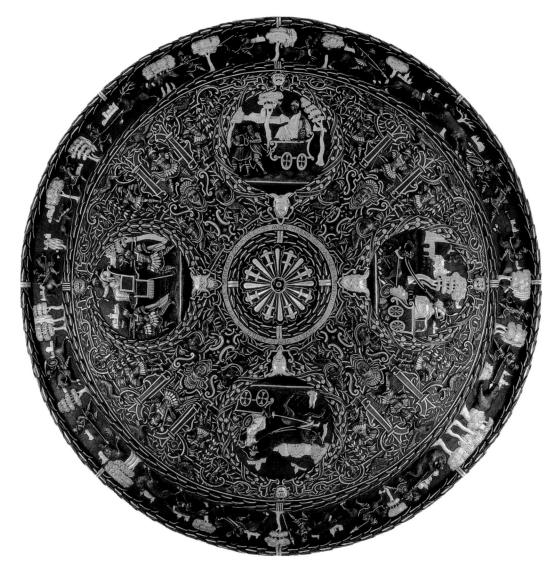

Ironically, Filippo, whose armor surpassed that of his cousins in technical virtuosity and aesthetic appeal, was, in the end, the least successful man. The execution of opulent embossed suits did not enrich the craftsman in proportion to the value of his work. In a world of low labor costs, substantial profits came from large-scale manufacture of medium- and lower-priced armor rather than from individual harnesses laboriously crafted for emperors and kings. The huge cost of luxury armor stemmed from the countless man-hours of work it required, as well as from the precious materials used in its decoration. The Parisian armorer Thomassin de Froimont needed three and a half months, likely assisted by three or four journeymen, to make two jousting harnesses for Philip the Good in 1425. In 1557 the armorer working on an etched and gilded suit of armor for Archduke Ferdinand II of Tirol took six to seven months to complete the job.[35] The production time increased considerably if armor was embossed. Filippo Negroli was, therefore, exceptional not only in his talent but also in his business practice of focusing on high-end suits.

Filippo died destitute on 24 November 1579. Already in 1570 he declared in his will that "having suffered for a long time from serious illnesses and being reduced to such great poverty, both because of these illnesses and because of the small income from his properties and finally because of the blindness that afflicts him,…he has not enough to feed or clothe himself or his family."[36] The inventory of his household effects upon his death does indeed reveal dire poverty: In the two rooms he occupied stood two beds, two tables, eight chairs, and a few other items of modest value. Meanwhile, his cousin Giovan Paolo had diversified production, forging not only elaborate embossed armor for the aristocracy but also large quantities of ordinary harnesses for the army. Furthermore, he maintained representatives in Rome, Turin, Antwerp, Brussels, and Paris. He prospered until the end of his life.[37]

In Germany the best armor was fashioned in the free imperial cities of Nuremberg and Augsburg and in the princely residences of Landshut and Innsbruck. Habsburg politics and patronage greatly profited this craft. German guilds forbade the large-scale, factory-like enterprises that made Milanese armorers thrive; the guilds sanctioned only businesses run by masters with two journeymen and up to four apprentices. German workshops, therefore, tended to produce lower-cost armor that was quicker and more lucrative to forge. The proximity of the Hungarian border benefited the armorers of Nuremberg: The continuous threat of Turkish invasion turned the city into a major supplier for the German armies fighting the enemy on that frontier.[38] In Augsburg the Helmschmid clan enjoyed the favor of the Habsburgs, and fashioned costly harnesses for elite patrons. Lorenz Helmschmid served the courts of Mantua and Urbino as well as Maximilian I, for whom in 1480 he made an elegant suit of armor with decorative fluting characteristic of German pieces (fig. IV-41). Desiderius Helmschmid was prized by Charles V and Philip II.

The Habsburgs, however, also eagerly bought Milanese suits, and the rivalry between the Germans and the Italians spilled onto their creations. On a shield from the above-mentioned parade armor of Philip II fashioned by Desiderius Helmschmid and Jörg Sigman (see fig. IV-32), the Augsburg masters asserted their superiority over their Milanese rivals: In the frieze on the perimeter of the shield (on the upper right side) they depicted a bull charging and overwhelming a warrior whose targe is inscribed NEGROL (fig. IV-42).[39]

Simultaneous patronage of armorers from diverse centers by most European potentates bespeaks the internationalism of taste for and production of luxury arts. Seeking the most potent expressions of their sovereignty, rulers assembled cosmopolitan creations and artisans at their courts. When Henry VIII Tudor founded a royal armory, first at Southwark and then at Greenwich, he imported masters from Italy, Germany, and Flanders. Henry's armor for infantry combat—constructed by Martin van Rone, who headed the royal workshop—confirms the success of the king's venture. Comprised of 235 pieces, the armor covered the king from head to toe and allowed as much movement as was possible while weighing 42 kg (93 lbs.). Only at the greatest courts did armorers enjoy the opportunity to execute such sophisticated designs. Most great nobles retained a permanent armorer in their households, but his duty was limited to cleaning, maintaining, and adjusting harnesses.

Because a ruler's need for battlefield, tournament, and parade armor never abated, the establishment of a court workshop offered a practical alternative to reliance on purchases from abroad. The court armory of the French king Francis I and his son

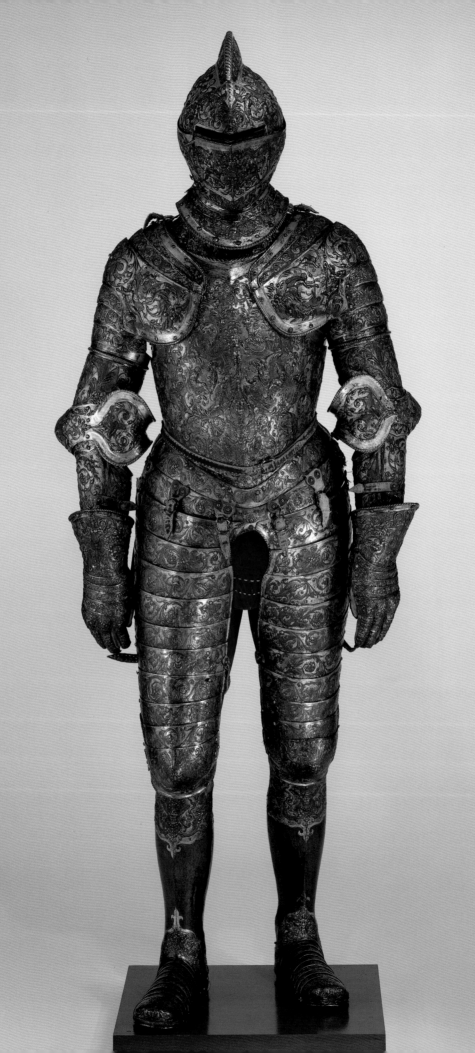

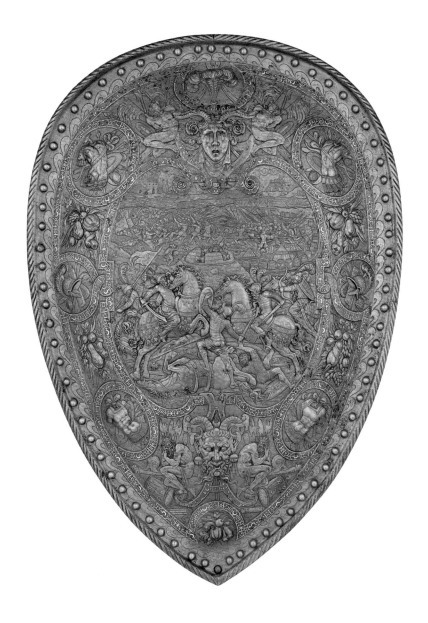

Fig. IV-43.
Design attributed to
ÉTIENNE DELAUNE (French,
1518/1519–1583), Armor of
Henry II of France, French,
probably made in the
Louvre Atelier of Royal
Armorers, ca. 1555. Steel,
embossed and gilded,
damascened with gold
and silver; brass, leather,
and red velvet, H. 1.89 m
(74½ in.). New York,
The Metropolitan Museum
of Art, Harris Brisbane
Dick Fund, 1939, inv.
39.121. © 1981 The
Metropolitan Museum
of Art.

Fig. IV-44.
Design attributed to
ÉTIENNE DELAUNE (French,
1518/19–1583), Parade
shield of Henry II of France,
ca. 1555. Steel, gold, and
silver, H. 63.5 cm (25 in.).
New York, The Metropolitan
Museum of Art, Harris
Brisbane Dick Fund, 1934,
inv. 34.85. © 1991 The
Metropolitan Museum
of Art.

Henry II, staffed mostly by Italian and Flemish craftsmen, produced Henry II's harness covered with a dense network of finely detailed foliage and figures—all embossed, silvered, and placed against a ground of gold (fig. IV-43). The court goldsmith Étienne Delaune, the supervising designer of the royal armory, likely conceived its decoration, and at least three armorers and other specialists brought it into being.[40] The same workshop fashioned Henry's parade shield with a heroic Roman exemplum: the last stand of the Roman consul Lucius Aemilius Paulus against Hannibal at the disastrous Battle of Cannae in 216 B.C. (fig. IV-44). The scene is rendered in subtly modulated embossed relief, with the foreground action projecting boldly from the surface, middle ground events appearing as smaller and shallower, and distant vistas barely protruding beyond their outlines. The rich polychromy (likely inspired by Homer's description of the shield of Achilles) that once adorned the shield and contributed vital pictorial details has, alas, vanished through overzealous cleaning, a fate of much of the Renaissance armor that survives.

Fig. IV-45.
Maximilian I in Konrad
Seusenhofer's workshop.
Woodcut. From Hans
Burgkmair the Elder
(German, 1473–ca. 1531),
Weisskunig, ca. 1512
(facsimile, Stuttgart, 1956),
pl. 42.

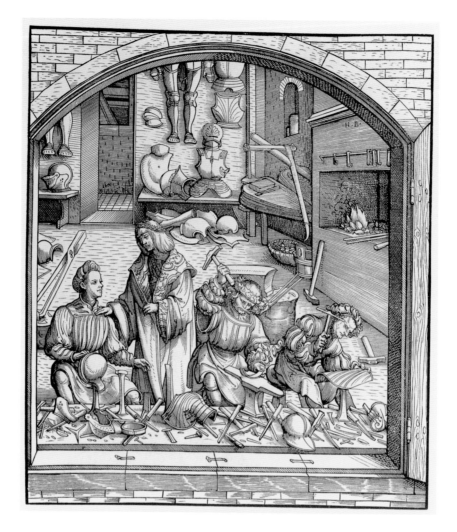

PRODUCTION AND TECHNIQUES

The reputation of top armorers rested on many factors, from their talent and expertise to the quality of the raw materials they used. The best armorers sought iron from the finest ore reserves—those in Austria around Innsbruck and in the southeastern state of Styria. German metal was harder and better tempered than other metal, hence Othello's reference to "a sword of . . . the ice-brook's temper."[41]

Once extracted from the mines, iron was shaped into thick plates, or billets. These were beaten into flat pieces and cut into shapes suitable for armor components. Armorers then modeled the rough plates into the desired forms by hammering them over anvils. A woodcut from Maximilian I's *Weisskunig*, depicting the emperor instructing his armorer Konrad Seusenhofer in the craft, shows the workshop stocked with a variety of tools; an assistant on the right models a breastplate over a stake (fig. IV-45). The 1514 inventory of Henry VIII's Greenwich armory details typical equipment: distinct anvils for making tubes, crests, visors, cuirasses, and helmets; a range of hammers for sculpting head pieces, crests, greaves, rivets, and embossing work.[42]

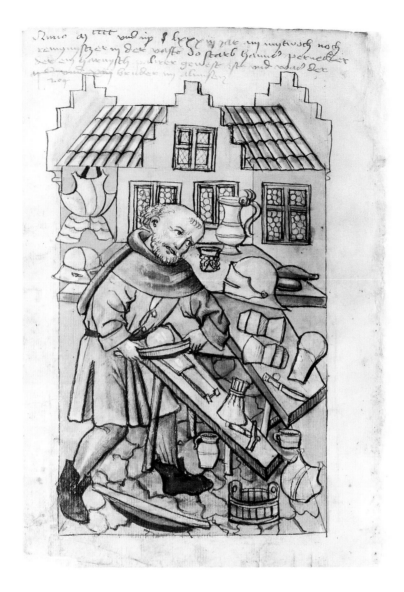

Fig. iv-46.
Polisher at work, from
*Hausbuch der Mendelschen
Zwölfbrüderstiftung*, 1483.
Nuremberg, Stadtbibliothek,
Amb 317.2, fol. 101v.

Throughout the production process the armorer had to remain alert to the physical changes in the metal: Hammering made it brittle and necessitated periodic heating, but too much annealing weakened the plates. The finished armor had to have an extremely hard surface and a somewhat malleable interior. The armorer also had to bear in mind each element's function and placement, insuring that plates were adequately thick in the most vulnerable areas and thinned out wherever possible to reduce the overall weight. In fine armor the thickness of the metal varied not only between different plates, but in different parts of the same plate. The left side was often heavier than the right, as it faced the enemy; the front of the helmet was generally thicker than the back.

After the parts had been shaped to perfection, they were dispatched to the grinding mill to even out the hammer marks. Next the polisher burnished the surface of each piece to a gleaming silvery finish either with water-driven wheels or by hand. The *Hausbuch der Mendelschen Zwölfbrüderstiftung* (The book of the Mendel family's

foundation of twelve brothers, 1483) shows the manual polishing of a pauldron (fig. IV-46). On the trestle table before the polisher lie a hammer for evening out remaining imperfections and a small pouch likely containing abrasive pumice, which, mixed with a small amount of oil, created a polishing paste.

After polishing came the decoration of the pieces, to which we shall return shortly. Once all armor elements had been completed and adorned, a locksmith fitted the strappings, buckles, and hinges to hold the pieces securely together; the exact fit of the pieces assured flexibility and full protection. Finally an upholsterer or tailor lined and padded the finished suit to prevent chafing and to provide cushioning for blows (costly silk was used to line the finest harnesses).

Custom-tailored suits of the elite fit most comfortably, moved most naturally, and best distributed the armor's weight. To acquire bespoke harnesses from far-away armorers, clients dispatched their measurements or pieces of clothing, such as arming doublets, (padded jackets worn underneath armor; see fig. IV-5). In 1512 a doublet and hose of the future Charles V were sent to Konrad Seusenhofer. In March 1520 Francis I asked for an arming doublet of Henry VIII so as to have a cuirass fashioned as a present for the English king.[43] Some armorers, however, insisted on personally measuring their clients. Konrad Richter, working on a suit for Ferdinand II of Tirol, stated that while he could deduce the length and width of the archduke from his garments, he could not ascertain whether his neck was long or short, or whether his legs were straight or curved. He was, therefore, asking for a fitting before hardening the plates, as alterations at a later stage would be difficult.[44] In 1466 Francesco Missaglia journeyed from Milan to measure Louis XI of France. The king requested that Missaglia study him by day and night, even when his highness was going to bed, so that his armor would not discomfort the royal body under any circumstances.[45] Emperor Charles V was so delighted with the suit made for him by Caremolo Modrone of Mantua that, according to the Mantuan ambassador in Spain, "His Majesty said that they [his armor elements] were more precious to him than a city. He then embraced Master Caremolo warmly . . . and said they were so excellent that . . . if he had taken the measurement a thousand times they could not fit better. . . . Caremolo is more beloved and revered than a member of the court."[46]

A completed set of armor was inspected and approved by the guild of the city where the armorer worked. Since major centers of manufacture competed for clientele, they stringently protected their reputation. Hence armor often bore the stamp of both the maker and his town, providing a guarantee of quality control. Armor was also regularly proofed (shot at close range with a weapon), the minor dent vouching for the suit's defensive merit.

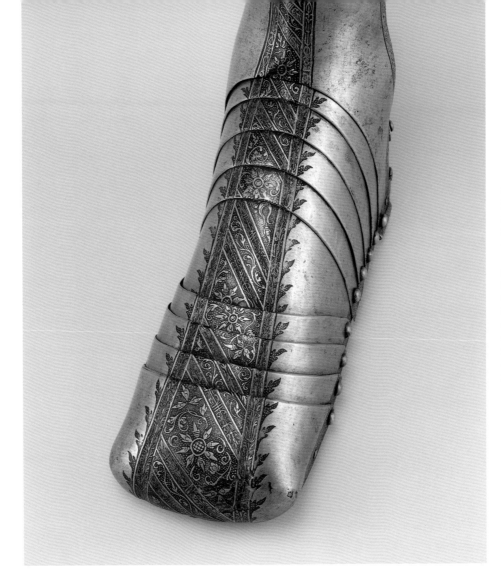

DECORATIONS

Engraving or incising lines into a metal plate with a sharply pointed tool was an old mode of decoration. Henry VIII's engraved suit, for example, is entirely covered with figurative designs executed by Paul van Vrelant, a goldsmith from Brussels and the king's "harness-gilder" (see fig. IV-7). While fairly straightforward, engraving was slow and laborious. Acid-etching, introduced in the late fifteenth century, greatly facilitated the application of ornament onto steel surfaces and became a popular technique. The process consisted of coating the plate with a protective acid-resistant varnish into which the design was scratched with an etching needle. The etcher then dipped the plate into acid, which ate into the uncovered areas, cutting permanent lines in the metal. Next the varnish was washed away with turpentine, the etched lines blackened with a mixture of lamp-black and oil, and the plate heated until the oil evaporated and the ornament remained as dark images standing out against the polished silvery surface. When gilded, etched designs assumed still greater richness. An exquisite sabaton (foot defense) ascribed to the armor of Wilhelm V, Duke of Jülich, Cleve, and Berg, has been acid-etched, blackened, fire-gilt, and lightly embossed. The delicate work is attributed to Wolfgang Großschedel of Landshut (fig. IV-47).[47]

The use of acid-etching in armor ornamentation developed simultaneously with the employment of this technique in printmaking. Indeed, armorers and printmakers worked closely together, lived next to each other, and frequently intermarried. Daniel Hopfer, one of the earliest printmakers to use etching, married a daughter of the armorer Coloman Colman, a.k.a. Helmschmid (son of Lorenz). Hopfer decorated a piece of armor produced by Colman for Charles V. A couple of decades later Coloman Colman moved to the house of the painter and print designer Hans Burgkmair the Elder, while Hans Burgkmair the Younger took over Colman's dwelling. Armorers needed engravers and etchers to ornament their suits; printmakers made their living by incising designs in metal, be it a printer's plate or a plate of armor. As Ferdinand I wrote to the city council of Augsburg in 1559, Hans Burgkmair the Elder (who died ca. 1531) had "served the Emperors Maximilian I and Charles V in the painting of armor as well as by etching in aid and support of the armorer and in other ways."[48] Albrecht Dürer and Hans Holbein also furnished designs for armor, the former for Maximilian I (figs. IV-48a and b), the latter for Henry VIII. The painter and book illustrator Jörg Sorg, who married into the Colman family, left one of the most extensive records of such collaboration—a large album illustrating some forty-five harnesses made in Augsburg between 1548 and 1563 for a distinguished international clientele. Each drawing included the name of the patron and the armorer. Sorg himself applied etched designs to all the suits. The close cooperation between armorers and other artists sheds light on the practical dimensions of Renaissance crafts, their interdependence for reasons of mutual benefit, and their simultaneous involvement in different arts.

Gilded embellishments constituted a major part of the opulence and cost of princely armor, amounting to up to a third of the total price. Gold decoration could be applied to harnesses in several ways. In fire-gilding an amalgam of powdered gold and mercury was placed on the surface of the plate. When heat was applied to the area, the mercury evaporated and the gold remained affixed. The procedure was highly toxic, ruining the health of many goldsmiths. A more innocuous process entailed painting the surface with a varnish, placing finely beaten gold leaf on top, and heating the decorated plate gently to dry the varnish and secure the gold.

Damascening, a metalworking technique of Eastern origin, consisted of inlaying precious metals into iron or steel. The surface of the plate to be decorated was first cross-hatched with files to roughen it and thus to facilitate the adhesion of the inlays. Gold or silver leaf or wire were then placed in these grooves, hammered in, and burnished flush with the surface. Francesco Negroli, one of the most gifted damasceners of the Renaissance, was so admired for his skill that Charles V appointed him his court gilder and goldsmith, and his son Philip II reconfirmed this post. The talented if boastful Benvenuto Cellini left a description of his work in this technique:

> About this time there fell into my hands some little Turkish poniards; the handle as well as the blade of these daggers was made of iron, and so too was the sheath. They were engraved by means of iron implements with foliage in the most exquisite Turkish style, very neatly filled with gold. The sight of them stirred in me a great desire to try my own skill in that branch, so different from the others which I practiced; and finding that I succeeded to my

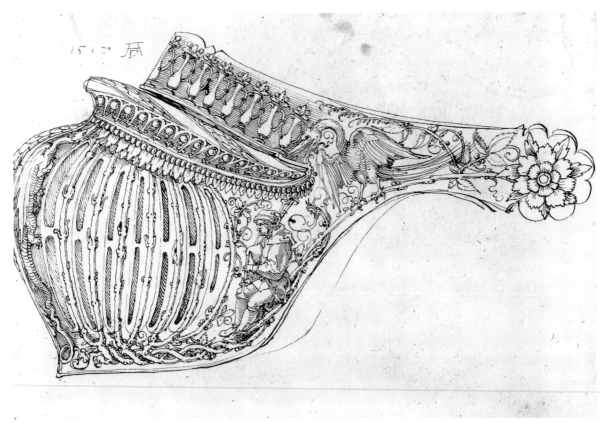

Fig. IV-48b.
Albrecht Dürer (German, 1471–1528), Design for a visor for Emperor Maximilian I, 1515–1516. Pen and brown ink, 19.4 × 27.5 cm (7⅝ × 10⅞ in.). Vienna, Albertina, inv. 3151.

satisfaction, I executed several pieces. Mine were far more beautiful and more durable than the Turkish pieces, and this for diverse reasons. One was that I cut my grooves much deeper and with wider trenches in the steel; for this is not usual in Turkish work. Another was that the Turkish arabesques are only composed of arum leaves with a few small sunflowers; and though these have a certain grace, they do not yield so lasting a pleasure as the patterns which we use.[49]

A sixteenth-century Ottoman sword and scabbard resemble the objects beheld and emulated by Cellini (figs. IV-49a–c). Continuous contacts between the Italians and the Ottomans contributed to cross-fertilization of their artistic traditions.

Perhaps the most technically and aesthetically spectacular technique of armor decoration was embossing—hammering plates from the underside so as to achieve relief designs on the visible surface. Details were then refined on the outside with chisels and punches. A traditional goldworking technique, embossing was all the more impressive for being executed on the hardest steel.

Embossed armor was habitually damascened or fire-gilded to enhance its raised ornament, as well as darkened through bluing. The dark hue was achieved by the process of fire bluing, or, heating up the polished plate at carefully controlled temperatures. Heating steel to ca. 220°C results in a pale yellow tint, 270°C produces a purple hue, and 310°C the black-blue shade. In the era before thermometers, gauging the temperature with such precision required a great deal of experience and skill. Many luxury suits that are now silver in appearance were originally blue-black. The darkened surface of harnesses provided both a striking background for applied decorations in silver and gold and an advantageous contrast for embossing. Bluing also protected metal from rusting, a common problem, given armor's frequent exposure to inclement weather, whether the wearer was at war or on parade.

Renaissance patrons and craftsmen viewed embossing as an antique method of armor ornamentation. Consequently, it adorned primarily *all'antica* suits.[50] This armor was striking on parade, but impractical in war, for embossing stretched and thinned the steel nearly to the cracking point, rendering it too brittle to be protective. The highs and lows of reliefs, moreover, contradicted the "glancing surface" logic of defense armor, creating endless opportunities for weapons to catch. The donning of embossed harnesses for purely ceremonial purposes testifies to the symbolic value of luxury armor as a sign of social ascendance, refined taste, and an ample budget.

Filippo Negroli was the greatest embosser of the Renaissance, his armor sought after and cherished by princes across Europe. His Medusa shield, created for Charles V, exemplifies the virtuosity of his art, as does Francesco Negroli's damascening, which completes the design (fig. IV-50). The head of Medusa featured frequently on Renaissance shields, associating the wearer both with Roman warriors, who thus embellished their armor, and with the legendary Perseus, who slayed the monster in the first place and turned her murderous gaze into his own weapon. Filippo hammered the Medusa head to rise up to two inches above the shield's convex surface, thus turning her into a palpable presence rather than a mere adornment. The head stops the onlooker in his tracks through a combination of its frightening visage and stunning execution. Inscriptions enclosed by diamond cartouches on the perimeter of the shield echo the visual threat: "This object inspires terror, for valor is shown through courage and fortune." The original blue-black surface has been obliterated by repeated cleanings, and

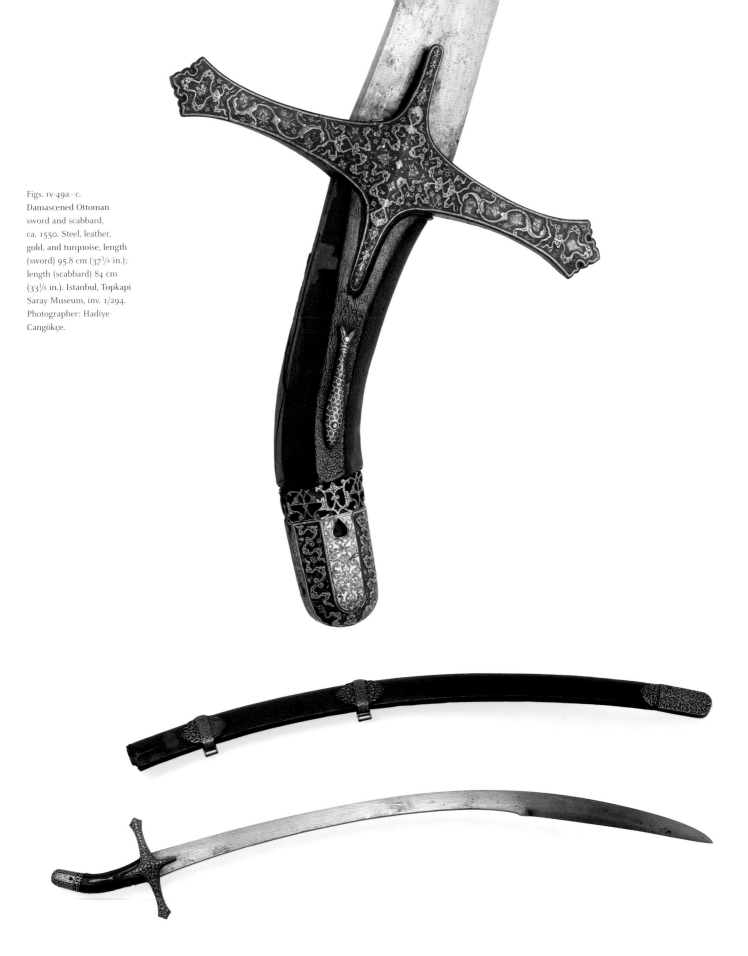

Figs. IV-49a–c.
Damascened Ottoman
sword and scabbard,
ca. 1550. Steel, leather,
gold, and turquoise, length
(sword) 95.8 cm (37¾ in.);
length (scabbard) 84 cm
(33⅛ in.). Istanbul, Topkapi
Saray Museum, inv. 1/294.
Photographer: Hadiye
Cangökçe.

some of the damascened decoration has likewise been erased. Still, Filippo's talent is readily apparent, as is the reason for his esteem by the most exalted and discriminating patrons of the day.

Filippo also crafted a burgonet (visored helmet) for Charles v (fig. IV-51). The intact dark surface of this helmet demonstrates the impact of such finish on the embossed and damascened decoration. The helmet itself is an exemplum of excellence. It is forged from a single piece of metal: Filippo appears to have been the first Italian armorer to fashion pseudoantique helmets from single plates rather than constructing them from several pieces as was the common contemporary practice. The design consists of a relief figure of a turbaned Turk in an *all'antica* breastplate bent over backward

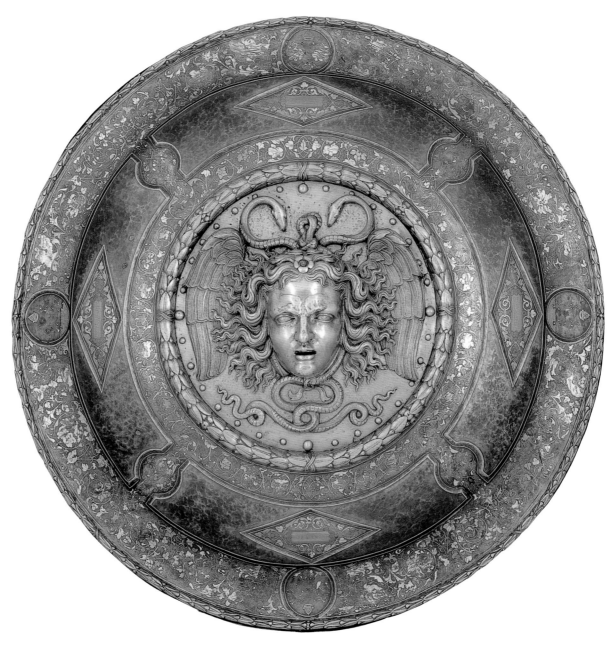

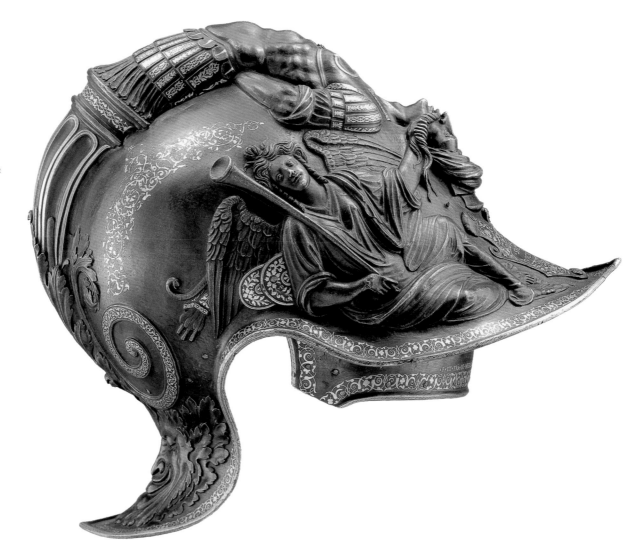

Fig. IV·51.
FILIPPO AND FRANCESCO
NEGROLI (Italian,
ca. 1510–1579 and
ca. 1522–1600), Burgonet
(visored helmet) for
Charles V, Milan, 1545.
Madrid, Real Armería,
inv. D 30. © Patrimonio
Nacional.

on the comb of the helmet with his arms tied behind his back. Allegorical figures of
Fame with a trumpet and Victory with a palm branch hold the captive firmly by his long
mustache. Military trophies against which they recline further spell their and Charles's
triumph. A scrolled cartouche under the prisoner's head declares this message in dama-
scened letters: "Thus Is Caesar Invincible." The helmet proclaims with power and inge-
nuity the emperor's victory over Islam and by extension over all his enemies. Filippo's
signature, prominent on the brow band, credits the armorer for transforming political
propaganda into the highest art.[51]

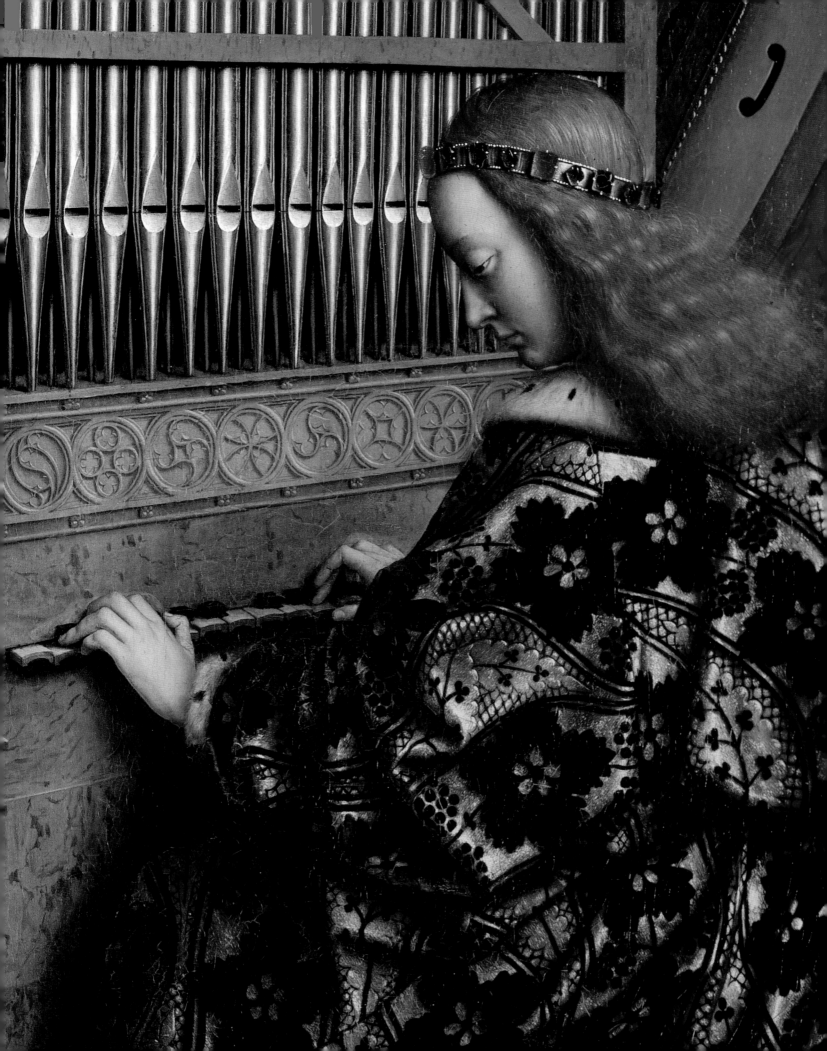

V SWEET VOICES AND FANFARES

Every year on the feast of Saint Mark (April 25), the doge and his entourage, the high officials of the state, the *scuole* (religious confraternities), and other citizens paraded through the streets of Venice in celebration of the patron saint under whose protection the republic flourished. An early seventeenth-century engraving depicts such a procession in the Piazza San Marco (fig. v-1), the spiritual and governmental heart of Venice. The doge, pictured in the foreground, is distinguished by the baldachin over his head. Marching in front of him, in the center of the print, are musicians who articulate his majesty, including the six trumpeters who blow silver horns. They accompanied the doge whenever he appeared in a solemn procession.[2]

Today we think of music as occupying an intellectual and physical space very different from that of the visual arts. And because music is so widely available to us, we do not associate it with luxury. In the Renaissance, however, music was employed alongside other forms of displays to articulate political and social ascendance and to create a religious aura. Sacred polyphony defined the realm of God and of rulers who could assemble and maintain highly skilled performers for their daily devotions. Secular songs and instrumental music were taught to and practiced by elites as signs of education and refinement. Thus, a portrait of a young woman, who may have been a member of the Frescobaldi, a powerful Florentine banking family, holds a book of music as an attribute of her status on a par with her luxurious dress (fig. v-2). Music also orchestrated diverse activities at courts. Dance was considered one of the liberal arts; its mastery prepared one for the subtleties and rigors of diplomacy. The possibility of hiring personal dance masters was open only to the loftiest women and men.

Music was a crucial component of splendor in Renaissance Europe, adding magnificence to urban and courtly events, births and deaths of rulers, their coronations

Otto Stendardi. Comanda-
dori.
Sei trombe de argento. Serui dell'Ambasciatorr.
Piffari.
Scudieri dell
doge.
Caualier
Secretary
Stocho.
Om brela.
Ambasciator Cesareo.
Doge.
Cusino.
Balotino
Diacono
Capelá
Catedra.
Illustrisima Signoria.
altri Ambasciatori Legato.
Cancelier grando.
Capitano grande.

Fig. V-1.
Procession in the Piazza San
Marco. Copper engraving.
From *Habiti d'hvomeni e
donne venetiane: Con la
processione della serma*
(Venice, 160–?). Los Angeles,
Research Library, Getty
Research Institute.

Fig. V-2.
Attributed to BACCHIACCA
(= Franceso Ubertini,
Italian, 1494–1557), *Portrait
of a Woman with a Book of
Music*, ca. 1540. Oil on
panel, 102.9 × 80 cm
(40½ × 31½ in.). Los
Angeles, The J. Paul Getty
Museum, inv. 78.PB.227.

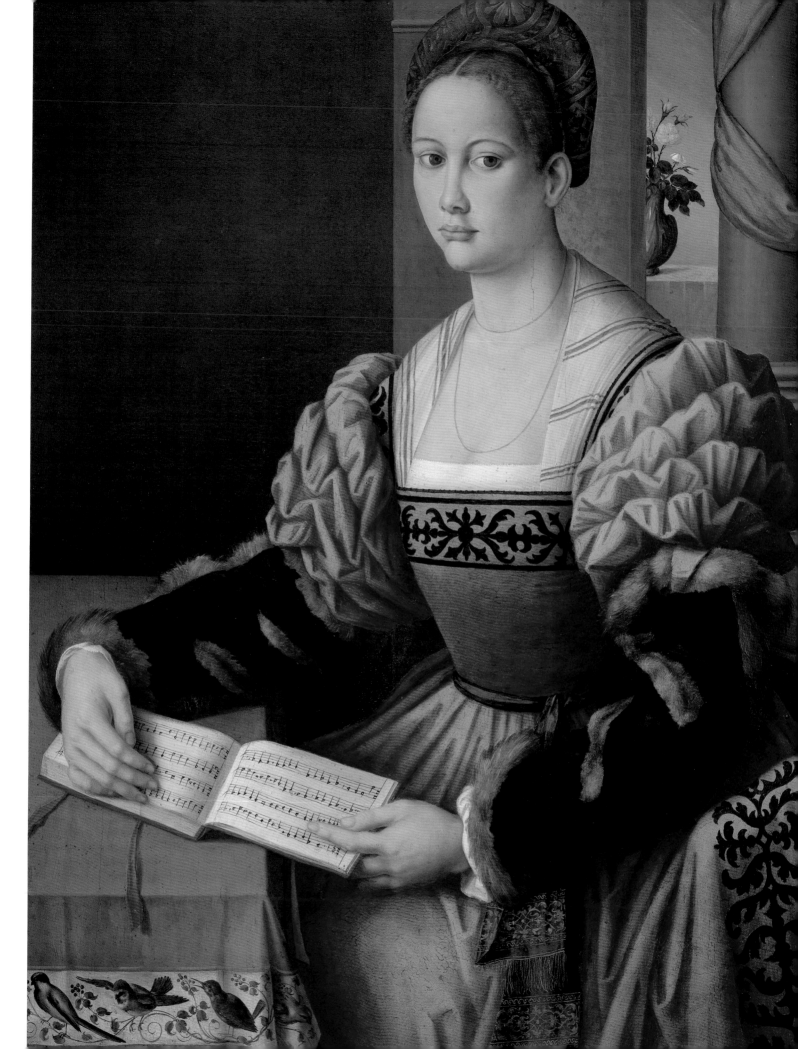

and state entries, banquets and hunts, as well as religious services in the palace and in the cathedral. Music therefore forms a logical part of the panorama of luxury arts. The procession in the Piazza San Marco demonstrates how wind players articulated the appearance of the doge. The guilds and confraternities of Venice sponsored musical performances to bolster their standing. Civic bodies employed musicians to enrich festivals and add brilliance to the reception of dignitaries.[3] Major events at courts warranted newly composed works, be they sacred motets or secular dances. Music manuscripts constituted prized diplomatic gifts. Campaigning to be elected Holy Roman Emperor, the future Charles v Habsburg dispatched three lavish volumes of sacred music to Pope Leo x, who did not vote directly but wielded power behind the scenes (fig. v-3). Comprised entirely of sacred music, the volumes contained compositions for use in daily services, the Requiem Mass, Easter, and other feasts.[4] The frequent comments on musical resources and performances of rulers by contemporary eulogists, chroniclers, and ambassadors bespeaks the value placed on this art and the expectation of its mastery by the elites.

Fig. v-3.
Music manuscript presented to Pope Leo x by the future emperor Charles v, early sixteenth century. Vatican, Sistine Chapel, ms. 160, fol. 3r. © Biblioteca Apostolica Vaticana.

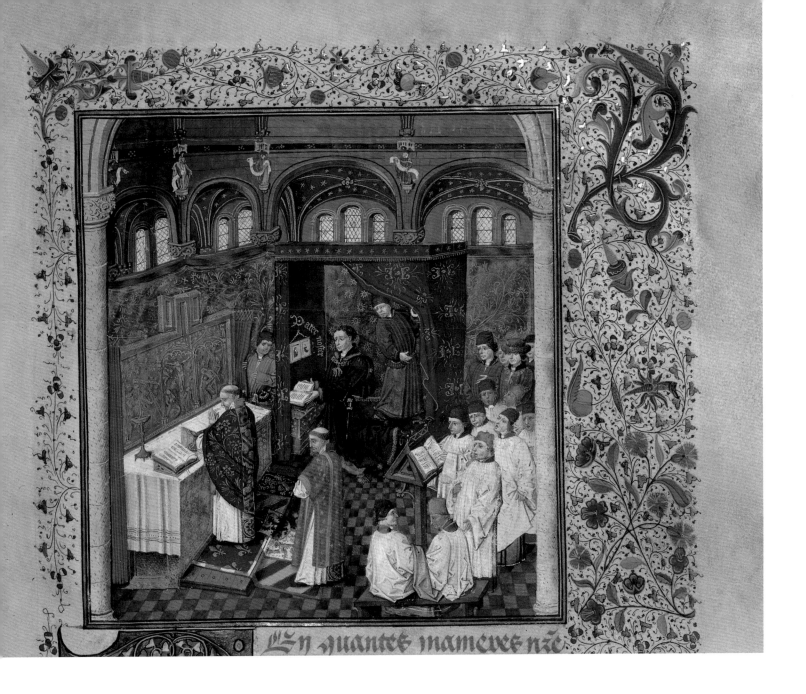

En quantes manieres n̄e

SACRED POLYPHONY

The most exalted music—polyphonic singing—solemnized Masses in church choirs and princely chapels (fig. v-4). On normal days the liturgy was accompanied by monophonic chant. But on major feast days the divine service became resplendent, and heavenly glory audible, through the performance of polyphonic Masses, hymns, and motets. Music affects one emotionally, and sublime singing can and was intended to bring listeners closer to God. It could also seduce them with sensual beauty. Ranked as a luxury, polyphony was symbolically suspended from the Sistine Chapel in the Vatican during Holy Week.[5]

A large and well-cared-for chapel choir revealed the power and distinction of its sponsor, be it an ecclesiastical institution or a secular potentate. Since expressions of piety furnished a vital arena for sovereign displays, and since most Renaissance rulers

Fig. v-4.
JEAN LE TAVERNIER (? Netherlandish, active ca. 1434–1460), *Philip the Good at Mass Accompanied by His Chapel Musicians.* From *Traité sur l'Oraison Dominicale* (Treatise on the Lord's Prayer), after 1457. Brussels, Bibliothèque royale Albert 1ᵉʳ, MS. 9092, fol. 9r. © Bibliothèque royale de Belgique.

heard Mass daily, their chapels constituted the foremost bodies in the organization of the court. Charles the Bold's household ordinances of 1469 devoted twelve of forty-eight folios to the detailed enumeration of the duties of his all-male chapel personnel and specified the range of voices indispensable for performances worthy of his exalted person and of God: "For singing polyphony there shall be at least six high voices, three tenors, three contrabasses and two contratenors, excluding the four chaplains for High Mass and the Sommeliers who, however, must sing with the above-mentioned if they are not occupied at the altar or in some other reasonable way."[6]

The Book of Hours of Jean de Berry, known as the *Très Riches Heures* because of its sumptuous illumination, depicts a Christmas Mass at court (fig. v-5). A choir of singers gathers around a volume propped up on a lectern to the right of the altar and adds aural splendor to the richly appointed celebration.

The importance of a superb chapel choir to both divine glory and the ruler's image was elucidated by the Netherlandish composer and musical theorist Johannes Tinctoris (ca. 1436–1511; fig. v-6). In his *Proportionale musices* (Proportions in music, 1476) Tinctoris describes the expansion of chapels at contemporary courts through an exemplary biblical allusion:

> The most Christian princes . . . desiring to enhance the divine service, founded chapels after the manner of David to which, at enormous expense, they appointed various singers to sing joyous and comely praise in different (but not conflicting) voices to our God. And since royal singers, if their princes are endowed with that generosity which brings men fame, are rewarded with honor, glory and wealth, many are kindled with a passionate zeal for study of this kind. As a result of this fervent upsurge, the development of our music has been so remarkable that it appears to be a whole new art.[7]

Tinctoris refers to the vogue in European princely circles for sacred polyphony. He also affirms the significance of a ruler's eminence in elevating an artist to honor and fame. For in Renaissance Europe the reputation of an artisan was linked to that of his patron, an attitude that went back to antiquity. As the Roman architect Vitruvius had written, "many excellent craftsmen never acquired renown because they failed to come upon rich and influential patrons."[8] Tinctoris, furthermore, comments on the diverse ranges of singers sought by cultivated patrons. Usually musically educated themselves, rulers carefully selected specialists in particular voices to enhance the quality of their chapels. King Ferrante of Naples, whom Tinctoris served from 1472 until the late 1480s or even 1492, was one such informed and discriminating listener. He had hired Tinctoris for his multiple abilities: as a singer, one of the chief musical theorists of the age, composer of numerous musical works and treatises, tutor for the king's daughter Beatrice, as well as legal advisor, for Tinctoris also held a degree in law.[9] The king then relied on Tinctoris to recruit additional singers for the royal chapel. A letter of 15 October 1487 preserves Ferrante's instructions for Tinctoris's trip north of the Alps, where the best vocalists were to be found:

Fig. v-5. *Christmas Mass.* From *Les Très Riches Heures du Duc de Berry,* early fifteenth century. Chantilly, Musée Condé, MS. 65/1284, fol. 158r. Photo: RMN/Art Resource, NY. Photographer: René-Gabriel Ojeda.

Fig. v-6.
NARDO RABICANO, *Portrait of Johannes Tinctoris*, Naples, ca. 1483. Valencia, Universitat, Biblioteca Histórica, MS. 835 [olim 844], fol. 2r.

Having need in our chapel, for the rendering of the divine service, of some singers of a certain type that we have described to you, and not finding them hereabouts, we want you to go across the mountains to France and to any other region, country, or place where you think you may find them, taking with you the letter of recommendation that we wrote for you to the Serene and Illustrious King of France and the King of the Romans; to exert and trouble yourself to find some good singer, of the type and register of which we told you: and, upon finding him, to bring him with you [that he may enter] our service and that of our chapel. And we shall honor quickly and to the letter any promises you make, concerning the salary as well as to other matters, to the said singers whom you bring.

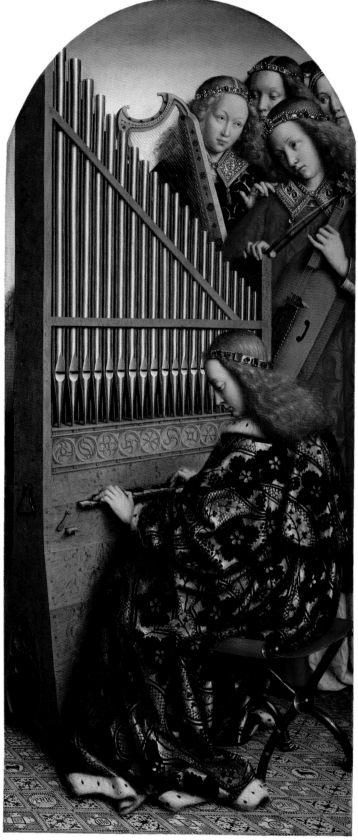

Ferrante's and Tinctoris's efforts bore such rich fruit that other rulers made raids on the Neapolitan chapel, luring away its personnel.

Church choirs, too, strove to assemble the most suitable vocalists. In July 1481 the Siena cathedral choir employed three sopranos and two contratenors, but their only tenor had failed to return from a leave of absence. The church authorities recorded their frustration: Had they known that the tenor was gone for good, they complained, they would have disbanded the entire choir, "for without a tenor it is impossible to sing."[11] Each musician was highly trained in a specific voice, and all were necessary for perfect music.

Jan van Eyck's *Ghent Altarpiece* depicts a group of angels, clad in liturgical vestments, performing in different voice ranges (fig. v-7). The three figures in the left foreground appear to sing the bass: their mouths and cheeks pull downward to produce the low sound. The two angels on the right seem to take a high range, as their expressions are somewhat strained and facial musculature directed upward. The three performers in the back probably sing in the middle voice. On a companion panel (fig. v-8) one angel plays an organ, the instrument that regularly accompanied church choirs, two others viol and harp. Combined, these pictures illustrate Psalm 150, *Praise the Lord*: "Praise God in his sanctuary: praise him in the firmament of his power . . . Praise him with the sound of the trumpet: praise him with the psaltery and harp. Praise him with the timbre and dance: praise him with stringed instruments and organs."[12] The association of the divine realm with music was articulated in numerous other Renaissance paintings. In Piero della Francesca's *Nativity* (fig. v-9), for example, angels sing and play musical instruments to announce the arrival of the son of God.

The exquisite voices of chapel musicians were perceived to convey something of the celestial glory. Hence expert singers of sacred polyphony were at a premium. Such singers made excellent diplomatic gifts between rulers—Louis XII of France sent three boy singers to Leo X upon his election to the papacy—and singers became objects of keen competition among princes.[13] The Sforza rulers of Milan, who attracted to their court some of the most famous musicians of the day—Gaspar van Weerbeke, Loyset Compère, Josquin des Prez, Alexander Agricola, and Johannes Cordier, among others— did not shrink from "diverting" the employees of other rulers to build an illustrious choir of their own.[14] On 6 November 1472, for instance, Galeazzo Maria Sforza instructed Francesco Maletta, his ambassador in Naples, to dispatch singers to him from under the Neapolitan king's nose:

Francesco, since we have decided to make a chapel, we are sending agents there to bring certain singers into our service, as you will understand more clearly from them. So that our wishes come about more easily, we want you, in a way that seems to come from you and not as if you have orders from us, to speak to those pointed out to you by the agents, urging them to enter our service. Promise them, as they have been told, that we will make them a good deal, providing them with good benefices and good salaries. We have given the money and

Fig. v-7.
JAN VAN EYCK (Flemish, ca. 1390–1441), Singing angels, detail of the altarpiece in the Cathedral of Saint Bavon, Ghent, 1432. Oil on wood. Photo: Scala/Art Resource, NY.

Fig. v-8.
JAN VAN EYCK (Flemish, ca. 1390–1441), Music-making angels, detail of the altarpiece in the Cathedral of Saint Bavon, Ghent, 1432. Oil on wood. Photo: Scala/Art Resource, NY. See also detail on p. 186.

means to the agents to bring these singers to us. Above all take care that neither his most serene majesty the king nor others might imagine that we have been the cause of removing these singers from those parts.[15]

Two years later, however, Galeazzo Maria became embroiled in a diplomatic quarrel with King Ferrante for having surreptitiously lured away Johannes Cordier, who was one of the most famous singers of his time. Born in Bruges, he began his career as a *tenorista* in the Collegiate Church of Saint Donatian, renowned for its music school. (The majority of prestigious performers of sacred polyphony in this era were trained in church and cathedral schools in northern France and the southern Netherlands.) In 1467 Cordier was recruited into Medici service. Between January 1469 and July 1471 he worked in the papal choir. Thence he joined the chapel of the king of Naples, until Galeazzo Maria Sforza "diverted" him to Milan (*disviare* being the polite Italian term for stealing).[16]

The conflict between Galeazzo Maria and King Ferrante over Cordier began when Ferrante demanded the return of his treasured singer. The duke of Milan retorted that he would not send back Cordier until Ferrante himself restored to him one Don Constantino, who had been enticed away from Milan. The dispute was still unresolved in March 1475, when the Milanese ambassador, Giovanni Pietro Panigarola, appealed for help to Charles the Bold, Duke of Burgundy, to whom Cordier, as a native of Bruges, owed allegiance. Charles promised to support the duke of Milan. A letter from the king of Naples followed, urging him otherwise. Having recently concluded an alliance with the traditionally pro-French Sforza, Charles adhered to his promise to Galeazzo Maria, and Cordier remained in Milan until 1477. He reputedly earned the huge sum of one hundred *ducats* a month, and his new employer even provided a large dowry for his mistress (whom, as a cleric, he could not officially maintain). Nonetheless, a few years later Cordier left for what must have been even more enticing opportunities at the court of Maximilian I Habsburg, where he sang in the 1480s, although he later returned to Milan.[17]

Such mobility was typical of the most desired and courted musicians of the day, as was the personal and passionate involvement of princes in musical matters and personnel. The escalating fees paid by rulers to top singers created a favorable climate for musicians who astutely played the job market and readily changed employers to gain greater financial and social rewards. It has even been suggested that the vast salaries and lucrative benefices dispensed by Galeazzo Maria Sforza to his performers may have contributed to the discontent that led to his assassination on 26 December 1476 by disgruntled subjects not equally favored by the duke.[18]

Chapel singers were usually clerics and thus eligible for benefices—sacred offices with the rights to collect revenues from the endowments attached to them. On top of monthly salaries, benefices significantly augmented musicians' income, offered stability and permanence of earnings in their otherwise highly itinerant lives, and provided financial security and comfortable retirement in old age. In the highly competitive market for musicians, princes used benefices within their reach to attract and retain the best performers. The procurement of benefices, however, was far from simple. Success depended less on talent or professional repute than on political savvy and good connections. Securing a benefice was, in itself, a form of art. The process by which Johannes Ockeghem, the protocapellanus of the French royal chapel—depicted as a distinguished

Fig. v-9.
PIERO DELLA FRANCESCA (Italian, ca. 1415/ 1420–1492), *The Nativity*, ca. 1470–1475. Oil on wood, 1.24 × 1.23 m (49 × 48⅜ in.). London, The National Gallery, inv. NG 908.

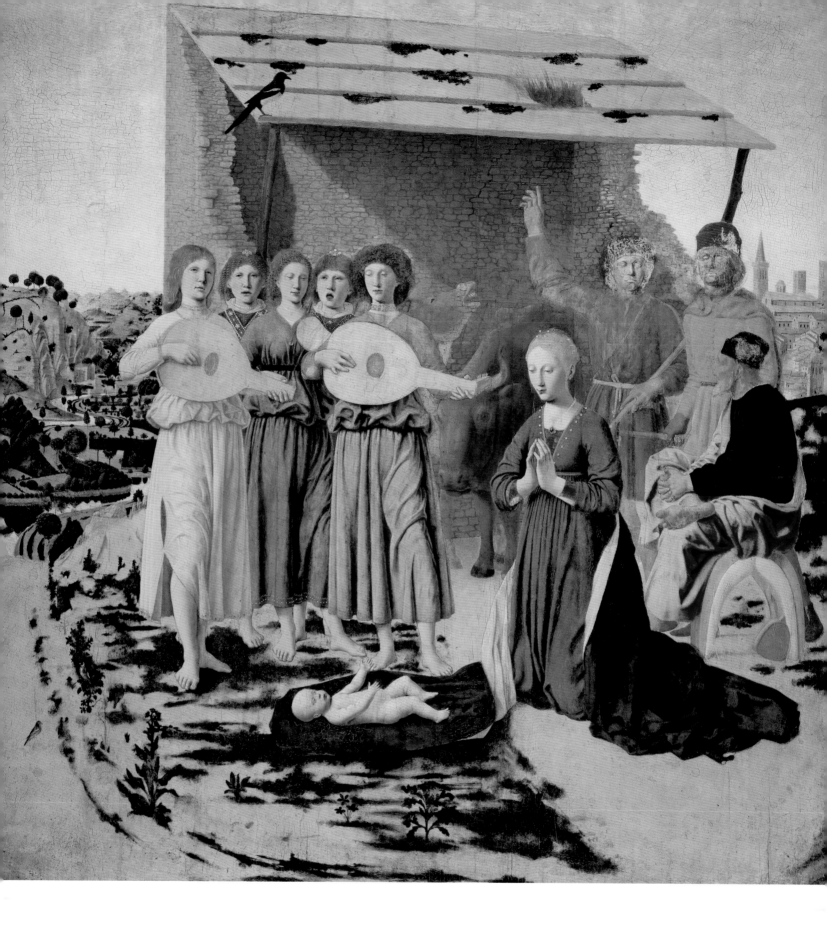

man in glasses in a contemporary manuscript (fig. v-10)—secured the provostship at the Church of Saint Martin at Tours and a canonry at the Cathedral of Notre Dame in Paris from Pope Paul II in 1466 illuminates the intricacies of such an undertaking.[19]

Ockeghem was a singer of great skill and a master composer. Tinctoris dedicated to him his *Book on the Nature and Properties of Tenor*, praising his voice as the finest

he knew and describing him as first among the most excellent composers of his generation. Yet arguably more vital than Ockeghem's musical faculties and his lofty post at a royal court was his hiring of a skillful procurator to shepherd his benefice petition through the Vatican bureaucracy. Ockeghem's guide through this perilous maze was Johannes Puyllois, a singer in the papal choir and a man versed both in the elaborate protocols for the expedition of papal supplications and in the subtleties of the Vatican system. In his more than twenty years as a member of the papal chapel, Puyllois lodged some forty-four petitions with four different popes on behalf of others and himself. By the end of his tenure in the Vatican he had accrued benefices earning more than four hundred *florins* a year on top of his salary. Leo X paid his choristers 6–8 *ducats* a month. (A *florin* was the equivalent of a *ducat*; both were gold coins, the former minted by Florence, the latter by Venice.)[20]

The process of procuring benefices began with the preparation of the petition. This document had to be carefully worded and meticulously executed by one of countless professional notaries residing in Rome so as not to sabotage the effort by sloppy presentation. The supplication outlined Ockeghem's credentials and the specifics of the desired benefices

in the most perfect style. It was signed by an official empowered to endorse such applications on behalf of the pope, in this case the *referendarius* Petrus Ferriz, Bishop of Tarazona (in Aragón, Spain). The completed petition then traveled to the office of the *datarius*, who imposed on it the crucial official date—in this case 24 May 1466—a mark that assured Ockeghem's legal right to the benefices, especially should they be contested by conflicting claimants. The dated document next proceeded to the Registry of Supplications, to be copied into a capacious folio-size volume. The second stage entailed drawing up a papal bull of provision and sealing it with a heavy lead *bulla*. At this point Puyllois was presented with the bill for the accrued fees, although he had also paid fees and tips throughout the progress of the petition from office to office. The last stage took Puyllois to yet another branch of the Curia, to furnish proof of Ockeghem's worthiness of the bestowed benefices—a notarized statement that the musician had passed examinations in grammar, writing, and singing. Finally, Puyllois had to pledge to produce the annates on the benefices—the first year's revenues being payable to the Papal Curia.

These efforts and expenses were not in vain. The benefice Ockeghem obtained at Saint Martin's at Tours made him the treasurer of the church as well as the baron of Châteauneuf—the surrounding quarter of the city. In the latter capacity Ockeghem held the right to enact ordinances governing the use of streets, highways, commerce, and trades within the barony; to administer justice; and to collect fines and penalties levied thereby. His revenues were further generated by fees for weights and measures for selling grain, oil, nuts, and wine in his domain; by taxes on a wide variety of foodstuffs and manufactured goods sold in the city market; by rents on property owned by the barony as well as by the treasurer's share in the income of the Church of Saint Martin.[21] And then there were his earnings from the canonry at Notre Dame in Paris.

Whether through their benefices or through additional obligations at court, the activities of chapel musicians were not limited to the performance of the Mass. Tinctoris, for example, furnished the king of Naples with legal advice and translated for him the statutes of the Order of the Golden Fleece from French into Italian after Ferrante had been admitted to its exalted membership in 1473.[22] In the household of Henry Algernon Percy, fifth Earl of Northumberland, the chapel choir not only sang at Mass but also embellished festivities that punctuated the religious calendar throughout the year. It performed in the *Play of the Nativity* on Christmas Day morning and in the *Play of the Resurrection* on Easter Sunday. At the Twelfth Night festival it sang carols at the evening banquet and participated in court revels. The *Great Chronicle of London* records the musical diversions produced by King Henry VII Tudor for the mayor and the French and Spanish ambassadors on Twelfth Night in 1494. Henry's chapel sang a "goodly Interlude," which was interrupted by the arrival of "oon of the kyngys Chapell namyd Cornysh" riding into the hall at Westminster dressed as Saint George. A fair Virgin followed, leading by a silken lace a terrible and huge red dragon that spewed fire. Cornish first recited a speech in "balad Royall," then sang an anthem of Saint George, "whereunto the kyngys Chapell which stood ffast answerid *Salvatorem Deprecare, ut Gubernet Angliam*, And soo sang owth alle the hool antempn wyth lusty Corage."[23]

As clerics and members of the chapel, singers of sacred polyphony outranked minstrels in status and visibility. In August and September of 1469 Charles the Bold compensated a cloth merchant and a furrier for materials used in tailoring two long robes of fine violet fabric lined with black lamb fur, which the duke gave to Antoine Busnois and Pasquier Louis, servants in his chapel.[24] These were standard robes of the ducal choristers, and the cost of the two garments equaled more than two months' salary of a full chaplain. Whether at court or on the battlefield, a ruler's splendor was gauged not only by the quality of his personnel but also by its appearance. In 1418 Antonio Tallander, a courtier of King Alfonso of Aragon, reported that the Burgundian musicians formed "the most sumptuous chapel that I have ever seen, and the best dressed and furred."[25] Ducal chamber performers, in contrast, wore more modest garments: long black woolen robes and black satin tunics.

As indispensable attributes of princely rank, musicians surrounded a ruler in peace and in war. Their number and quality—and the very ability of their employer to maintain a body of singers, players, and composers—were unmistakable signs of his magnificence. Setting off on his military campaigns, Charles the Bold brought along his entire chapel (fig. V-11). And in May 1475 the Milanese ambassador Giovanni Pietro Panigarola marveled that during the siege of Neuss, "even though he [Charles] is in camp, every evening he has something new sung in his quarters; and sometimes his

Fig. v-11.
The chapel of Charles the
Bold. From Jean Mansel,
La fleur des histoires,
fifteenth century. Brussels,
Bibliothèque royale Albert
1ᵉʳ, MS. 9232, fol. 269r.

Fig. v-11.
The chapel of Charles the
Bold. From Jean Mansel,
La fleur des histoires,
fifteenth century. Brussels,
Bibliothèque royale Albert
1ᵉʳ, MS. 9232, fol. 269r.

lordship sings, although he does not have a good voice; but he is skilled in music."[26] The
significance of music to the princely image rendered it a major item of diplomatic inter-
est, and peers and ambassadors listened closely to the excellence and novelty of musi-
cal offerings at rival courts.

Because musicians in princely employ played such a visible and audible role,
their careers are often well documented, and we catch glimpses of not only their suc-
cesses but also their failings. A case in point is Nicolas Gombert, a singer in the court
chapel of Charles v Habsburg (fig. v-12) from 1526 on, *maistre des enfans* (music
teacher) of the chapel choristers from 1529 to about 1538, and a frequent member of the
emperor's retinue on his many trips across Europe. Gombert also composed several

masses; some 160 motets for various state occasions, such as *Dicite in magni* in celebration of the birth of Charles's son Philip II, *Felix Austriae domus* in honor of the coronation of Charles's brother Ferdinand I as king of the Romans, and *Qui colis ausoniam* in commemoration of a treaty between the emperor and Pope Clement VII in 1533. Gombert furthermore wrote some seventy chansons. His compositions influenced musicians in the Low Countries, Germany, Italy, and Spain; and several collections wholly devoted to his motets were printed and reprinted in Venice between 1539 and 1552. Yet somewhere between 1538 and 1540 Gombert abruptly vanished from the imperial chapel rolls, to reappear again only in 1547 as a canon in Tournai.

The roughly contemporary Pavia-born philosopher, mathematician, and physician Jerome Cardin sheds light on Gombert's sudden disappearance and professional decline. Gombert, he writes, was condemned to the triremes for violating a boy in the service of the emperor. This tantalizing remark appears in Cardin's treatise *On tranquillity* as an illustration of activities, particularly sexual ones, that are inimical to serenity. In another treatise, *On the utility and benefits that can be gained from adversity*, Cardin elaborates on Gombert's fate. Discussing various kinds of incarceration and the possibility of eventual good deriving from such misfortune, Cardin cites Gombert's case as an exemplum:

Fig. V-12. JOHANNES AND LUCAS VAN DUETECUM, *The Band of Musicians*. Hand-colored copper engraving, 24 × ca. 34 cm (9½ × 13⅜ in.). From *La magnifique et sumptueuse pompe funebre faite aux obseques et funerailles du . . . empereur Charles Cinquième . . . en la vile de Bruxelles* (Brussels, 1559), pl. 2. Antwerp, Musée Plantin-Moretus, inv. R.44.8.

AMPLISSIMO HOC APPARATV ET PVLCHRO ORDINE
POMPA FVNEBRIS BRVXELLIS A PALATIO AD DIVÆ
GVDVLÆ TEMPLM PROCESSIT CVM REX HISPANIARVM
PHILIPPVS CAROLO V ROM . IMP. PARĒTI MŒSTISSIMVS
IVSTA SOLVERET

The courage of Nicolas Gombert is to be commended no less than his good fortune. For after he had been condemned to the triremes, while in chains he composed those swan songs with which he earned not only his pardon by the emperor, patron of all illustrious men, but also received a priest's benefice, so that he spent the remainder of his life in tranquillity. Gombert's penalty was not a hard one, for he endured a punishment he deserved.[27]

Charles v's *Capture of Tunis* tapestries (see fig. III-3) show his galleymen, their torsos bare and heads shaved, arduously propelling the imperial fleet. It is difficult to imagine how anyone could compose anything under such circumstances. Nonetheless, Gombert's *First Book of Motets for Four Voices*, published in Venice in 1539 and apparently compiled as a propitiatory gesture, contained both earlier and newly written pieces. The collection seems to have been woven into a unified rhetorical statement. The texts of the motets utter pleas for deliverance from sins of the flesh, evil, lies, and false accusations. They also call for mercy, pardon, the Virgin's intercession, and rescue from the sea. Meanwhile, older compositions recall Gombert's worthy service at the imperial court.[28] Thus, the opening text of the book declares: "Lord, Father and God of my life, do not give me lifting up of my eyes, and turn away from me every depraved desire. Take from me the desire of love, and let not desires of copulation take hold of me, and do not hand me over to an irreverent and unbridled spirit."

The closing two motets are set to the texts of the prayer of the dead and the story of Peter walking on the water to Jesus,

> God, creator and redeemer of all the faithful, grant remission of all sins
> to the souls of all the faithful dead, that they may perceive the
> kindness for which they have always hoped by their pious prayers.

> "Lord, if it is you, bid me come to you over the waters." And
> stretching out his hand he caught hold of him, and Jesus said, "You of
> little faith, why do you doubt?"

> When he saw the strong wind coming on, he was afraid, and as he
> began to sink, he cried out, "Lord, save me." And stretching out his
> hand he caught hold of him, and Jesus said, "You of little faith, why do
> you doubt?"

Gombert rose in the imperial service through his musical talents. Having fallen, he appears to have hoped to regain Charles v's grace by the same abilities for which he received it in the first place. Geronimo Scotto, the Venetian printer who compiled the anthology on Gombert's behalf, meanwhile dedicated the volume to the Spanish nobleman and general Alfonso d'Ávalos (see fig. IV-38), Charles v's governor of Milan, a man in a position to intercede:

> To the Great Marchese del Vasto [from] Geronimo Scotto. It is a great oversight, most illustrious Prince, which seems to be my own, not to publish the Music and compositions of Nicolas Gombert, knowing full well the artifice, the invention, and the harmony which are born of his truly Divine genius. But had the matter not been resolved for me by your Excellency, great doubts would have been born in me, because in bringing such work forward

one would become indebted to the glory of the famous Gombert, coming into light only under its shadow.

If Jerome Cardin is correct, Gombert's "swan songs" succeeded in freeing him from imprisonment. They did not restore him to the imperial service but did allow him to conclude his career and his life with relative dignity, as a humbled canon in Tournai.

SECULAR SONGS

While sacred polyphony enjoyed the highest esteem by offering a chance at religious epiphany, secular songs provided pleasure and entertainment and thus continually enriched life at court. (As we have seen, Charles, Duke of Orléans, even had a song, *Madame, je suis plus joyeux*, embroidered on his dress with hundreds of pearls.[29]) Singing was considered an indispensable facet of noble living. Young aristocrats and princes were taught to sing from an early age. The son and four daughters of the Catholic Monarchs of Spain, for example, were instructed by royal musicians. The court official Gonçalo Fernández de Oviedo recorded that

> my Lord prince Juan was naturally inclined to music and he understood it well, although his voice was not as good as he was persistent in singing; but it would pass with other voices. And for this purpose, during the siesta time, especially in the summer, Juan de Anchieta, his chapel master, and four or five boys, chapel boys with fine voices...went to the palace, and the prince sang with them for two hours, or however long he pleased to, and he took the tenor, and was very skillful in the art.[30]

Fernández de Oviedo's comments may represent a veiled discontent at countless disturbed siestas. Nonetheless, vocal education and musical pleasure formed an integral part of elite upbringing.

According to Baldesar Castiglione's *Book of the Courtier*, moreover, his lord, Guidobaldo da Montefeltro of Urbino proclaimed, "Gentlemen, you must know that I am not satisfied with our Courtier unless he be also a musician, and unless, besides understanding and being able to read music, he can play various instruments."[31]

Most Renaissance aristocrats and rulers played and many composed music, both vocal and instrumental. Lorenzo de' Medici wrote dances and songs, including racy carnival ditties. Henry VIII Tudor is credited with writing Masses; he also sang and played organ, lute, and virginal. One royal manuscript, a Latin psalter, depicts King David as Henry with a harp (fig. V-13). (The bulk of Henry's music was, of course, written and performed by professional musicians, some fifty-eight of whom he employed.)

Isabella d'Este was another accomplished musician. She played the cittern, clavichord, and *lira da braccio* (for improvisational music) and studied lute with Giovanni Angelo Testagrossa (fig. V-14). She also took voice lessons from Johannes Martini while still living in Ferrara, at the court of her father, Ercole d'Este. Having married and moved to Mantua, she was eager for further training. Writing home she implored: "Illustrious Lord and Father: I want to study the rules of singing and, not having anyone here who would satisfy me as would Zohan Martino...[who] has taught me previously, I pray your Excellency to be so kind as to send him to me for fifteen or twenty days."[32]

According to contemporary accounts, Isabella had a fine voice. In a letter of 1505 the humanist Pietro Bembo wrote to her, "I also wish that some of my verses could be recited and sung by Your Ladyship, remembering with what sweetness and suavity Your Ladyship sang."[33] Bembo was, of course, an experienced courtier, well versed in the uses of flattery. But Isabella did bear particular love for vocal music, and with her arrival at the Mantuan court in 1490 the size of the musical establishment there grew, and special emphasis was placed on vocalists.

Isabella began to concern herself with the Mantuan musical forces even before her marriage to Francesco Gonzaga. On 15 October 1489 she wrote to her future husband:

> I have heard that your Excellency has allowed Antonio, your player of pipe and tabor, to depart perhaps because of his insistence that his salary is not what he thinks he merits compared to the good treatment that the other instrumentalists of your Lord enjoy. Since he bears such a good reputation among the other players of pipe and tabor, I would be particularly pleased for him to remain with your Lordship, hoping myself to enjoy his merit at some time with the pleasure and permission of your Excellency, to whom I pray to be in your good will that you may wish to retain him still in your service.[34]

Good instrumentalists and singers of secular music were prized commodities. A certain Johannes Orbo of Munich, who played "marvelously every instrument" and sang lyric poetry set to music, worked in Mantua from 1470 to 1475. Galeazzo Maria Sforza and King Ferrante of Naples both wrote to request his services. Marchese Ludovico Gonzaga respectfully declined:

> Most Illustrious [Galeazzo Maria], etc.: I have seen how much your most illustrious Lordship writes requesting Orbo, the player from Munich, to which I reply that I want to satisfy your

Fig. v-14.
BARTOLOMEO VENETO AND WORKSHOP (Italian, active 1502–1555), *Lady Playing a Lute*, ca. 1530. Oil on panel, 55.9 × 41.3 cm (22 × 16¼ in.). Los Angeles, The J. Paul Getty Museum, inv. 78.PB.221.

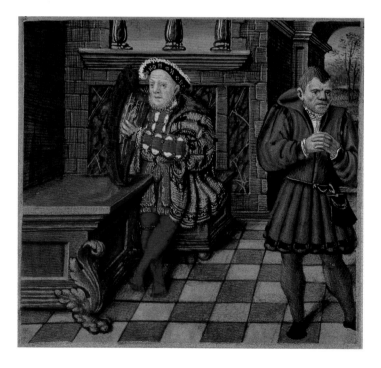

Fig. v-13.
Henry VIII with a harp.
From *Psalter of Henry VIII.* London, The British Library, Man. Roy. 2 A XVI, fol. 63v. By permission of The British Library.

every wish and pleasure where possible and would be pleased if he were to come, but there has been the greatest difficulty in the world in convincing him to come even to Mantua because he is the most suspicious man ever heard of and, outside his playing, he lives like a child and has taken this whim: that Italian instrumentalists will poison him for jealousy. Neither will he eat anything except what my daughter [Margaret of Bavaria] the most illustrious Consort of Federigo [I Gonzaga] has prepared for him by her ladies, in whom he has faith; neither will he eat anything prepared by my cooks.[35]

One could well suspect Ludovico of inventing a convincing excuse for not lending a beloved musician for fear of having him usurped for good, especially by such notoriously voracious patrons.

Fig. V-15.
LORENZO COSTA (Italian, ca. 1459/1460–1535), *A Concert*, ca. 1485–1490. The musical instrument is a *lira da braccio*. Oil on wood, 95.3 × 75.6 cm (37½ × 29¾ in.). London, The National Gallery, inv. NG 2486.

As did their colleagues in the chapel choir, secular musicians traveled when their employer so demanded, delighting their lord not only at court or at war, but even in prison. In 1509 Isabella's husband, Francesco Gonzaga, then commander of the French forces within the League of Cambrai, was captured at Legnano and taken prisoner by the Venetians. Given his stature, his incarceration was not unduly harsh. He was visited by the master of his stable, horses being his greatest love. Secular songs further eased his confinement, as did his own musical compositions. He sent his favorite pieces to his wife: "Illustrious Lady [and] beloved companion: We are sending to your Ladyship the enclosed *strambotto* that we like so much, together with the music that we have just written, believing that it must please you as much as it has us."[36]

Isabella reciprocated by dispatching Marchetto Cara to soothe her imprisoned spouse. Marchetto Cara lived and worked in Mantua from 1494 to 1525, from age 29 until his death at age 60. He played lute and sang, composed secular music, served as *maestro di capella* of the marchese's chapel, and accompanied Francesco Gonzaga to war. In 1495 he was in the latter's entourage when the marchese led the Italian forces against Charles VIII of France at Fornovo. Cara was a particularly prolific and renowned composer of *frottole*—improvised musical settings of verse typically devoted to subjects of love, some melancholic, other humorous—performed to the accompaniment of *lira da braccio* (fig. v-15). This Italian musical genre was especially nourished by Isabella.[37] Cara's works entered virtually every printed collection of *frottole* during his lifetime, and his reputation prompted other rulers, as well as poets, to send lyrics to him to be set to music. Accompanied by his wife, Giovanna Moreschi, Cara shuttled frequently between the palaces of the Gonzaga clan to entertain its different members. Castiglione celebrated the beauty of his singing in *The Book of the Courtier*:

> Consider music, the harmonies of which are now solemn and slow, now very fast and novel in mood and manner. And yet all give pleasure, although for different reasons, as is seen in Bidone's manner of singing which is so skilled, quick, vehement, impassioned, and has such various melodies that the spirits of his listeners are stirred and take fire, and are so entranced that they seem to be uplifted to heaven. Nor does our Marchetto Cara move us less by his singing, but only with a softer harmony. For in a manner serene and full of plaintive sweetness, he touches our souls, gently impressing a delightful sentiment upon them.[38]

When Cara set off to visit the imprisoned Francesco Gonzaga in Venice, he went together with the lute player Giovanni Angelo Testagrossa, Isabella d'Este's teacher. Testagrossa reported to his mistress on the progress of the visit:

> My most illustrious Lady,
> We arrived at Venice last Sunday and, as soon as we had dismounted, we went to S. Marco, and, after a short time, the Prince [Doge] and all of the *Signoria* came out, and when the Prince saw Messer Folenghino [a Gonzaga messenger], he greeted him most warmly.... I went to visit [the Marchese], and he embraced me and kissed me at least twice on the mouth, holding me tightly to him. And through me he duly commended himself to your Ladyship. ... After we finished talking, Messer Marchetto began to sing with his companions, and I began to play, so much that it was almost an hour after sunset when we left; and while singing and playing, his Lordship remained cheerful and laughing in enjoyment.[39]

INSTRUMENTAL MUSIC

Music can readily frame actors and events and instantly produce a particular mood. Instrumental music was, therefore, an indispensable component of life at court, creating a stately or festive atmosphere as the occasion demanded.[40] Heraldic minstrels, who played loud instruments—trumpets, tambourines, and bagpipes (*saqueboutes*)—served to attract and focus attention on a ruler and his actions. A miniature from an illuminated manuscript illustrates a royal entry: trumpets proclaim the approach of the king (fig. v-16). Trumpet fanfares framed all triumphal and military displays: They solemnized parades and great entries, punctuated the reading of proclamations, announced the opening of tournaments and the arrival of new dishes at banquets (fig. v-17). Reserved for the nobility, trumpets were markers of honor and distinction. Hence trumpeters were figures of importance at court; they were dressed in armor when attending their lord on the battlefield and regularly dispatched on diplomatic missions.

The social and martial significance of heraldic music demanded sophisticated technique. Dramatic fanfares and crucial battle signals could not be entrusted to amateurish or poorly trained players.[41] Correspondence between Christian III, King of Denmark, and Augustus, Elector of Saxony, sheds light on the refinement of this art. In 1548 Augustus's daughter, Anna, had married Christian III, and the two courts became linked politically and culturally. Thus, on 3 February 1557 Christian wrote to his father-in-law:

We hope that Your Highness will have paternal and Royal concern that some of our best trumpeters, who could play on all sorts of instruments, have left our service. Therefore, although we still have a few (who are good trumpeters and instrumentalists), we nevertheless require some good replacements as we wish them to practice the Italian style. Knowing that Your Highness's trumpeters play the Italian style better than others, we would really and truly like to have some of these, as many as you can spare.

Furthermore, we hope that Your Highness would paternally and Royally like to help us by permitting us, through your trumpeters, to obtain the Italian blowing-at-table and cavalry signals, just as Your Highness's trumpeters play them, written down in musical notation and with a descriptive commentary, so that ours may be able to establish the same style properly.

We also need a timpanist: could Your Highness, through your trumpeters, send us an apprenticed youth who can play timpani, and, moreover, a trumpeter, who is also an apprenticed youth, and who can play the Italian style and also cornets, schwerpfeiffs and other instruments at court? We would also like Your Highness to inform us of the fees and maintenance for good employ, for we are also troubled with these trifling things. All of these things, as stated above, will be used at court so that Your Highness will not complain that we have presumed to trouble Your Highness so much.[42]

Fig. V-17.
Jean Fouquet (French, ca. 1333–ca. 1405), *Banquet in Honor of Emperor Charles IV*. From *Les Grandes Chroniques de France*, ca. 1460. Paris, Bibliothèque nationale de France, MS. fr. 6465, fol. 444v.

Augustus's reply further illuminates the value, training, and fashions in heraldic music:

> In all friendliness we must inform Your Royal Highness that recently all of our Italian trumpeters (and also the other Italian instrumentalists, apart from two who are not trumpeters) have returned to Italy, apparently because they did not get enough money for their monthly wage, despite the fact that we gave them, in addition to board and clothing, two hundred gulden per year service payment. Thus, we have no Italian trumpeters at present, only German who have learnt the Italian style. But, as none of these is an instrumentalist, in order to maintain our instrumental music, we have written to Italy for others so that we may once more provide for the same; Your Royal Highness may rest assured that we will be most diligent not to forget him.
>
> Similarly, our timpanist died only half a year ago and we have had to use the apprentice he had trained. However, we are most willing to send Your Royal Highness a boy who had been learning from him for some time, as soon as he has mastered the art of the drum-beating.
>
> Furthermore, we are sending Your Royal Highness the Italian signals for "Boots and Saddles," "Mount Up," and "To the Standard," as well as a few signals, such as "Retire" and "The Watch"; moreover, a sonata which our trumpeters use for blowing-at-table, which is set in music and is played with six parts, according to the Italian trumpeters' method, which the trumpeters will easily understand. And as the sonatas for blowing-at-table are many and are often changed, we have sent Your Royal Highness the most common and most used example.[43]

The letters make clear the complexity and diversity of heraldic performances at court, for whether in the banquet hall or on the battlefield, music reflected the status and cultivation of the ruler. The fact that rulers took time personally to negotiate such cultural exchanges attests to the consequence of music to their politics and sovereign dignity. The correspondence also indicates that, just like chapel singers, heraldic minstrels knew their worth and left employment when they did not deem it lucrative enough.

While trumpeters performed primarily on public occasions, recreational minstrels, those specializing in low or soft instruments—flutes, recorders, harps, lutes, and viols—provided a more intimate musical ambiance at smaller gatherings. Rulers themselves played in such contexts and collected instruments for their own and their musicians' use. Henry VIII's treasury, inventoried on his death in 1547, included sixteen cornets, eighteen crumhorns, thirteen dulceuses, two fifes, seventy-two flutes, one tabor pipe, seventy-four recorders, seventeen shawms, a Venetian lute, and twenty-nine viols.[44] Maximilian I's autobiographical novel *Weisskunig* included a woodcut by Hans Burgkmair showing the sovereign in his music room amid his instruments and players (fig. v-18).

Striving to procure the best artistic resources, rulers habitually assembled international musical forces. The Burgundian dukes employed instrumentalists from France, England, Italy, Germany, Portugal, Sicily, and the Low Countries. Henry VIII engaged entire foreign consorts. Thus the Venetian Bassano family, specializing in winds, moved to England to form a recorder consort at the Tudor court. Apparently Jewish refugees from the town of Bassano, some forty miles from Venice, this family had relocated to

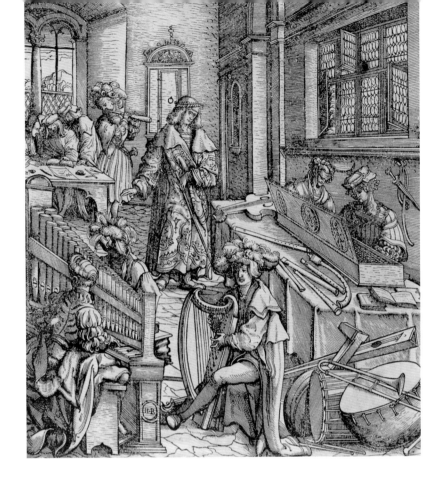

Fig. v-18.
Maximilian I Habsburg in
His Music Room. Woodcut.
From Hans Burgkmair
the Elder (German, 1473–
ca. 1531), *Weisskunig*,
ca. 1512 (facsimile,
Stuttgart, 1956), pl. 28.

Venice in the early sixteenth century and thence made their way across the English Channel. Religious persecution in Europe and Henry VIII's stance vis-à-vis the Catholic church drew numerous Jews to the Tudor court. They came not only from Italy but also from Spain and Portugal in the wake of their expulsion from the Iberian peninsula.[45]

The Bassano brothers—Alvise, Anthony, Jasper, and John—first worked for Henry in the 1520s and 1530s. For some reason they then went back to Venice. Henry took pains to secure their return. Letters flew back and forth between the Tudor court and the Venetian Republic, and on 6 April 1540 Henry was finally pleased to grant stipends to "Alvixus, John, Anthony, Jasper and Baptista de Bassani, brothers in the science or art of music."[46] He established them, apparently at no rent, in the former monks' quarters of the dissolved monastery of the Charterhouse between Aldersgate and St. John Streets, just outside and northwest of the City of London. Among the perks of their employment he bestowed upon them the courtesy titles of "gentlemen," and upon Anthony a license to import Gascon wine (for musicians, as well as other court artists, commonly engaged in multiple occupations to augment their incomes or elevate their social standing). Anthony had also been appointed "maker of divers instruments of music" to the court in 1538, his creations being "so beautiful and good that they are suited for dignitaries and potentates."

High-quality musical instruments were luxuries: fashioned from costly materials, turned into marvelous shapes, and frequently presented as gifts to lofty recipients. A fifteenth-century Italian rebec, for example, has been embellished with a figure of Venus derived from a famous ancient statue type (fig. v-19). An early sixteenth-century *lira da braccio* made by Giovanni d'Andrea in Verona transformed the body of the instrument into a monster's head (fig. v-20). And a group of shawms of Italian or South

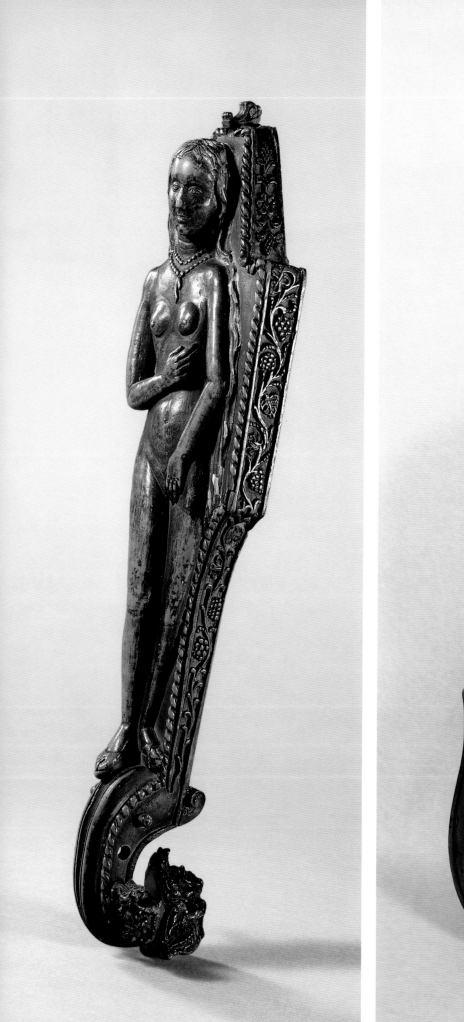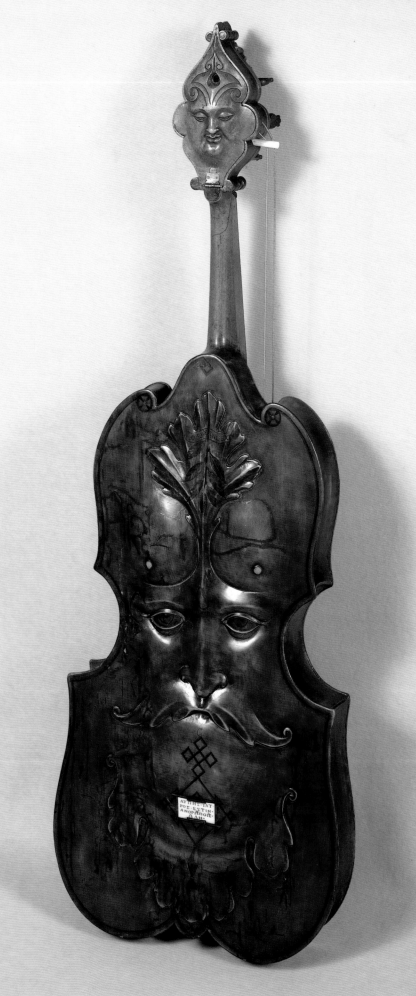

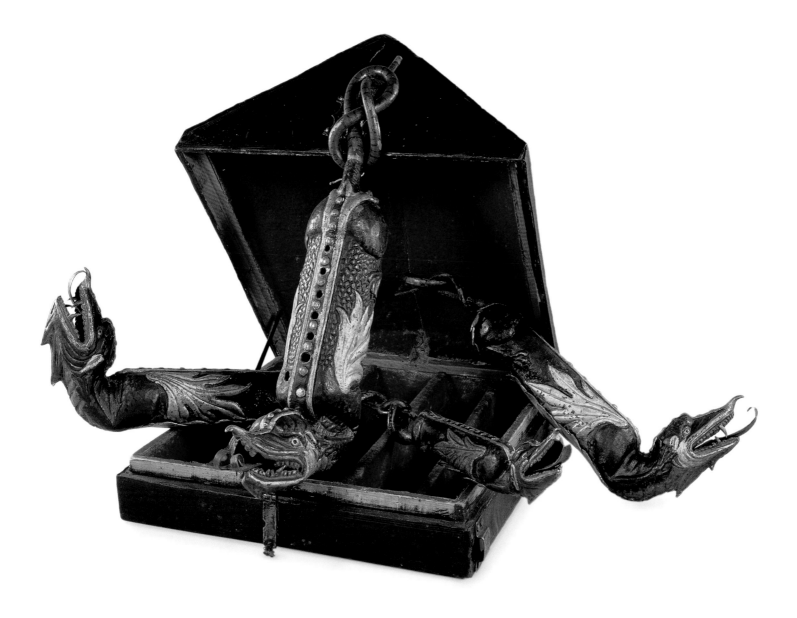

Fig. v-21.
Dragon shawms, Italy or
Southern Germany, six-
teenth century. Vienna,
Kunsthistorisches Museum,
inv. SAM 208–11.

Fig. v-19.
Rebec with a Medici Venus
decoration, Italy, fifteenth
century. Vienna, Kunst-
historisches Museum,
inv. SAM 433.

Fig. v-20.
Giovanni d'Andrea, *Lira da
braccio* embellished with a
monster head, Verona, 1511.
Vienna, Kunsthistorisches
Museum, inv. SAM 89.

German origin took the form of green dragons with yellow mouths and wings (fig. v-21). In 1518 Pope Leo x gave his master of ceremonies, Paride de' Grassi, "a very beautiful clavicembalo, or excellent monochord, which he used to have in his chambers, . . . because he knew that I delighted greatly in its sound. . . . And it was worth 100 ducats" (a year and a half of de' Grassi's salary).[47] Rulers and ecclesiastical institutions of France, Spain, and Germany happily possessed the Bassano creations.[48] Among the pieces offered for sale to the Bavarian court in 1571 were three lutes of black ebony linked with ivory, and five flutes of ivory tipped with enameled gold.[49]

Bassanos continued to serve as Tudor musicians for 125 years, eventually rising to the loftier realms of law and government service. It has been proposed that one member of the clan, the poet and courtesan Emilia Bassano, daughter of Baptista, may have been the "dark lady" of Shakespeare's sonnets. She may have inspired the Venetian, Jewish, and North Italian themes in *The Merchant of Venice, Two Gentlemen of Verona, The Taming of the Shrew*, and *Othello*.[50]

Like other forms of music, dance was a crucial ingredient of noble education and constituted a vital part of courtly life. In honor of births, weddings, and important visitors; at the conclusion of jousts and tournaments; and in celebration of holy days of the Christian calendar, rulers danced with pleasure and skill and strove to achieve perfection.[51] For along with classical languages, philosophy, and mathematics, dance counted as an *ars liberalis* and was thus an invaluable asset to an aristocrat. In antiquity music held a lofty place and encompassed the mastery of instruments, recitation of poetry, and dance.[52] As heirs of antiquity, Renaissance rulers considered musical training, including dancing, an attribute of their class.

Instruction in dance commenced as soon as a noble child began to enter the demanding world of courtly functions. Isabella d'Este started to learn this art from her dance master Guglielmo Ebreo at age six. Dancing helped to shape the whole person. It produced vigor and nimbleness of the body and quickness and precision of the feet—outward expressions of an equally strong and agile mind. Dancing also taught poise and grace required of a person of noble birth, as well as consideration for others—since the dancer had to adjust his or her steps and position to the available space and to other dancers. The intricate and elegant choreography of dances demanded discipline and memory—qualities useful, not only in the ballroom, but also in the halls of government. Furthermore, dancing ability closely related to military prowess. The teaching of military skills, such as fencing and riding, often fell within the range of competencies and duties of the dance master.

The most dignified and prestigious court dance was *basse dance* or *bassadanza*, literally a low dance, because of its slow and restrained movements with minimal elevation of feet and knees. A miniature by Jean de Wavrin in the *Chronique d'Angleterre* illustrates its stately grace and performance to the sound of a pipe and two cornets (fig. V-22).[53] *Basse dance* flourished particularly at the Burgundian court, whence it was exported to Italy and other parts of Europe. Performed by couples and usually set to music based on French chansons, *basse dance* employed established step units combined into codified patterns. Contemporary dance manuals stressed lightness and elegance of motion to be achieved by raising and lowering the body in a wavelike manner. A miniature by Loyset Liédet in the *History of Renaud de Montauban*, executed for Charles the Bold, captures something of this undulating progress (fig. V-23). Dance manuals provided notations for both the steps and the music, setting down a single line of a secular song (usually tenor used purely instrumentally) and corresponding choreographic movements shown by letters next to each note. A particularly refined manuscript with black leaves from the collection of Margaret of Austria indicates the music and the steps in silver and gold ink (fig. V-24).

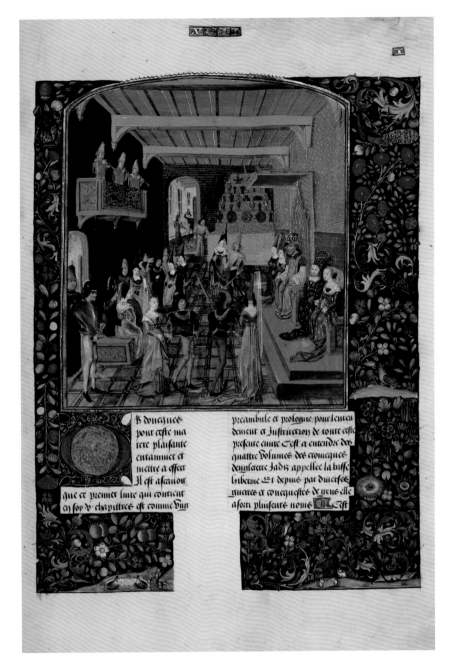

Fig. V-22.
Basse dance. From Jean de Wavrin (b. 1400), *Chronique d'Angleterre*, ca. 1471. Vienna, Österreichische Nationalbibliothek, Cod. 2534, fol. 17. Photo: Bildarchiv der Österreichischen Nationalbibliothek.

Ballo—an Italian invention—was a much quicker court dance with frequent changes of meter and tempo, more complex and varied choreography, and jumps and flourishes that required more active movement of the feet. It used a variety of figures and floor patterns: At times the dancers moved side by side, at other times in lines, squares, triangles, or in longways formations. Most of the *balli* expressed a play between the sexes: approaches and retreats, echoing and mirroring, circling and encircling—often accompanied by an ever-increasing tempo. The changes of tempo and meter emphasized specific gestures and heightened dramatic movement, turning the dance into a kind of theatrical enactment.[54]

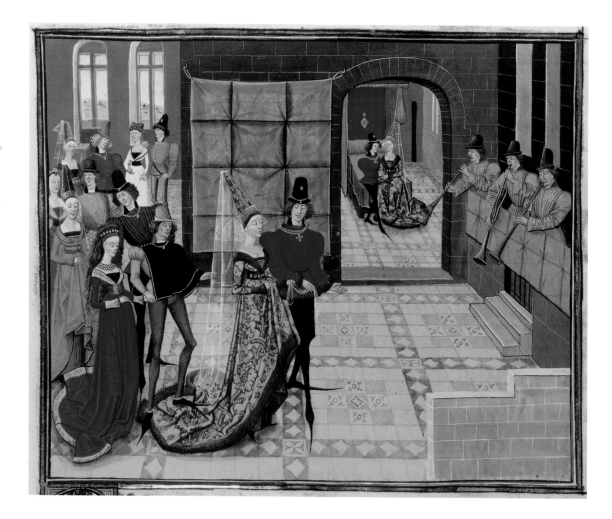

Fig. V-23.
Loyset Liédet (d. 1478),
Basse dance. From *History
of Renaud de Montauban,*
ca. 1468–1470. Paris,
Bibliothèque de l'Arsenal,
ms. 5073, fol. 117v.

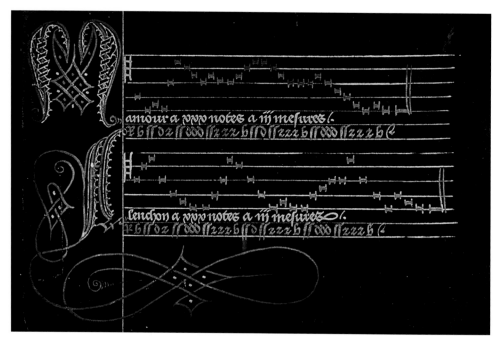

Fig. V-24.
Two *basses dances* from
the collection of Margaret
of Austria, ca. 1485, show-
ing notes and the sequence
of steps to be danced.
(R = *révérence,* or bow;
b = *branle,* a rocking
motion; s = two single
steps; d = double step; and
r = reprise.) Brussels,
Bibliothèque royale de
Belgique, ms. 9085, fol. 12.

The complexity of steps, timing, and space management in court dances necessitated the intervention of a professional dance master, who instructed young aristocrats in the basics of the art and taught specific or new dances in preparation for major events, such as weddings or receptions of dignitaries. Dance masters competed in offering their services to patrons, as several letters directed to Lorenzo de' Medici on the eve of his wedding attest. Thus Filippus Bassus wrote from Pisa on 10 April 1469:

> My magnificent and most distinguished and honorable lord: In the last few days I have learned that your Magnificence is about to bring your wife to the upcoming May festivities and that you are preparing a noble and triumphant celebration. This gives me the greatest pleasure for all your consolation and well being. A little before the Carnival I left Lombardy with the children of the Magnificent lord Roberto [Prince of Salerno] whom I have taught to dance and from that area in Lombardy I have brought some elegant, beautiful and dignified *balli* and *bassadanze*. These things are indeed worthy of lords such as yourself and not of just anyone. And I firmly believe that if your Magnificence were to see them performed, you would like them exceedingly and you would wish to learn them since they are so beautiful and delicate. Consequently, I have almost decided to come, if it pleases you, of course, to help honour you festa. And if you would like to learn two or three of these *balli* and a few *bassadanze* from me, I would come eight or ten days before the festa to teach them to you with my humble diligence and ability; and in that way it will also be possible to teach your brother Giuliano and your sisters so that you will be able to acquire honour and fame in this festa of yours by showing that not everyone has them [the dances], since they are so little known and rare. And thus I beg and pray, press and urge you to accept this unworthy and small offer of mine. [There is] nothing else to say now except that I recommend myself to Your Magnificence, for whose pleasures I offer my unfailing and ready service.[55]

Only the loftiest individuals could afford to retain private musicians and dance teachers. Wealthy citizens seeking to augment their festivities and social standing hired civic players for one-time engagements and danced well-familiar rather than new or custom-tailored dances. A fifteenth-century Florentine cassone (wedding chest) made for the nuptials of Boccaccio Adimari and Lisa Ricasoli depicts the performance of the *chiarenzana*, a popular wedding dance (fig. v-25). Five richly attired couples—the groom and the bride are last, she wears a hat of peacock feathers, and he a costly scarlet tunic—step to the music of three shawms and a slide trumpet just outside the Baptistry. The banners suspended from the instruments indicate that the musicians are employed by the city of Florence.

Two of the Renaissance dance masters best known today owe their fame not only to their services at a number of Italian courts but also to their written legacy—the treatises in which they set down the theoretical principles of their art as well as specific choreographies. Domenico da Piacenza was credited with fashioning and perfecting the *ballo*, although his book *On the art of dance and constructing dances* (ca. 1455) includes both *balli* and *bassadanze*, along with corresponding music.[56] The theoretical portion of the work explains that dancing, like the art of rhetoric, depends on a number of crucial components: *aere*, or graceful carriage; *memoria*, remembrance of the steps and their sequence; *maniera*, execution of the steps with suppleness and undulating motion; *misura*, keeping time with the music; *misura di terreno*, proportion of the steps to the available space; and *diversità di cose*, nuanced variation of steps to avoid dull

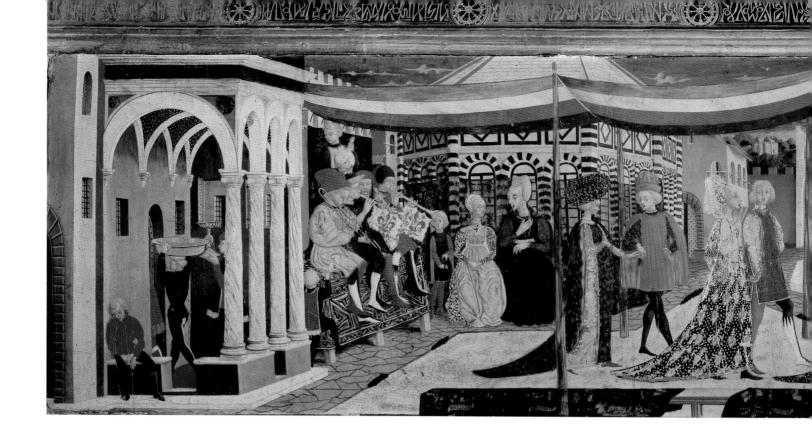

Fig. v-25.
MASTER OF THE ADIMARI
CASSONE (1406–1480?),
A wedding party dancing
the *chiarenzana* at the
wedding of Boccaccio
Adimari and Lisa Ricasoli,
ca. 1450. Distemper on
wood, 63 × 280 cm
(24 × 110¼ in.). Florence,
Galleria dell'Accademia.
Photo: Erich Lessing/Art
Resource, NY.

uniformity. Such terminology, as well as other aspects of dance, including the figures and patterns formed by the performers moving in space, influenced theoretical discussions of contemporary painting. The language by which dance was elucidated and treated as a form of intellectual activity derived from ancient oratory. When theorists of painting came to formulate their explanations of that art, they looked to the verbal language of rhetoric and the visual language of dance to articulate the arrangement of figures and compositions in pictures. Michael Baxandall argues that painters relied on their viewers' familiarity with dance in devising pictorial compositions.[57]

Domenico da Piacenza's self-professed disciple Guglielmo Ebreo da Pesaro enjoyed high repute and created dances for major festivities—weddings and carnivals, entries and state visits—at the courts of Camerino, Ravenna, Urbino, Milan, Florence, Naples, and Ferrara, where he taught Isabella d'Este. Whether for convenience, safety, advancement in his profession, or aspiration to knighthood, Guglielmo converted from Judaism to Christianity sometime between 1463 and 1466 and assumed the name Giovanni Ambrogio. In 1469 he was knighted by Emperor Friedrich III in Venice. Guglielmo's treatise, *The Practice or Art of the Dance* (1463), dedicated to Galeazzo Maria Sforza, opens with a theoretical introduction that emphasizes that dance is both an art and a science and seeks to prove its moral and ethical worth.[58] The dances themselves—the *bassadanze* and *balli*—are recorded with their choreographies and music. The book's single illustration shows a man, perhaps Guglielmo himself, leading two women in a dance to the music of a harp (fig. v-26). He holds each woman by one finger. All three, perfectly erect, step forward with their right foot and create undulating movement with their hips, their rocking motion emphasized by the folds of the women's skirts. Guglielmo places great weight on music itself, stating that "dancing is drawn and born from music as an outward show of its true nature, and without this harmony or consonance, the art of dancing would be nothing, nor would it be possible to do." The

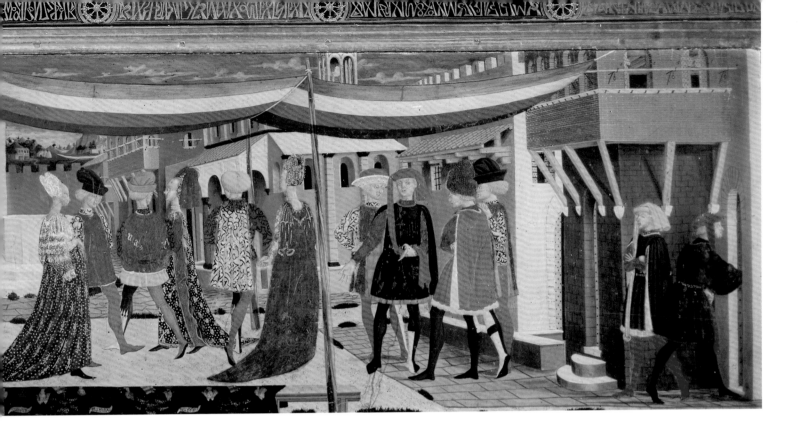

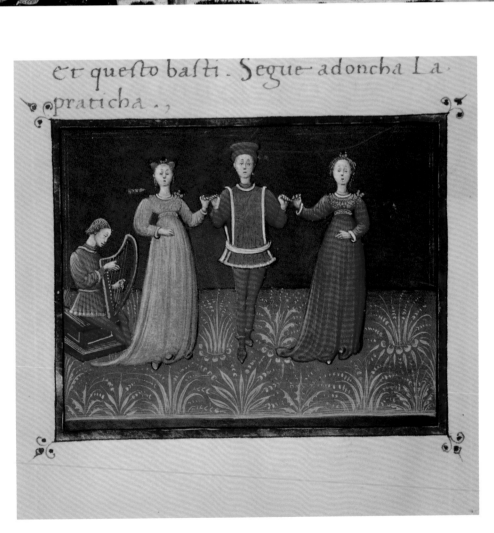

Fig. v-26.
Guglielmo Ebreo
(Giovanni Ambrogio, ca.
1420–ca. 1481), *The Practice
or Art of the Dance*, 1463.
Paris, Bibliothèque nationale
de France, ms. Italien 973,
fol. 21v.

choreography of his *balli* complements the music to exquisite effect; a good dancer must even be able to shape his performance to the style and character of particular instruments, a requirement that presupposes a very sophisticated musical understanding on the part of the dancer.

Bassadanze and *balli* expressed courtly and aristocratic refinement, both physical and mental. The *moresca*, another highly popular dance at courts across Europe, was, in contrast, mostly a spectator sport of the aristocracy, as it was performed primarily by professional dancers accompanied by pipe and tabor. Baldesar Castiglione admonished that if a courtier wished to dance the *moresca*, he had best do so in private.[59] Clearly it was perceived as not dignified enough for a man or woman of worth.

The constant threat of Muslim invasion lay behind the *moresca*—initially a theatrical enactment of a battle between Moors and Christians in Spain. Later the dance pitted a wide variety of opponents, and the name *moresca* became synonymous with the unusual and the exotic. The choreography of this dance underwent a continuous

Fig. v-27.
WORKSHOP OF JEAN DE WAVRIN (b. 1400), *Moresca*. From *Histoire du Chevalier Paris*(?), France, 1464. Brussels, Bibliothèque royale Albert 1ᵉʳ, MS. 9632–33, fol. 168r.

Fig. v-28.
ERASMUS GRASSER (German, ca. 1450–ca. 1518), *Moresca* dancer from the dance hall of the Munich town hall, 1480. Lindenwood, H. 63 cm (24³⁄₄ in.). Munich, Stadtmuseum, inv. Ic/225.

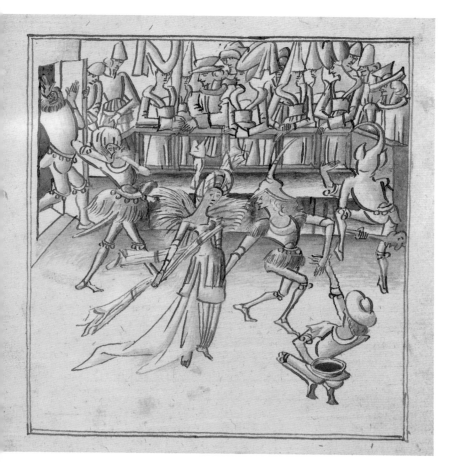

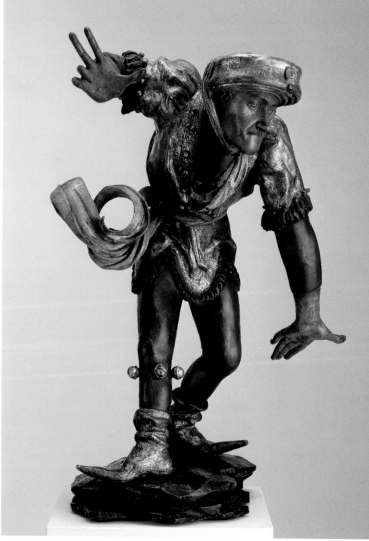

CHAPTER V

Fig. v-29.
Erasmus Grasser (German,
ca. 1450–ca. 1518), *Moresca*
dancer from the dance hall
of the Munich town hall,
1480. Lindenwood, H. 64 cm
(25¼ in.). Munich,
Stadtmuseum, inv. Ic/228.

evolution from the twelfth century onward, but the primary elements persisted: the confrontation of two lines of actors, variations on a circular formation, and the solo dance often performed by a woman with sinuous, gyrating movements (think of the dance of Salome; fig. v-27). Originally the *moresca* involved the blandishment of swords, but later they were replaced by sticks, castanets, or kerchiefs. The comic element often formed a significant part of the spectacle. Combatants missed one another, were carried forward by the strength of their own thrust, and stumbled into their new place in the formation to face the next adversary. Individual dancers displayed virtuosity through exaggerated movements and great leaps. A series of ten statuettes carved by Erasmus Grasser in 1480 for the dance room of the Munich town hall captures the intricacy and humor of the *moresca* (figs. v-28–30).[60] The carved men execute complex steps with crossed feet and contrasting gestures of arms and hands. Their backs arch, they bow, leap, tap their feet, and make comical faces. Bells tied to their legs, arms, and fanciful costumes add further liveliness to their act.

Fig. v-30.
Erasmus Grasser (German,
ca. 1450–ca. 1518), *Moresca*
dancer from the dance hall
of the Munich town hall,
1480. Lindenwood, H. 61 cm
(24 in.). Munich, Stadt-
museum, inv. Ic/ 229.

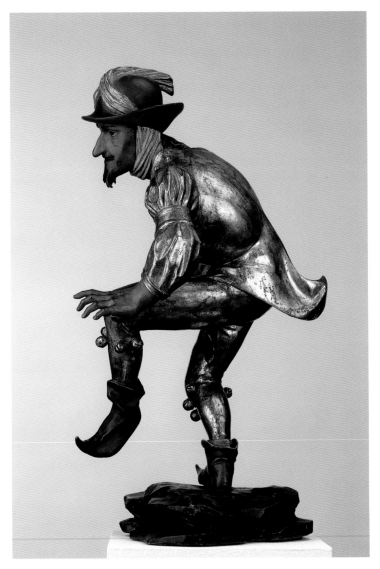

Fig. v-29.
Erasmus Grasser (German, ca. 1450–ca. 1518), *Moresca* dancer from the dance hall of the Munich town hall, 1480. Lindenwood, H. 64 cm (25¼ in.). Munich, Stadtmuseum, inv. Ic/228.

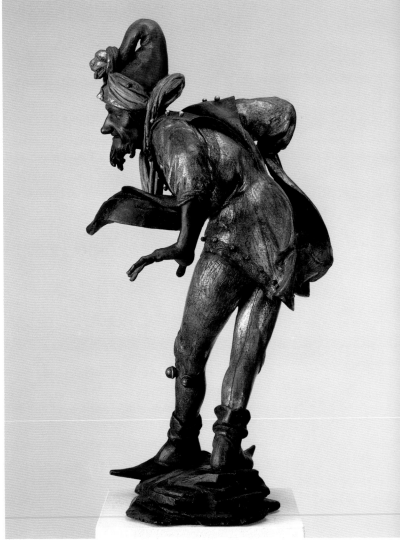

Fig. v-30.
Erasmus Grasser (German, ca. 1450–ca. 1518), *Moresca* dancer from the dance hall of the Munich town hall, 1480. Lindenwood, H. 61 cm (24 in.). Munich, Stadtmuseum, inv. Ic/ 229.

Many *morescas* entailed elaborate costumes and masques. At the wedding of Charles the Bold and Margaret of York one *moresca* was danced by men in the guise of monkeys, and another by Sirens engaged in a mock battle with sea knights. When courtiers and princes did take part in this dance, they, too, concealed their identity behind imaginative attire. One such disguise, however, led to a disaster. In January 1392, during the nuptials of a Norman knight and a lady-in-waiting to the French queen, King Charles VI of France and several noblemen decided to dance a *moresca* in wildmen costumes. The king's brother, Louis of Orléans, curious to discover who was hidden behind the elaborate getup, brought up a lit torch too close to the performers. Accidentally—or not—he set the revelers on fire. Four men died of burns. The king was barely saved. The duchess of Berry recognized him in the nick of time and threw her ermine mantle over his body, extinguishing the flames. The event went down in history as the *Ball of the Burning Ones* and was immortalized in the *Grandes Chroniques de France* (fig. v-31).[61]

COURT FESTIVITIES AND MUSIC

Renaissance sources, both written and pictorial, demonstrate that music—sung, played on instruments, and danced—was paramount to contemporary spectacles of power. Consider the accounts of the Feast of the Pheasant devised by the duke of Burgundy, Philip the Good, to rally the European nobility to the defense of Christendom after the fall of Constantinople.[62] The feast, staged at Lille on 17 February 1454, took place in a banqueting hall lined with tapestries narrating the Labors of Hercules. Three long tables stood covered with tablecloths of silk damask draped to the floor, while cushions embroidered with the ducal coats of arms softened the bench seats. The duke's place was distinguished by a canopy of black cloth of gold. A nearby buffet gleamed with precious plate studded with gems. In the center of the hall the figure of a naked woman with flowing hair and sweet wine spouting from her breasts stood chained to a column and was guarded by a live lion. She symbolized the captured Constantinople protected by the duke, the Lion of Flanders. On the ducal table rose a church, complete with stained-glass windows. Inside it three choirboys and a tenor sang to the accompaniment of an organ. At another table a huge pastry enclosed twenty-eight musicians who sang and played on recorders, rebecs, lutes, horns, dulcians, bagpipes, and a German cornet. The church and the pastry performed a musical number after every course of food and entertainment.

Eyewitnesses report that music punctuated and embellished the entire proceeding. Once the guests settled down at their tables, a musician in the church rang a "very high" bell, and three choirboys and the tenor inside the church performed "a very sweet chanson." Then a musician dressed like a shepherd played a bagpipe in a most novel fashion. Later a horse entered the hall backwards with two trumpeters sitting back to back astride it, blowing fanfares. The organ in the church played again, followed by the German cornet from within the pastry, sounding "very strange." As the feast progressed, music was presented in different theatrical configurations. Polyphonic chansons sung by ducal vocalists were followed by fanfares played on golden trumpets by musicians clad in white. These were followed by a wondrously great and beautiful white stag with golden antlers ridden by a twelve-year-old boy who sang either Dufay's or Binchois's chanson *Je ne veiz onques la pareille* (I have never seen one like it) in a high clear voice,

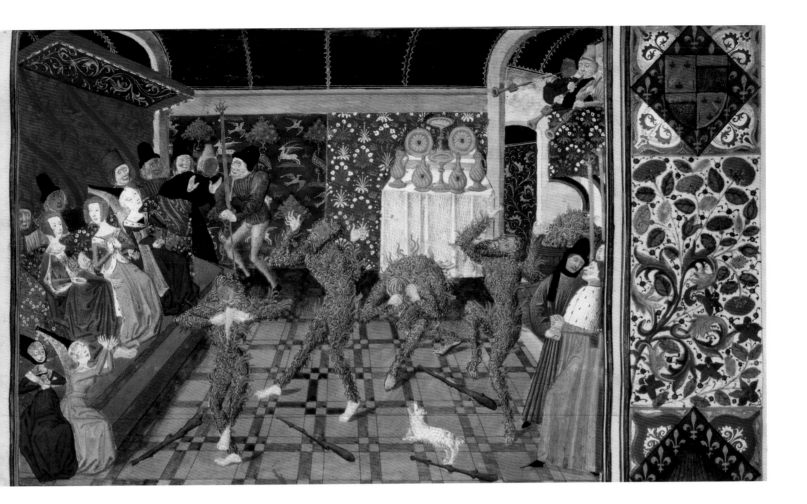

while the stag accompanied him in a tenor. A play entitled *The Mystery and Adventure of Jason*, presented on a stage, was opened by the choristers in the church, who sang the prologue, and a fanfare of four clarions hidden behind the stage curtain; it closed with an organ piece and a performance by four recorders.

At the culmination of the banquet a Saracen giant led an elephant into the hall. Within a fortified tower balanced on its back sat a lady "dressed in a robe of white satin very simply made in order to show her high birth and the noble place from whence she had come." She represented the Holy Church held captive by the infidel, and she leaned on the rampart of the tower, which stood for the faith. The Holy Church performed a motet of the *Lamentation of Constantinople* in a "piteous womanly voice," begging the duke and the assembled nobles to take up her defense. The most solemn component of the feast was thus rendered more splendid and weighty by being cast in a musical form. At the conclusion of the evening the tables were removed for the dance, conceived with as much care, political significance, and whimsy as the rest of the spectacles. "Into the hall entered by the great portal a horde of torch-bearers followed by many players on diverse instruments such as tabors, lutes, and harps." They were followed by a lady symbolizing the Grace of God and twelve masked knights, each bearing a torch and leading a lady representing one of the twelve virtues necessary for the duke to succeed in his

undertaking. They "began to dance a kind of mummery and to make much jollity so that the festivity might thereby end more joyously."

Music likewise embellished all celebrations at the court of Pope Leo X, from the Masses celebrated in the Sistine Chapel to the papal banquets. Himself a composer and a player of lute and harpsichord, Leo was passionate about music. Son of Lorenzo the Magnificent, he had probably been taught by Henrich Isaak, the Medici composer in Florence. As a cardinal Leo had acquired a reputation as an expert in musical science. Once pope, he fully indulged his love. Leo retained the famous Jewish lute player Gian Maria Giudeo, whom he ennobled, and he employed some thirty-two musicians in the papal choir, including composers Gaspar van Weerbeke, Antoine Bruhier, Andreas de Silva, and Carpentras. Leo put great care into the music of the liturgy, and he revolutionized the Sistine Chapel choir by enriching its sound with wind instruments.

The Venetian patrician Marcantonio Michiel, who accompanied Cardinals Cornaro and Pisani to Rome in 1518 and stayed there for two years, recorded in his diary the splendor of pontifical festivities and the role played by music at Leo's court.[63] The day after the feast of Saint Peter in Chains, celebrated on 1 August 1520, for example,

> the pope hosted a sumptuous luncheon and dinner for whichever cardinals wished to come. …And after dinner he presented a musical concert, on which he spent 500 ducats, as follows. First some ten musicians, dressed in violet, performed a Bergamasque song, singing and playing in alternation with a lirone, two flutes, a lute and a clavicembalo. Then another group, dressed in yellow, performed a German song, singing and playing in alternation on trombones and cornetts. Then yet another group, dressed in pink, sang a Spanish song, playing it alternately on lironi. Then crumhorns. Then boys, who sang in the English manner. Then all the instrumentalists and singers sang and played together in twelve parts. The English sang a macaronesque 'tano', with all the words on the subject of the first day of August and Bacchus, and between one performance and the other there was a nude Bacchus, and Maestro Andrea the buffoon, who was his translator, who read a supplication for the Germans, and all of them had garlands of grape leaves, satin jackets and cloth stockings.[64]

The international cast of the musical entertainment both flattered the assembled guests and reflected the far-flung power and resources of the pope. Leo normally paid his musicians 6–8 *ducats* a month, a very decent salary (his master of ceremonies, Paride de' Grassi, received 5 *ducats* monthly), and he augmented these wages with benefices. In the same years Cardinal Armellini spent about 266 *ducats* a month to support his household of a hundred persons, including his stables. A palace of moderate size could be rented for two to four hundred *ducats* annually.[65] Michiel's diary, meanwhile, suggests that the musical program of that August day alone cost the pope five hundred *ducats*. The sums spent on food, furnishings, and additional entertainments were doubtless no less extravagant. Leo was habitually generous when it came to music. His private accounts are replete with payments to musicians not even on the payroll: twenty-five *ducats* to German organists; forty *ducats* to a priest who makes viols; twenty *ducats* to a Ferrarese boy who played the monochord; ten *ducats* to a girl singer from Pistoia.[66]

Accustomed to such bountiful treatment, papal singers were peeved when their compensation fell short of their expectation. Paride de' Grassi reported on their subversive behavior during the Mass celebrated on 24 June 1520, the feast day of John the

Baptist, the patron saint of Florence. Contrary to their usually diligent conduct, the musicians "responded almost unwillingly," for the bishop celebrating the Mass had neglected to give them a gift, as was the custom. To rectify the omission, Grassi urged the pope to give the vocalists something to buy themselves a drink.[67]

Humor and levity were vital components of Renaissance festivities, and music often served as part of the less serious diversions. On 27 September 1520 Leo staged a celebration in honor of the feast of the Medici patron saints, Cosmas and Damian. Baldesar Castiglione reported on it to Federigo Gonzaga: "The day of St. Cosmas the pope held a delightful party: he invited twenty cardinals, many prelates and all the ambassadors to a splendid dinner, after which there were fifty-two musicians, all dressed as physicians, who sang and played various instruments, all together. Afterwards there was a comedy."

Michiel elaborated on the proceedings. After a solemn Mass celebrated in the Sistine Chapel, the pope gave an impressive banquet,

> and after dinner he presented singing and playing, and the music was done in this manner: some fifty singers and players of various instruments, dressed as physicians, that is in a long gown, partly pink and partly violet, and red stoles, came out two by two, led by Maestro Andrea and another buffoon, dressed up like Spirone and Maestro Archangelo, the pope's physicians. They imitated them, cracking many jokes, and made everyone laugh. And there before the pope alternately they sang and played a number of pieces, and at the end all, including the first, sang some songs about physicians, and for the finale everyone sang a motet for six voices. The costumes were made at the pope's expense. After the music a vernacular comedy was recited in a small room next to the large one. After the magnificent dinner, fruit of infinite sorts was handed out, especially boiled chestnuts, jujubes and pomegranates. The pope presents a ceremony in this manner every year on this day, according to the custom of his ancestors, since Saints Cosmas and Damian were physicians [*medici*], and they were descended from Medicis. The night before there were six large silk tapestries on the pope's tables which were made for him in Florence in the Levantine fashion, but with our own design, and they were very beautiful.[68]

Baldassare Peruzzi and Raphael designed the scenery for papal spectacles, but Michiel was most impressed by the richly varied music, the opulent tapestries, the lavish garments, and the parade of scrumptious dishes.

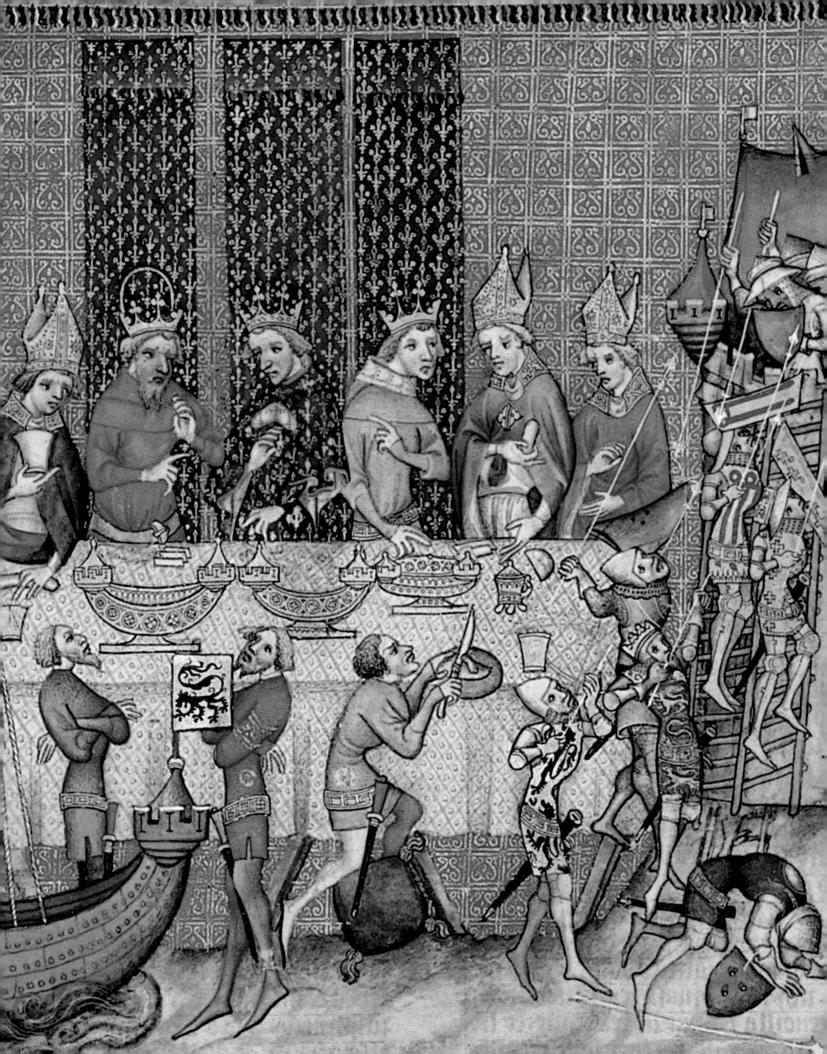

VI — THE SEDUCTION OF ALL SENSES

For I am certain that there must be sciences
By which illusions can be made, appliances
Such as these subtle jugglers use in play
At banquets. Very often, people say,
These conjurers can bring into a large
And lofty hall fresh water and a barge
And there they seem to row it up and down;
Sometimes a lion, grim and tawny-brown,
Sometimes a meadow full of flowery shapes,
Sometimes a vine with white and purple grapes,
Sometimes a castle which by some device,
Though stone and lime, will vanish in a trice,
Or seem at least to vanish, out of sight.

—GEOFFREY CHAUCER, *THE FRANKLIN'S TALE*, 1139–1151[1]

To entertain his uncle, Holy Roman Emperor Charles IV, King Charles V of France (r. 1364–1380) staged a lavish feast in the great hall of his palace. As guests, dressed in shimmering fabrics and gold jewels, partook of multiple courses of richly flavored food, a mock combat enfolded before their eyes. A ship rolled into the hall bearing twelve Christian knights as well as Peter the Hermit. A model of the city of Jerusalem followed, its holy temple occupied by Saracens—men with darkened faces and turbaned heads. The Christians besieged the citadel, re-enacting the conquest of Jerusalem in the First Crusade. The stirring spectacle was immortalized in word and image in Charles V's *Grandes Chroniques de France*. The illustration devoted to the banquet (fig. VI-1) depicts the king conversing with the emperor at his right, and the latter's son Wenceslas of Luxemburg, King of the Romans, speaking with one of the bishops in attendance. On the table three gold *nefs*—ship-shaped vessels for the personal utensils of the rulers—distinguish the loftiest diners. Weavings embroidered with the French fleur-de-lis hang behind them as cloths of honor. The large automated ship enters the scene from the left, and on the right armored men battle with the dark-skinned infidels at the foot of the Temple Mount.

Works of art were seldom used and viewed individually, as we tend to parse them today. Whether in royal palaces or aristocratic dwellings, church interiors or civic halls, luxury artifacts formed richly textured, overlapping ensembles. Princely births and funerals, dynastic weddings and diplomatic summits, triumphal processions and sacred ceremonies all relied on layers of artifacts to stimulate—indeed, almost assault—all the senses, so as to leave an indelible impression of the grandeur of their sponsors. In addition to permanent creations, ephemeral productions—temporary architecture and theatrical spectacles, fireworks and sugar sculpture—formed key components of such displays. Their fleeting nature added to the magic aura of these events, and the vast sums spent on illusory pleasures accentuated the might of those who paid

for and deserved such shows. Pictorial and verbal accounts of these happenings, whether manufactured out of awe, propaganda, or commercial calculation, made them live in memory and disseminated their fame for generations. As Chaucer's *Franklin's Tale* suggests, court entertainments were intended to evoke lasting wonder.[2]

This chapter aims to impart a more accurate understanding of how diverse types of artifacts, so far presented piecemeal, functioned together to articulate and augment the accomplishments and ambitions of ruling elites; to impress, intimidate, and manipulate peers, foes, and subordinates through the marshaling of vast and magnificent resources. Four case studies — the wedding of Charles the Bold and Margaret of York, the diplomatic summit between Henry VIII and Francis I at the Field of Cloth of Gold, the reception of Anne of Foix by the Venetian state, and the funeral of Charles V Habsburg — will elucidate the programmatic layering of luxury arts in the service of pressing and complex political and social needs. Living in a media-saturated world and imbued with democratic ideals, we may find it difficult to appreciate the impact and ideologies of Renaissance spectacles. The past, however, is indeed a foreign country, and just as we expand our horizons and come to comprehend ourselves better through travels abroad, so an investigation of these multifaceted events presents an opportunity to see the world as a larger and richer place and to amend the parochialism of our perspectives.

The Wedding of the Century

One of the most celebrated spectacles of the fifteenth century — judging by the number of reports and echoes it generated — was the wedding of the duke of Burgundy, Charles the Bold, to Margaret of York, sister of King Edward IV of England. Held in Bruges in July 1468, the nuptials were remembered for generations, and they inspired and challenged other rulers to match and surpass their splendor and renown.[3] The marriage aimed to consolidate the duke's alliance with the English king so as to present a united front against their common enemy, Louis XI of France. It benefited the commercial interests of both regions, whose trade was intertwined. The duke, moreover, desperately needed a male heir, for he was already in his mid-thirties and had only a daughter, Mary. Besides, at the time of the wedding, Charles had only recently ascended to rule. The festivities staged in Bruges were therefore intended to convince the assembled international guests of his eminence.

The committee charged with conceptualizing the festive displays included Olivier de la Marche, ducal chronicler and *maitre d'hotel*; Jaques de Villers, equerry and cupbearer of the duchess Isabella (Charles's mother); Jehan Scalkin, engineer of automata; and two painters, Jehan Hennekart and Pierre Coustain. (At this time the borders between different forms of artistic production were highly permeable, and no firm divide separated "high" from "applied or decorative" arts. The same masters often conceived and executed ephemeral creations and more durable artifacts.) The organizers of the Burgundian wedding, in their turn, recruited troops of artisans to realize the decorations and divertissements they had devised. Scores of masons and carpenters, painters and sculptors, wax carvers and leatherworkers, goldsmiths and tailors labored to render ducal aspirations into unforgettable productions.[4] The hectic pace of work, which lasted from March until July, is intimated by the record of payment: "To Master

Berthelomy, chaplain and worker in wax, for the celebration of the mass at the palace before the workers so that they would have no cause to go outside and would work more diligently."[5] There was no time to spare for a leisurely prayer away from the bustle of preparations.

The wedding, solemnized on 3 July 1468, was followed by nine days of lavish displays, held in part in the banquet hall erected in the courtyard of the ducal palace and in part in the market square of Bruges, where tournaments unfolded during the day.[6] The tableaux at the entrance to the ducal palace in Bruges established the themes of ducal power, devotion, and liberality. In a large tabernacle over the entryway lions displayed the arms of the dukes of Burgundy amid the blazons of their territories, heraldic devices, and Charles's personal motto, "I undertook it." Adjacent statues of Saints Andrew and George, patrons of Charles and of Burgundy, manifested the holy protection of the ruler, his palace, domains, and matrimonial union. Below the saints, and flanking the portal, sculpted and polychromed archers dispensed ducal generosity. On the left a Turk drew a bow and the red wine of Beaune flowed from the point of his arrow; on the right a German spouted the white wine of the Rhine from his musk. Both wines cascaded into stone basins below, to be enjoyed by everyone for the duration of the celebrations.[7]

Beyond the gateway, inside the courtyard, rose the temporary banqueting hall. It measured some 43 × 21 m (140 × 70 ft.) and was embellished with turrets and glass windows with gilded shutters. Two galleries along its inner walls accommodated trumpeters, clarions, and other minstrels, as well as guests who did not merit a seat among the loftier company at the tables. The Burgundian dukes were masters of public relations. To maximize the impact of their spectacles and propaganda, they habitually erected such stands in order to allow all the necessary ambassadors, nobles, and worthies to observe and spread the word of their magnificence. Many awestruck accounts of Burgundian celebrations come from such observers in the balconies.

Witnesses to the 1468 wedding banquets were overwhelmed by sensations. The hall shimmered with gold-and-silk tapestries and textiles lining the ceiling and the walls. Arrays of precious plate and ingenious lighting fixtures dazzled the eyes. Endless courses of rich food offered an overpowering succession of tastes and smells. Wine flowed freely and rose water scented the air from the table fountains. The garments and jewels of the bride and groom and their guests, the textured costumes of actors performing theatrical skits between courses, the juicy morsels of constantly renewed culinary offerings all titillated the sense of touch. Music of instrumentalists and singers delighted the ears. As for the mind, it had hardly a chance to rest between the tricks of automata and the divertissements between servings: strange beasts breaking into allegorical praise of the newlyweds; legendary heroes enacting great deeds; ever-changing visual metaphors of Burgundian power and ambitions. The resplendence, cleverness, and overabundance of the intertwining components of the celebration impressed the guests to no end and sent an emphatic political signal. Duke Charles the Bold was, indeed, a preeminent ruler: He commanded seemingly inexhaustible resources, surrounded himself with superhuman splendor, rivaling, indeed outdoing, titular kings. It was not any single form of visual, auditory, or literary expression, but an adroit assemblage of all of them that manifested the glory of the prince. Judging by contemporary accounts, the wedding guests and their far-flung correspondents took these displays to heart and both admired and feared the Burgundian duke.

Fig. VI-2. JEAN FROISSART (French, ca. 1333–ca. 1405), *Richard II Surrenders His Crown to Henry of Bolingbroke, Earl of Derby*. From *Les Grandes Chroniques de France*, ca. 1470. London, The British Library, MS. Harley 4380, fol. 184. By permission of The British Library.

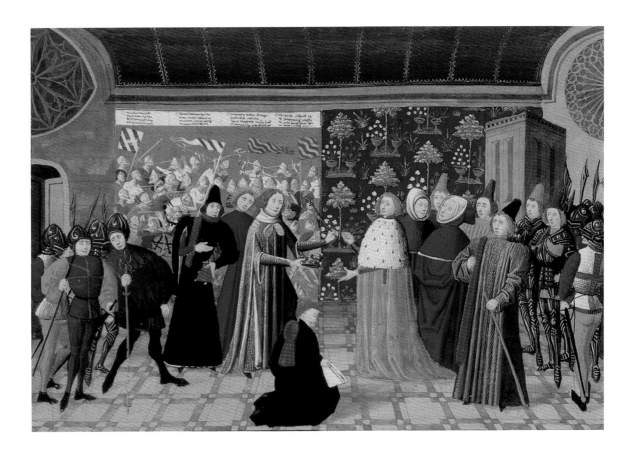

What made the Burgundian spectacles even more majestic was the quality and quantity of their constituent parts. Even examined piecemeal, the artifacts articulating ducal sovereignty were nothing short of marvelous. The chronicler Jehan de Haynin, lord of Louvignies, for example, recorded the textile adornments of the banqueting hall and the palace rooms opened to visitors. (We may get a sense of such decorations from contemporary illuminated manuscripts, such as that in fig. vi-2).

> The ceiling of the great hall was lined with white and blue silk or cloth, and the walls were hung with fine and rich tapestries depicting the story and mystery of Gideon and the Fleece. Behind and above the high table was, in the center, a very rich piece of gray cloth of gold with the Duke's arms embroidered on it and, on either side, several pieces of crimson, blue, and green cloth of gold.
>
> In the hall where the sideboard was situated were hung the tapestries of the great battle of Liège, where Duke John of Burgundy and Duke William of Bavaria, count of Hainault, defeated the Liégeois near Othée in the year 1408, on a Sunday, 23 September. The hall ... of the chamberlains was hung with a superb tapestry showing the coronation of King Clovis, called Louis, the first Christian king of France; the renewal of the alliance between him and King Gundobad of Burgundy; the wedding of King Clovis to Gundobad's niece; his baptism with the Holy Ampula [Ampulla]; his conquest of Soissons; how the stag showed him the way across a river which he had not dared to cross; and how the angel gave an azure cloth with three fleurs-de-lys in gold to a hermit, who gave it to the queen, who passed it on to the said King Clovis to bear for his coat of arms. ...

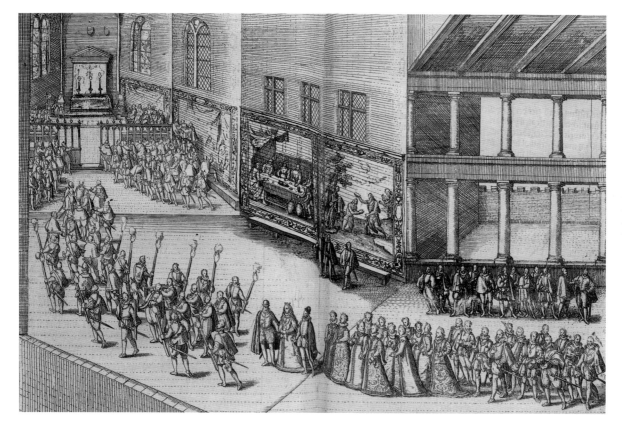

Fig. VI-3.
Chapel hung with tapestries for the wedding of Johann Wilhelm of Jülich, Cleve, and Berg, Düsseldorf, 1587. From Theodor Graminaeus, *Beschreibung derer Fürstlicher Jüligscher &c. Hochzeit* (Cologne, 1587), pl. 3. Los Angeles, Research Library, Getty Research Institute.

Before the festivities the hall in front of the chapel was hung with tapestries of the history of Duke Begues of Belin, brother of Garin de Loherant; how he set off from his house and his lands to go hunting the great boar and was killed as he stood by the animal he had killed, by one of the foresters of Fromont of Lens, who shot him with an arrow because he feared to fight him hand to hand. . . .

Just before the wedding day, another tapestry was hung in this place, of King Ahasuerus, who governed 127 provinces. . . . The chapel was hung with a fine embroidered tapestry of the Passion; before then it had been of the human pilgrimage. In the Duke's oratory, the altar cloth showed the Seven Sacraments. . . . In Madame's dressing-room, which was chequered throughout with white, red and green squares, the colours of the marguerite, was the history of the good Lucretia. . . . In Mademoiselle of Burgundy's room, a tapestry of trees and personages in antique fashion. In my lord the bastard's room, a tapestry with his arms and, in his dressing room, very rich embroidered ancient histories.[8]

We can see how tapestries decorated different spaces during princely weddings in an illustration of the nuptials of Johann Wilhelm of Jülich, Cleve, and Berg in Cologne in 1587. Here tapestries line the chapel where the wedding was solemnized (fig. VI-3). At the wedding of Charles the Bold the great number and frequent changes of weavings communicated the ducal fortune. The subject matter of the hangings—drawn from ancient and medieval history, the Bible and chivalric romances—delivered key political allusions. Haynin's detailed description demonstrates the attentiveness of contemporaries to tapestries and the close reading of their narratives and captions. Renaissance

beholders, accustomed to and well versed in this visual skill, clearly derived aesthetic and intellectual pleasure from the experience.

The banqueting hall further came to life with two automated chandeliers suspended from the ceiling, as described in chapter 2 (p. 71). They had been fashioned by Jehan Scalkin, one of the organizers of the wedding displays. The center of the room, meanwhile, was dominated by the exhibition of precious plate, displayed on a lozenge-shaped sideboard and framed by ducal armorial tapestry. The lowest step held the largest vessels, the highest the richest ones, the dishes ascending from silver-gilt to pure gold studded with gems. Two large and whole unicorn horns, prized for their exotic beauty and their power to detect and deflect poison, flanked the plate. None of the dishes, however, was touched during the dinner: The guests ate from a profusion of additional silver and gilt vessels.

A late fifteenth-century Netherlandish tapestry devoted to the story of Esther and Ahasuerus captures the opulence of the Burgundian feasts (fig. VI-4). Esther, an exemplar of ethics, enjoyed great popularity at that court. When Margaret of York, arriving for her nuptials, first disembarked at Sluis, she was greeted through elaborate

Fig. VI-4.
Esther and Ahasuerus
tapestry, South Netherlands,
ca. 1490. Wool and silk,
4.32 × 8.20 m (170⅛ ×
322⅞ in.). Zaragoza,
Museo de Tapices de la Seo,
inv. 1521. Photo courtesy of
the Cabildo Metropolitano
de Zaragoza and the Caja
Inmaculada de Zaragoza.

tableaux vivants as the "new Esther"; and a tapestry of that subject decorated the ducal palace. As art and life inspired each other, Ahasuerus's banquet in the weaving reflected those staged by the duke. The biblical king, presiding at the table, is framed by a cloth of gold that marks him as the loftiest actor in the proceedings. Before him is a pheasant on a gold platter decorated with three armorial banners. Ceremonially arrayed precious plate shines from the sideboard on the right. A group of musicians sounds fanfares from the left. The musical ensemble, the display of plate, and the cloth of gold are all attributes of the ruler and are emphasized as such by the architectural niches that frame them. The busy staff of richly dressed courtiers further adds to the dignity of the king. A man in a red-and-gold robe with a long staff in the left foreground is the master of ceremonies. He directs the servants to carry in the platters of food, refill the goblets, and slice the roast. A man on the right is the king's wine waiter. He pours rich red wine into the massive royal gold cup. All these details appear in descriptions of the Burgundian wedding banquet (where 515 men labored to prepare the meals, and a troop of servers brought them to the tables). A depiction of the wedding banquet of Johann Wilhelm of Jülich, Cleve, and Berg shows the feast in progress: The hall is lined with tapestries, servants bring in the next course, and musicians play in the foreground (fig. VI-5).

The very presentation of food at Charles and Margaret's feasts was meant to beguile. On one of the nights, the roasts arrived on thirty wooden ships, painted and gilded, complete with sailors, armed men, and golden riggings, and each with silken blazons bearing the name and coats of arms of ducal lands.[9] The tables, meanwhile, housed thirty large platters with covers shaped like tall castles, all painted blue and gold and inscribed with the names of the ducal cities. Gilded and silvered swans, peacocks, unicorns, and elephants (in fact, men dressed in animal costumes) walked between the tables proffering baskets of comfits, and harts carried panniers of oranges.[10] The guests were served ducal propaganda in the most palatable ways.

Entremets, or divertissements between courses, took the form of pageants, mechanical surprises, and musical numbers. They brought together engineering and textile arts, carpentry and painting, drama and music, all in the service of complex political allegories expressed in memorable ways. We see the wedding party of Johann Wilhelm watching the spectacle in the dining hall (fig. VI-6). On the first day of Charles and Margaret's nuptial celebrations a unicorn entered the hall. It was as large as a horse, painted in silver, and covered in taffeta decorated with the arms of England. A leopard, "very well made after nature" (another costumed actor), rode atop the unicorn, a large banner of England in its left paw, a marguerite daisy (the French form of the name Margaret) in its right paw. Circling the room to the accompaniment of trumpets and clarions, the unicorn halted before the duke. The *maitre d'hôtel* took the marguerite from the leopard's paw, knelt in front of Charles, and presented him the flower with the following homage: "The most excellent, lofty, and victorious prince, my formidable and sovereign lord, the noble and redoubtable leopard of England comes to visit the noble company, and for the satisfaction of yourself and your allies, countries, and subjects, makes you a present of a noble marguerite."[11]

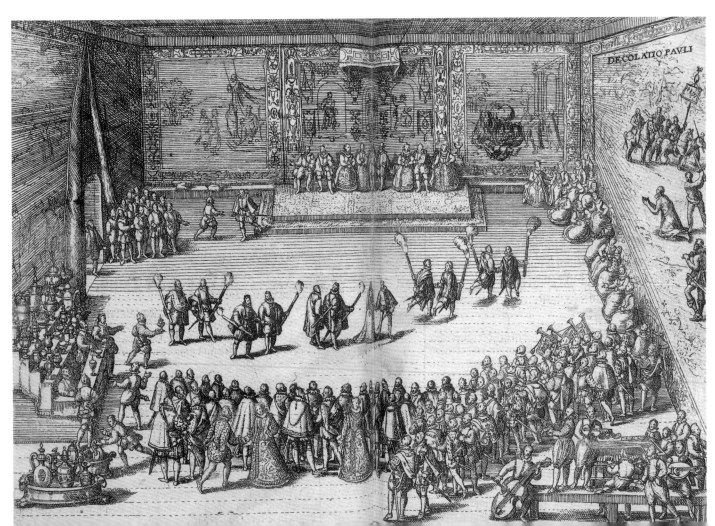

DECOLATIO PAVLI

The performance played on the newly concluded alliance with Edward IV sealed by the union with Margaret. Charles received the offering most cordially, and the unicorn left the hall. A while later a great golden lion made its entrance. It was covered in silk painted with the arms of Burgundy (financial accounts concerning the preparation of the *entremets* record its manufacture[12]). Atop the lion sat Madame de Beaugrant, the dwarf of Mary of Burgundy, the duke's daughter. The dwarf wore a dress of cloth of gold fashioned in the style of a shepherdess (a fascinating contradiction), she held a large banner of Burgundy and led a small greyhound on a chain. Circling the room, the lion sang in praise of the ducal reign and domains. When he approached the new duchess, the *maitre d'hôtel* addressed himself to Margaret on behalf of the animal that symbolized Burgundy. Welcoming Margaret to her new country, he offered her the shepherdess as a gift from all the noble shepherds who guard the Burgundian lands and protect their flocks. The lion sang another song and departed the hall. The third apparition that night was a large dromedary caparisoned in Saracen fashion with a wildman, richly dressed in gold and silk, riding between two baskets on its back. As the dromedary paraded around the hall, the wildman opened the baskets and tossed out live birds, colored and gilded "as if they came from India." Trumpets and clarions further embellished this spectacle.[13]

On three other nights Hercules performed his deeds before the assembled company (accomplishing four feats per evening). Each exploit and its moral lessons—offered as thinly veiled references to Burgundian politics, the accomplishments of Charles the Bold, and chivalric feats executed by the wedding guests in the concurrent tournament—were explained in a verse attached to the curtain drawn after each skit, as well as recited by a tenor. Trumpets accompanied and punctuated the plays.[14] Accounts recording the expenditure on the Hercules dramas capture something of their visual and logistical complexity. They list richly dressed ancient heroes, dragons and lions, cows and sheep, a beast with three heads and another with seven, devils and giants, armed women on horseback, big rocks and ships—made of various cloths, painted with gold and silver, and "as live looking as possible."[15] The intricate narratives and costumes of the actors echoed the layered plots and sumptuous details of the tapestries that lined the hall. The tapestries, the *entremets*, and the spectators themselves—whose own opulent attire and festive behavior resonated with such elements present on the walls and on the stage—re-enforced one another and augmented each component of splendor and its underlying values.

On yet another night thirty tents and thirty pavilions rose over the dinner tables, all covered with colored silks, enriched with paintings in gold, silver, and azure, and surmounted by ducal banners. The pavilions bore the names of the subject towns of the duke of Burgundy, the tents those of the great barons in vassalage to him. Inside these structures stood platters with food. A model of a tower that Charles was then building at Gorichem in Holland occupied the center of the hall, reaching to the ceiling. Cloth painted silver and blue covered its wooden framework, gold paint highlighted its architectural details, and the ducal arms decorated the fluttering flags. When the diners had settled down, a lookout appeared on top of the tower, blew a horn, and anxiously examined the multitude of tents around him, as if he were besieged. Recognizing that they had assembled to assist rather than to trouble him, he summoned his musicians to serenade the noble company. Presently four windows opened at the top of the tower, revealing four large boars who played trumpets and sang a ballad. Next four goats

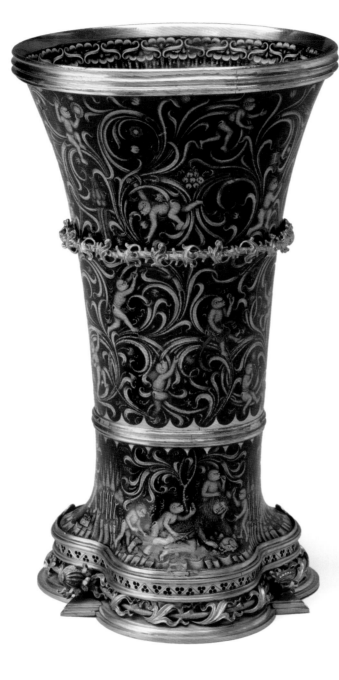

Fig. VI-7.
Beaker known as "The
Monkey Cup," Flemish,
ca. 1460. Silver, partly gilt,
and enamel, H. 20 cm
(7⅞ in.). New York,
The Metropolitan Museum
of Art, The Cloisters
Collection, 1952, inv. 52.50.
© 1984 The Metropolitan
Museum of Art.

peeked out of the four windows on the tier below and sang a motet. Then four wolves on the still lower level played flutes and sang a song. The final group of musicians, four donkeys "very well made," performed a polyphonic number. The skit concluded with a *moresca* executed at the foot of the tower by seven monkeys (ducal accounts record payments for the manufacture of the animal costumes for the musicians and dancers). As they danced, the monkeys discovered a peddler asleep by his wares. They promptly stole and distributed his trinkets to the delighted guests.[16] The monkey dance was, apparently, a popular entertainment: It was depicted also on enameled silver cups produced at the Burgundian court (fig. VI-7), one of which was acquired by the Medici.

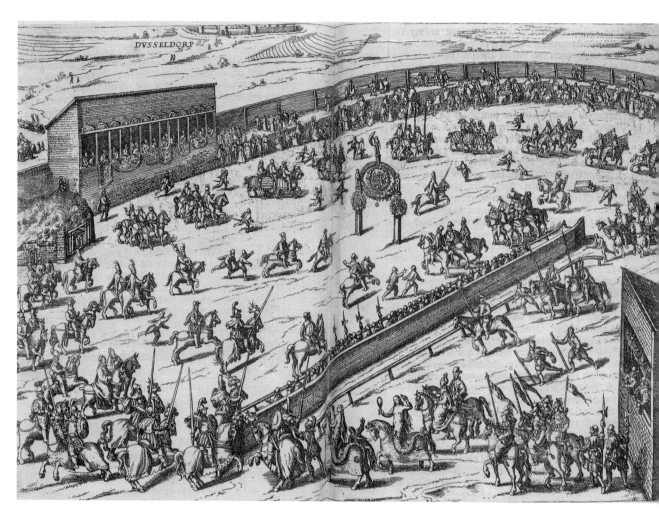

Fig. VI-8.
Tournament staged during
the wedding of Johann
Wilhelm of Jülich, Cleve,
and Berg, Düsseldorf, 1587.
From Theodor Graminaeus,
*Beschreibung derer
Fürstlicher Jüligscher &c.
Hochzeit* (Cologne, 1587),
pl. 9. Los Angeles, Research
Library, Getty Research
Institute.

Amazingly, the guests not only sat through hours-long banquets and danced till morning after the meals; they also had enough energy to take part in, or to watch, the tournaments held in the marketplace during the day[17] (fig. vi-8). The tournament organized by Charles's half-brother Anthony, known as the Great Bastard of Burgundy, revolved around an elaborate narrative trope. The "Lady of the Hidden Ile" bid Anthony as the count of La Roche to undertake three great tasks for her sake: to break 101 lances, or to have them broken against him; to make or to suffer 101 sword cuts; and to decorate a Golden Tree from her treasury with the coats of arms of illustrious champions. The court of Charles the Bold, the most distinguished and chivalrous in the world, would be the perfect site for these noble exploits. The Golden Tree, a gilded pine, was duly erected at the entry to the lists, and each participating knight hung his coat of arms on its branches. The Golden Tree also featured ubiquitously in the decorations of the jousting arena and in the attire of the combatants.

The participants, wearing gold and silver armor and great plumes, entered the lists on horses covered with cloth-of-gold caparisons. They impersonated ancient heroes, legendary knights, and complex allegories. Anthony of Luxembourg, Count of Roussy, for example, rode chained within a castle from which he could only be released with a golden key by the consent of the ladies. The Burgundian court chronicler and wedding organizer Olivier de la Marche paid keen attention to the appearance of each knight: The kinds of fabrics, colors, and goldwork he wore; the horses he rode; and the brilliance of his retinue. The beauty, costliness, and ingenuity of every element of costume and comportment confirmed the worthiness of the contestant to be included in this exalted event and honored the star of the show, Charles the Bold. The duke himself fought in a succession of dazzling garments. For the opening of the tournament he sported a long gown lined with marten fur and encrusted with gold and jewels, and, according to an anonymous English observer, "on his hede a blake hate one that hat a ballas [ruby] called the ballas of Flanders, a marvelous riche jewell." The Englishman

Fig. vi-9.
APOLLONIO DI GIOVANNI DI TOMMASO (Italian, Florence, ca. 1416–1465), *Tournament in the Piazza Santa Croce in Florence*, ca. 1440. Tempera and gold on panel, 45.4 × 153.4 cm (17⅞ × 60⅜ in.). New Haven, Yale University Art Gallery. University Purchase from James Jackson Jarves.

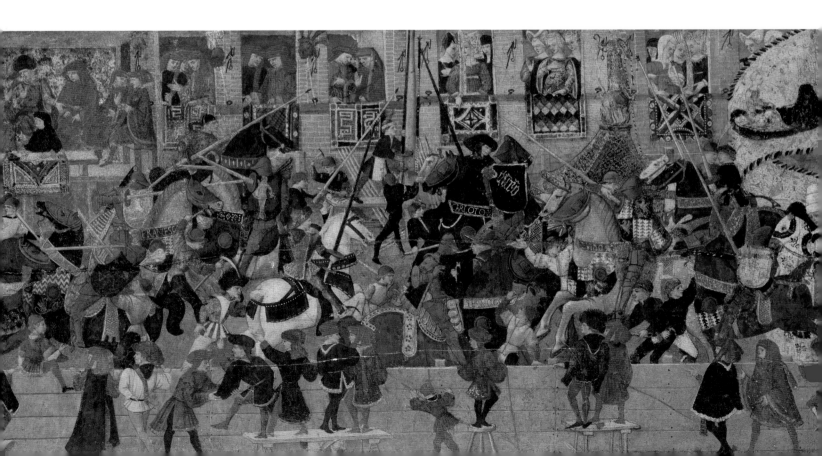

gasped that he had never seen "so great richez in soo littel a space." Charles's horse, too, was luxuriantly caparisoned and hung with large golden bells so that the shimmer of gold and jewels was echoed aurally by the tinkle of the bells.[18]

The richness and variety of attires, the fantasy of theatrical tropes, and the musical accompaniment of entries and exits made the tournaments of the Golden Tree, as well as the evening wedding banquets, paragons. In 1469 Lorenzo de' Medici, celebrating his betrothal to Clarice Orsini, his ascent to power, and the recent peace with Venice, staged a similar joust and banquets constructed around the theme of courtly love. The rich costumes of the participants formed the most impressive part of the spectacle, as one can see in the depiction of another tournament (fig. vi-9). By presenting his political accomplishments and ambitions in the language of chivalry, Lorenzo claimed the nobility of blood and hence the prerogative of rule that were his neither by birth nor by the traditional Florentine system of government.[19]

Likewise, the nuptials of Prince Arthur Tudor (the elder brother of the later king Henry viii) with Catherine of Aragon, held in London in 1501, drew on the Burgundian pageantry both in the banquet hall and in the lists in order to proclaim the rise of a new dynasty.[20] Today these spectacles may not appear to be true, high, or "Renaissance" arts. But the attention devoted to them by contemporaries testifies to their perception as the most exalted expressions of power and refinement, worthy of the highest accolades, for so effectively did they serve the most critical political needs.

THE EPHEMERAL WAR

Perhaps the most famous sixteenth-century princely spectacle—"the eighth wonder of the world," as one contemporary called it—was the meeting between Henry viii of England and Francis i of France staged from the 7th to the 24th of June 1520 near Calais (fig. vi-10). This rendezvous formed part of a series of hostilities between England and France fanned by the shifting alliances of the two kings with other major contenders for European supremacy—Holy Roman Emperor Charles v and a succession of popes. It was hoped that the festive encounter between Francis and Henry would open the path to a European peace. The magnificence of the ephemeral creations produced for the occasion impressed the onlookers no end. Alas, the political effect of the meeting was not correspondingly successful.[21] Henry's appointments with Charles v just before and after the summit created an aura of distrust at the Field of Cloth of Gold, and the English and French monarchs waged a fierce competition throughout the meeting—through luxury arts.

Whether the name of the event—the Field of Cloth of Gold—derived from the radiance of costumes, adornments, and displays, or from the ancient name of the "Golden Vale" where the kings held their rendezvous (the valley is situated between the village of Guisnes near the English-held Calais, and Ardres in the French territory), the brilliance of the occasion became legendary. It is hardly surprising, however, that the meeting failed to produce any peace. The splendid resources deployed by the two rulers—the opulent tents and temporary buildings, the dramatic tropes of the banquets and the jousts, the sublime music and the exquisite dishes, not to mention the bankrupting lavishness of costumes and jewelry—functioned as weapons in the battle of political one-upmanship.

Fig. vi-10. UNKNOWN ARTIST, *The Field of Cloth of Gold*, ca. 1550. Oil on canvas, 1.69 × 3.47 m (66½ × 136¾ in.). Windsor, The Royal Collection, RCIN 405794. © 2004, Her Majesty Queen Elizabeth ii.

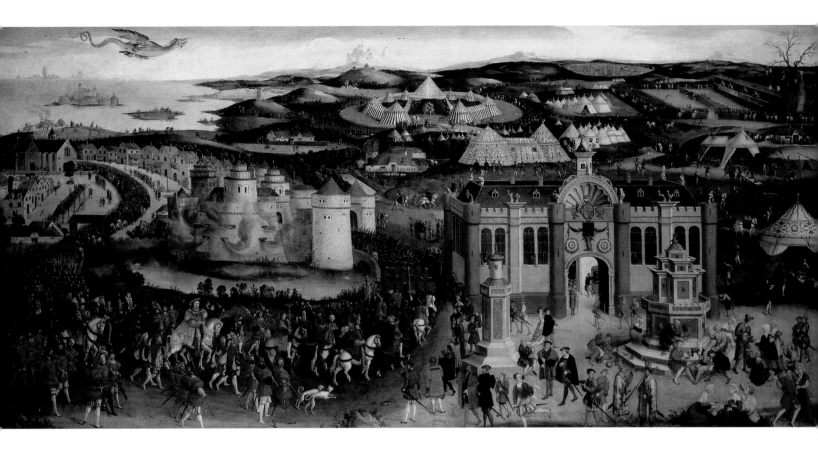

The temporary quarters for the two kings and their entourage provided one major arena for contest. The French erected a whole city of tents made of canvas covered with cloth of gold and silver and embroidered with heraldic devices. (Surviving designs for the English tents help us visualize the intended effect of these creations [fig. VI-11].) Hundreds of tentmakers and tailors worked on the French tents from February until June, and gunners mounted guard over their costly fittings. Francis's tent, eyewitnesses recounted, stood 37 m (120 ft.) high, was enveloped in cloth of gold with three lateral stripes of blue velvet, and was powdered with golden fleur-de-lis. Its summit was crowned by a life-size statue of Saint Michael, patron saint of France. Carved in walnut by Guillaume Arnoult and painted by Jean Bourdichon, Saint Michael wore a blue mantle strewn with golden fleur-de-lis, trampled a serpent and an apple (symbols of Satan and sin) under his feet, and held a lance and a shield with the arms of France. Inside the royal tent, *toille d'or*—a lighter version of cloth of gold—as well as blue velvet with gold fleur-de-lis lined the walls; gold fringes decorated the ceiling. Three similar tents housed a chapel, a wardrobe, and a council meeting hall. Still others sheltered the queen of France, the queen mother, and the great nobles. (Despite their outward opulence, these tents made rather uncomfortable dwellings, particularly in the storms that plagued the event.) The round banqueting pavilion, meanwhile, rose upon brick foundations and had plank walls painted to resemble brick. Azure velvet dotted with fleur-de-lis draped its exterior; tapestries lined its interior. Alas, the efforts and resources expended by the French were thwarted after only four days. The driving wind and rain destroyed many of the tents and broke the mast of the royal pavilion.

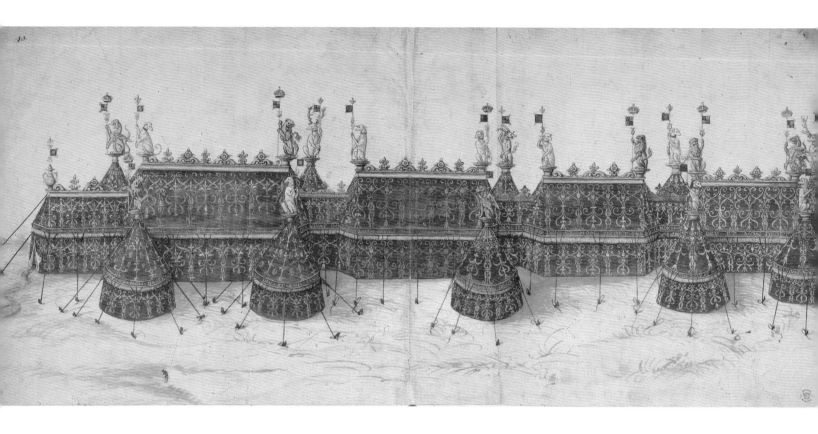

Henry VIII outdid his rival by constructing an entire temporary palace. An English painting commemorating the summit proudly placed the structure in the center foreground of the composition (see figs. VI-10 and 12). The image is not a precise representation, but a summary of key monuments and moments of the meeting. It is, nonetheless, a helpful resource for bringing the event back to life. Henry's palace was a square structure (100 m [328 ft.] to a side), built around a central court, with towers at the four corners. It stood on a stone foundation and a base of bricks that rose some 2.5 m (8 ft.) above the ground. Walls of timber 9 m (30 ft.) tall, painted to look like brick, constituted the next course. The *piano nobile* (main floor with public rooms) consisted largely of double windows divided by pilasters. This vast expanse of glass was the most spectacular feature of the palace: According to witnesses, the building appeared to be an open-air pavilion, yet it withstood the calamitous weather better than the French tents. A frieze of foliage and a cornice crowned the building. Its roof, of seared canvas, was painted to look like slate. Crenellations and embattlements gave the palace a defensive look, as did statues of men on the roof poised to cast down stones and shoot iron balls from canons and culverins. The gatehouse was flanked by two towers and surmounted by polychromed statues of ancient worthies, Hercules and Alexander among them. More than two thousand masons, carpenters, joiners, painters, glaziers, tailors, smiths, and other craftsmen, both from England and Flanders, labored to bring Henry's palace into being. Hundreds of tons of timber were shipped from England and Holland, and some 465 m² (4,500 ft.²) of glass arrived from nearby Saint-Omer.

Befitting the ruler's liberality, two fountains erected in front of Henry's palace distributed wine for all to partake of from silver cups provided by the king. One fountain, painted gold and blue, engraved with antique motifs, and surmounted by a statue of Bacchus, poured forth red, white, and claret wines under the inviting inscription "Let who will be merry." Another gilded fountain, shaped like a pillar supported by four lions, was crowned by Cupid.

Inside the palace the two lateral wings flanking the inner court housed the king and the queen. Their apartments were adorned with tapestries, cloths of gold, and gold and silver plate shipped from England in massive crates. The king's sister Mary, Duchess of Suffolk, occupied half a wing on one side of the gatehouse. Cardinal Wolsey, the chief strategist of the summit, inhabited the other side. His quarters were nearly as sumptuous as the king's. An Italian observer feasted his eyes on the gold-and-silk tapestry adorning the cardinal's audience hall, the bedstead with gilt posts and cloth-of-gold canopy, and crimson satin cushions. The wing parallel to the gatehouse at the back of the palace, meanwhile, housed the banqueting hall. A broad staircase leading up to it was guarded by armed "images of sore and terrible countenances" rendered in silver, as well as by gold "antique images" surrounded by olive branches—presumably ancient heroes and statesmen.

A chapel erected next to the palace aroused further admiration. Cloth of gold and silk decorated the choir, cloth of gold embroidered with pearls covered the altars. On the high altar stood five pairs of candlesticks, a large crucifix, and statues of the twelve apostles, "each as large as a child of four"—all made of gold. A gold-and-silver organ accompanied royal singers. Priests served the Mass in vestments sprinkled with red roses, stitched with fine gold, and embroidered with pearls and precious stones. All these elements bespoke the might of Henry VIII. In an age when luxury arts functioned as effective instruments of war, the English displays were not mere shows of ostentation, but powerful weapons aimed at Francis I.

The kings continued their competition through their attire. Italian observers praised the elegance of the French procession and were struck by the weight and brilliance of the gold chains worn by the English nobles, many of them also clad in cloth of gold. The garments of both kings were studded with diamonds, rubies, emeralds, and pearls; and jeweled collars of their respective Orders of the Garter and of Saint Michael glimmered on their chests. Henry's horse trappings were adorned with classical motifs as well as golden bells the size of eggs. Francis's horse was caparisoned in cloth of gold and a chestpiece studded with gems and pearls. Considering that the meeting took place in the summer, the discomfort of wearing such heavy garments and massive jewels must have been substantial. Yet they were indispensable for the dignity of the occasion and its protagonists.

Feats of arms served as another arena for rivalry. The area prepared for the tournament (shown much simplified in the upper right corner of the painting, fig. VI-12) was blocked off by barriers. Two gates shaped like triumphal arches orchestrated the entry into the lists. Tiered viewing galleries were differentiated according to the rank of the spectators: That reserved for the queens was glazed and hung with tapestries. A Tree of Honor formed the focal point of the lists. On it hung the three shields representing the three types of combat available to the contestants: jousting at the tilt, combat on foot, and open-field tournament. Knights announced their participation in a given sport by touching the appropriate shield. A hawthorn bush symbolic of England and one of

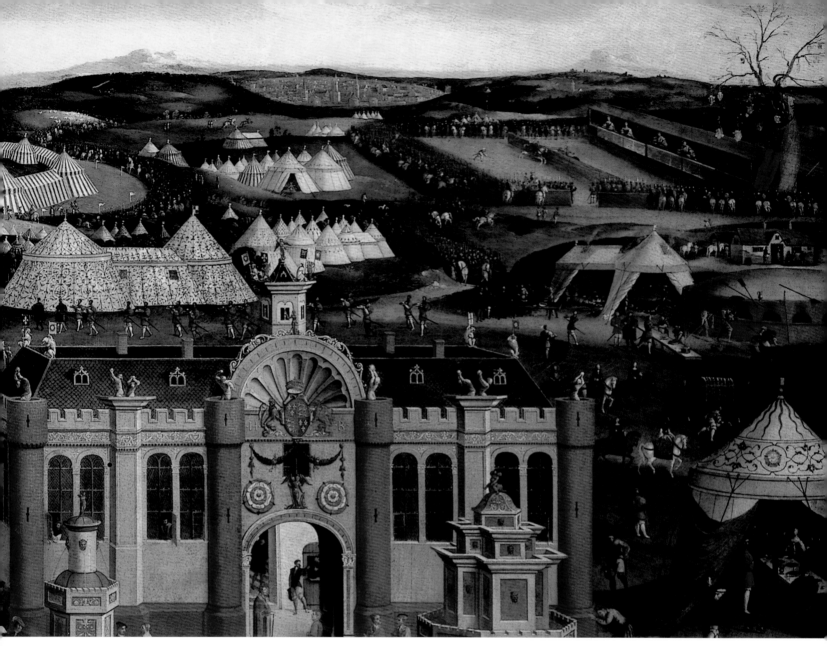

raspberry for France flanked the Tree of Honor. Constructed around wooden masts, the plants had branches of cloth of gold, leaves of green damask, and flowers and fruits of silver and Venetian gold.

Throughout the tournament, which stretched over several days, participants enacted substories through their narrative costumes. The French king's tale enfolded in serial fashion. On the first day his horse was barded in purple satin slashed with gold, and embroidered with black raven feathers. A raven in French is *corbin*, and the first syllable of the word was taken to stand for *coeur*, or heart. The feathers, *peines*, connoted pain. The buckles fastening the feathers to the bard provided the third part of the phrase "heart fastened in pain." The story continued on another day when Francis and his retinue wore purple satin garments embroidered with little rolls of white satin on which appeared the word *Quando*; letters *L* further dotted the costumes. Together they spelled out *quando elle*, or, "when she." The end of the phrase was revealed on a third day when the king and his horse appeared in purple velvet embroidered with little

books sewn from white satin. Each book bore the words *a me* and was surrounded by blue chains. The book, *liber*, the inscription, *a me*, and the chains added up to *libera me*, or "deliver me [from bonds]." Altogether the French charade spelled out a chivalric declaration, "Heart fastened in pain, when she delivers me [not from] bonds." Contemporaries were clearly expected to pay close attention to costumes and to decipher, not only the connotations of their fabrics and jewels, but also the riddles presented by additional embellishments.

Henry's costume, too, delivered coded messages. On one of the days the English king wore a dress of cloth of silver embroidered with gold letters. His horse's bard was adorned with mountains from which sprang gold basil branches; the leaves and stalks, loosely attached to the fabric, wavered as the rider and mount moved. The words and symbols of the royal attire issued a warning: "Break not these swete herbes of the riche mounte, doute for damage," or fear for hurt if you harm England. Just as today parts of the uniforms of sports figures are eagerly seized by fans, so in the Renaissance the rich costumes of tournament contestants were often plundered at the end of the competition. Royal accounts record that the French pulled off the gold basil leaves from the king's garments after all, and wore them in defiance of Henry's veiled admonition (or did they fail to understand it?).

Royal banquets at the Field of Cloth of Gold provided another venue for extravagant and competing displays; they were deemed by one writer to be worthy of a celestial court.[22] English records convey something of the scope of the preparations and the challenge of feeding some twelve thousand participants of the summit for two weeks (each king arrived with a retinue of about six thousand people). The English chronicler of the event, Edward Hall, writes that "Forestes, Parkes, felde, salte seas, Ryvers, Moates and Pondes, wer serched and sought through countreies for the delicacie of viandes, wel was that man rewarded that could bring any thinge of likinge or pleasure."[23] Given that "all noble men were served in gilte vessels, all other in silver vessels," mountains of precious plate also had to be imported for the occasion. Just as the heavily decorated costumes, so the precious plate and banquet offerings could not be scaled down without loss of face and hence authority.

Among the particularly ingenious culinary creations of the age—greatly valued and admired by contemporaries—were sugar sculptures, used as table decorations, consumable deserts, and diplomatic gifts. Sugar—expensive, imported, and luxurious—remained the preserve of the wealthy and the powerful. It was also considered a medicinal substance, prized for its warming effects and thus thought helpful for digestion and colds. The digestive benefits of sugar encouraged its use at the end of a feast. Indeed, there developed in fifteenth-century England a separate final course, called "banquetting stuffe," comprised of finely wrought sugar sculptures known as *sotelties*— delicate morsels that stimulated the mind and the stomach—as well as sweetmeats (sugar-coated spices), marzipan concoctions, and candied fruits. Eaten with spiced wine or flavored spirits, the "banquetting stuffe" was consumed in a separate building, preferably one that offered a pleasant vista. The Italians, meanwhile, called sugar creations *trionfi* and displayed them at the end of each banqueting course.[24] The Vatican kitchens had a special "room in which the *trionfi* are prepared."[25]

The introduction of gum tragacanth, the resin from a shrub of Eastern Mediterranean origin, helped sugar sculpture to develop into a fully fledged art form. The gum bonded and strengthened the sugar paste, permitting it to be fashioned into any shape. One could also melt sugar, cast it in molds, and finish the forms with chisels—in a process resembling bronzework. In fact, by the sixteenth century the most accomplished bronze sculptors produced sugar figures using the same molds for both materials (and today art historians must resort to surviving bronze sculptures to reconstruct the lost sugar masterpieces).[26] Often colored and gilded, sugar sculpture could also emulate enameled goldwork.[27] The costliness and visual intricacy of *sotelties* or *trionfi* made them useful tools for communicating religious, political, or whimsical themes in festive settings. They combined propaganda and pleasure in one palatable package.

Sugar sculptures took countless shapes. Heraldic beasts—salamanders, leopards, and ermines—decorated the royal tables at the banquets of the Field of Cloth of Gold. Legendary and allegorical figures, as well as biblical scenes also delighted exalted diners. The Florentine diarist Luca Landucci recorded on 18 October 1513: "We heard that the king of Portugal had sent his submission to the Pope and had presented him with the following things: a Pope made of sugar, with twelve cardinals all of sugar, life size; 300 torches of sugar, each three *braccia* [arms] long; 100 chests of sugar; and many chests of delicate spices, cinnamon, cloves, and other things." Jennifer Montagu comments on the seeming contradiction between the more somber themes expressed in *trionfi* and the context of their use, such as papal feasts (fig. VI-13):

> One of the stangest aspects, at least to modern sensitivity, is the subjects depicted by these *trionfi* . . . scenes of Christ's Passion, . . . a crucifix, with angels holding the instruments of the Passion; in this irreligious age it is hard to reconcile the combination of scenes which we have been led to believe should inspire feelings of grief or penitence, if not actual tears, with the jollity and lavish over-indulgence in the pleasures of the flesh that we should expect to accompany a banquet. And we may find it hard to imagine the dinner-conversation when Cardinal Altieri entertained the cardinals during Holy Week of 1675, and the sugar *trionfi* represented scenes from the scriptures. Perhaps art historians should bear these customs in mind, before assuming that men of the cloth must necessarily have been inspired to pious thoughts by the works of religious art with which they surrounded themselves.[28]

We might well imagine a cardinal absent-mindedly breaking a sugar head of a saint and munching on it while sipping some fine after-dinner cordial.

Historical accounts also mention sugar hunting scenes and architectural structures. In 1527 Cardinal Wolsey treated the French ambassadors at Hampton Court to over one hundred *sotelties* at the second course alone: They included a castle and Saint Paul's cathedral, beasts and birds, personages engaged in fighting and dancing; as well as a complete chess set, which the cardinal gave to his guests as a parting gift, packed into a specially designed case. An illustration of the table setting on the occasion of the wedding of Johann Wilhelm of Jülich, Cleve, and Berg in Düsseldorf in 1587 shows what such pieces looked like (fig. VI-14).

Fig. VI-13.
PIERRE PAUL SEVIN (French, 1650–1710), Banquet table with *trionfi* arranged for Pope Clement IX on Maundy Thursday, 1669. Pen and brown ink, gray wash, 33 × 24.5 cm (13 × 9⅝ in.). Stockholm, National-museum, inv. THC 3611.

Fig. VI-14.
Sugar sculpture at the wedding banquet of Johann Wilhelm of Jülich, Cleve, and Berg, Düsseldorf, 1587. From Theodor Graminaeus, *Beschreibung derer Fürstlicher Jüligscher &c. Hochzeit* (Cologne, 1587), pl. 7. Los Angeles, Research Library, Getty Research Institute.

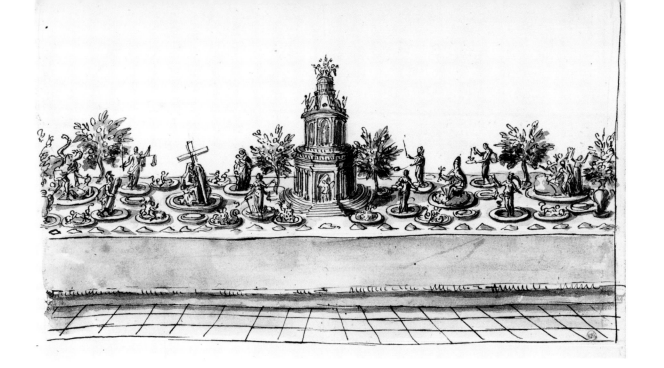

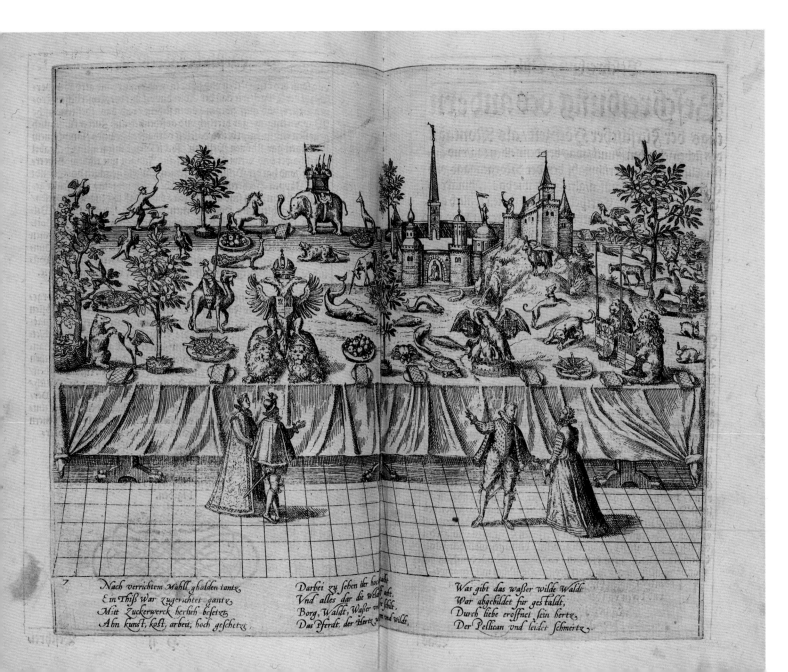

7 Nach verrichtem Mahll ghalten tantz, Darbei zu sehen ther hoch ... Was gibt das waſſer wilde Waldt,
 Ein Thiß war zugerichtet gantz, Vnd alles dar die welt ... , War abgebildet fur gestaldt,
 Mitt Zuckerwerck herlich beſetzt, Borg, Waldt, Waſſer vn ... schilt, Durch liebe eroffnet ſein hertz,
 Ahn kunſt, koſt, arbeit, hoch geſchetzt, Das Pferdt, der Herrſ ... vnd wildt, Der Pellican vnd leidet ſchmertz.

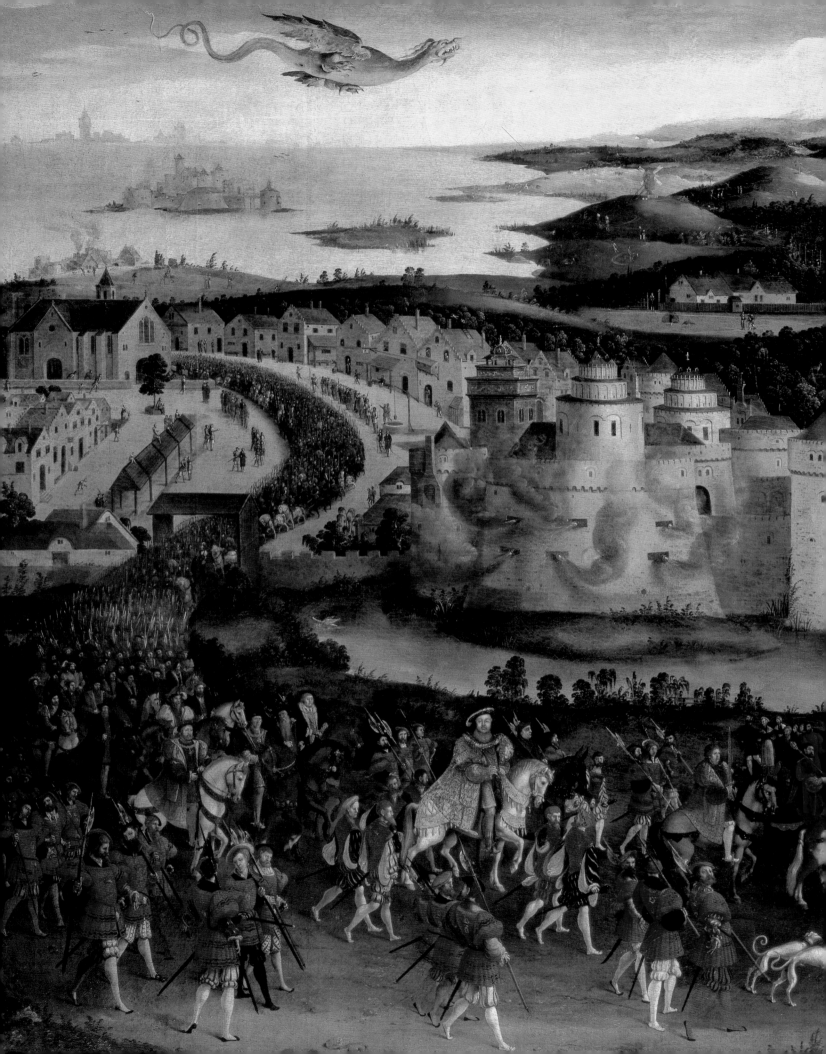

As layers of luxuries magnified the impact of individual creations, so gastronomic showpieces were enhanced by the spaces in which they were served. The closing feasts at the Field of Cloth of Gold took place in a circular theater some 27 m (89 ft.) in diameter, built around a central pillar, with walls of cloth attached to wood supports. Blue cloth covered its ceiling; gold stars, planets, the sun, and the moon—all shaped from mirrors—shimmered like true celestial bodies in the flickering light of candles and torches held by carved figures on the chandeliers suspended from the ceiling. The painted walls showed at the lower level the sea with boats, fish, and sea monsters; the middle register depicted the land dotted with windmills, towers, houses, and forests full of animals; birds and winds flew through the painted air. Statues placed around the theater held shields with armorial devices of the two kings and Latin inscriptions extolling the joys of friendship and banqueting. Statues of Hercules and King Arthur greeted guests at the entrance.[29]

A special Mass concluded the conference on June 23.[30] "A goodlie and large chappell which was richlie behanged and garnished with divers saints and reliques, which chappell was buylded and garnished at the king our master's coste with the appurtenances" rose on the site of the lists. The altar—surmounted by ten large silvergilt images, two golden candlesticks, and a large jeweled crucifix—stood opposite the galleries from which the queens had previously viewed the tournaments, and which were now converted into royal pews. Between the altar and the pews an open space accommodated two royal choirs, the organists, and other musicians. The English and the French choirs alternated, amplifying the majesty of the performance and the dignity of the service.

At the preface to the Mass a strange vision appeared in the sky: A dragon 3.6 m (12 ft.) long floated over the camp at the height of the bow's shot, and at a man's walking pace. It was a firework in the shape of the Tudor dragon (the accounts of the Revels Office for 1520 note the purchase of linen for its creation; fig. VI-15). Fireworks frequently garnished princely festivities, in general, and the feast of John the Baptist, celebrated on June 23, in particular. This firework, apt for honoring both the saint and the English king, was likely intended for the evening's entertainment, but went off too soon. Still, it was so impressive as to be immortalized in the painting that commemorated the diplomatically sterile but visually fecund summit.

CIVIC PRIDE AND PRIVATE OSTENTATION

Joyous entries, whether those of sovereigns coming to assert control over a subject town, or of dignitaries visiting a city, prompted local institutions and individuals to exhibit civic pride and personal accomplishments through impressive visual displays. At a time when the rest of Italy seems to have been continuously crisscrossed by hostile armies, and when most cities on the peninsula were compelled to offer lavish welcomes to their conquerors, Venice appeared to enjoy the privilege of hosting desired guests only. The image of peace and prosperity projected by the Most Serene Republic on such occasions aimed to demonstrate to both domestic and international observers the happy concord of a people grown rich and invincible through their maritime empire.[31] To impress foreign guests, civic bodies and private individuals ostentatiously paraded their wealth. Such was the public face of the city, but its daily reality was more complex.

In 1502 Venice welcomed the French princess Anne of Foix, the new queen of Ladislaw, King of Hungary, on her way to join her husband. The more distinguished the guest, the more elaborate and opulent the state salutation. The unique watery setting of the republic not only rendered Venice more defensible than other cities, but also made its receptions more spectacular. The islands of the lagoon helped to orchestrate the stages of greeting, as honored guests were ferried from stop to stop, met by an ever-growing body of patricians, and transferred to ever more ornate vessels. The glorious vista of the city at the last leg of the journey—as the visitor docked at the Doge's Palace next to Piazza San Marco—presented Venice as a marvelous stage set. As Anne made her entry, she reached each island in an ever more sumptuously appointed barge fitted with tapestries, gold drapery, and crimson satin. Ever-ascending ranks of city elites, dressed in cloth of gold, velvet, damask, crimson satin, and silk awaited her at each stop. As the journey progressed, the crowd of greeters swelled to several hundred who float-ed alongside the royal boat in hundreds of smaller vessels (fig. vi-16). Doge Leonardo Loredan (fig. vi-17), accompanied by his own retinue, arrived in the ceremonial barge of his office, the *Bucintoro*, described by Anne's man-at-arms, Pierre Choques, as a "galleon all covered and hung with drapes of silk and adorned with gentlewomen admirably conspicuous for gold, gems and every sort of feminine *galanterie*."[32] Transferred onto the *Bucintoro*, Anne assumed a place next to the doge at the stern of the galley. In the main section Pierre Choques counted 240 noble ladies, glittering with diamonds, rubies, emeralds, topazes, pearls, and other stones. A delegation of them brought to Anne three hundred vessels of gold and silver with confections of sugar in the form of animals—to the "surprise and admiration of all."

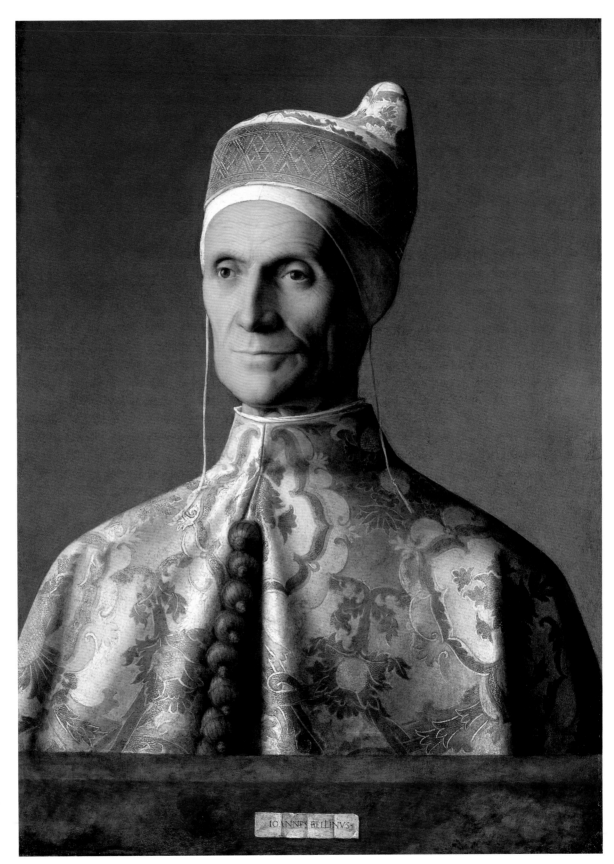

Fig. VI-17.
GIOVANNI BELLINI (Italian,
ca. 1430–1516), *The Doge
Leonardo Loredan*,
ca. 1501–1505. Oil on wood,
61.6 × 45.1 cm (24¼ ×
17¾ in.). London,
The National Gallery,
inv. NG 189.

Venice was famed for its riches—the dividends of its commercial empire in the East—and for the resultant affluence of its inhabitants, seemingly always decked out in modish attire and numerous jewels.[33] Such was the image the republic cultivated for its international reputation. Wealth translated into power, power into invincibility. When not receiving foreign dignitaries, however, the Venetian senate made strenuous efforts to curb private luxury so as to maintain a carefully balanced social order. Throughout the Renaissance the government passed sumptuary laws, relaxed only by special decrees on politically sensitive occasions.[34] Commenting on the welcome of Emperor Friedrich III and his spouse in 1452, the Venetian chronicler Marino Sanuto (1466–1536) noted that the greeters included "about 200 ladies very well adorned with jewels, and with gowns of gold and silk, since it had been voted to suspend the law, already passed, against dressing in gold, for this occasion."[35] The display of not only civic but also private riches through costly dress and adornments formed an essential component of state receptions because it honored both the hosts and the guests. In fact, at such times the Venetians were forbidden to wear mourning clothes.[36] Because apparel constituted an eloquent form of communication, however, it posed a potential threat to local authorities and the status quo. Therefore, on regular days, sumptuary laws (both in Venice and elsewhere in Europe) strove to curtail these visible manifestations of power, be it by aristocrats or by social climbers, as well as to safeguard family and city fortunes and preserve public morals. The Church, too, took a keen interest in protecting its flock against the sin of *luxuria* and often set down sumptuary legislation attacking not only attire, but also other extravagances. In his treatise on the cardinalate (*De cardinalatu*, 1510), Paolo Cortesi declared that "gluttony and lust are fostered by perfumers, venders of delicacies, poulterers, honey venders, and cooks of sweet and savory foods"; therefore a cardinal's household should be situated at a safe remove from such luxury-mongering neighbors.[37]

A declaration of the Venetian senate passed on 15 October 1504, however, clearly illustrates the uphill battle of the lawmakers:

> Among all the superfluous and useless expenditure for the purpose of ostentation made by the women of this city, the most injurious to the substance of the gentlemen and citizens is the constant change made by the women in the form of their clothes. For example, whereas formerly they wore trains to the dresses, the fashion was then introduced of wearing the dresses round and without any trains. But in the last few months certain women have begun again to use large and ample trains, trailing on the ground, and without doubt all others will desire to follow their example, if measures be not taken, and very great harm would be wrought to the fortunes of our said gentlemen and citizens, as every member of this Council, in his prudence, very well understands. For the aforesaid dresses which have been cut short would be thrown away, and it would be necessary to make new dresses, which would lead to great expense. . . . It is convenient that what the aforementioned women have once desired, with the same they should be obliged to be content.[38]

Fig. VI-18.
VITTORE CARPACCIO (Italian, ca. 1460–1525/1526), *Hunting on the Lagoon* (top half) and *Two Venetian Courtesans* (bottom half), ca. 1495. Oil and tempera on wood, top half: 94 × 64 cm (37 × 25¼ in.); bottom half: 94.5 × 63.5 cm (37¼ × 25 in.). Los Angeles, The J. Paul Getty Museum, inv. 79.PB.72 (top half); Venice, Museo Civico Correr, inv. 46 (bottom half). See also detail on p. 226.

Because of the very nature of fashion and conspicuous consumption, authorities were always playing catch-up, as resourceful and determined women and men devised ever new ways to show off their status and means. Circumventing hostile decrees by cleverly altering styles of clothes or gastronomic inventions, they dodged specific prohibitions and sent legislators to postulate new laws. The very wording of restrictions inadvertently stimulated the imagination and issued a challenge for further creativity (fig. VI-18).

Sumptuary laws shed light on the commodities charged with particular potency in this period.[39] Legislators and churchmen targeted expenditures on dowries, weddings, and funerals; the amount and type of privately worn jewelry and the specific quality and size of gems and pearls; the kinds of fabrics from which citizens cut their dress, especially silks, cloths of gold and silver, and furs; banquets, their frequency, the number of invited guests, specific foods, and even the weight of wax torches illuminating them.[40] On 12 January 1472, for example, the Venetian senate limited the number of viands that might be offered at a feast to three, beside the sweets, which were to be small confetti only; it also banned pheasants, peacocks, partridges, and doves. Poultry and fowl were the repast of nobles, as was the method of their cooking, roasting equipment being the preserve of the upper classes.[41]

Lurking under the surface of propriety was the financial gain of enforced humility. In Venice the fines collected and the articles confiscated from violators of sumptuary laws were divided between the commune, the *Arsenale* (the Venetian shipyard), the officers responsible for enforcing these strictures, and the secret accusers who denounced the offenders.[42] Slaves could gain freedom for bringing those who flaunted sumptuary laws to the attention of the authorities. Many of the rich, however, chose to pay the fines, which was called *pagare le pompe* (paying [for] the pomp), and then carry on as they pleased. In 1438 the Venetian noble woman Cristina Corner supplicated the pope for a license to wear the clothes and ornaments she possessed "in honor of her parents and in respect of her own beauty." By paying a fee she was allowed to adorn herself as she wished.[43]

A more sophisticated argument for such liberty of self-expression was formulated by the Bolognese aristocrat Nicolosa Sanuti. The beautiful and learned wife of Nicolò, Count of Porretta, and mistress of the local ruler, Bentivoglio Sante, Nicolosa was much admired by contemporary humanists. Sabadino degli Arienti described her, clad in a gown of purple silk and a rose-colored cloak lined with ermine, sitting on the hillside above the river Reno, presiding over the company of the rich and famous who gathered at the baths of Porretta—the resort of rank and fashion under the authority of her husband.[44] Responding to the sumptuary edict passed by Cardinal Bessarion on 24 March 1453, Nicolosa composed an entire oration, inspired by Livy and translated for her into Latin. Nicolosa reminded the churchman that although Roman women had been limited in their use of gold and precious cloth during the rigors of the Second Punic War, freedom and finery were restored to them when peace returned. The histories of women in antiquity and those of her own day, furthermore, demonstrated that feminine abilities could equal those of men, yet their scope of action was severely circumscribed. Women, therefore, deserved freedom of choice in their clothes, for it was to clothes that they were reduced: "Magistracies are not conceded to women; they do not strive for priesthood, triumphs, the spoils of war, because these are considered the honors of men. Ornament and apparel, because they are our insignia of worth, we cannot suffer to be taken from us." As patricians differed from the people, Nicolosa further argued, so should remarkable women differ from obscure ones. Hence Bessarion's sumptuary restrictions should be lifted.[45] The outcome of Nicolosa's appeal is unknown, but the logic of sumptuary legislation was, in any case, tempered by circumstances. Cardinal Bessarion denied Bentivoglio Sante's bridal cortege access to the Church of San Petronio because it defied his restrictions on wedding pomp. Yet he presented the newlyweds with twenty-four boxes of sweetmeats, twenty-four wax candles, six live peacocks, and a cask of malmsey (sweet wine).[46] The cardinal's inconsistency in his war on *luxuria* reflects the difficulty of balancing the decorum incumbent on a particular social rank with the desire to curtail ostentatious expenditure.

Back in Venice, sumptuary laws were lifted when the city needed to appear at its best, as when a royal worthy, such as Anne of Foix, had to be impressed with a reception commensurate with her dignity. As the queen proceeded to the heart of Venice amid the splendidly dressed inhabitants, she was entertained further by *tableaux vivants* and masquerades presenting classical and chivalric themes on small floating stages. Pierre Choques recorded that one of them represented "a god of love, standing on a pillar green with foliage, who pointed his finger at that lady [the Queen], and said in his speech: *Soyer amoureux* [may you be in love]; he was accompanied by some ladies dressed in the Italian manner and some doctors holding books. Each of them said that there was no life without love."[47]

Another float broached a more somber political topic—the threat of Turkish expansion that continuously preoccupied Europe. The floating stage supported a castle before which three Turks fought three sword-wielding kings, representing France, Hungary, and Venice. Upon their victory a lady dressed in the French fashion (alluding to Anne) arrived to perform a celebratory dance.[48] Music accompanied all the diversions staged for the queen.

Fireworks set off in honor of distinguished guests also benefited from Venetian geography. As they lit up the sky, they simultaneously created a secondary show on the water, rendering the spectacle all the more magical (fig. VI-19). When Henry III, as the

Fig. VI-19.
Fireworks sea battle.
Etching, 20 × 15.2 cm
(7 3/4 × 5 7/8 in.). From
Jean Appier-Hanzelet,
La pyrotechnie (Pont-à-
Mousson, 1630), facing
p. 252. Los Angeles,
Research Library, Getty
Research Institute.

new king of France, visited Venice in 1574, the lightshow consisted of lilies, pyramids, crowns, and other devices. A contemporary observer reported: "And because all the lights reflected in the water with splendor, it seemed that below the canal was another starry sky."[49]

Not all state visits proceeded smoothly, despite the best efforts of the organizers. According to Sanuto, during the Venetian sojourn of Cardinal Giovanni Borgia of Valencia, nephew of Pope Alexander VI, "in the house of the Marchese where they stayed, his Spaniards had robbed two carpets and linens belonging to our Signoria." Another local, Domenico Malipiero, elaborated: "And those of his company had taken away blankets, curtains of gold, fine linens [and] tapestries; and at Murano they robbed a cloth of gold, taken from the high altar where it had been placed."[50]

On other occasions the Venetians themselves faltered in their decorum. During the visit of the duke of Milan in 1530, Sanuto complained, some fellow patricians behaved appallingly at a meal that followed a mock naval battle. The magnificent repast presented to the guests included 250 sugar sculptures,

> It was a most beautiful collation, but badly served, because the Milanese gentlemen who were on the viewing platform with the ladies did not receive anything, but many [Venetian] senators stuffed their sleeves with confections to the great shame of those who saw them, and among others, Ser Victor Morosini of S. Polo who stuffed *himself* with many confections.[51]

Clearly observers paid close attention to ephemeral decorations, and their use and abuse.

THE FINAL JOURNEY AND PERPETUAL MEMORY

In death, as in life, a ruler's dignity and accomplishments were articulated through layers of magnificent creations. The death of Charles v Habsburg on 21 September 1558 in Spain prompted commemorations throughout his domains. The most opulent ceremony was staged by his son and heir, Philip II, in Brussels on 29 and 30 December 1558. Philip was in the Netherlands when his father died, and he organized a splendid funeral both to honor the deceased emperor and to reassert his own right to succession. The spectacle, viewed by relatively few, but of interest to many whose lives had been affected by Charles's far-flung ambitions, was immortalized in a printed frieze designed by Hieronymus Cock, engraved by the brothers Johannes and Lucas Duetecum who worked in his shop, and distributed by Christopher Plantin (fig. VI-20). Thirty-four copper engravings detailed the ephemeral displays, and extensive

Fig. VI-20.
JOHANNES AND LUCAS VAN DUETECUM, *Part of the Funerary Pageant of Charles v.* Hand-colored copper engravings, ca. 23.5 × 34.2 cm (9¼ × 13½ in.) and 23.5 × 35 cm (9¼ × 13¾ in.). From *La magnifique et sumptueuse pompe funebre faite aux obseques et funerailles du . . . empereur Charles Cinquième . . . en la vile de Bruxelles* (Brussels, 1559), pls. 6 and 7. Antwerp, Musée Plantin-Moretus, inv. R.44.8.

Fig. VI-21.
CLAUS SLUTER AND WORK-SHOP, *Tomb of Philip the Bold*, detail of the mourners, 1404–1406. Marble. Dijon, Musée des Beaux-Arts, inv. CA 1416. 2004 © Musée des Beaux-Arts de Dijon. Photographer: François Jay.

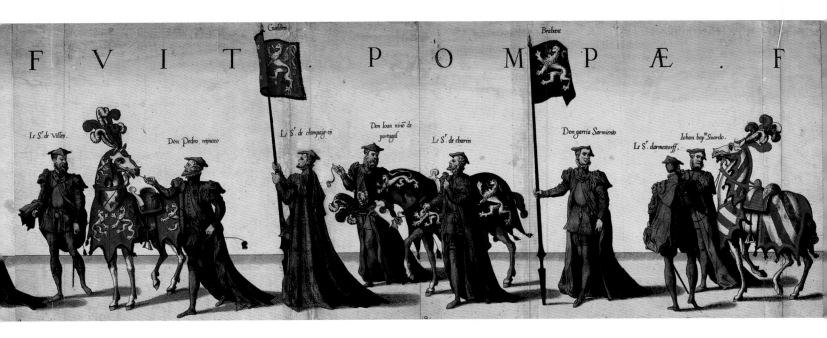

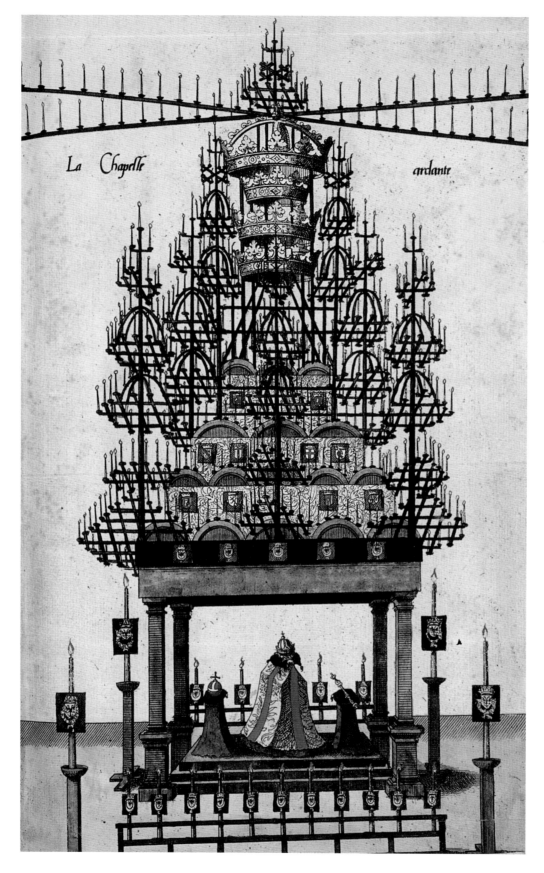

La Chapelle ardante

Fig. VI-22.
JOHANNES AND LUCAS VAN
DUETECUM, *The Funerary
Chapel* (*La chapelle ardente*).
Hand-colored copper engrav-
ing, 29 × 18.7 cm (11⅜ ×
7⅜ in.). From *La magnifique
et sumptueuse pompe fune-
bre faite aux obseques et
funerailles du…empereur
Charles Cinquième…en la
vile de Bruxelles* (Brussels,
1559), pl. 1. Antwerp, Musée
Plantin-Moretus, inv. R.44.8.

textual commentaries solidified their remembrance. Dutch, French, German, Italian, and Spanish editions were produced, and Plantin sold at least 180 copies between April 1560 and 1565. He had only just begun his career when the lucrative project came his way; through it he gained immediate recognition and lasting fame.[52] The medium of print became a powerful tool for preserving the memory and spreading the reputation of Renaissance spectacles and their protagonists. Both rulers and printers seized the propaganda and mass-marketing potential of this art as a great political and commercial opportunity.

Charles v's funeral cortege set out from the Royal Palace, passed along the streets of Brussels lined with black mourning cloth, and ended at the Cathedral of Sainte-Gudule, where the Solemn Mass was held. The procession included the clergy, the musicians of the royal chapel, officers of the imperial household, notables of the city, and two hundred poor, who carried lighted torches and marched in long robes with hoods—in the manner of mourners at funerals of the Burgundian dukes, whose political and cultural ancestry the Habsburg cherished and cultivated (figs. vi-21). Standard-bearers dressed in imperial colors followed. Behind them sailed the allegorical ship, to which we shall return shortly. Captains and dignitaries lead the empty horse of the emperor and carried his helmet, mantle of cloth of gold, scepter, sword, orb, crown, and the collar of the Order of the Golden Fleece. Each region of Charles's kingdom was represented by nobles in mourning clothes, an empty horse plumed in black, and a mounted captain carrying a banner with appropriate armorial devices. Philip ii, dressed in a mourning gown whose long black train was carried by three dignitaries, headed the Knights of the Order of the Golden Fleece, his golden collar gleaming against his dark clothes.

In the cathedral a catafalque—surmounted by a quadruple crown referring to the four titular claims of Charles v and illuminated by some three thousand burning candles—housed the emperor's coffin, which was draped with a cloth of gold embroidered with a red cross (fig. vi-22). The royal crown lay on top of the coffin. On either side of it, on top of elevated platforms, lay the imperial orb and scepter. As colorful standards flanking the bier glowed in the flickering light, the highest clergy read the funeral Mass. Choir song accompanied the soul's ascent to its final home.[53]

The almost 12-m (39-ft.) long printed roll commemorating the funeral began with the funeral chapel and the catafalque. This opening pictorially established the reason for the following narrative, as well as the beginning of the emperor's ultimate journey. The visual chronicle then detailed the procession of musicians, imperial officials, riderless horses, standard-bearers, major international dignitaries, and members of the Order of the Golden Fleece. The most complex contrivance of the obsequies—the allegorical ship that enacted the voyage of the emperor to the celestial throne—occasioned the largest and most spectacular print, although the linear design hardly does justice to the richly textured original (fig. vi-23). The 6.1-m (20-ft.) long ship, the accompanying text states, was fashioned in an antique manner, its body decorated with depictions of Charles's battles, its poop embellished with engravings and gold relief. Its sails were furled, but long multicolored standards bore the arms of the kingdoms and territories of His Imperial Majesty. The ship rested on a platform painted to look like the sea, and, according to eyewitnesses, the vessel "by a great artifice appeared to move without apparent help from horses or men, and seemed to have been drawn by two sea monsters." A finely dressed young woman, personifying Hope, stood on the prow, holding a

silver anchor in her hand and appearing eager to gain the port. Before the great mast and at the foot of the empty imperial throne another female figure dressed in pure white—a personification of Faith—sat on a square block inscribed with the word *Christus* and held a red cross in her hand. On the poop rode the figure of Charity, full of ardor, holding a burning heart in one hand and steering the ship with the other. Behind her a large black sail bore golden epitaphs explaining how with the help of this virtue the emperor had navigated the tempestuous seas of mortal life, acquired many previously unknown lands, given them the light of the holy Catholic faith, and with such victories filled his ship. Two tritons following the ship drew two large columns perched on two rocks in the middle of the sea and topped by imperial crowns. The inscription attached to the right column read, "You have rightfully assumed the Herculean pillars as your device," the left column's plaque stated, "The very tamer of monsters of your time." The Pillars of Hercules, Charles's personal device, had boastfully declared the boundless extent of his ambitions and domains. Now, having sailed passed the Straits of Gibraltar to the New World, combatted the enemies of religion at home and abroad, and spread far and wide the message of Christ, the imperial ship was turning its prow toward heaven. The imperial eagle at the tip of its battering ram symbolically drew the vessel to the skies.

Charles's funeral was as carefully composed as were the flattering eulogies of his reign in his tapestries, armor, music, and other arts produced for him during his life. He had deployed them all to achieve the power and glory that would surpass and vanquish his enemies and competitors against whom he fought throughout his reign. To this day, these arts continue to induce wonder and to put a glossy face on the unflattering realities of imperial wars, conquests, and failures.

Single objects preserved in museums today, be they tapestries or gold statuettes, suites of armor or illustrated books, cannot bring back to life the richly textured processions of kings, courtiers, and citizens decked out in their finery, slowly moving through streets noisy with excited crowds, the sounds of trumpets, and the ringing voices of actors delivering edifying lines on temporary stages. Nor can they convey the experience of princely banquets with their sideboards loaded with precious plate set against backdrops of shimmering weavings in great halls resonant with music and suffused with smells of succulent foods presented to opulently attired guests as they watch elaborate theatrical performances and the antics of ingenious automata. The sensory overload brought on by overlapping layers of luxury creations was part of the alchemy that marked the realm of the great and distinguished momentous events from mundane routines. Princely celebrations—weddings and funerals, banquets and tournaments, receptions of notable guests and diplomatic gatherings—were epicenters at which the most important politics and values were articulated and whence ideas and tastes radiated across Europe and beyond. In looking closely at the paramount artifacts of the Renaissance and pondering their functions and their meanings within their culture, we gain a richer understanding of the ever-elusive past.

Fig. VI-23. JOHANNES AND LUCAS VAN DUETECUM, *Allegorical ship of Charles V.* Hand-colored copper engraving, ca. 44.5 × 62 cm (17½ × 24⅜ in.). From *La magnifique et sumptueuse pompe funebre faite aux obseques et funerailles du...empereur Charles Cinquième...en la vile de Bruxelles* (Brussels, 1559), pl. 5. Antwerp, Musée Plantin-Moretus, inv. R.44.8.

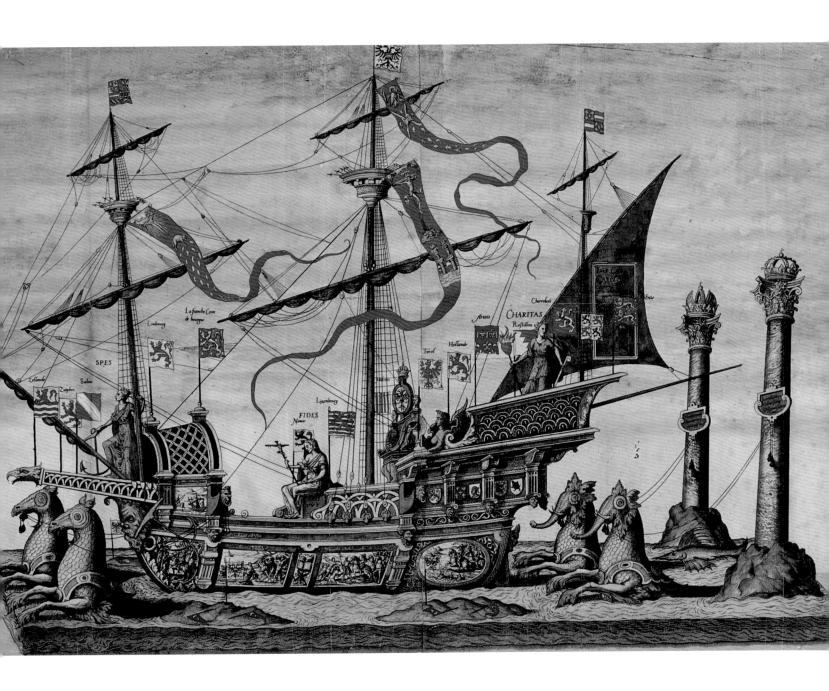

Notes

Prologue

1. Aristotle *Nicomachean Ethics* 1122, trans. W. D. Ross (Oxford, 1925).
2. For Renaissance political theory, see Jenkins 1970; Harris 1965, 58–69; Kipling 1977, 28–30; and Skinner 1978, vol. 1: 84–101, 118–28.
3. Scott 1995, 81.

I The Demise of Luxury Arts

1. Kristeller 1990, 164.
2. Aristotle *Politics* 3.5.10, 1278a.
3. Plutarch *Life of Perikles* 2.1.
4. Stewart 1990, 69–72, discusses the status of various artisans in antiquity.
5. Cast 1988, 414; Burke 1986, 74–82, on the status of the arts in Italy; Campbell 1998, 21, 31–32, on Northerners' views.
6. Alberti 1972/1991; Cennini 1960; Kemp and Walker 1989; Blunt 1962, ch. 4; Kemp 1992.
7. Bull 1987, 123.
8. Goldthwaite 1993, 248.
9. Wohl 1999.
10. Kristeller 1990, 166–67.
11. Wohl 1999, 67.
12. Hatfield 1970, 233.
13. Montagu 1989, 115.
14. Barzman 2000.
15. Goldstein 1996, 28.
16. A. Hughes 1986, pt. 2, 57.
17. A. Hughes 1986, pt. 2, 50, 51.
18. A. Hughes 1986, pt. 2, 53.
19. A. Hughes 1986, pt. 2, 59, 61.
20. Rubin 1995 provides an extensive analysis and bibliography of this subject.
21. Vasari, "Life of Brunelleschi," 1996, vol. 1: 326.
22. Collareta 1995.
23. Vasari, "Life of Marc' Antonio," 1996, vol. 2: 77.
24. Pilliod 1998, 30–52.
25. Rubin 1995, 142, notes that "with this form of editing Vasari both extracted the artist from a dependent position and exalted his production by putting it in his name." She further observes (407) that "As a historian Vasari was an opportunist.... He was also a careerist. The hope for personal success as well as professional glory permeates the text."
26. Rubin 1995.
27. Scheicher 1985.
28. Muccini 1997, 150.
29. Ovid *Metamorphoses* 4.742–60, trans. A. D. Melville (Oxford and New York, 1986).
30. Olmi 1985.
31. Distelberger 1985.
32. Montagu 1989, 188–90.
33. Montagu 1989, 116. Frames, too, could be extremely valuable, with painting produced to fill them. Among the gifts distributed by the pope to distinguished visitors in seventeenth-century Rome were copper devotional paintings set into silver frames. The frames were made first, and cost from sixty to a hundred *scudi*, not including their engraved and gilded backs, whereas the paintings produced to fit inside them cost thirty *scudi* (Montagu 1989, 119).
34. Crow 1985, 21–27; Lux 1982.
35. Scott 1995.
36. Strümer 1979, 506.
37. Cited by Strümer 1979, 507.
38. *Charles Le Brun* 1963, nos. 119–22.
39. Goldstein 1996, 253–54.
40. Dunkerton et al. 1991, 110. The chests were produced for the marriage of Matteo di Morello to Donna Vaggia di Tanai di Francesco de Nerli.
41. Scott 1995, 31.
42. Scott 1995, 75.
43. Scott 1989; Pevsner 1940, 105–6.
44. Crow 1985, 107.
45. Scott 1989, 59.
46. Goldstein 1996, 52; Crow 1985.
47. Bazin 1967, 115.
48. Kristeller 1990, 199–202.
49. Labriolle-Rutherford 1963; Morize 1909/1970; Saisselin 1981.
50. Sargenton 1996.
51. Stafford 1994, 248.
52. McClellan 1994, 80.
53. Stafford 1994, 266. Printed explanatory guides became a mandatory part of a visitor's experience of an art museum or a cabinet of natural history. Duncan and Wallach 1980 discuss the didactic dimensions of new art museums.
54. *Crystal Palace Exhibition* 1851.
55. Leben 1993, 99–118.
56. Baker and Richardson 1997, 40.
57. G. Semper, *Der Stil in den technischen und tektonischen Künsten* (1860–1862); trans. H. F. Mallgrave and M. Robinson, *Style in the Technical and Tectonic Arts* (Los Angeles, 2004).
58. Baker and Richardson 1997, 34.
59. Goldstein 1996, 256–59; Naylor 1971.
60. Haskell 1993, 236–52.

61. A. Loos, "Ornament und Verbrechen," written in 1908; first published in German in 1929; English trans. by M. Mitchell in *Ornament and Crime: Selected Essays* (Riverside, CA, 1998).
62. Goldstein 1996, 261–62; Whitford 1986; Franciscono 1971, 13–25.
63. Goldstein 1996, 202.
64. Price 1989, 77–79, 100–107; Shiner 1994, 226–34.
65. Montagu 1989, 197.
66. Kristeller 1990, 226–27.

II THE POWERS OF GOLD AND PRECIOUS STONES

1. Brown and Lorenzoni 1972; C. M. Brown 1997, 87; Fletcher 1981.
2. Luzio 1908.
3. The medal was cast by Gian Cristoforo Romano, sculptor, architect, and musician to Isabella's sister Beatrice, Duchess of Milan, upon whose death he moved to Mantua.
4. Fletcher 1981, 62.
5. Massinelli and Tuena 1992; *Princely Magnificence* 1980.
6. Panofsky 1979, 20–21, 63–65 (Abbot Suger, *Liber de rebus in administratione sua gestis*, 1144–1148/1149). Anagogical understanding refers to the interpretation of texts that finds beyond the literal, allegorical, and moral senses the ultimate spiritual or mystical sense.
7. Panofsky 1979, 53; Gerson 1986.
8. Goldthwaite 1993, 74–75.
9. Panofsky 1979, 65.
10. Panofsky 1979, 67.
11. Panofsky 1979, 79.
12. Shearman 1972, 2.
13. Shearman 1972, 11.
14. Meiss 1967, 39.
15. The legendary treasures of Saint Marks Basilica in Venice, for example, proclaimed the republic's commercial reach and crusading exploits.
16. Lightbown 1979 discusses votives in precious metals.
17. Laborde 1849–1852, vol. 1: 1929; Velden 2000.
18. Pliny *Historia Naturalis*, Book 37; Theophrastus 1956. On diverse powers of precious stones, see Meiss 1967, 50–54, 69–70; Panofsky 1979, 188; Evans 1922, 72–80.
19. Marbode 1977; Evans 1922.
20. Albertus Magnus 1967; Riddle and Mulholland 1980.
21. Ficino 1989; Walker 1958, 3–53, 75–84.
22. Ficino 1989, 1.20.
23. Ficino 1989, 1.23.
24. Ficino 1989, 3.1.
25. On the import of gold, gems, and pearls, see Cherry 1992, 19–32; Lightbown 1992, 27–32.
26. Tafur 1926, 83–84.
27. Dürer 1913/1995, 3.
28. Dürer 1913/1995, 9–10.
29. Daston and Park 1998, 88.
30. Luchinat 1997, 37; Spallanzani 1992.
31. Heikamp 1974.
32. *Treasury of San Marco* 1984.
33. Panofsky 1979, 79; Heckscher 1938.
34. *Le trésor de Saint-Denis* 1991, 183–85.
35. Meiss 1967, 42.
36. Guiffrey 1894–1896, vol. 1: 209–10, no. 806, and 214, no. 826.
37. *Treasury of San Marco* 1984, 216–21.
38. Starkey 1991, 126–35, esp. 130; Cocks 1977, 183, on the standardization of gifts.
39. Starkey 1991, 127.
40. *Das goldene Rössl* 1995.
41. *Das goldene Rössl* 1995, 52–57.
42. Meiss 1967, I, 45.
43. Cox-Rearick 1995, 79.
44. Cox-Rearick 1995, 79.
45. Starkey 1991, 84–85.
46. Chapuis and Droz 1958; Drachmann 1948; Eamon 1983; Maurice and Mayr 1980.
47. Bedini 1964, 32.
48. Sullivan 1985; on automata in medieval literature, see also Sherwood 1947; Eamon 1983.
49. Sullivan 1985, 13.
50. Sullivan 1985, 13–16.
51. Marche 1883–1888, vol. 3: 118–19; Laborde 1849–1852, vol. 2: 4437, 4881; Kipling 1977, 107.
52. Laborde 1849–1852, vol. 2: 4437, 4881.
53. Daston and Park 1998, 91; on the courtly associations of magic, see Kieckhefer 1989, 95–115; Eamon 1994, ch. 2.
54. Daston and Park 1998, 107.
55. Bedini 1964, 32–33.
56. *Gothic and Renaissance Art in Nuremberg* 1986, 282–83; Rowlands 1988, 72–74.
57. Bedini 1964, 33; Lightbown 1978, 45–46; Fliegel 2002.
58. Wilhelm Schlüsselfelder (1483–1549) was the first documented owner of the ship. *Gothic and Renaissance Art in Nuremberg* 1986, 224–27.
59. Groiss 1980, 75.
60. Bedini 1980, 20.
61. Dürer 1913/1995, 64.
62. Delmarcel 1999, 60–62. The tapestry was presented to the Zaragoza cathedral in 1520 by Archbishop Don Alonso de Aragón, the natural son of the Catholic King Ferdinand of Aragon.
63. Meiss 1967, 45. The duke played chess with pieces made of gilded silver or jasper and crystal.
64. Lindahl 1962.
65. Guenée and Lehoux 1968, 86–95; Chastellain 1863–1866, vol. 4: ch. 39, and vol. 6: ch. 37; Clercq 1823, ch. 32; Smith 1979, 95–96.
66. Chastellain 1863–1866, vol. 4: 61–62, 85–86.
67. Rowland 1998, 242.
68. Belozerskaya 2004.
69. Henisch 1976, esp. 104–9.
70. *Les Français en Amérique* 1946, 79–112; Quinn 1975, 169–90; Wroth 1970.
71. Hackenbroch 1979, 64.
72. Hackenbroch 1996.
73. Cited in Hackenbroch 1979, 17–18.
74. Lightbown 1992, 371; Masson 1926.
75. Hackenbroch 1979, 29–31.

III WOVEN NARRATIVES OF RULE

1. Horn 1989, 111ff.
2. Horn 1989, 177–78.
3. Horn 1989, 189.
4. Finch 1989, 68–69.
5. Horn 1989, vol. 2: Appendix.
6. Horn 1989, doc. 4, 348–51, doc. 12, 360.
7. Horn 1989, docs. 49, 50, 397–98; Duverger 1972; *Maria van Hongarije* 1993.
8. Horn 1989, 126.

9. Horn 1989, doc. 38, 386, doc. 41, 389.
10. Vaughan 1970, 141–42, 56.
11. Deuchler 1963, 75–91.
12. Saintenoy 1921, 17–19.
13. Brassat 1992; Brown and Delmarcel 1996; Eichberger 1992; Smith 1989.
14. Laborde 1849–1850, vol. 1: 1605; Lestocquoy 1938; Saintenoy 1934, 54–56; Smith 1979, 151 ff.
15. Kendall and Ilardy 1970–1971, vol. 2: 348–52.
16. Müntz 1890, 56–67; Starkey 1998.
17. Delmarcel 2000.
18. Asselberghs 1967, no. 7; Crick-Kuntziger 1938; Duverger 1960; Hulst 1966, 49–58.
19. Doutrepont 1909, 186; Pinchart 1878, 30.
20. Haynin 1905–1906, vol. 2: 156–60; Quicke 1943, 65–68.
21. Lestoquoy 1978, 78, 82, 100; Martens 1952, 221–34; Ross 1974, 104–25.
22. Adelson 1985, 148.
23. Meoni 1998, vol. 1: 35–61.
24. Adelson 1983, 909–12.
25. Heinz 1963, 251–76, 285–317.
26. Adelson 1983, 1985; Meoni 1998, vol. 1: 35–61, 121–41.
27. Small 1982, 189–90, 193.
28. Adelson 1985, 173–74.
29. Vasari 1996, vol. 2, 367.
30. Adelson 1985, 151–53.
31. Shearman 1972, 14.
32. Vasari 1996, vol. 1, 731.
33. Albèri 1846, 96ff.
34. Shearman 1972, 9.
35. Shearman 1972, 10, 12, 13.
36. Antonio de Beatis 1979, 95.
37. Froissart 1867–1877, vol. 15: 339; Vaughan 1962, 71–72.
38. Van Mander 1994–1999, vol. 3: 76.
39. Necipoglu 1989, 411.
40. Kellenblenz 1965, 363–65, 371–74.
41. Necipoglu 1989, 419.
42. Asselberghs 1970; McKendrick 1991; Smith 1979, 338–40.
43. Brown and Delmarcel 1996, 215 and n. 2.
44. Crick-Kuntziger 1942; Le Maire 1956; *Masterpieces of Tapestry* 1973, 201–8; *Tapisseries bruxelloises* 1976, 85–99.
45. Cavallo 1967, vol. 1: 56–58, vol. 2: pls. 4, 5.
46. T. Campbell 1995–1996.
47. *Masterpieces of Tapestry* 1973, 93–95.
48. *Masterpieces of Tapestry* 1973, 121–23.
49. *Masterpieces of Tapestry* 1973, 95–96.
50. *Masterpieces of Tapestry* 1973, 19–20.
51. Schneebalg-Perelman 1969.
52. Grunzweig 1931, 26–38, 98–99.
53. Schneebalg-Perelman 1969, 29.
54. Roover 1948, 89, 91.
55. Tafur 1926, 203–4.
56. Delmarcel 1999, 95, 117.
57. Saulnier-Pernuit 1993.
58. *Masterpieces of Tapestry* 1973, 163–68.

IV Armor: The High Art of War

1. Scheicher 1990.
2. Notzing 1981.
3. Conde Valencia de Don Juan 1889.
4. Blair 1965.
5. Laborde 1849–1852, vol. 2: no. 3131.

6. Marche 1883–1888, vol. 2: 11.
7. Gaier-Lhoest 1973, 81.
8. Pfaffenbichler 1992, 37–38.
9. Fanfani 1864; Gori 1930, 88–93; Rochon 1963, 97–99; Ricciardi 1992, 166–74; Carew-Reid 1995, 31–35; Pulci 1527.
10. Machiavelli 1909, 359.
11. Kurz 1969; Sanuto 1879–1903, vol. 55: 634–36; vol. 56: 10–11.
12. Sanuto 1879–1903, vol. 55: 635; vol. 56: 6–7.
13. Necipoglu 1989, 401–27.
14. Mitchell 1979, 19–25; Sanuto 1879–1903, vol. 52: 142–45, 180–99, 205–6, 259–75, 604–19, 624–82.
15. Sanuto 1879–1903, vol. 56: 791, 826.
16. Necipoglu 1989, 407–9; Sanuto 1879–1903, vol. 56: 870–71.
17. Castiglione 1959, 15.
18. Grancsay 1986b.
19. Cennini 1960, 108–9.
20. Lannoy 1878, 456–57, trans. Vale 1981, 15.
21. Scheicher 1983, 43–92.
22. Dennistoun 1851/1909, vol. 3: 97; Pyhrr and Godoy 1998, 278–84.
23. Pyhrr and Godoy 1998, 136–46.
24. *Resplendence of the Spanish Monarchy* 1991, 155–64.
25. Pyhrr and Godoy 1998, 272–77
26. Grancsay 1986c.
27. Blair 1965; Borg 1974.
28. Pyhrr and Godoy 1998, 160–70.
29. Pyhrr and Godoy 1998, 42.
30. Pfaffenbichler 1992, 48–50.
31. Pyhrr and Godoy 1998, 4.
32. Gaier-Lhoest 1973, 167, n. 165; Martens 1952, 226–27.
33. Pfaffenbichler 1992, 55.
34. Pyhrr and Godoy 1998, 4–5.
35. Pfaffenbichler 1992, 53.
36. Pyhrr and Godoy 1998, 75.
37. Pyhrr and Godoy 48–49, 225.
38. Pfaffenbichler 1992, 14.
39. *Resplendence of the Spanish Monarchy* 1991, 155–64.
40. Grancsay 1986a.
41. Shakespeare *Othello*, v.2.253.
42. Karcheski 1995, 66; Pfaffenbichler 1992, 62.
43. ffoulkes 1912/1988, 104.
44. Pfaffenbichler 1992, 66.
45. Pfaffenbichler 1992, 66.
46. Cited by Karcheski 1995, 77.
47. Karcheski 1995, 71.
48. Mann 1942, 24.
49. Cellini 1927.
50. Pyhrr and Godoy 1998, 15.
51. Pyhrr and Godoy 1998, 186.

V Sweet Voices and Fanfares

1. Perkins 1999, 208.
2. M. H. Brown 1981.
3. Perkins 1999, 149–74; Strohm 1990.
4. Kellman and Jas 1999; Meoni 1999, 29–30.
5. Shearman 1972, 13.
6. Bodleian, ms. Hatton 13; Fallows 1983, 110, 145–59; Marix 1939, 128–31.
7. Woodley 1982, 312–13.
8. Vitruvius *De architectura* 3, pref. 2.

9. Atlas 1985, 38–39; Bentley 1987, 75; Woodley 1981 and 1988.
10. Atlas 1985, 73; Woodley 1981, 245, Doc. 6.
11. Fallows 1983, 116.
12. Seebass 1983, 30–33.
13. Pirro 1935, 8.
14. Merkley and Merkley 1999, esp. 77–80 and ch. 2; Prizer 1989; Welch 1993.
15. Merkley and Merkley 1999, 42.
16. Strohm 1990, 37–38.
17. Prizer 1989, 147; Walsh 1978; Welch 1995, 197, 247.
18. Merkley and Merkley 1999, 148.
19. Starr 1992, 228–34.
20. Starr 1987, 211.
21. Perkins 1982, 524–26.
22. Atlas 1985, 38–39; Bentley 1987, 75; Woodley 1981 and 1988.
23. Thomas and Thornley 1938, 251–52; Anglo 1959.
24. Doorslaer 1934, 21–57, 139–61; Higgins 1986, 44.
25. Marix 1939, 64; Wright 1979, 102.
26. Higgins 1986, 60; Vaughan 1973, 162.
27. Miller 1972, 413.
28. Lewis 1999.
29. Masson 1926, 140–41. See here p. 85.
30. Fernández de Oviedo 1870, 182–83; Knighton 1989, 343–44.
31. Castiglione 1959, 74.
32. Prizer 1980, 12.
33. For this and following, see Prizer 1980.
34. Translation adapted from Prizer 1980, 11.
35. Prizer 1980, 3–4.
36. Prizer 1980, 13, 51.
37. Prizer 1980, 105.
38. Castiglione 1959, 60.
39. Prizer 1980, 43.
40. Westfall 1990, 63–107.
41. Westfall 1990, 68.
42. Downey 1981.
43. Downey 1981.
44. Lasocki 1985, 121.
45. Prior 1983.
46. Lasocki 1985.
47. Blackburn 1992, 20.
48. Kenyon de Pascual 1987, 74–75.
49. Lasocki 1985, 120–21.
50. Prior 1995.
51. Brainard 1979, 21.
52. Plato *Republic* 2.376e; Kristeller 1990, 169.
53. Gombosi 1941, 293.
54. Sparti 1986.
55. McGee 1988, 205.
56. A. W. Smith 1995, 5–67.
57. Baxandall 1972, 77–81.
58. Sparti 1993.
59. Brainard 1981.
60. Halm 1928.
61. Froissart 1867, vol. 1: 63–64, 122ff., 323–25; Pintoin 1839–1852, vol. 2: 65–71.
62. Marche 1883–1888, vol. 2: 348ff.; Escouchy 1863–1864, vol. 2: 116ff.
63. Blackburn 1992.
64. Blackburn 1992, 5.
65. Blackburn 1992, 17–18.
66. Blackburn 1992, 24.
67. Blackburn 1992, 19.
68. Blackburn 1992, 25–26.

VI **THE SEDUCTION OF ALL SENSES**

1. Geoffrey Chaucer, *The Canterbury Tales*, trans. N. Coghill (Harmondsworth, 1951), 438.
2. Loomis 1958.
3. Haynin 1905–1906, vol. 2: 17–62; Marche 1883–1888, vol. 3: 101–201, and vol. 4: 95–144; S. Bentley 1831, 223–39; Vaughan 1973, 48–53.
4. Laborde 1849–1852, vol. 2: 4443–4899.
5. Ibid., 4757.
6. Ibid., 293–381, 322ff.
7. Ibid., 4441.
8. Haynin 1905–1906, adapted from translation by Vaughan 1973, 50–51.
9. Laborde 1849–1852, vol. 2: 4420.
10. Marche 1883–1888, vol. 3: 133–34.
11. Ibid., 134–35.
12. Laborde 1849–1852, vol. 2: 4423.
13. Marche 1883–1888, vol. 3: 136–37; Laborde 1849–1852, vol. 2: 4426.
14. Marche 1883–1888, vol. 3: 143–47.
15. Laborde 1849–1852, vol. 2: 4422.
16. Marche 1883–1888, vol. 3: 151–54; Laborde 1849–1852, vol. 2: 4428.
17. Marche 1883–1888, vol. 3: 123–33; Cartellieri 1970, 124–34.
18. Marche 1883–1888, vol. 3: 122–23; S. Bentley 1831, 235–36.
19. Carew-Reid 1995, 31–35; Pulci 1527; Ricciardi 1992, 166–74.
20. Anglo 1968, 34–40.
21. Russell 1969; Anglo 1960 and 1966; Hall 1904.
22. Anglo 1960, 113.
23. Hall 1904, 1, 210.
24. Mason 1966; Montagu 1989, 192–97; Root 1979, 39; Watson 1978; Wilson 1991.
25. Montagu 1989, 192.
26. Montagu 1989; Watson 1978.
27. Wilson 1991, 19.
28. Montagu 1989, 195; Landucci 1883, 272.
29. Anglo 1960, 127–32.
30. Russell 1969, 171–76.
31. P. F. Brown 1990.
32. Choques 1861, 177.
33. Newton 1988.
34. Hughes 1983; Newett 1907.
35. Cited by P. F. Brown 1990, 147.
36. P. F. Brown 1990, 147.
37. Weil-Garris and d'Amico 1980, 73.
38. Cited by Newett 1907, 247–48.
39. Hunt 1996; Killerby 1994.
40. Newett 1907, 273; Redon 1992.
41. Laurioux 1992.
42. Newett 1907, 256.
43. Newett 1907, 259–60.
44. Ady 1937, 56–57.
45. D. O. Hughes 1983, 86–87.
46. Ady 1937, 50.
47. Choques 1861, 178.
48. Choques 1861, 179.
49. P. F. Brown 1990, 145.
50. Cited by P. F. Brown 1990, 142.
51. Cited by P. F. Brown 1990, 147.
52. *Magnifique et sumptueuse pompe funebre* 1559; Voet and Voet-Grisolle 1980–1983, vol. 2: 603–11; Schrader 1998.
53. Jacquot 1960, 467–73.

Bibliography

Adelson, C. 1983. "Cosimo I de' Medici and the Foundation of Tapestry Production in Florence." In *Firenze e la Toscana dei Medici nell'Europa del '500*. Vol. 3: 899–924. Florence.

———. 1985. "Documents for the Foundation of Tapestry Weaving Under Cosimo I de'Medici." In *Renaissance Studies in Honor of Craig Hugh Smyth*, ed. A. Morrogh et al. Vol. 2: 3–17. Florence.

Ady, C. M. 1937. *The Bentivoglio of Bologna: A Study in Despotism*. Oxford.

Albèri, E. 1846. *Relazioni degli ambasciatori veneti al Senato*. Ser. 2.3. Florence.

Alberti, L. B. 1972/1991. *De Pictura* (1435). *On Painting*. Trans. C. Grayson. Harmondsworth.

Albertus Magnus. 1967. *Book of Minerals* [*De mineralibus*]. Trans. D. Wyckoff. Oxford.

Anglo, S. 1959. "William Cornish in a Play, Pageant, Prison, and Politics." *Review of English Studies*, n.s. 10, no. 40: 347–60.

———. 1960. "Le camp du drap d'or et les entrevues d'Henri VIII et de Charles Quint." In *Fêtes et cérémonies au temps de Charles Quint*, ed. J. Jacquot, 113–32. Paris.

———. 1966. "The Hampton Court Painting of the Field of Cloth of Gold Considered as an Historical Document." *The Antiquaries Journal* 46: 287–307.

———. 1968. *The Great Tournament Roll of Westminster*. 2 vols. Oxford.

———. 1992. *Images of Tudor Kingship*. London.

Antonio de Beatis. 1979. *The Travel Journal of Antonio de Beatis: Germany, Switzerland, the Low Countries, France and Italy, 1517–1518*. Trans. and ed. J. R. Hale and J. M. A. Lindon. London.

Asselberghs, J.-P. 1967. *La Tapisserie Tournaisienne au XVᵉ siècle*. Tournai.

———. 1970. "Les Tapisseries Tournaisiennes de la Guerre de Troie." *Revue belge d'archéologie et d'histoire de l'art* 39: 93–183.

Atlas, A. W. 1985. *The Music at the Aragonese Court of Naples*. Cambridge.

Baker, M., and B. Richardson, eds. 1997. *A Grand Design: The Art of the Victoria and Albert Museum*. New York.

Barzman, K.-E. 2000. *The Florentine Academy and the Early Modern State: The Discipline of Disegno*. Cambridge.

Baudrillart, H. J. L. 1878–1880. *Histoire de luxe privé et public depuis l'antiquité jusqu'à nos jours*. 4 vols. Paris.

Baxandall, M. 1972. *Painting and Experience in Fifteenth-Century Italy*. Oxford.

Bazin, G. 1967. *The Museum Age*. Trans. J. van Nuis Cahill. New York.

Bedini, S. A. 1980. "The Mechanical Clock and the Scientific Revolution." In Maurice and Mayr, 19–26.

———. 1964. "The Role of Automata in the History of Technology." *Technology and Culture* 5: 24–42.

Belozerskaya, M. 2002. *Rethinking the Renaissance: Burgundian Arts across Europe*. Cambridge.

———. 2004 "Cellini's *Saliera*: The Salt of the Earth at the Table of the King." In *Benvenuto Cellini 1500–1571: Sculptor, Goldsmith, Writer*, ed. M. A. Gallucci and P. L. Rossi, 71–96. Cambridge.

Bentley, J. H. 1987. *Politics and Culture in Renaissance Naples*. Princeton.

Bentley, S., ed. 1831. *Excerpta Historica*. London.

Blackburn, B. J. 1992. "Music and Festivities at the Court of Leo X: A Venetian View." *Early Music History* 11: 1–37.

Blair, C. 1965. "The Emperor Maximilian's Gift of Armor to King Henry VIII and the Silvered and Engraved Armour at the Tower of London." *Archaeologia* 99: 1–52.

Blunt, A. 1962. *Artistic Theory in Italy 1450–1600*. Oxford.

Boogert, B. van den, and J. Kerkhoff, eds. 1993. *Maria van Hongarije: Koningin tussen keizers en kunstenaars, 1505–1558*. Zwolle.

Borg, A. 1974. "The Ram's Horn Helmet." *The Journal of the Arms and Armour Society* 8: 127–37.

Bouckaert, B. 1999. "The Capilla Flamenca: The Composition and Duties of the Music Ensemble at the Court of Charles V, 1515–1558." In *The Empire Resounds: Music in the Days of Charles V*, ed. F. Maes, 37–45. Leuven.

Brainard, I. 1979. "The Role of the Dancing Master in 15th Century Courtly Society." *Fifteenth Century Studies* 2: 21–44.

———. 1981. "An Exotic Court Dance and Dance Spectacle of the Renaissance: La Moresca." In *Report of the Twelfth Congress of the International Musicological Society, Berkeley 1977*: 715–27. Kassel.

Brassat, W. 1992. *Tapisserien und Politik: Functionen, Kontexte und Rezeption eines repräsentativen Mediums*. Berlin.

Brown, C. M. 1997. "Isabella d'Este Gonzaga's *Augustus and Livia* Cameo and the *Alexander and Olympias* Gems in Vienna and Saint Petersburg." In *Engraved Gems: Survivals and Revivals*, ed. C. M. Brown, 85–107. Washington, D.C.

Brown, C. M., and G. Delmarcel. 1996. *Tapestries for the Courts of Federico II, Ercole, and Ferrante Gonzaga, 1522–1563*. Seattle.

Brown, C. M., and A. M. Lorenzoni. 1972. "An Art Auction in Venice in 1506." *L'Arte* 5: 121–36.

Brown, M. H. 1981. "On Gentile Bellini's *Processione in San Marco* (1496)." In *Report of the Twelfth Congress of the International Musicological Society, Berkeley 1977*, 649–58. Kassel.

Brown, P. F. 1990. "Measured Friendship, Calculated Pomp: The Ceremonial Welcomes of the Venetian Republic." In "All the world's a stage . . .": *Art and Pageantry in the Renaissance and Baroque*, ed. B. Wisch and S. S. Munshower, vol. 1: 136–86. University Park, PA.

Bull, G., ed. and trans. 1987. *Michelangelo: Life, Letters, and Poetry*. Oxford.

Burke, P. 1986. *The Italian Renaissance: Culture and Society in Italy*. Princeton.

Campbell, L. 1998. *The Fifteenth Century Netherlandish Schools*. National Gallery Catalogues. London.

Campbell, T. 1995–1996. "Tapestry Quality in Tudor England." *Studies in the Decorative Arts* 3.1: 29–50.

Carew-Reid, N. 1995. *Les Fêtes florentines au temps de Lorenzo il Magnifico*. Florence.

Cartellieri, O. 1970. *The Court of Burgundy: Studies in the History of Civilization*. Trans. M. Letts. New York.

Cast, D. 1988. "Humanism and Art." In *Renaissance Humanism: Foundations, Forms, and Legacy*, ed. A. Rabil, Jr., vol. 3: 412–49. Philadelphia.

Castiglione, B. 1959. *The Book of the Courtier*. Trans. C. S. Singleton. Garden City, NY.

Cavallo, A. S. 1967. *Tapestries of Europe and Colonial Peru in the Museum of Fine Arts, Boston*. 2 vols. Boston.

———. 1993. *Medieval Tapestries in the Metropolitan Museum of Art*. New York.

———. 1998. *The Unicorn Tapestries in the Metropolitan Museum of Art*. New York.

Cellini, B. 1927. *The Autobiography of Benvenuto Cellini*. Trans. J. A. Symonds. New York.

Cennini, C. 1933/1960. *The Craftsman's Handbook*. Trans. D. V. Thompson. New York.

Chapuis, A., and E. Droz. 1958. *Automata. A Historical and Technological Study*. Trans. A. Reid. Neuchâtel.

Charles Le Brun, 1619–1690: Peintre et dessinateur. 1963. Exh. cat. Versailles.

Chastellain, G. 1863–1866. *Oeuvres de Georges Chastellain*. 8 vols. Ed. K. de Lettenhove. Brussels.

Cherry, J. 1992. *Goldsmiths*. London.

Choques, P. 1861. "Discours sur le voyage d'Anne de Foix dans la Seigneurie de Venice." *Bibliothèque de l'École des Chartes*, series 5.2: 156–85, 422–39.

Clercq, J. du. 1823. *Mémoires*. Ed. Baron de Reiffenberg. Brussels.

Cocks, A. S. 1977. "The Myth of 'Burgundian' Goldsmithing." *Connoisseur* 194: 180–86.

Collareta, M. 1995. "L'Historien de la technique: Sur le rôle de l'orfèvrerie dans les *Vite* de Vasari." In *Histoire de l'histoire de l'art*, ed. E. Pommier, vol. 1: 165–76. Paris.

Conde de Valencia de Don Juan, ed. 1889. "Bildinventar der Waffen, Rüstungen, Gewänder und Standarten Karl v. in der Armeria Real zu Madrid." *Jahrbuch der Kunsthistorischen Sammlungen des allerhöchsten Kaiserhauses*, vol. 10.

Cox-Rearick, J. 1995. *The Collection of Francis I: Royal Treasures*. Antwerp.

Crick-Kuntziger, M. 1938. "Notes sur les tapisseries de l'Histoire d'Alexandre du Palais Doria." *Bulletin de l'Institut historique belge de Rome* 19: 273–76.

———. 1942. *La Tenture de la légende de Notre-Dame du Sablon*. Antwerp.

Crow, T. E. 1985. *Painters and Public Life in Eighteenth-Century Paris*. New Haven.

Crystal Palace Exhibition. Illustrated Catalogue. 1851. London.

Daston, L., and K. Park. 1998. *Wonders and the Order of Nature 1150–1750*. New York.

Delmarcel, G. 1999. *Flemish Tapestry*. Trans. A. Weir. London.

———. 2000. *Los Honores: Flemish Tapestries for the Emperor Charles V*. [Antwerp].

Dennistoun, J. 1851/1909. *Memoirs of the Dukes of Urbino Illustrating the Arms, Arts, and Literature of Italy, from 1440 to 1630*. 3 vols. London.

Deuchler, F. 1963. *Die Burgunderbeute*. Bern.

Distelberger, R. 1985 "The Habsburg Collection in Vienna during the Seventeenth Century." In Impey and MacGregor, 39–46.

Dodwell, C. R. 1982. *Anglo-Saxon Arts: A New Perspective*. Manchester.

Domínguez Ortiz, A. *Resplendence of the Spanish Monarchy: Renaissance Tapestries and Armor from the Patrimonio Nacional*. 1991. Exh. cat. New York.

Doorslaer, G. van. 1934. "La Chapelle musicale de Philippe le Beau." *Revue Belge d'Archéologie et d'Histoire d'Art* 4: 21–57, 139–61.

Doutrepont, G. 1909. *La Littérature française à la cour des ducs de Bourgogne*. Paris.

Downey, P. 1981. "A Renaissance Correspondence Concerning Trumpet Music." *Early Music* 9/13: 325–29.

Drachmann, A. G. 1948. *Ktesibios, Philon and Heron: A Study in Ancient Pneumatics*. Copenhagen.

Duncan, C., and A. Wallach. 1980. "The Universal Survey Museum." *Art History* 3: 448–69.

Dunkerton, J., et al., eds. 1991. *Giotto to Dürer: Early Renaissance Painting in the National Gallery*. London.

Dürer, A. 1913/1995. *Records of Journeys to Venice and the Low Countries*. Ed. R. Fry. Boston.

Duverger, J. 1960. "Aantekeningen betreffende laat-mideleeuwse tapijten met de geschiedenis van Alexander de Grote." *Artes Textiles* 5: 31–43.

———. 1972. "Marie de Hongrie, gouvernante des Pays-Bas, et la Renaissance." Actes du XXIIᵉ Congrès International d'Histoire de l'Art, Budapest, 1969. *Évolution générale et développements régionaux en histoire de l'art*. Vol. 1: 715–26. Budapest.

Eames, P. 1977. *Furniture in England, France and the Netherlands from the Twelfth to the Fifteenth Century*. London.

Eamon, W. 1983. "Technology as magic in the late Middle Ages and the Renaissance." *Janus* 70: 171–212.

———. 1994. *Science and the Secrets of Nature: Books of Secrets in Medieval and Early Modern Culture*. Princeton.

Eichberger, D. 1992. "Tapestry Production in the Burgundian Netherlands, Art for Export and Pleasure." *Australian Journal of Art* 10: 23–43.

Escouchy, M. d'. 1863–1864. *Chronique de Mathieu d'Escouchy*. Ed. Du Fresne de Beaucourt. Paris.

Evans, J. 1922. *Magical Jewels of the Middle Ages and the Renaissance particularly in England*. Oxford.

Fallows, D. 1983. "Specific Information on the Ensembles for Composed Polyphony, 1400–1474." In *Studies in the Performance of Late Medieval Music*, ed. S. Boorman, 109–59. Cambridge.

Fanfani, P. 1864. "Ricordo d'una giostra fatta a Firenze a dì 7 febbraio 1468." *Il Borghini* 2: 475–83, 530–47.

Fenlon, I., ed. 1989. *The Renaissance: From the 1470s to the End of the 16th Century*. Vol. 1. Englewood Cliffs, NJ.

Fernández de Oviedo, G. 1870. *Libro de la cámara real del príncipe don Juan*. Madrid.

ffoulkes, C. J. 1909. "The Craft of the Armourer." *The Connoisseur* 24: 99–104.

———. 1912/1988. *The Armourer and His Craft from the xith to the xvith Century*. New York.

Ficino, M. 1989. *Three Books on Life*. Ed. and trans. C. V. Kaske and J. R. Clark. Binghamton, NY.

Finch, K. 1989. "Tapestries: Conservation and Original Design." In *The Conservation of Tapestries and Embroideries*, 67–74. Los Angeles.

Fletcher, J. 1981. "Isabella d'Este, Patron and Collector." In *Splendors of the Gonzaga*, ed. D. Chambers and J. Martineau, 51–63. London.

Fliegel, S. 2002. "The Cleveland Table Fountain and Gothic Automata." *Cleveland Studies in the History of Art* 7: 6–49.

Franciscono, M. 1971. *Walter Gropius and the Creation of the Bauhaus in Weimar: The Ideals and Artistic Theories of Its Founding Years*. Urbana, IL.

Frank, I., ed. 2000. *The Theory of Decorative Art*. Trans. D. Britt. New Haven and London.

Freeman, M. B. 1976. *The Unicorn Tapestries*. New York.

Froissart, J. 1867–1877. *Oeuvres de Froissart: Chroniques*. Ed. K. de Lettenhove. 25 vols. Brussels.

Gaier-Lhoest, C. 1973. *L'Industrie et le commerce des armes dans les anciennes principautés belges du xiii^me à la fin du xv^me siècle*. Paris.

Gairdner, J., ed. 1876. *The Historical Collections of a Citizen of London in the Fifteenth Century*. Westminster.

Gerson, P. L., ed. 1986. *Abbot Suger and Saint-Denis: A Symposium*. New York.

Das goldene Rössl: Ein Meisterwerk der Pariser Hofkunst um 1400. 1995. Exh. cat. Munich.

Goldstein, C. 1996. *Teaching Art: Academies and Schools from Vasari to Albers*. Cambridge.

Goldthwaite, R. 1993. *Wealth and the Demand for Art in Italy 1300–1600*. Baltimore.

Gombosi, O. 1941. "About Dance and Dance Music in the Late Middle Ages." *Music Quarterly* 27: 289–305.

Gori, P. 1930. *Le feste Fiorentine attraverso i secoli*. Vol. 2, *Firenze magnifica*. Florence.

Gothic and Renaissance Art in Nuremberg 1300–1550. 1986. Exh. cat. New York.

Gottfried, M. 1980 "The Role of Clocks in the Imperial Honoraria for the Turks." In Maurice and Mayr, 37–48.

Grancsay, S. V. 1986a. "A Harness of the King of France." In *Arms and Armor: Essays by Stephen V. Grancsay from the* Metropolitan Museum of Art Bulletin *1920–1964*, 244–48. New York.

———. 1986b. "A Helm for the Baston Course." In *Arms and Armor: Essays by Stephen V. Grancsay from the* Metropolitan Museum of Art Bulletin *1920–1964*, 279–82. New York.

———. 1986c. "A Parade Shield of Charles v." In *Arms and Armor: Essays by Stephen V. Grancsay from the* Metropolitan Museum of Art Bulletin *1920–1964*, 348–62. New York.

Groiss, E. 1980. "The Augsburg Clockmakers' Craft." In Maurice and Mayr, 57–86.

Grunzweig, A. 1931. *Correspondance de la filiale de Bruges des Medici*. Brussels.

Guenée, B., and F. Lehoux. 1968. *Les Entrées royales françaises de 1328 à 1515*. Paris.

Guiffrey, J. 1894. *Inventaire de Jean, Duc de Berry (1401–1416)*. Paris.

Hackenbroch, Y. 1979. *Renaissance Jewellery*. London.

———. 1996. *Enseignes*. Florence.

Haggh, B. 1995. "The Archives of the Order of the Golden Fleece and Music." *Journal of the Royal Musical Association* 120: 1–43.

Hall, E. 1904. *Henry viii*. In *The triumphant reigne of Kyng Henry the viii. Lives of the Kings*, ed. C. Whibley. London.

Halm, P. M. 1928. *Erasmus Grasser*. Augsburg.

Harris, W. O. 1965. *Skelton's Magnyfycence and the Cardinal Virtue Tradition*. Chapel Hill, NC.

Haskell, F. 1993. *History and Its Images: Art and the Interpretation of the Past*. New Haven.

Hatfield, R. 1970. "Some Unknown Descriptions of the Medici Palace in 1459." *Art Bulletin* 52: 232–49.

Haynin, J. de. 1905–1906. *Mémoires, 1465–1477*, ed. D. D. Brouwers. Liège.

Heckscher, W. S. 1938. "Relics of Pagan Antiquity in Medieval Settings." *Journal of the Warburg and Courtauld Institutes* 1: 204–20.

Heikamp, D. 1974. "Vasi in pietra dura nelle fonti italiane." In *Il tesoro di Lorenzo il Magnifico*, vol. 2, *I vasi*, ed. D. Heikamp and A. Grote, 58–78. Exh. cat. Florence.

Heinz, D. 1963. *Europäische Wandteppiche: Ein Handbuch für Sammler und Liebhaber*. Braunschweig.

Henisch, B. A. 1976. *Fast and Feast: Food in Medieval Society*. University Park, PA.

Hersey, G. L. 1973. *The Aragonese Arch at Naples, 1443–1475*. New Haven.

Higgins, P. 1986. "*In hydraulis* Revisited: New Light on the Career of Antoine Busnois." *Journal of the American Musicological Society* 39: 36–86.

Horn, H. J. 1989. *Jan Cornelisz Vermeyen, Painter of Charles v and His Conquest of Tunis*. 2 vols. Doornspijk.

Hoyoux, R. 1985. "L'Organization musicale à la cour des ducs de Bourgogne." *Publication du centre européen d'études bourguignonnes* 25: 57–71.

Hughes, A. 1986. "'An Academy for Doing.'" *Oxford Art Journal* 9: 3–10, 50–62.

Hughes, D. O. 1983. "Sumptuary Law and Social Relations in Renaissance Italy." In *Disputes and Settlements: Law and Human Relations in the West*, ed. J. Bossy, 69–99. Cambridge.

Hulst, R. A. d'. 1966. *Tapisseries flamandes du xiv^e au xviii^e siècle*. 2nd. edn. Brussels.

Hunt, A. 1996. *Governance of the Consuming Passions: A History of Sumptuary Law*. New York.

Impey, O., and A. MacGregor. 1985. *The Origins of Museums: The Cabinet of Curiosities in Sixteenth- and Seventeenth-Century Europe*. Oxford.

Jacquot, J. 1960. "Panorama des fêtes et cérémonies du règne." In *Fêtes et cérémonies au temps de Charles Quint*, ed. J. Jacquot, 413–91. Paris.

Jenkins, A. D. F. 1970. "Cosimo de' Medici's Patronage of Architecture and the Theory of Magnificence." *Journal of the Warburg and Courtauld Institutes* 33: 162–70.

Julien, Ch.-A., et al., eds. 1946. *Les Français en Amérique pendant la première moitié du xvıᵉ siècle*. Paris.

Karcheski, W. J., Jr. 1995. *Arms and Armor in the Art Institute of Chicago*. Boston.

Kellenblenz, H. 1965. "Jacob Rehlinger, ein Augsburger Kaufmann in Venedig." In *Beiträge zur Wirtschafts- und Stadtgeschichte. Festschrift für Hektor Ammann*, ed. H. Aubin et al., 362–79. Wiesbaden.

Kellman, H., ed. 1999. *The Treasury of Petrus Alamire: Music and Art in Flemish Court Manuscripts, 1500–1535*. Ghent.

Kemp, M. 1992. "Virtuous Artists and Virtuous Art: Alberti and Leonardo on Decorum in Life and Art." In *Decorum in Renaissance Narrative Art*, ed. F. Ames-Lewis and A. Bednarek, 15–23. London.

Kemp, M., and M. Walker, eds. 1989. *Leonardo on Painting: An Anthology of Writings*. London.

Kendall, P. M., and V. Ilardi, eds. 1970. *Dispatches with Related Documents of Milanese Ambassadors in France and Burgundy, 1450–1483*. 3 vols. Athens, OH.

Kenyon de Pascual, B. 1987. "Bassano Instruments in Spain?" *The Galpin Society Journal* 40: 74–75.

Kervyn de Lettenhove. 1869. "Relations du mariage du duc Charles de Bourgogne et de Marguerite d'York." *Bulletin de la Commission Royale d'histoire*, 3e série, 10: 245–66.

Kieckhefer, R. 1989. *Magic in the Middle Ages*. Cambridge.

Killerby, C. K. 1994. "Practical Problems in the Enforcement of Italian Sumptuary Law, 1200–1500." In *Crime, Society, and the Law in Renaissance Italy*, ed. T. Dean and K. J. P. Lowe, 99–120. Cambridge.

Kipling, G. 1977. *The Triumph of Honour: Burgundian Origins of the Elizabethan Renaissance*. Leiden.

Knighton, T. 1989. "The Spanish Court of Ferdinand and Isabella." In *The Renaissance: From the 1470s to the End of the Sixteenth Century. Man and Music* series, ed. I. Fenlon, 341–60. London.

Kristeller, P. O. 1990. *Renaissance Thought and the Arts: Collected Essays*. Princeton.

Kruse, J. 1993. "Hunting, Magnificence and the Court of Leo x." *Renaissance Studies* 7: 243–57.

Kurke, L. 1992. "The Politics of *habrosune* in Archaic Greece." *Classical Antiquity* 11: 91–120.

Kurz, O. 1969. "A Gold Helmet Made in Venice for Sultan Sulayman the Magnificent." *Gazette des Beaux-Arts* 74: 249–58.

Laborde, L. 1849–1852. *Les Ducs de Bourgogne: Études sur les lettres, les arts et l'industrie pendant le xvᵉ siècle*. 3 vols. Paris.

Labriolle-Rutherford, M. R. de. 1963. "L'Evolution de la notion du luxe depuis Mandeville jusqu'à la Révolution." *Studies on Voltaire* 26: 1025–36.

Landucci, L. 1883. *Diario Fiorentino: A Florentine Diary from 1450 to 1516*. Trans. R. Jervis. Florence.

Lannoy, G. de. 1878. *Oeuvres*, ed. C. T. Potvin. Louvain.

Lasocki, D. 1985. "The Anglo-Venetian Bassano Family as Instrument Makers and Repairers." *The Galpin Society Journal* 38: 112–32.

Laurioux, B. 1992. "Table et hiérarchie sociale à la fin du Moyen Âge." In *Du Manuscrit à la table*, ed. C. Lambert, 87–108. Montreal and Paris.

Le Maire, O. 1956. "François de Tassis (1459–1517), organizateur des postes internationales et la tapisserie de la légende de N. D. du Sablon." *De Schakel* 1: 3–15.

Leben, U. 1993. "New Light on the École Gratuite de Dessin: The Years 1766–1815." *Studies in the Decorative Arts*, Fall: 99–118.

Lestocquoy, J. 1938. "L'Atelier de Bauduin de Bailleul et la tapisserie de Gédéon." *Revue belge d'archéologie et d'histoire de l'art* 8: 119–37.

———. 1978. *Deux siècles de l'histoire de la tapisserie 1300–1500*. Arras.

Lewis, A. 1999. "Nicolas Gombert's First Book of Four-Voice Motets: Anthology or Apologia." In *The Empire Resounds: Music in the Days of Charles v*, ed. F. Maes, 47–62. Leuven.

Lightbown, R. W. 1978. *Secular Goldsmiths' Work in Medieval France: A History*. London.

———. 1979. "Ex-Votos in Gold and Silver: A Forgotten Art." *Burlington Magazine* 121: 353–59.

———. 1992. *Medieval European Jewelry*. London.

Lindahl, F. 1962. "Tandstikkere fra Christian ıvˢ tid." *Nationalmuseets Arbejdsmark*, 5–17.

Lockwood, L. 1984. *Music in Renaissance Ferrara, 1400–1505*. Cambridge, MA.

Loomis, L. H. 1958. "Secular Dramatics in the Royal Palace, Paris, 1378, 1389, and Chaucer's Tregetoures." *Speculum* 33: 242–55.

Luchinat, C. A., ed. 1997. *Treasures of Florence: The Medici Collection, 1400–1700*. Munich.

Lux, D. 1982. "Patronage in the Age of Absolutism: Royal Academies and State Building Policy in Seventeenth-Century France." *Proceedings of the ixth Annual Meeting of the Western Society for French History*, 85–95.

Luzio, A. 1906. "Isabella d'Este nei primordi del papato di Leone x e il suo viaggio a Roma nel 1514–1515." *Archivio storico lombardo*, ser. 4, 6: 99–180, 454–89.

———. 1908. "L'inventario della Grotta d'Isabella d'Este." *Archivio storico lombardo* 35: 413–25.

Machiavelli, N. 1909. *Florentine History*. Trans. W. K. Marriott. London.

La magnifique et sumptueuse Pompe Funebre faite aux Obseques et Funerailles du tresgrand et tresvicto- rieus Empereur Charles Cinquième, Celebrées en la Vile de Bruxelles le xxıx iour du Mois de Decembre mdlvııı par Philippes Roy Catholique d'Espaigne son Fils. 1559. Antwerp.

Malipiero, D. 1843–1844. *Annali veneti, dall'anno 1457–1500*, ed. Agostino Sagredo. *Archivio storico italiano*, ser. 1, 7: 1–2.

Mann, J. G. 1942. "The Etched Decoration of Armour." *Proceedings of the British Academy* 28: 17–45.

Marche, O. de la. 1883–1888. *Mémoires d'Olivier de la Marche*, ed. H. Beaune and J. d'Arbaumont. 4 vols. Paris.

Marix, J. 1939. *Histoire de la musique et des musiciens de la cour de Bourgogne sous le règne de Philippe le Bon (1420–1467)*. Strasbourg.

Martens, M. 1952. "La Correspondance de caractère économique échangée par Francesco Sforza, duc de Milan, et Philippe le Bon, duc de Bourgogne (1450–1466)." *Bulletin de l'Institut historique belge de Rome* 27: 221–34.

Mason, G. 1966. "Food as a Fine Art in Seventeenth-Century Rome." *Apollo* 83: 338–41.

Massinelli, A. M., and F. M. Tuena. 1992. *Treasures of the Medici*. New York.

Masson, A. 1926. "La robe brodée de musique du poète Charles d'Orléans (Bibliothèque de Rouen-Leber 5685)." *Les Trésors des bibliothèques de France*. Vol. 1: 140–41. Paris.

Masterpieces of Tapestry from the Fourteenth to the Sixteenth Century. 1974. Exh. cat. New York.

Maurice, K., and O. Mayr, eds. 1980. *The Clockwork Universe: German Clocks and Automata, 1550–1650*. New York.

McClellan, A. 1994. *Inventing the Louvre: Art, Politics, and the Origins of the Modern Museum in Eighteenth-Century Paris*. Cambridge.

McGee, T. 1988. "Dancing Masters and the Medici Court in the 15th Century." *Studi Musicali* 17: 201–24.

McKendrick, S. 1988. "Classical Mythology and Ancient History in Works of Art at the Courts of France, Burgundy and England 1364–1500." Ph.D. diss., Courtauld Institute, London.

———. 1991. "The *Great History of Troy*: A Reassessment of the Development of a Secular Theme in Late Medieval Art." *Journal of the Warburg and Courtauld Institutes* 54: 43–82.

Meconi, H. 1999. "Foundation for an Empire: The Musical Inheritance of Charles v." In *The Empire Resounds: Music in the Days of Charles v*, ed. F. Maes, 19–34. Leuven.

Meiss, M. 1967. *French Painting in the Time of Jean de Berry*. Vols. 1–2, *The Late Fourteenth Century and the Patronage of the Duke*. London and New York.

Meoni, L. 1998. *Gli arazzi nei musei fiorentini: La collezione medicea: Catalogo completo*. Vol. 1. *Manufattura da Cosimo I a Cosimo II (1545–1621)*. Livorno.

Merkley, P. A., and L. L. M. Merkley. 1999. *Music and Patronage in the Sforza Court*. Turnhout.

Miller, C. A. 1972. "Jerome Cardan on Gombert, Phinot, and Carpentras." *The Musical Quarterly* 58: 412–19.

Mitchell, B. 1979. *Italian Civic Pageantry in the High Renaissance*. Florence.

Montagu, J. 1989. *Roman Baroque Sculpture: The Industry of Art*. New Haven.

Morize, A. 1909/1970. *L'Apologie du luxe au XVIIIe siecle et le Mondain de Voltaire*. Geneva.

Muccini, U. 1997. *Painting, Sculpture and Architecture in Palazzo Vecchio of Florence*. Florence.

Müntz, E. 1876. "La Tapisserie à Rome au XVe siecle." *Gazette des Beaux-Arts* 14: 5ff.

———. 1890. *Les Archives des arts: Recueil de documents inédits ou peu connus par Eugène Müntz*. Paris.

Naylor, G. 1971. *The Arts and Crafts Movement: A Study of Its Sources, Ideals, and Influence on Design Theory*. Cambridge, MA.

Necipoglu, G. 1989. "Süleyman the Magnificent and the Representation of Power in the Context of Ottoman-Hapsburg-Papal Rivalry." *Art Bulletin* 71: 401–27.

Newett, M. M. 1907. "The Sumptuary Laws in Venice in the Fourteenth and Fifteenth Centuries." In *Historical Essays by Members of the Owens College, Manchester*, ed. T. F. Tout and J. Tait, 244–76. Manchester.

Newton, S. M. 1988. *The Dress of the Venetians, 1495–1525*. Aldershot.

Notzing, Jakob Schrenck von. 1981. *Armamentarium Heroicum, Die Heldenrüstkammer Erzherzog Ferdinands II. auf Schloss Ambras bei Innsbruck*. Innsbruck, 1603. Facsimile ed. B. Thomas. Osnabrück.

Olmi, G. 1985. "Science—Honour—Metaphor: Italian Cabinets of the Sixteenth and Seventeenth Centuries." In Impey and MacGregor 1985: 5–16.

Panofsky, E., ed. and trans. 1979. *Abbot Suger on the Abbey Church of Saint-Denis and Its Art Treasures*. 2nd edn. Princeton.

Pastor, L. 1923–1969. *The History of the Popes, from the Close of the Middle Ages*. 40 vols. St. Louis, MO.

Perkins, L. L. 1982. "Musical Patronage at the Royal Court of France." *Journal of the American Musicological Society* 37: 507–66.

———. 1999. *Music in the Age of the Renaissance*. New York.

Pevsner, N. 1940. *Academies of Art: Past and Present*. Cambridge.

Pfaffenbichler, M. 1992. *Armourers*. Toronto.

Picker, M., ed. 1965. *The Chanson Albums of Marguerite of Austria*. Berkeley.

Pilliod, E. 1998. "Representation, Misrepresentation, and Non-Representation: Vasari and His Competitors." In *Vasari's Florence: Artists and Literati at the Medicean Court*, ed. P. Jacks, 30–52. Cambridge.

Pinchart, A. 1878–1885. *Histoire de la tapisserie dans les Flandres*. Paris.

Pintoin, M. 1839–1852. *Chronique du religieux de Saint-Denys*, ed. L. F. Bellaguet. 6 vols. Paris.

Pirro, A. 1935. "Leo x and Music." *The Musical Quarterly* 21: 1–13.

Pliny the Elder. 1967. *Historia Naturalis*. Trans. D. E. Eichholz. Cambridge.

Price, S. 1989. *Primitive Art in Civilized Places*. Chicago.

Princely Magnificence: Court Jewels of the Renaissance, 1500–1630. Exh. cat. 1980. London.

Prior, R. 1983. "Jewish Musicians at the Tudor Court." *The Musical Quarterly* 69: 253–65.

———. 1995. "Was Emilia Bassano the Dark Lady of Shakespeare's Sonnets?" In *The Bassanos: Venetian Musicians and Instrument Makers in England, 1531–1665*, ed. D. Lasocki and R. Prior, 114–39. Aldershot.

Prizer, W. F. 1980. *Courtly Pastimes: The Frottole of Marchetto Cara*. Ann Arbor, MI.

———. 1985. "Music and Ceremonial in the Low Countries: Philip the Fair and the Order of the Golden Fleece." *Early Music History* 5: 113–53.

———. 1989. "Music at the Court of the Sforza: The Birth and Death of a Musical Center." *Musica Disciplina* 43: 141–93.

Prost, B. 1902–1908. *Inventaires mobiliers et extraits des comptes des ducs de Bourgogne*. 2 vols. Paris.

Pulci, L. 1527. *La Giostra di Lorenzo de' Medici*. Venice.

Pyhrr, S. W., and J.-A. Godoy. 1998. *Heroic Armor of the Italian Renaissance: Filippo Negroli and His Contemporaries.* New York.

Quicke, F., ed. 1943. *Les Chroniqueurs des fastes Bourguignons.* Brussels.
Quinn, D. B. 1977. *North America from Earliest Discovery to First Settlements: The Norse Voyages to 1612.* New York.

Redon, O. 1992. "La Réglementation des banquets par les lois somptuaires dans les villes d'Italie (xiii\u1d49–xv\u1d49 siècles). In *Du Manuscrit à la table*, ed. C. Lambert, 109–20. Montreal and Paris.
Reitlinger, G. 1961–1970. *The Economics of Taste.* 3 vols. London.
Ricciardi, L. 1992. *Col senno, col tesoro, e colla lancia: Riti e giochi cavallereschi nella Firenze del Magnifico Lorenzo.* Florence.
Riddle, J. M. 1977. *Marbode of Rennes.* De lapidibus: *Considered as a Medical Treatise with Text, Commentary and C. W. King's Translation.* Wiesbaden.
Riddle, J. M., and J. A. Mulholland. 1980. "Albert on Stones and Minerals." In *Albertus Magnus and the Sciences*, ed. J. A. Weisheipl, 203–34. Toronto.
Rochon, A. 1963. *La Jeunesse de Laurent de Médicis (1449–1478).* Paris.
Root, W. L. 1971. *The Food of Italy.* New York.
Roover, R. De. 1948. *Money, Banking and Credit in Mediaeval Bruges.* Cambridge, MA.
Rosenthal, E. R. 1973. "The Invention of the Columnar Device of Emperor Charles v at the Court of Burgundy in Flanders in 1516." *Journal of the Warburg and Courtauld Institutes* 36: 199–230.
Ross, C. D. 1974. *Edward iv.* London.
Rowland, I. D. 1998. *The Culture of the High Renaissance: Ancients and Moderns in Sixteenth-Century Rome.* Cambridge.
Rowlands, J. 1988. *The Age of Dürer and Holbein: German Drawings 1400–1550.* London.
Rubin, P. 1995. *Giorgio Vasari: Art and History.* New Haven.
Russell, J. G. 1969. *The Field of Cloth of Gold: Men and Manners in 1520.* London.
Ryder, A. F. C. 1976. *The Kingdom of Naples under Alfonso the Magnanimous: The Making of a Modern State.* Oxford.

Saintenoy, P. 1921. "Les tapisseries de la Cour de Bruxelles sous Charles v." *Annales de la Société royale d'archéologie de Bruxelles* 30: 5–31.
———. 1932–1934. *Les Arts et les artistes à la cour de Bruxelles.* 2 vols. Brussels.
Saisselin, R. G. 1981. "Neo-Classicism: Images of Public Virtue and Realities of Private Luxury." *Art History* 4: 14–36.
Sanuto, M. 1879–1903. *I diarii di Marino Sanuto.* Ed. R. Fulin et al. Venice.
Sargentson, C. 1996. *Merchants and Luxury Markets: The* Marchands Merciers *of Eighteenth-Century Paris.* Los Angeles.
Saulnier-Pernuit, L. 1993. *Les Trois couronnements: Tapisserie du Trésor de la Cathédrale de Sens.* Paris.
Scheicher, E. 1983. "Die *Imagines gentis Austriacae* des Francesco Terzio." *Jahrbuch der Kunsthistorischen Sammlungen in Wien* 79: 43–92.

———. 1985. "The Collection of Archduke Ferdinand ii at Schloss Ambras: Its Purpose, Composition and Evolution." In Impey and MacGregor 1985, 29–38.
———. 1990. "Historiography and Display: The 'Heldenrüstkammer' of Archduke Ferdinand ii in Schloss Ambras." *Journal of the History of Collections* 2: 69–79.
Schneebalg-Perelman, S. 1961. "'Le Retouchage' dans la tapisserie bruxelloise, ou, Les origines de l'edit imperiale de 1544." *Annales de la Société royale de l'archéologie de Bruxelles* 50.
———. 1969. "Le Rôle de la banque de Medicis dans la diffusion des tapisseries flamandes." *Revue belge d'archéologie et d'histoire de l'art* 38: 19–40.
Schrader, S. 1998. "'Greater than ever He Was.' Ritual and Power in Charles v's 1558 Funeral Procession." *Nederlands Kunsthistorische Jaarboek* 49: 68–93.
Scott, K. 1989. "Hierarchy, Liberty and Order: Languages of Art and Institutional Conflict in Paris (1766–1776)." *The Oxford Art Journal* 12: 59–70.
———. 1995. *The Rococo Interior: Decoration and Social Spaces in Early Eighteenth-Century Paris.* New Haven.
Seebass, T. 1983. "The Visualization of Music through Pictorial Imagery and Notation in Late Mediaeval France." In *Studies in the Performance of Late Mediaeval Music*, ed. S. Boorman, 19–34. Cambridge.
Shearman, J. K. G. 1972. *Raphael's Cartoons in the Collection of Her Majesty the Queen, and the Tapestries for the Sistine Chapel.* London.
Sherwood, M. 1947. "Magic and Mechanics in Medieval Fiction." *Studies in Philology*: 567–92.
Shiner, L. 1994. "Primitive Fakes, Tourist Art and the Ideology of Authenticity." *Journal of Aesthetics and Art Criticism* 52: 226–34.
Skinner, Q. 1978. *The Foundations of Modern Political Thought.* 2 vols. Cambridge.
Small, G. 1982. "Cosimo i and the Joseph Tapestries for the Palazzo Vecchio." *Renaissance and Reformation* 6: 183–96.
Smith, A. W., ed. and trans. 1995. *Fifteenth-Century Dance and Music: Twelve Transcribed Italian Treatises and Collections in the Tradition of Domenico da Piacenza.* Stuyvesant, NY.
Smith, J. C. 1979. "Artistic Patronage of Philip the Good, Duke of Burgundy (1419–1467)." Ph.D. diss., Columbia University.
———. 1989. "Portable Propaganda—Tapestries as Princely Metaphors at the Courts of Philip the Good and Charles the Bold." *Art Journal*: 123–29.
Spallanzani, M., and G. G. Bertelà, eds. 1992. *Libro d'inventario dei beni di Lorenzo il Magnifico.* Florence.
Sparti, B. 1986. "The 15th-Century *balli* Tunes: A New Look." *Early Music* 14: 346–57.
———, ed. and trans. 1993. *Guglielmo Ebreo of Pesaro,* De Pratica seu arte Tripudii. On the Practice or Art of Dancing. Oxford.
Stafford, B. M. 1994. *Artful Science: Enlightenment, Entertainment, and the Eclipse of Visual Education.* Cambridge, MA.
Starkey, D., ed. 1991. *Henry viii: A European Court in England.* New York.
———. 1998. *The Inventory of King Henry viii.* London.
Starr, P. F. 1987. "Music and Music Patronage at the Papal Court, 1447–1464." Ph.D. diss., Yale University.

———. 1992. "Rome as the Center of the Universe: Papal Grace and Music Patronage." *Early Music History* 11: 223–62.

Stewart, A. F. 1990. *Greek Sculpture: An Exploration*. 2 vols. New Haven.

Strohm, R. 1990. *Music in Late Medieval Bruges*. Rev. edn. Oxford.

———. 1993. *The Rise of European Music, 1380–1500*. Cambridge.

Strümer, M. 1979. "An Economy of Delight: Court Artisans of the Eighteenth Century." *Business History Review* 53: 496–528.

Sullivan, P. 1985. "Medieval Automata: The 'Chambre de Beautés' in Benoît's *Roman de Troie*." *Romance Studies* 6: 1–20.

Tafur, P. 1926. *Travels and Adventures 1435–1438*. Ed. M. Letts. London.

Tapestry in the Renaissance: Art and Magnificence. 2000. Exh. cat. New York, The Metropolitan Museum of Art.

Tapisseries bruxelloises de la pré-Renaissance. 1976. Exh. cat. Brussels.

Theophrastus. 1956. *On stones*, trans. E. R. Caley and J. F. C. Richards. Columbus, OH.

Thomas, A. H., and I. D. Thornley, eds. 1938. *The Great Chronicle of London (Guildhall Library MS 3313)*. London.

Thomson, W. G. 1973. *History of Tapestry from the Earliest Times until the Present Day*. 3rd edn. East Ardsley, England.

Treasury of San Marco, Venice. 1984. Exh. cat. Los Angeles and Milan.

Le Trésor de Saint-Denis. 1991. Exh. cat. Louvre, Paris.

Van Mander, C. 1994–1999. *The Lives of the Illustrious Netherlandish and German Painters*, ed. H. Miedema. 6 vols. Doornspijk.

Vasari, G. 1996. *Lives of the Painters, Sculptors and Architects*, trans. G. du C. de Vere. 2 vols. New York.

Vaughan, R. 1962. *Philip the Bold: The Formation of the Burgundian State*. Cambridge, MA.

———. 1970. *Philip the Good: The Apogee of Burgundy*. New York.

———. 1973. *Charles the Bold: The Last Valois Duke of Burgundy*. London.

———. 1975. *Valois Burgundy*. London.

Velden, H. van der. 2000. *The Donor's Image: Gerard Loyet and the Votive Portraits of Charles the Bold*. Turnhout.

Voet, L., and J. Voet-Grisolle. 1980–1983. *The Plantin Press (1555–1589): A Bibliography of the Works Printed and Published by Christopher Plantin at Antwerp and Leiden*. 6 vols. Amsterdam.

Wagner, A. R. 1959. "The Swan Badge and the Swan Knight." *Archeologia* 97: 127–38.

Walker, D. P. 1958. *Spiritual and Demonic Magic: From Ficino to Campanella*. London.

Walsh, R. 1978. "Music and Quattrocento Diplomacy: The Singer Jean Cordier between Milan, Naples and Burgundy in 1475." *Archiv für Kulturgeschichte* 60: 439–42.

Watson, K. J. 1978. "Sugar Sculpture for Grand Ducal Weddings from the Giambologna Workshop." *Connoisseur* 199: 20–26.

Weil-Garris, K., and J. F. d'Amico. 1980. "The Renaissance Cardinal's Ideal Palace: A Chapter from Cortesi's *De Cardinalatu*." In *Studies in Italian Art and Architecture, 15th through 18th Centuries*, ed. H. A. Millon, 45–124. Cambridge, MA.

Welch, E. S. 1993. "Sight, Sound and Ceremony in the Chapel of Galeazzo Maria Sforza." *Early Music History* 12: 151–90.

———. 1995. *Art and Authority in Renaissance Milan*. New Haven.

Westfall, S. R. 1990. *Patrons and Performance: Early Tudor Household Revels*. Oxford.

Whitford, F. 1984. *Bauhaus*. London.

Wilson, C. A., ed. 1991. *"Banqueting Stuffe": The Fare and Social Background of the Tudor and Stuart Banquet*. Edinburgh.

Wohl, H. 1999. *The Aesthetics of Italian Renaissance Art: A Reconsideration of Style*. Cambridge.

Woodley, R. 1981. "Iohannes Tinctoris: A Review of the Documentary Biographical Evidence." *Journal of the American Musicological Society* 34: 217–48.

———. 1982. "The *Proportionale musices* of Iohannes Tinctoris: A Critical Edition, Translation and Study." D.Phil. thesis, University of Oxford.

———. 1988. "Tinctoris's Italian Translation of the Golden Fleece Statutes: A Text and a (Possible) Context." *Early Music History* 8: 173–244.

Wright, C. M. 1975. "Dufay at Cambrai: Discoveries and Revisions." *Journal of the American Musicological Society* 28: 175–229.

———. 1979. *Music at the Court of Burgundy, 1364–1419: A Documentary History*. Henryville, PA.

Wroth, L. C. 1970. *The Voyages of Giovanni da Verrazzano, 1524–1528*. New Haven.

Index

© 2005 J. Paul Getty Trust

Getty Publications
1200 Getty Center Drive, Suite 500
Los Angeles, California 90049-1682
www.getty.edu

Christopher Hudson, Publisher
Mark Greenberg, Editor in Chief

Benedicte Gilman, Manuscript Editor
Kurt Hauser, Designer
Amita Molloy, Production Coordinator
Carol Roberts, Indexer

Typography by Diane Franco

Color separations by Professional Graphics Inc.,
Rockford, Illinois

Printed and bound by CS Graphics Pte. Ltd., Singapore

Unless otherwise specified, photographs are provided
and reproduced by courtesy of the owners of the
objects.

Front and back covers: Details of fig. III-8.

Title page: Detail of fig. IV-43.

Page viii: Detail of fig. 6.

Page 12: Detail of fig. I-10.

Page 46: Detail of fig. II-22.

Page 88: Detail of fig. III-24.

Page 134: Detail of fig. IV-34.

Page 186: Detail of fig. V-8.

Page 226: Detail of fig. VI-1.

Page 262: Detail of fig. 8.

Library of Congress Cataloguing-in-Publication Data

Belozerskaya, Marina
 Luxury arts of the Renaissance / Marina Belozerskaya.
 p. cm.
 Includes bibliographical references and index.
 ISBN-13: 978-0-89236-785-6 (hardcover)
 ISBN-10: 0-89236-785-7 (hardcover)
 1. Decorative arts, Renaissance. 2. Decorative arts—
Europe. 3. Luxuries–Europe. I. Title.
 NK925.B44 2005
 745'094'09024–dc22
 2005005151